THE CINEMA OF BRITAIN AND IRELAND

First published in Great Britain in 2005 by
Wallflower Press
4th Floor, 26 Shacklewell Lane, London E8 2EZ
www.wallflowerpress.co.uk

A catalogue for this book is available from the British Library

ISBN 1-904764-38-X (paperback)
ISBN 1-904764-39-8 (hardback)

Printed by Antony Rowe Ltd., Chippenham, Wiltshire

THE CINEMA OF
BRITAIN AND IRELAND

EDITED BY

BRIAN McFARLANE

 WALLFLOWER PRESS LONDON & NEW YORK

24 FRAMES is a major new series focusing on national and regional cinemas from around the world. Rather than offering a 'best of' selection, the feature films and documentaries selected in each volume serve to highlight the specific elements of that territory's cinema, elucidating the historical and industrial context of production, the key genres and modes of representation, and foregrounding the work of the most important directors and their exemplary films. In taking an explicitly text-centred approach, the titles in this list offer 24 diverse entry-points into each national and regional cinema, and thus contribute to the appreciation of the rich traditions of global cinema.

Series Editors: Yoram Allon & Ian Haydn Smith

OTHER TITLES IN THE **24 FRAMES** SERIES:

THE CINEMA OF LATIN AMERICA *edited by Alberto Elena and Marina Díaz López*

THE CINEMA OF THE LOW COUNTRIES *edited by Ernest Mathijs*

THE CINEMA OF ITALY *edited by Giorgio Bertellini*

THE CINEMA OF JAPAN AND KOREA *edited by Justin Bowyer*

THE CINEMA OF CENTRAL EUROPE *edited by Peter Hames*

THE CINEMA OF SPAIN AND PORTUGAL *edited by Alberto Mira*

THE CINEMA OF SCANDINAVIA *edited by Tytti Soila*

FORTHCOMING TITLES:

THE CINEMA OF FRANCE *edited by Phil Powrie*

THE CINEMA OF CANADA *edited by Jerry White*

THE CINEMA OF THE BALKANS *edited by Dina Iordanova*

THE CINEMA OF AUSTRALIA AND NEW ZEALAND *edited by Geoff Mayer and Keith Beattie*

THE CINEMA OF RUSSIA AND THE FORMER SOVIET UNION *edited by Birgit Beumers*

THE CINEMA OF NORTH AFRICA AND THE MIDDLE EAST *edited by Gönül Donmez-Colin*

THE CINEMA OF INDIA *edited by Lalitha Gopalan*

CONTENTS

For my grandchildren – Edvard and Emma Håkansson, Henrietta and Dougall McFarlane, and Declan Scully – with love.

NOTES ON CONTRIBUTORS

TONY ALDGATE is Reader in Film and History at The Open University of the United Kingdom, and a much published writer on British cinema history. His publications include *Censorship and the Permissive Society: British Cinema and Theatre 1955–1965* (Clarendon Press, 1995) and, as co-author, *Best of British: Cinema and Society from 1930 to the Present* (I. B. Tauris, 1999).

BRUCE BABINGTON is Professor of Film at the University of Newcastle upon Tyne. Among his books are *British Stars and Stardom* (Manchester University Press, 2001) and *Launder and Gilliat* (Manchester University Press, 2002), and, as co-editor, *The Trouble With Men: Masculinities in European and Hollywood Cinema* (Wallflower Press, 2004).

CHARLES BARR is Professor of Film Studies at the University of East Anglia and is the author of *Ealing Studios* (Studio Vista, revised edn., 1993), *English Hitchcock* (Cameron & Hollis, 1999) and the editor of *All Our Yesterdays: 90 Years of British Cinema* (British Film Institute, 1986), and of many articles on British Cinema.

IAN BRITAIN has lectured in history, film and literature. He has published several books, including *Fabianism and Culture* (Cambridge University Press, 1982), *Once an Australian* (Oxford University Press, 1997), and is currently the editor of *Meanjin* magazine, Melbourne.

GEOFF BROWN writes on music and film for *The Times*. His books on British cinema books include *Walter Forde* (British Film Institute, 1977), *Launder and Gilliat* (British Film Institute, 1977) and *The Common Touch: The Films of John Baxter* (British Film Institute, 1989).

STEVE CHIBNALL is Co-ordinator of the British Cinema and Television Research Group, De Montfort University, Leicester, UK. He has published widely on British crime and horror films, and on the directors J. Lee Thompson and Pete Walker, and is co-authoring a book on the British 'B' movie.

WENDY EVERETT is Senior Lecturer at the University of Bath. Recent publications include *European Identity in Cinema* (Intellect, 1996), *The Seeing Century: Film, Vision, and Identity* (Rodopi, 2000), *Terence Davies* (Manchester University Press, 2004), and numerous journal articles and book chapters.

CHRISTINE GERAGHTY is Professor of Film and Television Studies at the University of Glasgow. She is the author of *British Cinema in the Fifties: Gender, Genre and the 'New Look'* (Routledge, 2000) and her most recent book is a study of *My Beautiful Laundrette* (I. B. Tauris, 2004).

PHILIP GILLETT is a freelance writer on film and author of *The British Working Class in Postwar Film* (Manchester University Press, 2003), and is now working on a study of neglected British films.

KEVIN GOUGH-YATES taught for many years at the University of Westminster and now works for Channel 4. He is currently a Visiting Fellow at the University of Southampton. His forthcoming books are on German exiles in Britain (for I. B. Tauris) and on Powell and Pressburger (for Manchester University Press).

JOHN HILL is Professor of Media Studies at the University of Ulster. He is the author, co-author or co-editor of a number of books, including *Sex, Class and Realism: British Cinema 1956–63* (British Film Institute, 1986), *Cinema and Ireland* (Routledge, 1988), *The Oxford Guide to Film Studies* (1998) and *British Cinema in the 1980s* (Clarendon Press, 1999).

ROSE LUCAS is Senior lecturer in the School of Literary, Visual and Performance Studies at Monash University, Melbourne, and has published widely in the areas of cinema, women's literature and psychoanalysis. Her publications include, as co-author, *Bridgings: Readings in Australian Women's Poetry* (Oxford University Press, 1996).

LUKE McKERNAN is the author of *Topical Budget* (1992) and *Who's Who of Victorian Cinema* (1996), and is researching the life of Charles Urban. He is Head of Information at the British Universities Film and Video Council.

BRIAN McFARLANE is Honorary Associate Professor at the School of English, Communication and Performance Studies at Monash University, Melbourne. His books include *Novel to Film: An*

Introduction to the Theory of Adaptation (Clarendon Press, 1996), *An Autobiography of British Cinema* (Methuen/British Film Institute, 1997) and *Lance Comfort* (Manchester Univeresity Press, 1999). He has recently compiled and edited *The Encyclopedia of British Film* (Methuen/British Film Institute, 2003; 2nd edn. 2005) and is co-authoring a book on the British 'B' movie.

MARTIN McLOONE is Senior Lecturer in Media Studies at the University of Ulster, Coleraine and author of *Irish Film: The Emergence of a Contemporary Cinema* (British Film Institute, 2000).

ROBERT MURPHY is Professor of Film Studies at De Montfort University and is the author of *British Cinema and the Second World War* (Continuum, 2000) and other books on British cinema. He is also the editor of *The British Cinema Book* (British Film Institute, 1997; second edition, 2001).

JOHN OLIVER is a cataloguer with the National Film and Television Archive, London.

EMER ROCKETT is Lecturer in Film Studies, having taught at University College Dublin and the National College of Art and Design, and is co-author of *Neil Jordan: Exploring Boundaries* (The Liffey Press, 2003).

KEVIN ROCKETT is Lecturer in Film Studies at Trinity College Dublin. He is co-author of *Cinema and Ireland* (Routledge, 1987), *Still Irish* (Red Mountain Press, 1995), *The Companion to British and Irish Cinema* (Continuum, 1996) and *Neil Jordan: Exploring Boundaries* (The Liffey Press, 2003), he is editor and compiler of *The Irish Filmography: Fiction Films 1896–1996* (Red Mountain Press, 1996).

DAVE ROLINSON is Lecturer in Film Studies at the University of Hull, and author of *Alan Clarke* (Manchester University Press, 2005).

TOM RYALL is Professor of Film History at Sheffield Hallam University. His books include *Alfred Hitchcock and the British Cinema* (University of Illinois Press, 1986) and *Britain and the American Cinema* (Sage Publications, 2001). He is currently working on a study of the films of Anthony Asquith.

NEIL SINYARD is Senior Lecturer in Film Studies at Hull University. He has authored many books on the cinema, including studies of Jack Clayton, Richard Lester and Nicolas Roeg, and co-edited *British Cinema of the 1950s: A Celebration* (Manchester University Press, 2003).

ANDREW SPICER teaches at the University of the West of England. He has written numerous articles on British cinema, and the books *Typical Men: the Representation of Masculinity in Popular British Cinema* (I. B. Tauris, 2001) and *Film Noir* (Longman, 2002). He is presently writing a book on Sydney Box (for Manchester University Press) and editing Box's autobiography (for Scarecrow).

MELANIE WILLIAMS is Lecturer in Film Studies at the University of Hull. She has written articles on various aspects of British cinema for the *Quarterly Review of Film and Video*, the *Journal of Popular British Cinema* and the *Journal of Gender Studies* and contributed to *British Cinema in the Fifties* (Manchester University Press, 2003).

PREFACE

The story of the cinema in Britain and Ireland began, as it did in several other countries, in 1895. The films were silent and very short. They were shown to the public in ordinary shops, which were rigged up for the purpose by blacking out the windows and installing wooden benches for seating. The effect was tremendously exciting. Admittedly it was like a magic lantern show, but now with pictures that moved! Perhaps a piano was brought in, with a pianist who attempted to follow the mood of the pictures.

The novelty of the thing attracted a large public, but their curiosity was quickly satisfied and the new cinema-goers drifted away. After all, it was only a fad and would come to nothing. A bit of a joke really. It was nothing like the theatre, with real people, where you got a story, or the music halls, which were fun. Anyway, it was nothing like a good book. It was widely held that the new fad of roller-skating rinks would prevail over the cinema, so financiers put their money into building huge rooms that looked like dance halls with concrete floors. However, the film pioneers responded with improved cameras and film and they began to tell stories, *Rescued by Rover, Scenes from Shakespeare*, and so on. Slowly the public responded and some of the rinks were converted into cinemas. A cinema-going audience began to form, but the theatre and the music hall easily held their own against the competition. Also the national devotion to reading and all things literary was unaltered.

Then the war came, which changed everything. The national response to the Great War of 1914–18 was one of total dedication to the matter in hand. Nobody thought about anything else. The cinema did its bit with newsreel, documentary and propaganda but the cinematic side of life was ignored like everything else except the War. Any development in film production was forgotten and soon the imports began to arrive: hilarious comedy with great stars like Buster Keaton and Charlie Chaplin, epics from D. W. Griffith, appealing light drama with Mary Pickford, and so on.

The aftermath, the famous 1920s, was a period of alternating exhaustion and hysteria. Film production began to pick up and proper cinemas were opened, but still 'the flicks' were not to be taken seriously. A common description was 'Nine pennyworth of dark', which meant a double seat at the back for two together. The Establishment continued its attitude of lofty

disdain. For one thing, it completely ignored the importance of exporting films, conveying impressions of the British way of life. Nevertheless, home audiences were developing rapidly and began a habit of regular weekly attendance, sometimes twice weekly. This brought a degree of stability to a muddle of fly-by-night enterprises that were shaping into an industry. As Samuel Goldwyn said, 'God forbid they should ever lose the habit.' Well, they did lose it, but not until many years had passed.

The distributors and exhibitors now settled into real business, which, to them, meant buying Hollywood films at low rates. They disregarded British films except in one or two cases that featured star attractions. There were some good films made here during that period, directed by Maurice Elvey and Victor Saville among others. Michael Balcon was emerging as a great producer but the exhibitors moaned that although some of the films were good, a lot of publicity was needed to persuade the public to come and they could not afford it.

American producers, as soon as they discovered new stars, put them into picture after picture as quickly as possible, making sure their faces were before the public almost constantly and backing them with intense publicity. They could afford to build up their industry because their domestic market was six times or more larger than any other. In this comfortable position American distributors looked upon foreign sales as bunce and so they captured the foreign markets with attractive prices. An impression of the American way of life was soon implanted. The wonderful cars, the magnificent homes…

There was another important production centre exercising influence of a different kind – Soviet Russia. After the revolution there, the regime was the first to understand the immense power of film as propaganda and they produced some brilliant examples. Aside from the social messages, these films were written, directed, photographed and edited by people who treated film making as an art, a popular art which would reach millions, internationally. A small number of the intelligentsia in Britain, mostly those working in documentary, picked up the hint. There was firm ground here for raising new perspectives. Maybe so, but…

By the middle of the 1920s public sentiment was heading for depression. British production was stifled and investment was extremely risky. There was still a large proportion of influential people, politicians and professionals generally, who had no interest in the cinema and were by their nature disinclined to involve themselves. The Quota Act had been well-intentioned but had mainly brought the production of 'quota quickies'. Some cinemas had been grouped together here and there in small chains but the film studios were mostly converted

country houses and altogether it was a bit of a tinpot effort, not a real industry. As to art, well, art was poetry, music, painting, theatre – that sort of thing.

By 1927–28 audiences were again beginning to dwindle in America and all the major studios were searching for something to perk things up, such as wide-screen presentation. This was dropped at once when Al Jolson burst on to the screen – All Talking! All Singing! All Dancing!

At last the cinema, except for colour photography, was complete. People flocked to it. Cinema was now able to establish itself as part and parcel of the community. Michael Balcon and the Ostrer Brothers built the Gaumont-British studios at Shepherd's Bush – the first studio to be purpose-built for staging talking pictures. Some of the country-house studios now erected large barns and soundproofed them as best as they were able. Alexander Korda arrived, producing films that raised the levels of sophistication dramatically. He too built a new studio at Denham. Studios at Elstree were hugely enlarged. There was a general build-up of technicians and resources. Yet, still the Establishment retained its attitude. For instance, it was known that there were flocks of immigrants in America who knew no English. It seemed that nobody appreciated the fact that the newcomers were crowding the movie houses (that were cheap and warm) watching foreign films that had dialogue in their native languages, together with sub-titles in English. That was just one of the aspects of exporting films.

When the Second World War broke out all cinemas and theatres were closed for fear of air-raids but they were soon re-opened and attendances rose to new heights. This lasted for nearly twenty years and Rank at Pinewood and ABPC at Elstree, together with the Gaumont-Odeon and ABC circuits, prospered, but in the 1960s television made its presence felt and once again film production was well nigh impossible. Producers had no answer to the problem. Colour had already come in, during the 1930s. So they dug up widescreen, which had been shelved at the advent of sound. All to no avail, but toward the end of the century, the wheel turned again and people returned to the cinema. They missed the ambience of an audience and a big screen.

The first hundred years have been a long-haul production. After all the contempt and indifference and carping criticism it has endured, it now merits its place in the society in which we all live and work. Cinema is an art, but it is not like picking up a pencil and writing a poem. The inspiration required to guide the pencil and the camera is comparable, but cinema needs the apparatus of an industry to enable it to function. Our small home market will always be a restricting factor but exports are expanding.

This volume is, among other things, a tribute to all those writers, directors, and all departments who have contributed to the establishment of cinema in Britain. The focus is not on the stars who are deservedly well-known and their contribution to the general good is acknowledged. This book offers serious consideration of some works by artists who are not so well-known. The films all relate to the time and place of their conception. They are certainly good works. In the hurly-burly of distribution and exhibition they have been overlooked, which is no criticism of them. It is most intriguing to reconsider them – and their authors. And ponder. We all have a picture or two that never quite made it.

Roy Ward Baker
London
April 2005

INTRODUCTION

When I was a young student in Australia, filmgoing was an intellectually respectable activity if you went to see foreign-language films. You did not have to enjoy them; it was enough to have gone and to be able to report back. The next-best thing in the aesthetic hierarchy was to have gone to a 'good British film'. There was not quite the cachet that came from reading subtitles, but these films were – so the received wisdom ran – 'restrained' and 'natural' and 'true to life'. They were imbued with the sort of virtues that seemed to put them in a category with good manners or stout walking shoes. Hollywood was nowhere – except with the great public, and what could it know? Well, as it turned out, a great deal. No one could have anticipated that from the late 1960s on there would be a deluge of writing about Hollywood at both popular levels and in the sometimes arcane reaches of academic criticism. 'Foreign' retained a good deal of clout but, somehow, much as some of us loved it, British cinema never quite made it anywhere along the pop-academic spectrum. And, of course, there was virtually no such thing as 'Irish cinema'.

Nevertheless, three much-quoted formulations about British cinema have by now surely outlived their usefulness. First came the Indian director Satyajit Ray's reflection that 'the British are [not] temperamentally equipped to make the best use of the movie camera'. This was followed, in similar vein, by François Truffaut's silly aphorism about 'a certain incompatibility between the terms "cinema" and "Britain"', perhaps meant as a throwaway remark but, if so, caught by too many willing hands that took up pen to endorse it. Then in 1969, Alan Lovell headed a BFI discussion paper, resonantly entitled 'The British Cinema: The Unknown Cinema'. In the introduction to his 1986 anthology, *All Our Yesterdays: 90 Years of British Cinema*, Charles Barr cited all three of these pronouncements. Now, nearly twenty years further on, they seem more than a little out of touch with the reality. Perhaps the fact that it can no longer be thought of as an 'unknown cinema', in the way that Lovell properly used the term in 1969, has worked substantially to undermine whatever validity the first two sententiae may once have seemed to exhibit.

If this is so, the changed situation is partly the result of some of the people writing in this present volume, including Barr, John Hill, Robert Murphy and several others. As editor, I am privileged to have these 'pioneering' figures represented here. They and many others like them

have contrived, in the last two decades, to ensure that British cinema is no longer 'unknown', and the rich pickings that their work has yielded means that there is no longer any need to take either Ray or Truffaut's put-downs seriously. Still, this is all pretty recent. In the 1970s there were Raymond Durgnat's *A Mirror for England*, Alexander Walker's *Hollywood, England*, Barr's *Ealing Studios*, Roy Armes' *A Critical History of British Cinema* and Geoff Brown's impeccably researched director dossiers, *Walter Forde* and *Launder and Gilliat*.

Durgnat's idiosyncratic and stimulating account was perhaps the first book on British cinema one could respect. Wide-ranging in its ideas and in the films it chose through which to articulate those ideas, it was no respecter of auteurism or, indeed, of any other received wisdom. Durgnat was, for instance, willing to find in Compton Bennett's *Daybreak* (1947), 'a weird power lacking in more sensible movies' and later praises Powell and Pressburger's *Tales of Hoffmann* (1951) as '[this] gallimaufry of Gothicisms' that 'seeks to recapture the full-blown romantic urge'. This was a heady antidote to the negativism of the first issue of the journal *Movie* (1962) which pronounced British cinema 'as dead as it was before [the "New Wave"]' and in a now-notorious 'histogram' found only two directors in British films (Losey and Fregonese, neither as it happens British) anywhere in the top three categories of 'Great' (none), 'Brilliant' (Losey) and 'Very talented' (Fregonese). *Movie*'s auteurist, anti-British, fervently pro-Hollywood line may well have hindered the cause of British film scholarship for nearly twenty years.

Walker's volume and Barr's analysis of the output of the quintessential British studio have both become classics of scholarly research, but one needs to remember how rare they were then. As for Armes' survey text, it may now seem conventional in its organisation and in its kinds of emphases (with chapters on 'Balcon at Ealing', 'Literary Cinema – Asquith, Reed and Lean', 'From Free Cinema to Woodfall', and so on), with not much room for, say, melodrama or genre filmmaking, and none at all for the prolific post-war B-movie industry. Again, though, one needs to recall how ambitious a work it was in the late 1970s and the extent to which it helped to lay the ground for the more segmented approaches that have characterised the flood of books on British cinema from the 1980s on.

We have had since studies of decades (Robert Murphy's exemplary study of the 1940s, *Realism and Tinsel*, Christine Geraghty's excavatory *British Cinema in the Fifties*, John Hill's *British Cinema in the 1980s*), of studios (for example, Patricia Warren's exhaustive *British Film Studios*), of genres (including Peter Hutchings' *Hammer and Beyond: The British Horror Film*, Sue Harper's *Picturing the Past: The Rise and Fall of the British Costume Melodrama*), of stars, directors, cinematographers, and of industrial and legislative matters relating to the exhibition

of British cinema – and much too prolific to do other than hint at here. There is now no pressing need for a further comprehensive survey work (though Armes' book cries out for a second edition that would bring it up to date).

What is still worth doing is to draw attention to films and filmmakers that have somehow slipped through the critical nets. There are films which, for one reason or other, failed to elicit much contemporary attention but which, in hindsight, can be seen to be redolent of the periods of their making. They may have been bypassed in auteurist-based writings or deemed not worthy of a place in broader surveys. They may have been examples of genres that awaited later decades for analytic attention. It is one of the aims of this volume to bring several such films and their makers to attention, sometimes for the first time, while acknowledging equally that there are some key films that are due for reappraisal in the light of the intervening decades.

And it is another aim, as the book's title suggests, to acknowledge that there is now an emerging Irish cinema. In proportion to the output of British cinema, Irish production remains slight, but in three essays near the end of this book it is clear that Irish cinema is now becoming an entity. In ten years' time, say, one would hope that either its representation in a volume such as this would be considerably greater or, better still, that it would have its own volume. Robert Flaherty's *Man of Aran*, filmed in the West of Ireland in 1934, was financed by the British company, Gainsborough, and, until the 1980s, most 'Irish' films were produced by American or British companies. The cultural distance between *Man of Aran* and the three Irish films discussed towards the end of this book is considerable indeed.

In accordance with these aims, certain principles have governed the choice of the twenty-four films examined. To begin with, the films were not to have been the subject of exhaustive analysis in various other texts. A film like *Room at the Top* (Jack Clayton, 1959) certainly attracted a great deal of notice on its release for its unusual candour about class and sexual matters, but it is typical of films that may have had watershed status at the time but have not been subject to much subsequent scrutiny. In this light, Tony Aldgate's careful sifting of the censorship difficulties surrounding its production and exhibition in this volume provides a valuable complement to Neil Sinyard's treatment of the film in his recent study of its director. Of the other films, has anyone *ever* looked carefully at, say, *Holiday Camp* (Ken Annakin, 1947) as Geoff Brown does, placing it in its post-war context, both socially and industrially? Or at the 'runaway' MGM-British costume adventure, *Knights of the Round Table* (Richard Thorpe, 1953) which Tom Ryall uses as a focus for examining the ways in which American involvement enabled British filmmaking to compete in wider markets?

A further criterion of choice was that the films ought to suggest something of the range of British filmmaking over a long period. The book opens with Luke McKernan's analysis of the late silent, *Shooting Stars* (Anthony Asquith and A. V. Bramble, 1928) and closes with Dave Rolinson's appreciation of *Sweet Sixteen* (Ken Loach, 2002). These two films are separated by about 75 years, and their directors are graphic emblems of the diversity of genres and styles in range of British cinema. Whereas Asquith came to be associated above all with civilised, discreetly cinematic versions of literary works, especially the plays of Terence Rattigan and George Bernard Shaw, Loach is perhaps the prime exemplar of the realist strand of British cinema. Between them, that is, they embrace two of the most critically admired kinds of British film: in the 1940s, when Britain was acquiring an international reputation more potent than it had previously known, it was essentially its literary and realist strains that were responsible for this acclaim.

In terms of chronological spread, the films chosen here span the decades more or less evenly, but other criteria have seemed more important. I wanted directors who have not usually been seen as ripe for *auteurist* treatment to be given a prominence that for other reasons – prolificacy, proficiency across a genre range, capacity to tap the concerns of their times, sheer popularity – they seemed entitled to. Christine Geraghty's chapter on *80,000 Suspects* (Val Guest, 1963) is a prime example: its director may be the British filmmaker with most in common with the old Hollywood studio-era directors, like Michael Curtiz or Henry Hathaway, but he has never been the subject of sustained study. Guest's capacity to work in many popular genres, including comedies broad and sophisticated, musicals, thrillers, science fiction and war films, and the sheer volume of his output cry out for attention.

There are no chapters on films directed by David Lean, Powell and Pressburger, Carol Reed or Alfred Hitchcock. They are certainly high among the most gifted British filmmakers and their names recur throughout the essays in this book as one would expect. However, they have received immense amounts of critical coverage, thus helping to ensure that Britain's is no longer an 'unknown cinema'. On the other hand, the likes of Victor Saville and Ronald Neame, responsible for some very attractive entertainments, or Robert Hamer, for whom one might argue a case that he is the most remarkable director in late 1940s/early 1950s Britain, await comparable exploration. Charles Barr argues persuasively for the sheer representativeness of Saville's *The Good Companions* (1933) and Neil Sinyard's account of Neame's *Tunes of Glory* (1960) reminds one of its director's unobtrusive craftsmanship, and both reinforce the importance of the literary adaptation in British cinema. Two Hamer films, neither of which has

been given its critical due, have been included without apology. Robert Murphy does justice to one of Hamer's least known films, *The Long Memory* (1952), and Brian McFarlane relishes the stylish melodrama and star performance of Hamer's undervalued *Pink String and Sealing Wax* (1945). Some of the other directors featured here have been more amply treated in critical writing, but in general they are represented by less obvious choices: for instance, John Boorman by *Hope and Glory* (1980) in Kevin Gough-Yates' affectionate appraisal, or Neil Jordan by the little seen *The Miracle* (1990) in Kevin Rockett's essay.

All the contributors to this volume were asked to place the films under discussion in a wider context. The films, that is, were not simply (or even complexly) to be subjected to minute, inward-turning critical scrutiny. Certainly, each work would need to be evoked with some vividness and particularity, but equally, if the book was to give some sort of feel for the enterprise of British cinema, the film concerned should be treated in such ways as to illuminate its place in the whole story.

Two of the 1930s films selected make this point. John Oliver takes *A Night Like This* (Tom Walls, 1932) as representative of the wholesale adaptation of Aldwych farces by personnel much associated with their stage réclame, and in doing so suggests a strand of commercial film production at the other end of the spectrum from Robert Flaherty's Irish-set *Man of Aran* (1934). This famous documentary is one of the films in need of reassessment and this is what is offered in Martin McLoone's chapter. The documentary and the fiction film had virtually nothing to do with each other in pre-war British film, and these two essays testify to the dichotomy.

Melanie Williams's study of *No Love for Johnnie* (1961) contemplates the serious rendering of opportunism in political life in the oeuvre of the highly successful producer/director partnership of Betty E. Box and Ralph Thomas, calling up a decade or more of contrastingly popular genre filmmaking. Andrew Spicer views *Demons of the Mind* (Peter Sykes, 1972) as a neglected and underrated example of late Hammer horror, finding in it qualities that set it apart from more famous titles in the studio's output; Philip Gillett's chapter on *The Rocking Horse Winner* (Anthony Pelissier, 1949) and Rose Lucas's on *Orlando* (Sally Potter, 1993) bear witness to the tenacity of British cinema's dealings with major twentieth-century authors, here D. H. Lawrence and Virginia Woolf respectively, in films made almost a half-century apart; and *Sunday Bloody Sunday* (John Schlesinger, 1971), as Ian Britain's recapturing of the 'moment' of its director's 'amused detachment and heartfelt critique' makes plain, was a film utterly in tune with the late 1960s/early 1970s *zeitgeist*.

Surprisingly, neither the heist classic *The Italian Job* (Peter Collinson, 1969) nor *Scandal* (Michael Caton-Jones, 1989), the re-enactment of the Profumo affair, has been the subject of sustained critical attention until now, in chapters by Steve Chibnall and Bruce Babington respectively. Combat films and Ealing comedy are the unexpected bedfellows adduced by Chibnall, whereas Babington connects *Scandal*'s protagonist to other formidable 1980s types like Miranda Richardson's Ruth Ellis in *Dance with a Stranger* (Mike Newell, 1984) and Emily Watson in *Wish You Were Here* (David Leland, 1987).

Man of Aran stands in, too, for what passed as 'Irish' filmmaking in the early days of talkies, just as, perhaps, *Whisky Galore* (Alexander Mackendrick, 1949) might once have evoked Scotland, or *Room at the Top* the 'North'. Now, though, it seemed appropriate that five of the last six essays in this volume should suggest a different approach. Hence, Wendy Everett's examination of a Northern childhood in Terence Davies' intensely autobiographical *Distant Voices, Still Lives* (1988) values a film that is a long way from the New Wave. Emer Rockett finds in *Ordinary Decent Criminals* (Thaddeus O'Sullivan, 2000), despite its borrowings from American genre films, 'the cultural specificity that is contemporary Ireland'; John Hill places *Divorcing Jack* (David Caffrey, 1998) in the sporadic history of filming in Northern Ireland, which 'only really gathered momentum in the 1990s'; and Kevin Rockett situates *The Miracle* not only in the context of Neil Jordan's career but also of Irish filmmaking at large. And the book closes with *Sweet Dreams*, a Scottish Screen co-production, which not merely asserts the continuity of Ken Loach's concern with the socially marginalised but suggests that British cinema is no longer, as Lindsay Anderson indicted it in *Declaration*, 'an *English* cinema (and Southern English at that), metropolitan in attitude, and entirely middle-class'.

The industry may now be ramshackle in its post-Rank, post-ABPC days, but the output continues to give fresh heart, and it seemed important that this book should reflect some of the ways in which recent British and Irish cinema has ramified from what may once have been thought of legitimately as a primarily middle-class affair. Miss C. A. Lejeune, once so highly regarded a Sunday paper reviewer, would scarcely have understood a word of *Sweet Sixteen*, on grounds of both region and profanity. Even in evoking earlier days, those two deeply respectable terms for critically privileged modes of British cinema – 'literary' and 'realist'– take no heed of Googie Withers hurling herself over a Brighton cliff in *Pink String and Sealing Wax*, or the Hollywood-style polish of *Knights of the Round Table* or the Mini-marathon of *The Italian Job* or the stylish horrors of *Demons of the Mind*, let alone the poeticism of the more recent *Distant Voices, Still Lives*. And they would leave the Irish films very much to one side. British film

has through thick and – as the case often was – thin been more varied than it was sometimes given credit for and it is one of the aims of this collection to reflect that variety. A mere twenty-four films among several thousand can scarcely be seen as representative, but they can suggest stylistic, thematic and generic versatility.

The question of what is a British film is now in danger of becoming a tiresomely unproductive bone of contention. There are films like *Open Range* (Kevin Costner, 2003) which *Sight and Sound* lists as a US/UK co-production; one can only assume that this is on the basis of financial involvement, since, apart from Michael Gambon's appearance, it is in all creative senses an American film. On the other hand, *Sense and Sensibility* (1995), with its Taiwanese director and American producer (Ang Lee and Lindsay Doran, respectively), while similarly designated, seems in most important creative respects (casting, production and costume design, locations, cinematography, screenplay, music) a British film. However, this is not the place to engage in a full discussion of this matter though it may well be of crucial importance to the industry. The chapters in this volume give some sense of shifts in the 'Britishness' of British film: from the clear satire at Hollywood's expense in *Shooting Stars*, through the intensely indigenous *The Good Companions*, the cunning melding of Hollywood and Britain in *Knights of the Round Table*, the entrepreneurial internationalism of *Orlando* and the emergence of Irish and Scottish cinema towards and after the turn of the century. All the films discussed in this book belong in key ways to the 'British Isles' and if that means predominantly 'England', then that is a true reflection of where the emphasis has fallen in British filmmaking – for better and worse.

Finally, one other minor consideration was to have contributions authored both by those who have significant track records in film scholarship or criticism from earlier decades – important for what they had to say about their subject when few were saying anything – and by newer voices who have found new and sometimes surprising things to say about that field of cultural production which is uniquely 'British cinema'. I am grateful to them all.

Brian McFarlane

REFERENCES

Anderson, L. (1957) 'Get Out and Push', in T. Maschler (ed.) *Declaration*. St Albans: MacGibbon & Kee.

Armes, R. (1978) *A Critical History of British Cinema*. London: Secker and Warburg.

Barr, C. (ed.) (1986) *All Our Yesterdays: 90 years of British Cinema*. London: British Film

Institute.

_____ (1997 [1977]) *Ealing Studios* (revised edition). London: Cameron & Tayleur/David & Charles.

Brown G. (1977a) *Walter Forde*. London: British Film Institute.

_____ (1977b) *Launder and Gilliat*. London: British Film Institute.

Durgnat, R. (1970) *A Mirror for England: British Movies from Austerity to Affluence*. London: Faber and Faber.

Geraghty C. (2000) *British Cinema in the Fifties: Gender, Genre and the 'New Look'*. London and New York: Routledge.

Harper S. (1994) *Picturing the Past: The Rise and Fall of the British Costume Melodrama*. London: British Film Institute.

Hill, J. (1999) *British Cinema in the 1980s: Issues and Themes*. Oxford: Clarendon Press.

Hutchings P. (1993) *Hammer and Beyond: The British Horror Film*. Manchester: Manchester University Press.

Murphy, R. (1989) *Realism and Tinsel: Cinema and Society in Britain 1939–1948*. London: Routledge.

Sinyard, N. (2001) *Jack Clayton*. Manchester: Manchester University Press.

Walker, A. (1986) *Hollywood, England: British Cinema in the Sixties*. London: Harrap.

Warren, P. (2001) *British Film Studios: An Illustrated History* (revised edition). London: B. T. Batsford.

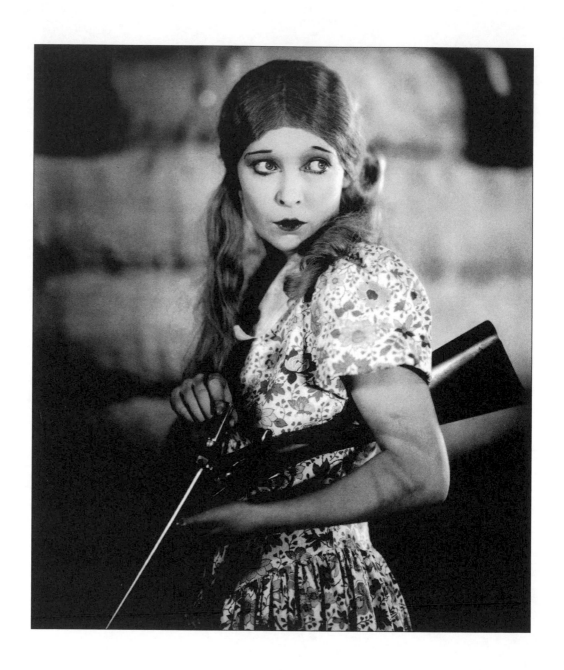

SHOOTING STARS

ANTHONY ASQUITH & A. V. BRAMBLE, UK, 1928

The opening sequence of *Shooting Stars* (1928) is a hesitant but nevertheless ambitious crane-shot swooping over an active film studio. The location is the Stoll Film Company studios, Cricklewood, and through this opening vista the self-reflexive theme is introduced. This is a film about the process of making a film. It is constructed as a comment on its own creation. As such, for its time, it was something quite new in British film, and it remains in many ways a landmark production. Not until *Peeping Tom* (Michael Powell, 1960), over thirty years later, would a British film so knowingly and so effectively turn its own camera on itself. It is a young man's film, the first effort of someone representative of a new creative spirit in British film, and it displays much of the excitement at what the medium can do that characterises such notable later debuts as *Citizen Kane* (Orson Welles, 1941), *A Bout de Souffle* (Jean-Luc Godard, 1960) and *Reservoir Dogs* (Quentin Tarantino, 1992). If it is a lesser artistic work than such notable films, it nevertheless achieves the same goal of giving us the filmmaker's eyes and looking at film as though for the first time.

Shooting Stars tells the story of a love triangle involving three film stars, leading to the 'accidental' death of one of them. The three are Mae Feather (Annette Benson), an actress who in her mixture of simpering performance onscreen and sour manner offscreen seems an amalgam of Hollywood actresses of the period; her husband Julian Gordon (Brian Aherne), an uncertain action-hero actor; and Chaplinesque comedian Andy Wilks (Donald Calthrop). Unknown to her husband, Mae Feather is conducting an affair with Wilks.

The film opens with Feather and Gordon being filmed in a western, 'Prairie Love', while elsewhere in the studio Wilks is making a knockabout comedy. Feather has a row with her husband and the director, and goes off to watch Wilks being filmed. To a magazine reporter, however, she expresses her deep devotion towards her husband. She then sets out with Wilks, while Gordon visits a cinema in a despondent mood, only to be temporarily lifted by seeing one of his own films where he is able to be more of a daredevil and a success with women than he is in real life. The young boys in the cinema who cheer the film along with him are indicative of his infantilism and naïveté.

Feather and Wilks plan to leave together for America. The following day, however, Wilks' double is injured in a comic stunt by the sea, but the news gets out that it is Wilks himself who has been injured. Feather is startled to see him when he comes to her flat, but then Gordon returns unexpectedly early to find the two lovers. He decides to divorce her, which Feather knows will lose her a promised Hollywood contract and ruin her career. Desperate, she decides to kill her husband by staging an accident. She puts a live bullet into a film prop gun. A shot is fired at Gordon while he is acting, but it is a blank cartridge that is fired. The loaded gun is then used in a scene for Wilks' film, and he is shot dead while swinging from a chandelier.

Feather breaks down, and Gordon divorces her. Years later, Gordon has become a famous film director, while Feather is completely forgotten. She gains work on her former husband's film as an extra, and in the film's outstanding sequence, is seen praying in a church which is dismantled about her, it being only a film set. She asks the director, 'Will you want me any more?', to which he shakes his head, not even recognising her. She walks, in an extended take unbroken except for a cut back to Gordon with a puzzled look on his face as if he half-remembered the voice, through the dark of the studio until silhouetted by a door in the far distance, after which she disappears, and the film ends. It is the final scene from *The Third Man* (Carol Reed, 1949), in reverse.

The scenario of *Shooting Stars* is not an especially subtle one, and its picture of the film-making process and the double standards practised by (particularly American) film people is tuppenny moralism. Its importance lies in its particular position in the history of British film production to that date, and in the attitudes it expresses that position British film as a distinct identity in contrast to Hollywood.

The story was written by Anthony Asquith, and *Shooting Stars* is very much an Anthony Asquith film. This is despite the director's credit, which went to British film veteran A. V. Bramble. This remains the modern understanding of the film's authorship, and it was the same at the time of the film's release, much to Bramble's chagrin. Even the novelisation by E. C. Vivian was subtitled 'From the film by Anthony Asquith'. The difference between the two men is symptomatic of the state of affairs in British film at the time. Bramble was a stolid, efficient director of the old school in British film, which in creative terms meant very little. His past credits as a director included *The Laughing Cavalier* (1917), *Wuthering Heights* (1920), *The Card* (1922) and co-director of Harry Bruce Woolfe's *Zeebrugge* (1924). None of Bramble's surviving work indicates any filmic gift, and the relatively long career of such a journeyman talent indicates the impoverished nature of British film in the early to mid-1920s.

Anthony Asquith was a very different character, and one representative of a new spirit sweeping through British film in the late 1920s. Asquith was the son of the former Liberal prime minister, Herbert Asquith, and his gifted socialite wife Margot. He was brought up in a privileged, intellectual world. Born in 1902, he came to maturity at the start of the 1920s and was very much one of the generation too young to have gone to war and anxious for cultural regeneration and discovery. Cinema, for an intellectual elite, became one avenue for this new spirit of adventure, and Asquith was an early member of the Film Society. This organisation, established in 1925, showed, under licence, films which were either refused a general cinema exhibition certificate by the British Board of Film Censors or did not have a distributor at all. Other members included Ivor Montagu, Sidney Bernstein, H. G. Wells, George Bernard Shaw, J. B. S. Haldane, Michael Balcon, Victor Saville, John Maynard Keynes, Julian Huxley and John Gielgud – the cream of British cultural and intellectual life, and a sure indication of the excitement generated by the artistic possibilities of film for the intelligentsia. Principally, the Film Society was able to show the best of the films coming out of the Soviet Union, and at the Film Society Asquith was introduced to the works of Eisenstein, Pudovkin, Vertov and others, revolutionary in content and in style, as well as films of the German Expressionist movement, the avant-garde, scientific and documentary film, and films selected for their importance in an emerging history of film practice. Asquith knew his film history, he understood its radical power, and he knew in what techniques lay its greatest potential.

Asquith was keen to become involved in film production, and doors were bound to be open to the son of a prime minister. The British film industry was tickled to find the Honourable Anthony Asquith entering its portals, and his progress was followed with much interest. He first worked on *Boadicea* (1926), directed by Sinclair Hill for Stoll, before he joined that film's producer, Bruce Woolfe, at British Instructional Films (BIF). There he was the brightest star among a number of young talents Woolfe was gathering around him, including Mary Field, J. O. C. Orton and Arthur Woods. Asquith co-wrote the scenario (with Orton) from his own story for his first BIF film, *Shooting Stars*, but in view of his inexperience the old hand Bramble was brought in and given the director's credit, principally for his knowledge in the handling of actors. Asquith was named Assistant Director, but in every scene of *Shooting Stars* it is palpably obvious that a young man, brimful of ideas, is the guiding spirit behind the film.

The influence of the Soviet school is clear throughout, as would be the German Expressionist influence in Asquith's later silents, *Underground* (1928) and *A Cottage on Dartmoor*

(1930). The influence is shown most obviously in two bravura sequences that have no parallel in anything filmed in a British studio prior to *Shooting Stars*. First is the scene in which Andy Wilks' double cycles down a hill, a stunt which gets out of control and leads to a crash. Point-of-view shots from the bicycle hurtling downhill, intercut with angled shots of the bicycle coming towards the camera with the startled actor's face, create a memorable if jarring sequence. The impression is solely one of technique, and somewhat faltering editing technique at that, but it takes the film out of the ordinary even if the import of the scene does not truly match up to the means chosen to deliver it.

The second scene is more impressively executed, namely the one where Wilks is fatally shot during filming in the studio. Again, self-conscious editing intercuts the unknowing actors and crew with close shots of the actor swinging, first alive, then dead, from the chandelier. Here the technique is appropriate to the action, the irony of performance over reality chiming in with the film's primary theme, while the cuts from conventional studio scenes to the jarring shots of the dead actor swinging on high emblematise the shift between British cinema old and new that the film represents.

Beyond the Soviet influence, *Shooting Stars* illustrates throughout Asquith's interest in the culture of cinema and its history. This is displayed through the ironic view of conventional filmmaking that is the film's hallmark. The joke on Hollywood is at its strongest in the opening scenes of 'Prairie Love' being filmed, where a stereotypical view of the cowboy hero and his sweetheart is deconstructed as the camera pulls back and we see that she is sitting not on a horse but on a dummy, and the romantic West is revealed to be located in a cold, vast film studio. The bare mechanics of cinematic illusion are revealed in this key establishing sequence. Its theme is then echoed in a shot of Andy Wilks removing his make-up, turning the merry comic into the mean and bitter little man that he is in reality. The filming of the knockabout comic scene by the sea contrasts the sunny action with the dismal reality of a drab English seaside location.

The Englishness of the seaside setting points up a problem that the film does not resolve. Are the satiric barbs aimed at American filmmaking, at British filmmaking, or filmmaking in general? If Hollywood is the target, as 'Prairie Love' and the Mack Sennett-style knockabout of Wilks would seem to indicate, then how to explain the English settings, the English film studio, the obviously English character actors (particularly Wally Patch as a cockney stage hand)? Mae Feather has been offered a Hollywood contract (dependent upon her good behaviour), which indicates most clearly that we are in Britain. But if British filmmaking is the target, then how to

explain the filming of a western or the Sennett comedy, when only Walter Forde was making films in such a vein in Britain at the time? The film is caught between a wish to strip the illusions away from classical Hollywood conventions, while being forced to do so with the impoverished resources of a British film studio. If there is a resolution to this dilemma, it is an argument that the British filmmaking process, through its very poverty, could expose the Hollywood aura for the sham that it was. Actors, scenery, studio, publicity, the film's title itself – all fall away to reveal the shabby reality beneath.

The film succeeds in its satirical intentions, but its fundamental weakness lies in its failure to take the argument any further. For all the excellence of the three central players (the film is notable for a realism in performance which alone marks it out as something new in British film – and something for which A.V. Bramble should probably receive more credit than he has previously been allowed), their characters are only ciphers. It is not, after all, a startling revelation to demonstrate that film exhibits an illusion, and the film needs to make much more of its unpeeling of reality. *Shooting Stars* is a clever film, one conducted with wit and cinematic verve, but it has no depth. No character rises out of the essential banality of the story to give it a greater resonance, and thereby to encourage us to feel that here is a film with feeling to match its virtuoso technique, a film classic. The final scene with Mae Feather praying in the film-set church is poignant and thematically precise, but (to this observer at least) it is an exercise in ingenuity, not in tragic dénouement. Hence the final walk into the distance equals the finale of *The Third Man* in its brilliance, but not in its satisfying emotional truth. Asquith (and Bramble) has not truly shown us anything beneath the façade.

The comparison with *The Third Man* is worth pursuing. Carol Reed was another director whose brilliant technique could not mask a failure to engage with the deeper emotions of human beings in crisis, a failing he rose above in *The Third Man*, if not (arguably) at any other time. Asquith would go on to become a skilled director, if not one keen to demonstrate the flashy techniques learned from the German and Soviet masters after his silent period; instead one whose films would trade on the director's affinity with English reserve. But the intriguing parallel between *Shooting Stars* and *The Third Man* is the alliance with the western. *The Third Man* is the quintessential British western: Holly Martins, the writer of cheap western novels, arrives like a lone gunslinger in Vienna, finds himself in a confusing role when he tries to uphold honour, and the climax to the film is a traditional shoot-out. *The Third Man* plays out Martins' western imagination, in its banality and ineffectualness in the face of complex reality, to full ironic effect.

Shooting Stars similarly, if a little less profoundly, takes the western form and uses its shallow conventionalities as a means to uncover real human crises. This begins with the film's title, at once ironic and silly, gun-toting in the cinema alongside the transience of fame. 'Prairie Love' itself, if only seen briefly as a stereotypical sentimental western romance, nevertheless sets up the idea that the love triangle – that most obvious of dramatic constructions – in being played out in real life, echoes the expected forms of cinematic narrative. We have Hero, Heroine and Villain. The gun (and how seldom were guns seen in British films at this time, except where aping American conventions) in the studio is meant to fire only blanks. The climactic shoot-out brutally brings reality to the film studio when we see that guns can kill after all. Life on the range only truly becomes life when removed from the screen.

The film plays with too many styles, and is not so profoundly thought-out, to bear too great a comparison with *The Third Man* in the adoption of the western motif. Half the time it is a western, the other half it could be any story with the same basic conventions. If the ironic position of the western in a British film studio could have been exploited more fully, *Shooting Stars* nevertheless does make a clear enough point about dowdy reality, and in particular exposes for a British audience the falsity of the dream expounded by the Hollywood that dominated its screens. It is in this exposure that the film is probably at its strongest.

Shooting Stars is certainly among the finest British silent feature films. Probably only Alfred Hitchcock's *The Lodger* (1927), *The Ring* (1927) and *The Manxman* (1929), and Maurice Elvey's *The Life Story of David Lloyd George* (1918) and *Hindle Wakes* (1927) are equal to it. In its ambition and confident execution, it marked a new standard for British film, hovering on the cusp of sound. It displayed an affinity with the works of German and Soviet masters that seemed to indicate that an invigorated British cinema was attaining artistic maturity at last. Those judging it in this fashion were looking back on two decades of impoverished film culture, where miniscule budgets combined with filmmakers of narrow ability and stars of limited appeal to create a national cinema that seemed emblematic of a fall in national status generally. British films became defined by what they were not – that is, American. It is therefore notable that *Shooting Stars* should so confidently (allowing for the inconsistency noted above) target Hollywood, making a good film out of exposing the falsity of the medium.

The film came at the end of some thirty years of British fiction-film production which, by conventional consent, combined artistic failure with commercial failure. There has been sufficient critical argument in recent years to overturn the traditional view of British silent cinema as being characterised by low achievement, but it is unquestionably true that, at the

time, all but its most blinkered practitioners viewed British film in a highly critical light. It was a cinema manned by a host of A.V. Brambles: earnest, modestly talented journeymen, who displayed a profound lack of understanding of the medium in which they were working. Directors of minimal vision were allied to technical staff and studio equipment of only the most basic competence, scripts that could not imagine the leap from the printed word to the screen, and performers caught between the mannerisms of the theatre and a desperate aping of the stylings of American film.

Out of this picture of artistic emptiness, which reached its nadir around 1925, unexpectedly arose a small renaissance in British filmmaking that can still excite the viewer today. Anthony Asquith was not the only talent that arose at this time. Alfred Hitchcock, Graham Cutts, Maurice Elvey, Victor Saville, George Pearson, Sinclair Hill and Adrian Brunel were indicative of a new spirit of inventiveness, of solutions to narrative questions answered in cinematic terms, even if some (Elvey, Hill, Pearson) were old hands brought up in old ways. The real secret behind the renaissance was a new breed of producer and investor. Michael Balcon, Harry Bruce Woolfe, John Maxwell, Herbert Wilcox and the Ostrer brothers were the leading figures. A new artistic confidence, demonstrated by Asquith's eager adoption of the German and Soviet styles he witnessed at the Film Society, was matched by new, soundly considered investment in the British film industry. While the early 1920s had seen the wastefulness and absurd over-optimism of Sir Oswald Stoll's determined efforts to enter the film industry with Stoll Film Studios, and Cecil Hepworth's ill-fated attempt to expand his existing production business, the end of the decade had the Ostrers registering the Gaumont-British Picture Corporation as a public company in 1927 (associated with Michael Balcon's Gainsborough Pictures), with a £2.5 million investment. Bruce Woolfe's British Instructional Films, begun modestly in 1919, bought by Stoll in 1924, was purchased by investor A. F. Bundy in 1927 and then floated as a public company. Herbert Wilcox formed British and Dominions Film Corporation in 1927, while Maxwell's British International Pictures, also formed in 1927, was the largest and most successful British production company by the end of the 1920s.

The new breed of confident businessman did not occur at this time by simple coincidence; 1927 was the year of the quota. Government legislation introduced in the Cinematograph Act of 1927 ensured that a percentage of the films distributed and exhibited in Britain had to be British in origin. The eventual result, in the 1930s, was to be an onrush of shoddy, cheap productions ('quota quickies') guaranteed some sort of a screening so as to fill exhibitors' quota obligations, but in the late 1920s the effect was liberating. The guarantee of exhibition for a cer-

tain percentage of British-produced films (previously many British films could wait months for a cinema release, blocked out by American product, leaving producers without a guaranteed return), removed some of the fears investors had. Capital flooded into the British film business, beginning in the year in which *Shooting Stars* was made.

The film therefore appeared at a dynamic period for British film production – probably the first such period in its history. False dawns and naïve assumptions of films' popularity based on audience demand for Hollywood product, seemed to be a thing of the past. *Shooting Stars* is a film of the Cinematograph Act. It is an expression of the confidence that investors were starting to have in the industry, and of an emerging solidity to that industry. It is equally an expression of intellectual excitement at the artistic and expressive possibilities of the medium, qualities established by the programmes of the Film Society and specifically qualities generally absent from the prevailing Hollywood product and certainly from British fiction film production to that date. *Shooting Stars* encapsulates this new spirit – not simply by the quality of its filmmaking, but by its self-consciousness. It stands for a cinema that is newly aware of itself and its possibilities.

Equally, however, *Shooting Stars*, is emblematic of the underlying uncertainty that persisted in British film. Just as the cowboy's horse is really an absurd dummy, just as the supposed sunny beach setting is a cold and dreary English seaside, so behind the façade of an active film business is the reality that British films needed government intervention to sustain them. Without the imposition of a quota, British films were struggling to find an audience in their own country, and even with the quota there was no guarantee that audiences would choose to see them. And the enthusiasm for the innovations of the German and Soviet cinema espoused by Asquith, also reflected in other British films of the period (*The Informer* [Arthur Robison, 1929], *Moulin Rouge* [E. A. Dupont, 1928], *Piccadilly* [E. A. Dupont, 1929]), only exposed an emptiness in British films themselves. Was this not merely the importing of an alien style onto a national cinema which needed its own defining characteristics?

Shooting Stars is a film full of contradictions. It is unable to express absolutely where its heart lies, caught between Hollywood hegemony, the artistic revelations of the German and Soviet cinema, and the aspirations of British film production. In the end, in this dilemma lies its particular strength. *Shooting Stars* turns the camera on itself in a rewarding and effective manner. It is a landmark film, and a creative delight.

Luke McKernan

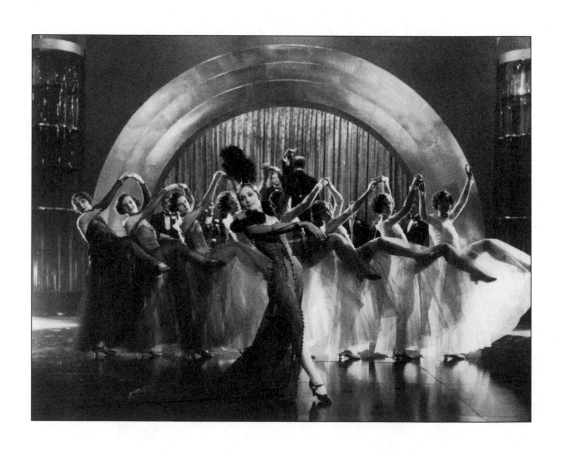

A NIGHT LIKE THIS

TOM WALLS, UK, 1932

> There is something quite infectious about these Aldwych farces, whether you see them
> on the stage or in their screen translations months later … In this case the translation
> process has been accomplished with a definite eye to motion-picture requirements.

A Night Like This (Tom Walls, 1932), the film referred to in the 1932 *Sunday Dispatch* quote above, was the third in the series of films, following *Rookery Nook* (Byron Haskin and Tom Walls, 1930) and *Plunder* (Tom Walls, 1931), to be based on the famous farces written by Ben Travers and staged at London's Aldwych Theatre between 1925 and 1933. Celebrated for their craftsmanship in construction, rich characterisations and, above all, for the sharp, sometimes risqué, dialogue, the success of the farces made Travers one of the most feted playwrights of his time. The Aldwych farces also gave rise to one of the most legendary teams of farceurs to have worked in theatre. This team consisted of Tom Walls, invariably as the hard-boiled, no nonsense, man-about-town (he also directed both the stage and film incarnations of the farces); the monocled, buck-toothed Ralph Lynn as the silly ass *par excellence*; the balding, diminutive Robertson Hare as the browbeaten 'little man' or hen-pecked husband; and, at different times, such players as Winifred Shotter, Mary Brough, Norma Varden, Gordon James (real name Sydney Lynn, brother of Ralph), Ethel Coleridge, Yvonne Arnaud and Kenneth Kove, whose rendition of a silly ass could make even Lynn appear to verge on the cerebral.

From 1930, the success that the farces were enjoying at the Aldwych Theatre was to be replicated on the screens of British cinemas. In all, eight of the nine farces written by Travers and staged at the Aldwych would be adapted for the screen between 1930 and 1934. Initially successful with both public and critics alike, the Aldwych farces were regarded, not only as a crucial catalyst in the emergence of British film comedy as a distinctive national genre, but to the newly invigorated British film industry (courtesy of the 1927 Cinematograph Films Act), following the production slump of the 1920s. 'Until the arrival of *Rookery Nook*, no distinctively British type of picture had been evolved. Now the British screen comedy is a recognised cinema attraction with a reputation that extends already far beyond the British Isles', noted

Film Weekly (16 May 1931), while the *Daily Mirror* (10 August 1931) expressed the view that the Aldwych adaptations were important, not only to British comedy, but to the industry as a whole for having 'started the boom in British production'. By the time *A Night Like This* itself was in production, Tom Walls and Ralph Lynn, according to *Picturegoer* (11 July 1931), were perceived as having 'made British talkies brighter than they have ever been before'. Aldwych farces, therefore, were in the vanguard of what was to be the most prolific and successful genre in British film production in the 1930s and, owing to this position, of critical value in the renaissance of the industry and the struggle against Hollywood's domination of British cinema screens.

However, notwithstanding the laurels with which the first two films in the series had been garlanded for their role in the resurgence of British cinema, they had also been greeted with the acknowledgement that they were nevertheless stage-bound, straightforward recreations of the stage originals, although, with the euphoria that surrounded the early films, this was a criticism that was generally dismissed at the time, even by those who wrote it, as unimportant. Although Walls had attempted nothing more than a 'straightforward camera representation of the play', *Kinematograph Weekly* (13 February 1930) commented on *Rookery Nook* that 'the lines are so witty and the reproductions so good that this does not matter'. *A Night Like This*, however, demonstrates a conscious decision to progress beyond this static theatrical technique and to broaden the appeal of the farces by integrating popular dance band music of the period into the narrative. The film was patently not intended as a purely 'straightforward' transferral to the screen of the original stage production. It was, as the opening quote indicated, produced 'with a definite eye to motion-picture requirements' in comparison to its predecessors, and would become in the process the most radical of the Aldwych adaptations in its divergence from the stage original.

Herbert Wilcox, head of the British and Dominions Film Corporation, having adapted his Elstree Studios for sound production in 1929, had quickly begun to sign up stage talent in order to make 'talkies'. Among the first to be put under con-tract were sophisticated singer and light comedian Jack Buchanan, northern comedian Sydney Howard, and the team of Aldwych farceurs. The first two Aldwych screen adaptations, as noted earlier, had been rudimentary ffairs which appeared to have been successful despite their over-riding theatrical form and style. This may have been apparent to Wilcox who, with the advances made in sound film production, prevailed upon Travers and Walls to collaborate on a project that would attempt to bolster the theatrical substance at the heart of the farces with the trappings of popular music,

thereby producing a film that remained faithful to the essence of the stage original but was more cinematic in its visual and aural impact, broadening the popular appeal of the film in the process.

Wilcox had already been utilising dance band music in a number of his films in this period, from *Splinters* (1930) onwards. An adaptation of one of Travers' non-Aldwych stage farces, *The Chance of a Night-Time* (1931), which Wilcox himself had co-directed with the film's star, Ralph Lynn, had already featured popular music with the appearance, albeit briefly, of popular crooner, Al Bowlly. Although the integration of such music, therefore, was not unknown in Wilcox's films (or a Travers farce), the use to which it would be employed in *A Night Like This* was probably unique, going beyond anything that occurred in the producer's other films. Partly as a result, *A Night Like This*, in both style (at least to a degree) and content, would be an improvement on the first two films and ultimately the most accomplished and enjoyable of all the adaptations to be produced from the original stage farces.

However, in order for *A Night Like This* to be embellished with the addition of music, the original stage play would need to undergo radical alteration. In the stage version, performed at the Aldwych between February and November 1930, budding actress Cora Mellish (Winifred Shotter) lives in a flat adjoining that of Edgar Pryor (John R. Turnbull), who also happens to run an illegal gambling den on the premises. To reinforce his villainy, Pryor also owns a garage that handles stolen cars. Mellish is being blackmailed by Pryor for handing over a stolen necklace as security for the gambling debts owed by her feather-brained beau, Aubrey Slott (Kenneth Kove). Unbeknownst to her, the necklace actually belongs to Slott's aunt, Mrs Tuckett (Norma Varden), which he had taken without her knowledge while she was away. Now that his aunt has returned, Slott desperately wants to retrieve the necklace so he can replace it before she notices that it has gone. Mellish is aided in her efforts at retrieval by ambitious policeman Michael Marsden (Tom Walls), who wants to apprehend the villains in order to aid his chances of promotion, and the gallant, if ever so slightly asinine, would-be playboy, Clifford Tope (Ralph Lynn).

For the film, Pryor has been changed into two characters, Koski (Boris Ranevsky) and the 'Chief', Micky the Mailer (C. V. France), a master criminal in the Dr Mabuse mould, 'wanted by the police on five continents' as he himself proudly boasts. In a step up from the play's combination of flat and garage, these villains now run the Moonstone nightclub, a setting obviously holding greater cinematic potential, with the gambling den on the floor above. Within this new milieu, the central plot remains relatively faithful to the stage play, with Clifford Tope

(Lynn) and police constable Michael Mahoney (Walls, with a change of surname for some reason) aiding damsel in distress, Mellish (Shotter), to retrieve the necklace given to her by Slott (Claude Hulbert, replacing Kenneth Kove from the stage original).

With the potential for music and dance presented to the film by the new nightclub setting, Cora Mellish has been transformed from an actress into a dancer, providing two opportunities for dance numbers to be inserted into the film, with Shotter (an unconvincing dancer, it must be said) supported by a troupe of chorus girls. In addition to these dance numbers, the night-club setting also provides an opportunity for the integration of Roy Fox's popular dance band into the film, appearing in all the nightclub scenes playing their music as an accompaniment to the comic proceedings. Singer Al Bowlly, making a welcome reappearance in a Wilcox film, also appears with the band, singing three songs on the soundtrack: 'London on a Night Like This', 'Considering' and 'If Anything Happened to You'. What distinguishes the film, however, in the decision to incorporate popular music is that, in addition to the band appearing in the nightclub itself, its music is also utilised non-diegetically throughout the film. When there is a cut from a nightclub scene to a different setting, for example, the music audible in the former can continue uninterrupted into and throughout the latter. Whether in scenes on London streets, in the gambling den, public houses, or the homes of some of the characters, dance-band music is ever-present on the soundtrack. According to a programme for the Empire Cinema of an unnamed locality held in the British Film Institute's Special Collections, this use of music throughout the film was intended as a 'musical commentary rather than an accompaniment', with the intention of 'achieving by this means many amusing and novel effects'. In yet a further change to the stage original, and as an illustration of one of those 'amusing and novel effects', the film concludes with the entire cast marching down the steps of the Moonstone in time to 'London on a Night Like This' on the soundtrack. As the stage version originally concluded with a lengthy scene in Bow Street police station, this again illustrates how the screen version of *A Night Like This* was adapted, with situations specifically amended in order to accommodate popular music.

While this musical embellishment of the narrative is appealing, the film's success rests on the strength of its script, acting and direction. Although the directorial style of Tom Walls certainly demonstrated signs of improvement on *Rookery Nook* and *Plunder*, he was still largely beholden to the techniques of the stage. In 1933, Walls commented in *Picturegoer* (25 November 1933) that 'not many people know it … but it is very risky to leave any scene on the screen for longer than forty seconds without a cut or a change'. Walls may have believed this in 1933, but

it was not a philosophy he had adopted in 1931–32. When there is little or no dialogue the film has a greater vibrancy in its pacing, with relatively lively cutting. This is apparent in an opening montage sequence, showing various characters in a stereotypical London 'pea-souper' (with 'London on a Night Like This' on the soundtrack) and a later fight scene between Walls and the villains, with Lynn jumping in and out from behind a curtain to hit the latter over the head with a poker. When dialogue enters the equation, however, 'stage technique' has a tendency to dominate, and the theatrical ambience of the earlier films is largely reconstituted, with the camera seem-ingly fixed to the studio floor. In these instances, two or three characters are invariably shown together, in mid-shot or mid-long shot, for the scene's duration. Thus, not only are shots held for over forty seconds, but those lasting between one and one-and-a-half minutes are quite common. Some are even longer. To give one example of the latter, when Lynn first visits Shotter in her dressing room, they are shown talking together in mid-long shot for two minutes and 38 seconds, with only a brief cutaway to Hulbert leaving the room as respite. Other scenes are then interpolated, but when we later return to Lynn and Shotter, the same viewpoint is retained, although now in mid-shot, and this is then held for a further two minutes and 13 seconds.

Although these static shots of varying length do tend to dominate the film, *A Night Like This* nevertheless provides evidence that Walls was beginning to realise the potential of film, with his favouring of mid- and mid-long shots over the long and extreme long shots he had primarily employed in his earlier films, together with some instances of intercutting between characters within the same scene. In a scene when Mellish's dresser, Mrs Decent (Mary Brough), visits the Tucketts' house to complain about their nephew's influence on Cora, the dialogue between the characters is conveyed via intercutting between Mrs Tuckett (Varden) in one shot and Mr Tuckett (Robertson Hare) and Brough in the other. A further instance occurs in the scene where Tope (Lynn) goes to the offce of Koski (Ranevsky) to demand the return of the necklace: although the scene consists primarily of both actors in an exchange of dialogue held within the one long shot, it also includes some mid-shots of Lynn cut into the scene – and not merely of reaction shots. These may be small incidents within the film as a whole, but they do demonstrate that Walls was learning his craft. A few days prior to the 17 March première of *A Night Like This*, the *Daily Express* (4 March 1932) reported Walls as having 'abandoned the photographed play method' and was now 'concentrating on the new technique which assures a fast-moving story decorated here and there with whatever dialogue is essential'. It is difficult to say with any certainty whether Walls had undergone this Damascene conversion before or

after *A Night Like This*, but the film as it stands does appear to demonstrate the first tentative steps taken by Walls to put into practice his new found 'cinematic' technique. As *Film Weekly* (18 March 1932) observed: 'Tom Walls, who directed, has improved greatly … since the days when he simply photographed and recorded his stage productions.'

Despite his progression in mastering some semblance of a cinematic technique, Walls had to endure scathing attacks on his work throughout his career. In 1934 *Film Weekly* (6 April) scathingly wrote, 'Both his direction and acting are theatrical and, therefore, from a screen point of view, amateurish.' In a responsive broadside across the bows of critics such as these, *Picturegoer* (25 November) quoted Walls remarking, 'I know more about the type of farce we do than anybody … I should like to know whom one would suggest could direct the Aldwych team (as we are called) better than I do?' There is indeed a kernel of truth in his statement, as it was the performances of this 'team' and, it has to be acknowledged, owing to his concentration on the actors rather than the camera, Walls' direction of the 'team' that makes *A Night Like This*, and the majority of the other Aldwych films, such a pleasure to watch today.

One particular scene in *A Night Like This* that was cited as the highlight of both the stage and screen versions serves as an encapsulation of that vital teamwork. An Aldwych farce invariably included what Travers refered to as a 'traditional victimisation of Robertson Hare scene', where the hapless Hare suffered a variety of indignities wrought upon him by Walls, Lynn or his stage/screen wife, usually played by the imperious Norma Varden. In *A Night Like This*, the 'traditional' scene occurs where Hare is 'debagged' by Walls and Lynn in order to prevent him from leaving Shotter's flat to go to the nightclub to confront the dancer over the missing necklace. The scene may have changed little if at all from the stage version (except for the obvious omission of the nightclub). Walls and Lynn use 'guile' (as it was also termed in the play) to separate Hare from his trousers, beginning with the removal of his coat, then his jacket, moving on to his waistcoat, before finally successfully removing the trousers. Throughout his ordeal, Hare commendably never loses his bowler hat, which serves to amplify the humour of the scene when he is in his final state of undress. 'The film is one long laugh, with the highlight a most amusing scene in which that pillar of respectability, J. Robertson Hare, is "debagged"', enthused *The Daily Mirror London Film Review* (18 March 1932). The scene demonstrates how the sheer quality of the performances can override a static shooting style sated with long takes. The scene, running to seven-and-a-half minutes of screen time, largely consists of the one single take lasting five minutes and 11 seconds, with the three actors held in mid-shot, apart from two brief cutaways to Walls and Lynn together. Nevertheless, it is a consummately performed scene,

particularly by Hare and Lynn, and demonstrates how the comic brilliance of the members of the team performing together in the absurd situations devised by Travers is something that not even sedentary filmmaking techniques can diminish. This is where the true strength of an Aldwych farce lies, and why *A Night Like This* remains so eminently watchable.

By the time that the film was released, however, in March 1932, the popularity of the Aldwych films may already have begun to wane. The critical reception of the film was generally affrmative, with *Film Weekly* (18 March 1932), for example, declaring it to be 'a real rival to *Rookery Nook*. Not since their screen debut three years ago have we had such fun as the Aldwych players provide in *A Night Like This*.' The incorporation of music and dance in the film, and the refashioning of the original play that this necessitated, strangely brought forth little response, the use of dance band music and the appearances of Roy Fox's Band and Al Bowlly receiving minimal coverage in the contemporary reviews, although *Picturegoer* (27 August 1932) believed that the playing of music 'is certainly an added attraction to this feast of photographic fun'. P. L. Mannock appears to have been aware of the film's cinematic pretensions compared to earlier Aldwych adaptations when he observed in the *Daily Herald* (21 March 1932) that 'this specimen has sagging moments when it reverts to stage technique' (my italics). However, the *Sunday Dispatch*, with its comment on the film's having been 'accomplished with a definite eye to motion-picture requirements', would appear to have been in the minority in acknowledging that *A Night Like This* was an attempt to produce some-thing distinctive and original in the transferral of an Aldwych farce from stage to screen.

With the popularity of individual films in this period now diffcult to gauge, box-offce figures being unavailable, one has to resort to the use of popularity polls published in journals and magazines in order to gain some sort of perspective, however insubstantial and relatively deficient these may be. In the 1933 annual 'Best of British' poll held in *Film Weekly* (26 May), *A Night Like This* was voted into twentieth position by the magazine's readership, whereas *Rookery Nook* and *Plunder* had appeared in the top ten of their respective years of 1931 and 1932. *Thark* (Tom Walls, 1932), the next Aldwych film to appear after *A Night Like This*, was voted into ninth place in the same poll. With regard to a slightly later period, the mid-1930s, Jeffrey Richards argues (using as evidence box-offce returns published in the *Motion Picture Herald* from 1936 onwards) that the decline in popularity of the Aldwych farces coincided with the rise to cinema fame of working-class comedians, namely Gracie Fields and George Formby, indicat-ing that the middle-class, drawing-room foolery of such types as Walls and Lynn was being supplanted by something more down-to-earth. David Sutton uses similar figures

published in the *Kinematograph Weekly* from 1937 onwards to support the same argument. Although the applicability of the *Film Weekly* polls as evidence for national cinemagoing trends may be classified as tenuous, as no further Aldwych films were to feature in the polls after 1933 (polls were a feature of the magazine throughout the 1930s), the comparative positions of the farces over the years within the same magazine's annual polls indicate that *A Night Like This* was released at a time when this decline was becoming apparent.

However, the decline in the popularity of the farces, and the comparative standing of *A Night Like This* set against the other Aldwych films, should not be overemphasised. To place the issue of popular decline into perspective, 158 British films were actually trade-shown in 1932 (from information in the *Kine Year Books* 1933 and 1934), therefore to be placed twentieth in a list of the top British films of the year cannot be viewed as a disaster when one takes the volume of films into consideration. The combination of the Aldwych farceurs and the music of Roy Fox would no doubt exert some pulling power among the British public; it certainly makes the film one of the most interesting and appealing of the farces today. Whether it held as much appeal with audiences in 1932 is open to debate. Perhaps the confluence of popular music and farce served to divide audiences, hence the lower positioning in the *Film Weekly* poll, as *Thark*, produced as a more straightforward adaptation of the stage original, was placed far higher in the same year. Possibly the core audience for an Aldwych farce preferred them to be adapted in a 'straightforward' fashion, minus any populist embellishments – the experiment with popular music and dance was certainly not to be repeated.

Apart from *Just My Luck* (1933), which Travers adapted from an H. F. Maltby play, and *Up to the Neck* (1933), which Travers wrote specifically for Ralph Lynn (Walls had no involvement in either film), *Thark* was to be the final Aldwych farce made for Herbert Wilcox. Following *Thark*, the whole team decamped to Michael Balcon's Gainsborough Pictures/Gaumont-British Picture Corporation combine, to continue producing screen adaptations of the farces, main-taining the 'straightforward' template as they did so. Nevertheless, the hybrid quality of *A Night Like This*, with its mixture of farce and popular music, the superlative ensemble playing and the wit of Travers' script, helped to make the film the most consistently entertaining and funniest of the screen adaptations of the stage originals. This was a position it was to retain within the Aldwych series as a whole until the mid-1930s (paradoxically when the farces were in their period of most marked decline, if the evidence of trade papers is accepted), when its crown was handed over to such splendidly funny works as *Fighting Stock* (1935), *Foreign Affaires* (1935), and *Stormy Weather* (1936), all now written by Travers for the screen and directed by Tom Walls.

Comedy, which the Aldwych farces had played such a leading role in establishing in British cinema, was to retain its position throughout the 1930s as the staple genre through which to find success at the British box office. Although the farces themselves were no longer at the forefront of the movement, they evidently retained some popularity. *A Night Like This* was to be succeeded by a further sixteen films with a Travers/Walls/Lynn connection (produced up to 1938), this fact alone demonstrating that they obviously retained a following among sections of the cinemagoing public. Walls, however, despite becoming more cinematically aware and assured in his direction, continued to be criticised for a lack of style, and the films were generally unfairly accused of being stuck in a rut and uncinematic. This unwarranted reception of the later films has subsequently coloured the reputation of the Aldwych farces which, in its turn, has unfortunately led to the films' being relatively neglected in critical overviews of British cinema. However, with their peerless ensemble playing, not to be equalled in British cinema until the *Carry On* team were in their stride, their significance to British film comedy in the 1930s, and the importance once attached to the films with regard to the resurgence of the British film industry itself in the early years of that decade, the Aldwych farces are long overdue for reappraisal.

John Oliver

REFERENCES

Richards, J. (1984) *The Age of the Dream Palace: Cinema and Society 1930–1939*. London, Boston, Melbourne, Henley-on-Thames: Routledge & Kegan Paul.

Sutton, D. (2000) *A Chorus of Raspberries: British Film Comedy 1929–1939*. Exeter: University of Exeter Press.

Travers, Ben (1978) *A-sitting on a Gate*. London: W. H. Allen.

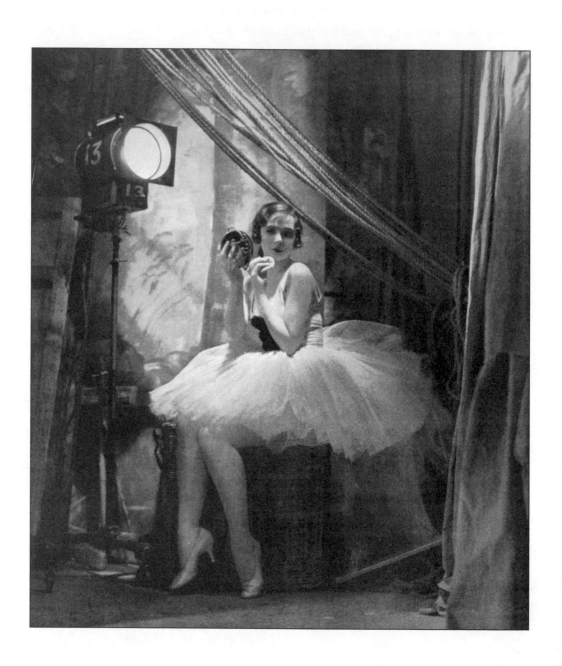

THE GOOD COMPANIONS

VICTOR SAVILLE, UK, 1933

If, in the service of some imperious archival programmer, one had to nominate a single film to represent 1930s British cinema, I cannot think of a better choice than Victor Saville's *The Good Companions*, a Gaumont-British production given its première in London in March 1933. Unlike the more obvious candidates – such as *The Private Life of Henry VIII* (Alexander Korda, 1933), *The 39 Steps* (Alfred Hitchcock, 1935), John Grierson's *Night Mail* (Harry Watt and Basil Wright, 1936) and *Goodbye, Mr Chips* (Sam Wood, 1939) – it is seldom seen or even invoked, and it remains, at the time of writing, unavailable in any VHS or DVD format, though the National Film and Television Archive holds a serviceable print. Even the novel by J. B. Priestley on which it was based, hugely popular in its time, adapted again for cinema in 1957 and for television in 1980, has by now slipped out of print. It never had much currency in academic circles; the vinegary attacks on the book and the novelist by the two Leavises have made a stronger critical impact than any defence. Yet it stands up both as an eloquent document of its time and as an absorbing narrative, and the same is true of the film, which brings together a striking team of people at three levels: characters, cast and filmmakers. It is as if the theatrical teamwork celebrated in the book's title has called for, and got, a comparable teamwork from those filming it, on both sides of the camera – a teamwork that offers a way of dealing with the problems, equally, of the England of the Depression and of the ever-struggling indigenous film industry.

Looking back, this acquires enormously greater resonance from our knowledge of what was to happen a few years later. Priestley himself, as writer and broadcaster, would become a key figure in wartime propaganda, and so would two in particular of the Gaumont-British production team, Michael Balcon and Ian Dalrymple, who went on to run two of the major filmmaking companies of the 1940s, respectively Ealing Studios and the Government's documentary unit, Crown – two groups whose most memorable wartime productions would be, precisely, celebrations of teamwork in action, of people coming together from diverse backgrounds to serve a common cause, as we will see *The Good Companions* doing.

The film's first, long-held image is a map of England. Strictly, it should be called a map of England and Wales, since it's impossible to cut Wales off neatly, but Scotland *is* cut off, Ireland

is absent, and the film's focus will be exclusively English. Exclusively, and also *inclusively*: this combination is what makes it so seductive, at the same time reproducing and transcending the ingrained limitations of what we habitually refer to as 'British' cinema. In writing on Hitchcock's work of the same period, I began by acknowledging that 'Lindsay Anderson was surely right to make the point, in his polemical essay in the collection *Declaration*, that British cinema has normally meant English, and southern English at that'. *The Good Companions* is English all right, but not just southern English. Its project of inclusiveness is set up at the start both visually and verbally, in a sequence of wit and energy.

The credits end with a full-screen title: 'Prologue Spoken by Henry Ainley.' Against the screen-filling image of the map, his voice tells us that, 'This is a story of the roads and the wandering players of modern England. The story of how Jess Oakroyd left his home in Bruddersford and took to the road; and how Inigo Jollifant walked out of his school at Washbury Manor, and how Elisabeth, daughter of old Colonel Trant, suddenly went off into the blue; and how chance brought these three to one small town in the Midlands, together with a broken-down troupe of entertainers, the Dinky Doos.'

Meanwhile, on the map, four areas are highlighted in black, forming three points of a triangle, corresponding to Yorkshire (or part of it) in the North, Cambridgeshire in the East, Gloucestershire in the West and, in the centre, Warwickshire. There could hardly be a bolder laying out of the film's project to stir things up and create a new national mix.

Next, the camera tracks in successively on the highlighted areas of what is revealed as a jigsaw, as a pair of hands intrudes from off-screen and puts the relevant piece into each black space. The piece labelled Bruddersford – an amalgam of Huddersfield and Priestley's own city of Bradford, where a prominent statue still commemorates him – dissolves into the back of a head in close-up, as the Prologue voice continues: 'At Bruddersford there was working at Higden's Mill a carpenter, Mr Oakroyd.' Then it addresses him: '*Hey, Jess Oakroyd!*' Next, the second piece of the jigsaw: '…and in the Fen country at Washbury Manor School for sons of gentlemen was Inigo Jollifant. *I say, Jollifant!*' Then the third: '…and in the sleepy West Country where the Trants had always lived, is the daughter of old Colonel Trant, Elisabeth. *Miss Trant!*'

On being addressed, each character turns towards the camera. Jess Oakroyd (Edmund Gwenn) smiles warmly and replies, '*Hello, how are you?*' He wears waistcoat, tie and flat cap, and tucks a pencil behind his ear. Inigo Jollifant (John Gielgud) smiles nervously; he wears a mortar board, and fiddles with his bow tie as he replies, '*Absolutely!*' Miss Trant (Mary Glynne) neither speaks nor looks at the camera; instead, she removes her glasses and looks off at an angle. Her

repeated identification as simply 'the daughter of Old Colonel Trant' seems to explain her lack of a voice and her inability to meet the camera's gaze. One woman and two men; one working class, and two somewhere in the upper reaches of the middle class; North, West and East. The film has introduced the three main characters of the Priestley novel, and their contexts, in vividly diagrammatic form.

The final sentence of George Orwell's *The Road to Wigan Pier* (1937) expresses a desire that 'this misery of class-prejudice will fade away', and that 'we of the sinking middle class … may sink without further struggles into the working class where we belong, and probably when we get there it will not be so dreadful as we feared, for, after all, we have nothing to lose but our aitches'. The ellipsis in that sentence is filled by a list of representatives of the middle class, beginning with 'the private schoolmaster, the half-starved freelance journalist, the colonel's spinster daughter with £75 a year, the jobless Cambridge graduate…'. Orwell always wrote dismissively, or at best patronisingly, about Priestley, but there is surely an unacknowledged echo here, conscious or not, of *The Good Companions*, whether book or film or both (another possibility is the intermediate stage version), as Orwell in effect sandwiches himself, the journalist, between Inigo Jollifant – the private schoolmaster who walks out and becomes, for a time, a jobless Cambridge graduate – and Elisabeth Trant, who, on the death of her colonel father, is told that she can expect an income of around £1 a week. Valentine Cunningham has pointed to the Orwell book's unacknowledged debt to Priestley's *English Journey* of 1934, and there is clearly more to the link between the two men than this. Here in *The Good Companions* Priestley's teacher and spinster are about to head off on a fictional 'English journey' akin to the later real-life ones of both writers, through the country's landscape and class-system, ready to participate, to work, rather than simply to observe and report. They never learn to drop their aitches, but their experience is indeed far from dreadful; both film and novel will stitch together an invigorating narrative of breaking out, an upbeat fantasy vision of change and renewal of the kind into which Orwell could never altogether liberate himself.

The industrial North, the private school of the East and the rural West country: before telling us anything more about the respective individuals, the film gives us images of their environment, each time in a quick montage of a few shots. North: factory production, smoking chimneys, crowds streaming away from a football match. East: school uniform, a school song and football on a different kind of playing field. West: pastoral images of landscape, livestock, village pond and timeless stone buildings. These are like compressed versions of three kinds of film that would already have been familiar to many audiences: urban documentary, rural

documentary and, in between them, the iconography of privilege and heritage that would get its most systematic and seductive use in *Goodbye, Mr Chips* but which was already there to be drawn on in films like Hitchcock's fourth feature, *Downhill* (1927), whose framing narrative is set in a boys' boarding school. Six of the early films produced at the Empire Marketing Board Film Unit (EMB) by John Grierson had been given a theatrical release in 1932–33, among them titles like *O'er Hill and Dale* (Basil Wright, 1932) and *Industrial Britain* (Robert Flaherty, 1933), and, as Iris Barry pointed out in her book of 1926, *Let's Go to the Movies*, documentary was already firmly established in British film culture, both as a term and as a practice, well before Grierson's alleged invention of it. Further research might well identify these three deft montage sequences, or at least their component shots, as being lifted from pre-existing films, but they in any case have the effect of evoking already stereotyped patterns of imagery, insidiously attractive, but expressing class-bound ruts out of which the characters have to climb – which they quickly start to do.

Jess Oakroyd comes home bitterly from work, having resigned his job after a row with his foreman, and gets no sympathy from his wife. Inigo Jollifant is part of a seedy common-room exploited by the Headmaster and his wife (again an Orwell connection comes to mind: his hostile account of the couple who presided over his own preparatory-school years in the essay *Such Were the Joys*). Elisabeth Trant is expected by the pillars of her community – lawyer, vicar, vicar's wife – simply to keep going in reduced circumstances in her dead father's house. All three, in short intercut scenes, make their definitive break: Oakroyd to go 'down South' (hitching a ride on a lorry); Jollifant to go 'out into the blue' wherever the next train will take him; Miss Trant to drive east in her impulsively-bought old car.

All three characters have escaped from a parody of community. What made Oakroyd snap was the way his mean-minded foreman at work nevertheless persisted in calling him *comrade*. Jollifant is trapped within a grotesque parody of the conviviality of the *communal* staff meal: eaten in silence, with separate provision for employers and mere teachers. And Miss Trant is expected by all to act as a paid *companion* to some rich old lady, in order to eke out her modest income. More genuine versions of community and companionship lie ahead.

So, by devious routes and means of transport, they converge on the Middle England of Rawsley. Miss Trant and Jollifant are both homing in on the small-time theatrical troupe, the Dinky Doos, she because a chance encounter has given her a parcel to deliver to them, he because of an equally chance encounter with a freelance entertainer who is meeting up with them, Morton Mitcham (Percy Parsons). And Oakroyd, robbed during his journey from the North and now on

foot, has happened to meet and help and accompany Miss Trant when her car breaks down. The two pairs arrive simultaneously at the café where the troupe is holding a depressed meeting, multiple introductions are made, and the main business of the film is ready to begin.

All of this represents a typical Priestley structure, plucking people abruptly out of their everyday surroundings to confront them with fresh encounters and challenges. Variations of it are found in the novel *Benighted* (1927), filmed by James Whale in Hollywood as *The Old Dark House* (1932), and in the exhilaratingly didactic theatre of *They Came to a City*, a parable for wartime England staged in London in 1943 and filmed by Ealing in 1944. The Ealing film boldly respects the play's schematism first by having Priestley himself summarise its device on camera – 'Let's suppose we took a cross-section of our people … let's imagine these people suddenly find themselves out of their ordinary surroundings' – and then by using the magic of editing to transfer a succession of individuals instantly, to their bewilderment, from their everyday lives into a new space where they are forced to interact, in a sort of workshop for constructing a good society. Both the novel and the film of *The Good Companions* find an effective balance between this kind of schematism – evident in the structure of both, and in the film's diagrammatic opening – and a more accessible naturalism. By the time of the café meeting, forty minutes into a 110-minute film, the opening voice-over is long forgotten, and we are ready to be caught up in a fresh narrative of striving, obstacles and fulfilment.

The Dinky Doos have been stranded by an absconding manager. A final vignette of false companionship is supplied by the café proprietor, a hard-faced woman who turns them out for sitting too long over their cups of tea. Miss Trant is spurred into answering the woman back, paying the bill, and offering to back them for a few weeks, if they can get their act together properly, by drawing on her modest legacy. Jollifant, already established as a fluent light pianist and composer, matches this by standing them all dinner in a local pub. This leads to a scene, at last, of true conviviality, whose climax is the choosing of a new name for the troupe. Picking up a phrase from Jollifant's impromptu address, Miss Trant suggests 'The Good Companions'. Though others demur (it is too long to fit easily on the bills), this has two crucial voices in instinctive support: from Oakroyd, and from the group's talented ingenue singer and dancer, Susie Dean (Jessie Matthews). So The Good Companions they become, with Jollifant and Mitcham as part of the team, Miss Trant as manager and Oakroyd as carpenter and general handyman.

Susie is the star of the show, as Jessie Matthews is of the film, and both of them will rise above the level of the Good Companions team: Susie to West End stardom, Jessie Matthews to a series of starring vehicles that nearly took her to Hollywood (whereas even Gielgud, after his

unhappy association with Hitchcock on *Secret Agent* in 1936, virtually dropped out of films for twenty years). But she is a loyal team member, whose loyalty and comradeship in effect *earn* her eventual stardom. She relates to the three travelling incomers as respectively sister, daughter and lover. Miss Trant has a wistful memory of a romance with a ship's doctor, cut short when she returned home to nurse her ailing father; it is Susie who will, in the spirit of sisterhood, elicit her story, secretly track down the doctor and reunite them. Oakroyd is alienated from his wife and son, but not from his daughter, who has married and gone to Canada; Susie slips, tactfully and affectionately, into the daughter role, until such time as father and daughter can meet again. And she slips also into an intimacy with Jollifant which never quite moves from the professional and companionate to the sexual, though Gielgud is more convincing as a heterosexual lover than he would be in the Hitchcock film, or anywhere else. There is an inevitable tension between the Good Companions ideal and the fact of Susie/Jessie's steady progress to stardom, but it does not seriously compromise the film's project or its spirit. Indeed, Lawrence Napper points out that small-time provincial show-business is itself, for Susie, the rut from which she needs to climb out, as the others climb out of theirs *into* show-business; raised by itinerant entertainers, she has no regional roots of her own, and seems likely at the end to settle happily in London.

Meanwhile the inaugural dinner, and the choice of name, and Miss Trant's backing, and the accession to the team of Jollifant, Oakroyd and Mitcham, have got the show back on the road, with the other members of the ensemble having their own voices and idiosyncrasies and moments in the spotlight. The remainder of the story will hinge on two more big communal scenes. The first follows a series of poor attendances. A heat wave goes on and on, the money is running out, and Miss Trant's gamble seems to have failed. After one more sweltering failure, the troupe gathers round a big table for a crisis meeting, to decide whether to disband. Oakroyd speaks out against this, urging the Northern values of persistence, and starts a new fighting fund by putting on the table the money that he had been saving to send to his daughter. Others, in quick succession, follow his example. As the money builds up, rain starts to beat down on the roof; the drought has broken. It is like a magic spell, a moment out of *The Golden Bough*. Virtue – personal sacrifice for the good of the group – has been rewarded. The previous montage of failure is succeeded by a montage of success, an English version of the Hollywood montage of the triumphant musical tour punctuated by train images and posters: for Chicago and St Louis, read Buxton and Loughborough.

The second big communal scene comes when the Companions' success has become so spectacular that it provokes attack from a rival Midlands entrepreneur whose profits have been

hit. He sabotages the show, on Susie's benefit night, by planting hecklers among the audience and provoking a riot which causes the police to close down the performance. The cast rallies round, and so does the audience, to whose acclamation the show goes on after all. Among them is an impresario from London (Finlay Currie, his familiar Scots tones overlaid by an American accent) who signs up Susie to a star contract, and signs Jollifant too in musical support, paving the way for the happy ending.

The character, motives and actions of the vicious rival entrepreneur, played by the reliable D. A. Clarke-Smith, are carried over fairly directly from the book, which introduces him thus: 'This is Mr Ridvers, but when he is in his tiny office he calls himself the Triangle New Era Cinema Co., and it is from here he controls the destinies of The Tivoli Picture Palace, Gatford, the Coliseum Picture House, Mundley, and the Royal Cinema, Stort, the only three cinemas of any importance in the district.' Priestley will repeat this pointed opposition between films and live performance in his non-fictional *English Journey*. On reaching Leicester and looking for entertainment in the evening, he is disconcerted 'to discover that the music hall where I had formerly seen a good robust show was now given up to Constance Bennett. In the whole of Leicester that night there was only one performance being given by living players, in a touring musical comedy … Soon we shall be as badly off as America, where I would find myself in large cities that had not a single living actor performing in them, nothing but films, films, films.'

In the film, however, Ridvers runs not a cinema business but a music hall one. How do we make sense of this shift? It would, of course, be a strange piece of masochism for the film to reproduce the anti-film implications of the two books, but it is not just a defensive manoeuvre: the film is making an implicit claim to be inheriting, and taking over, some of the 'good robust' traditions of the modes of live variety entertainment. We never actually see anything of the Ridvers show, but the implication is that the robustness associated with the old music hall in *English Journey* has degenerated, in this version of it, into seedy vulgarity. The happy manager of the theatre to which the Companions have attracted full houses tells Ridvers that the lesson is to 'keep it clean'. This concert party, or pierrot show, is like a safer, sanitised version of a music hall tradition which was already in steep decline – a decline hastened by the cinema's still-recent conversion to synchronised sound, which made it so much simpler and more attractive to appropriate materials and performers from Music Hall, as from musical theatre (and it is worth noting that the earlier visit to Leicester to which Priestley looks back nostalgically seems to have happened in the 1920s, when films were still silent). In turn, the *Good Companions*

adaptation itself represents a form of cinema that draws productively on the style and spirit of these kinds of live performance, part of an important strand in British cinema that has been foregrounded in a definitive article by Andy Medhurst. He traces the difficulties, caused by factors of good taste and censorship, of transferring adequately to cinema those 'robust' qualities Priestley enjoyed in music hall, as evidenced by the film experiences of Max Miller: 'His popularity was such that he made many films, but that same popularity was based on telling jokes so "blue" that they could never be allowed on screen. Thus Miller, visibly ill-at-ease, was put into various unsuitable genres … or made to sleepwalk through the tamest of farces.' And Max Miller himself, in fact, has a cameo role in *The Good Companions*, just before the Ridvers episode, as a fast-talking sheet-music man who wants to sign up Jollifant. Not 'blue', but not ill-at-ease either; safely incorporated as an *attraction* that engagingly but unthreateningly stretches the framework of classical narrative.

The key opposition is the one the film has established right from the start, between false and true community. In stage terms, it is an opposition between the Ridvers concept of entertainment and the Companions one; in film terms, between – by implication – a slick Americanised or stilted British cinema, and the accessible indigenous democratic one represented by this film, which, in the best tradition of the old Music Hall, brings together the high-prestige Shakespearean star (Gielgud), the singer-and-dancer (Matthews), the stand-up comedian (Miller), a wealth of character 'turns', and much more beside. Again it is tempting to cut through the years to the cinema of wartime: to the climax of the celebrated documentary for the Crown Film Unit, *Listen to Britain* (Humphrey Jennings and Stewart McAllister, 1942), which cuts from Flanagan and Allen singing in a factory canteen to a Myra Hess concert in the National Gallery; to Ealing's wartime celebration of the Victorian Music Hall in *Champagne Charlie* (Alberto Cavalcanti, 1944); and to the celebration of a more contemporary Music Hall in *Let the People Sing* (John Baxter, 1942). One can trace a direct continuity from *The Good Companions* in the involvement in these subsequent films of, respectively, Ian Dalrymple, editor of *The Good Companions* and a very hands-on producer of *Listen to Britain*; Michael Balcon, head of production at Ealing from 1938; and of Priestley himself, author of the 1939 novel that was the basis for *Let the People Sing*. More than that, *The Good Companions* in its narrative structure provides, as hinted earlier, a wonderfully clear template for a range of wartime films that bring people together from diverse backgrounds and regions to form a purposeful team – not only at Crown and Ealing, but in films like *The Way Ahead* (Carol Reed, 1944) for the services and, for the home front, *Millions Like Us* (Sydney Gilliat and Frank Launder, 1943).

However, as Lawrence Napper argues, it would be wrong to be too teleological about this: 'The film, is interesting for its predictive qualities, for its protean nature. It points towards the kind of cinema of which we might be proud, and, crucially, the moment at which that cinema actually occurs is the Second World War. The manoeuvre is not uncommon in British film studies … against this shining example, the British cinema of the 1930s is often obscured.'

It ought not to be. If some key members of the *Good Companions* production team were influential figures in Second World War cinema, others were not. For a variety of reasons, none of the main actors were, nor was the film's director, Victor Saville, who, like Hitchcock, left Britain for Hollywood in 1939. It may seem perverse not to have mentioned Saville at all until now, but the ease of the omission makes the point that the production is truly, like the Companions' own enterprise, a team effort. But Saville brought to the film indispensable professional qualities, and an intense feeling for English forms of melodrama, that he had built up in a busy career which had started, alongside Hitchcock, in silent films at Gainsborough a decade earlier. *The Good Companions* builds exuberantly on strong indigenous generic and thematic materials, drawn from literature, theatre and Music Hall, as well on directorial craftsmanship developed and practised, likewise, through a decade of work in English studios.

The Good Companions, then, looks back as much as it looks forward. It is a director's film, a writer's film, a star vehicle and an authentic product of teamwork; and a film that is overdue for rescuing from obscurity.

Charles Barr

REFERENCES

Anderson, L. (1957) 'Get Out and Push', in T. Maschler (ed.) *Declaration*. St Albans: MacGibbon & Kee.

Barr, C. (1999) *English Hitchcock*. Moffat: Cameron and Hollis.

Barry, I. (1926) *Let's Go to the Movies*. London: Chatto and Windus.

Cunningham, V. (1988) *British Writers of the Thirties*. Oxford: Oxford University Press.

Medhurst, A. (1986) 'British Cinema and Music Hall' in C. Barr (ed.) *All Our Yesterdays: 90 Years of British Cinema*. London: British Film Institute.

Napper, L. (2001) *The Middlebrow, 'National Culture' and British Cinema 1920–1939*. PhD thesis, University of East Anglia.

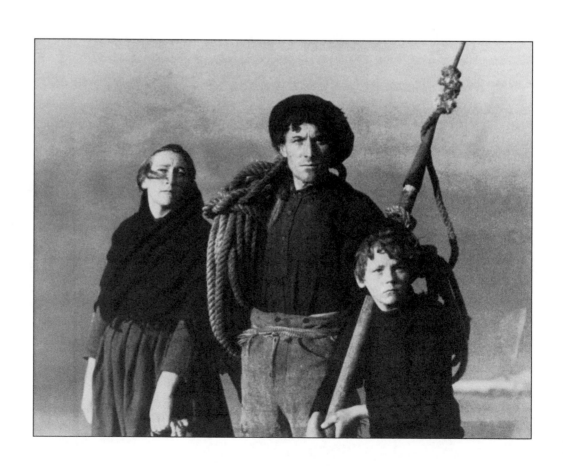

MAN OF ARAN

ROBERT FLAHERTY, UK/IRELAND, 1934

Shortly before his death in 1951, Robert Flaherty was working on a documentary about the triumphant and controversial return from Korea of the bombastic General MacArthur. He was experimenting with the new Cinerama process, an elaborate 3D system then being developed by the film industry as a commercial response to the growing threat of television. Two years earlier, Flaherty had begun but never finished an intimate film on Picasso's disturbing and impassioned anti-war painting 'Guernica' in collaboration with New York's Museum of Modern Art. These seem remarkably contradictory projects in terms of scale and theme but then nearly everything about Flaherty's life and work was contradictory. He was, for example, credited with inventing the documentary form of filmmaking with his study of Inuit life, *Nanook of the North* (1922) and his portrait of life in Samoa, *Moana* (1926). Yet he was castigated in 1934 for betraying that form with the release of *Man of Aran*, his film about life on the Aran Islands off the west coast of Ireland.

Flaherty was born of mixed Irish/German parentage on 16 February 1884 in Iron Mountain, Michigan and grew up close to the iron mine owned and managed by his father. Part of his early adolescence was spent in the Canadian wilderness with his father prospecting for iron ore and living a primitive frontier life with miners, drifters and displaced Native Americans. He retained a deep and abiding interest in the concept of the 'primitive' and these early experiences were to influence his particular approach to filmmaking. In later life Flaherty was to declare, 'I am an explorer first and a filmmaker a long way after', and certainly his development as a filmmaker was a slow and almost accidental process. By the time he was 22 he was exploring and surveying Western Canada for various railroad and mining syndicates and in 1910, was contracted by Canada's most powerful industrialist, Sir William Mackenzie, to prospect for iron ore deposits in the sub-arctic wastes north of Hudson Bay.

Over the next five years he made four trips to northern Canada, discovering and mapping the Belcher Islands and locating large deposits of iron ore for his employer. During one of these expeditions, Flaherty took with him, apparently at Mackenzie's suggestion, 'one of those new-fangled movie picture cameras'. His only formal training in filmmaking was a three-week

course in Toronto before setting off and it is indicative of his initial naïveté and ignorance of film that all the footage he shot on this trip was destroyed in a fire caused by his own cigarette ash falling onto the highly inflammable nitrate film stock. He was, however, intrigued by the new medium and began a lifelong obsession with exploring its potential. In a way, Flaherty adopted the same attitude to filmmaking as he did to mining: he probed, explored and experimented with the medium and, when he needed to, he was happy to seek patronage from corporate business to help him realise his projects.

His achievements as an explorer, geologist and even anthropologist were quite considerable by this stage but when he set off again for the Far North in 1920 it was with the express purpose of making a film about the Inuit life he had encountered on his previous trips. This expedition was generously financed by the French fur-trading company, Revillion Frères, and he was able to take with him what amounted to a full mobile film laboratory. The working methods of a lifetime, so influential in the development of documentary filmmaking generally, were established on this trip. Flaherty lived among the Inuit of the Ungava peninsula for over a year, shooting a large amount of footage and building his film around the struggle for survival of one man and his family.

The resulting film, *Nanook of the North*, was released in New York in June 1922 and was an immediate sensation with both critics and audiences. The film went on to become an international box-office hit. The irony was that this film was so unlike established commercial cinema that all the main distributors refused to handle it. *Nanook of the North* was finally released by Pathé through the intercession of Revillion Frères. Its commercial success, however, was not lost on Jesse Lasky of Paramount who, with characteristic Hollywood sensitivity and insight, offered Flaherty a budget big enough to go anywhere in the world and 'bring back another Nanook'.

Flaherty chose to go to the South Sea island of Samoa. His wife, Frances, an accomplished photographer, was by now his main collaborator and with a full crew and mobile laboratory, the Flaherty family settled among the Polynesian natives for the next two years. By the time the resulting film, *Moana*, was finished Flaherty had shot 240,000 feet of film and was $53,000 over budget. Paramount were neither pleased with Flaherty nor with the film (one disgruntled executive complaining that there were no blizzards in *Moana*). The film was only half-heartedly released under the enticing, misleading and ultimately insulting sub-title of *The Love Life of a South Sea Siren*. Flaherty and Hollywood were to hold each other in mutual contempt for the next twenty years – 'Hollywood is like sailing over a sewer in a glass-bottomed boat', he once famously declared.

Moana was, however, a significant critical success, especially among European critics, and it is no coincidence that in 1930, Flaherty was to leave America and base his filmmaking in England for the next ten years. By this time he was generally regarded as a great and innovative filmmaker whose films displayed an admirable concern with the lives of ordinary people struggling for survival in their own environment. Increasingly, Flaherty was seen as the antithesis of Hollywood's commercial and melodramatic artifice and he had become an inspiration for the emerging documentary film movement in Britain. Indeed, the main patron and theorist of this movement, John Grierson, is often credited with inventing (more accurately adapting) the term 'documentary' to the kind of actuality filming that Flaherty pioneered and that he and the British filmmakers were trying to develop. When Flaherty came to Britain in 1930 Grierson became his main supporter, finding him film work with his own Empire Marketing Board film unit. In 1931 he secured Flaherty the funding from Gaumont-British (under the guidance of Michael Balcon, the British industry's own Jesse Lasky) to make *Man of Aran*.

Balcon had very clear reasons for financing Flaherty, despite his reputation as a profligate filmmaker and his patchy commercial appeal. Balcon was quite simply buying Flaherty's prestige and artistic credentials for the Gaumont-British company. The company had come under increasing fire from Britain's influential film critics (among them C. A. Lejeune in the *Observer* and writer Graham Greene in the *Spectator*) for the banality and unreality of its 'pale imitation Hollywood' films and the lack of serious purpose in British cinema generally. The budget he gave Flaherty for *Man of Aran* (at £10,000, substantially less than the budget for *Nanook of the North* ten years earlier) was a small price to play for the artistic kudos that would ensue. 'A sop to Cerberus' was how Flaherty's biographer, Arthur Calder-Marshall, described the arrangement.

The reasons for Flaherty choosing Ireland and the Aran islands for his next major project are more obscure. Unlike that other great Irish-American filmmaker, John Ford, Flaherty seems to have been fairly uninterested in his Irish ancestry. He felt no compelling need to return to his roots and paid scant attention to the country after he completed the film. He says he became interested in the idea after meeting a Corkman on the boat to Europe in 1930, who regaled him with tales of the Aran islands and the enormity of the seas around their shores. This has been dismissed by some critics as Flaherty's own attempt at overblown blarney. What is indisputable is that Flaherty's main concern was to make a film about 'man's struggle with the sea', the kind of elemental struggle that the sedate life of Samoa had failed to deliver. On Grierson's advice, Flaherty read Synge's *Riders to the Sea* and *The Aran Islands* in preparation for such a film and,

in January 1932, the family decamped to Inishmore, the largest of the three Aran islands to begin what would prove to be a two-year sojourn.

Flaherty quickly established his working environment on Inishmore, building studio and laboratory facilities and setting about finding a 'family' around which to build his film. Over the next two years he shot an enormous amount of film, observing the Man of Aran (played by Tiger King) and his family (his wife, played by Maggie Dirrane and their son Mikeleen, played by Michael Dillane) performing a variety of mundane or downright dangerous tasks. The film's narrative, such as it is, is built around a number of set pieces. The film begins with a storm and observes a flimsy curragh containing three fishermen landing against the force of the wind and the huge waves. Next, we see some of the hardships of mundane Aran life: making a field on the barren rocks using seaweed and soil scraped out from rock crevices; fixing holes in the boat with a mixture of cloth and tar; rendering the liver of the giant basking shark into oil for lamps. The centrepiece of the film is the hunting of the basking shark and the film follows one such excursion as the men of Aran harpoon the huge beasts from the flimsy security of their curraghs. The film ends with another storm sequence in which the distressed family on shore watch the prolonged struggle of the boat to land safely against the elements. During the two years of filming Flaherty experimented with different lenses and pioneered the use of lenses of extreme focal length which allowed him to film the mountainous seas of the Aran islands from the safety of a boat or from dry land. In the end, he shot nearly 37 hours of negative from which the final 76-minute film was edited.

The film had its world première at the New Gallery in London on 25 April 1934. Inevitably, this screening had been preceded by a major publicity drive organised by the film's backers, Gaumont-British, and the première itself became a major social and commercial event. The islanders themselves were brought over to London and paraded before the press and general public in their simple homespun island garb. A stuffed basking shark was put on display in the window of the Gaumont-British Wardour Street office and the band of the Irish Guards played Irish airs to the first-night audience. Of course, as far as Gaumont-British was concerned, this was an event of profound artistic importance confirming the company's commitment to cultural excellence as well as commercial success. Audience response and initial reviews were positive and Flaherty's spectacular cinematography was particularly praised. Balcon's faith was vindicated and Flaherty's status as the poet of the cinema seemed secure.

When the film opened in Dublin on 6 May it was a national event of some cultural and political significance to the nascent Irish Free State. The screening was attended by Ireland's

charismatic leader Eamon de Valera and by most members of his cabinet. The enthusiastic reception accorded the film in Ireland was summed up by nationalist historian and close supporter of de Valera, Dorothy Macardle, who saw in its portrayal of the heroic struggle of the Aran islanders nothing less than the rehabilitation of the Irish people in the eyes of the world. For her, and most of the Irish critics, Flaherty's unsentimental portrayal of the Irish – the documentary truth of his vision of the Aran islands – was an important riposte to enduring stage Irish stereotypes and Hollywood's romantic caricatures. 'Here is Irish realism, at last,' one reviewer proclaimed, 'a grim, sad realism that grips at the heart of the nation'.

This intertwining of seemingly contradictory impulses – art and commerce, film and politics, truth and fiction, realism and romanticism – was to characterise the critical reception of the film at the time and continues to influence its reputation today. Flaherty's films generally have been central to documentary film debate and the historical importance of *Man of Aran* is that, more than any other film, it has generated the most profound controversies about documentary practice and aesthetics.

As far as the debate about the documentary form was concerned, Flaherty was, in a sense, the victim of John Grierson's patronage. As noted above, Grierson had originally coined the word 'documentary' in reference to Flaherty's *Moana*. As he himself said, he used the word originally as an adjective but he initiated a debate about the nature of the word as a noun, one that came to signify a certain kind of non-fiction film that had defined working methods and an overtly social purpose. He established and promoted a kind of filmmaking in Britain that was documentary in its approach to real people and, at the same time, attempted to expose and rectify the pressing social problems that afflicted them. Writing about documentary film in 1935 Ralph Bond, one of the more left-wing filmmakers associated with the movement, wrote: 'Have we something to sell? Yes, we are trying to sell working-class ideas and working-class politics through a medium that is popular in every town and village. The cinema is probably the most powerful form of propaganda yet devised by modern civilisation. But like everything else, it is under the control of vested interests who use it not only to make profits but to put across propaganda for their own class interests … Our purpose in making films must be to dramatise the lives and struggles of the workers.'

Grierson's continuing support for Flaherty brought the latter's particular cinematic vision into the ambit of this debate. It is hardly surprising, therefore, that the politically committed filmmakers and critics who clustered around documentary filmmaking in Britain at the

time should find Flaherty's high romanticism particularly problematic. Thus Ivor Montagu, in his review in the *New Statesman and Nation* on 28 April 1934, lamented the lack of realism in Flaherty's film. 'Man's struggle with Nature is incomplete unless it embraces the struggle of man with man', he declared. He then famously turned Flaherty's supposed opposition to Hollywood on its head. 'No less than Hollywood', he continued, 'Flaherty is busy turning reality into romance. The tragedy is that, being a poet with a poet's eye, his lie is the greater, for he can make the romance seem real.'

Ralph Bond again, writing in *Cinema Quarterly* (Summer, 1934) accused *Man of Aran* of being escapist in tendency and described Flaherty as a 'romantic idealist striving to escape the stern and brutal realities of life, seeking ever to discover some backwater of civilisation untouched by the problems and evils affecting the greater world outside'. Again in *Cinema Quarterly* (Autumn, 1934) David Schrire described the film as 'evasive documentary' that avoided all the important social and political issues in favour of an anachronistic portrayal of the 'noble savage' and his struggle against nature. The film is thus condemned for what it avoids – social relationships, capitalist exploitation, evictions, the class struggle – the whole reality, in other words, of 'man's struggle with man'.

The film also raises serious issues about Flaherty's method and those aspects of Aran life that he chose to include. British documentary filmmakers were committed to an aesthetic practice that interfered as little as possible with the objective reality of life as the camera found it, faithfully recording the social relationships and the ordinariness of lived experience. But as Brian Winston argues, far from living with the people in their actual environment, Flaherty's filming trips 'became family outings in a particularly imperial mould, replete with nannies and large rented houses' (and in the case of Aran, a *cordon bleu* cook). Even so, Flaherty had pioneered the method of participant observation that Grierson in particular so admired and had elevated the ordinary experience to the level of art through his insistence on location shooting. However, his insistence on staging and recreating his own dramas in this raw reality was seen as a travesty. Thus the two centrepieces of *Man of Aran* – the building of a field on the barren rocks and the shark hunt – were practices that had long since died out. The basking sharks, though undoubtedly impressive in their dimensions, are docile creatures and not the dangerous monsters that Flaherty depicts. ('On Aran, he made of the peaceful basking shark a prototype Jaws', as Winston acerbically puts it). Even Flaherty's chosen family, central to his depiction of the struggle for existence on the island, was constructed around the need for photogenic faces and the Man himself, Tiger King, was a blacksmith by trade and knew little about fishing and boats.

He looked good though, and, as Flaherty himself said, it is surprising how few faces can stand the test of the camera.

Much of the controversy, therefore, has centred on questions of content (both what was included and what was avoided) but the meaning of *Man of Aran* resides primarily in its visual style and here, the much-praised cinematography is crucial. Flaherty manipulated reality, on its most mundane and banal level, for the sake of the camera and to dramatise and elevate their significance. His assistant on the shoot, local man Pat Mullan, describes the way in which scenes were staged for the camera: 'Mr. Flaherty picked out with his camera the spot where Mikeleen was to fish from, and I must say that that damn camera seemed to be possessed of the evil eye. It had the faculty of picking out the hardest and most dangerous places to get at.' And of Flaherty's choice of location for building the field, Mullan reportedly said to him, 'It is the last place on Aran I would want to pick out … but as usual that camera of yours has the faculty of picking out the most contrary places.'

We can see this visual manipulation in two key sequences in particular. In the field-making sequence Flaherty shows the tedious process of laying out a field on the barren rocky landscape of the island in minute detail. However, the way in which this sequence is shot and edited imposes a certain judgement on the characters and their lifestyle which is anything but realist. Flaherty uses a combination of low-angle shots and high, panoramic shots of the people against landscapes and seascapes. Often the characters are framed against the skyline, sometimes in silhouette. We can see this clearly in the soil-gathering sequence in general but in the rock-breaking scene in particular. The camera captures the Man in a low-angle shot. He dominates the frame, towering above the camera and caught against the sky. As he lifts the boulder above his head there is a series of rapid edits, showing the action from a number of perspectives in a montage that emphasises the character's physical strength and determination. The combination of shooting style, framing and editing works to heroicise the Man and to give an epic dimension to his rather mundane tasks. Similarly, we see his wife carrying a basket of soil or seaweed over the barren landscape, heroically framed on the horizon against this same elemental skyline.

In another sequence at the end of the film, the family has just rescued the fishing nets from the sea and the Man himself has narrowly escaped drowning in the tempestuous waters. As the three characters walk away from the shore, they pause on the edge of the cliff and look back at the crashing waves. Flaherty edits a series of low-angle shots of the human characters framed against the skyline with contrasting shots of the thunderous waves. The way in which

he does so again imposes a meaning that is highly romantic and, in the political terms of the documentary debate, extremely reactionary. The first shot shows all three characters framed in this typical manner. When we return to the human characters after the first sea shots, we get a low-angle shot of the father himself. On cue, he turns his head slightly to offer a perfect profile of his chiselled good looks, framed against the skyline by the 'tam-o'-shanter' head-gear which Flaherty insisted that the characters wear. As with the rock-breaking sequence we get here a perfect realisation of Stakhanovite virility. More shots of the crashing seas follow this stylised, monumental pose before finally cutting to a low-angle shot of the son in similar pensive pose. The sequence ends with a three-shot again of the family, walking home against the majesty of the sky, fragile human beings tenuously holding on to a cultural space against the awesome power of nature. The main ideological impact of the sequence, however, is to suggest continuity between father and son – implying that the father's struggle will eventually become the son's and that this elemental existence is set to continue in an unending cycle. It is hardly surprising that Flaherty's stylised heroics would appear so reactionary to a group of filmmakers and critics committed to social change and to a form of non-fiction film that would facilitate this.

To achieve his epic vision of the 'noble savage', Flaherty took considerable liberties with the objective reality of life on Aran as he found it. However, even if everything he showed was objectively true, the film could still be dismissed as stylised romanticism because of its visual style and editing.

At the 1934 Venice Film Festival *Man of Aran* won the top prize for the best foreign film, 'the Mussolini Cup', and this was to cause Flaherty more grief and abuse. The ideological climate of the early Venice festival was clearly demonstrated at that year's festival when Gustav Machaty's Czechoslovakian entry *Extase*, featuring the infamous nude shot of Hedwig Kiesler (Hedy Lamarr), was condemned for 'bringing adultery, eroticism and crime against maternity to the screen'. Against this, Flaherty's vision of a pure and noble humanity must surely have impressed. The Nazi filmmaker Leni Riefenstahl was to win the Mussolini Cup in 1938 for *Olympia,* her documentary about the 1936 Berlin Olympics, and Brian Winston has argued that her aesthetics of manipulation owed much to the pioneering work of Flaherty. Her re-arrangement of material to make coherent sequences out of disparate footage, he argues, 'matches anything in Flaherty. For her implicit authority for these manipulations at all levels is Flaherty, as theorised by Grierson … The point is not the mendacity or otherwise of the final film; it is simply that the material has been treated; it has been dramatised.'

All of this evidence is circumstantial and it does seem harsh today that Flaherty should have had to contend with the implication that his film displayed a fascist sensibility. He was certainly no fascist but his essentially nineteenth-century sensibility, his anthropological instincts and his celebration of a Rousseauesque primitivism made him vulnerable to the charge in the heated political context of the 1930s. The particular confluence of his aesthetics and that of the Fascist art of the times seems to give the claim some legitimacy.

In a famous essay on Leni Riefenstahl, Susan Sontag did attempt to define what fascist aesthetics are and her, admittedly tentative, conclusions provide an interesting codicil to the debate on *Man of Aran*. Riefenstahl had made two notorious Nazi propaganda films for Hitler in the 1930s, *Triumph of the Will* in 1934 and *Olympia*. In the 1970s she attempted to re-instate her artistic credentials through the publication of a number of photographic studies and Sontag was reviewing her book on the Nuba tribespeople of Sudan. She took the opportunity to look again at Riefenstahl's career and to consider whether or not there was something in her work that might be considered inherently 'fascist'. Admitting the difficulty of definition that this posed, she nonetheless argued that 'National Socialism – or more broadly, fascism – stands for an ideal, and one that is persistent today under other banners: the ideal of life as art, the cult of beauty, the fetishism of courage, the dissolution of alienation in ecstatic feelings of community, the repudiation of the intellect, the family of man (under the parenthood of leaders)'.

Man of Aran is certainly guilty of most if not all of these traits, and it is a measure of the apolitical nature of Flaherty's vision that he was unaware of the problem inherent in his nineteenth-century primitive sensibility. Even removed from the political hothouse atmosphere of the 1930s, Flaherty's film still provides a suggestive insight into the implications of a concerted romantic gaze – one that evacuates the material reality of existence and denies the complexity of human culture in the pursuit of an idealised essence. Worrying still is the generally enthusiastic reception accorded the film in Ireland at the time.

Man of Aran was promoted and largely accepted in Ireland as a realistic portrayal of life in contemporary Aran and part of the huge attraction of the film for audiences at the time was precisely its so-called realism. Translated into the Ireland of the early 1930s, this realism had a profoundly nationalist dimension. As we have seen, Dorothy Macardle saw in the film a realistic response to the romantic or hostile stereotypes of the past. How can such a heroic romanticisation have been mistaken for realism? Luke Gibbons offers one possible explanation for a general misrecognition of the film. He usefully points out that the pastoral genre has in fact two romantic variations. Following the art critic Erwin Panofsky, Gibbons refers to these as

'soft' and 'hard' primitivism. Soft primitivism is the romanticism that is most obvious, 'a golden age of plenty, innocence and happiness – in other words, civilised life purged of its vices'. Hard primitivism is more problematic, in that it casts a romantic eye on the less attractive aspects of landscape and rural life – it 'conceives of primitive life as an almost subhuman existence full of terrible hardships and devoid of all comforts'. This, as Gibbons points out, is a perfect description of *Man of Aran*.

The problem, though, is that at the time of its release in Ireland in 1934, the film was received as a realistic representation of the Aran Islands, its hard primitivist romanticism mistaken for a slice of social realism. The image of the islanders that the film promoted no doubt dove-tailed the prevailing ethos of Irish nationalism at the time and seemed to offer visual credence to de Valera's own vision of an Ireland of frugal self-sufficiency. But if the romanticism of Flaherty's film can be mistaken for realism on one hand and stands accused of fascism on the other, what does this say about the conception of the nation that saw its own image in the film?

The legacy of *Man of Aran* and the dangers inherent in its romantic excesses have been deeply significant for the development of indigenous filmmaking in Ireland. The myths embodied in Irish landscape and the ideological constructions of the west of Ireland – the way in which a particular form of Irish identity was imagined, in other words – have provided one important theme in recent Irish cinema. Thus one of this new Irish cinema's main projects has been to demythologise rural Ireland and to question the ascetic nationalism that underpinned it. In this regard, the romantic excesses of *Man of Aran* have become an important point of departure.

In hindsight it can now be seen that the political and cultural context of the early 1930s dictated the reception of *Man of Aran* to the point that it exposed rather starkly the paradoxical nature of Flaherty's essentially nineteenth-century romantic sensibility. First, the film became the focus of an aesthetic debate about the nature and social purpose of the documentary form itself and this clouded its reception, especially in Britain. Second, the political thrust of this debate was heightened by the depression and by the rise of fascism in Europe, both of which occasioned an international anxiety about the relationship between culture and politics generally. *Man of Aran* looked suspiciously reactionary in such a climate. Third, in Ireland, the film arrived just as the de Valera government was reinvigorating the ideals of cultural nationalism and it provided an almost perfect cinematic expression of the ascetic romanticism that lay behind this whole project. *Man of Aran* does have its supporters but its reputation today

rests as much on the debate and controversies that it raises as it does on Flaherty's aesthetic achievement.

Martin McLoone

MAN OF ARAN

REFERENCES

Bond, R. (1935) 'Making Films with a Purpose', in D. Macpherson (ed.) *British Cinema: Traditions of Independence*. London: British Film Institute.

Calder-Marshall, A. (1963) *The Innocent Eye: The Life of Robert Flaherty*. Harmondsworth: Penguin.

Gibbons, L. (1988) 'Romanticism, Realism and Irish Cinema', in K. Rockett, L. Gibbons and J. Hill (eds) *Cinema and Ireland*. London: Routledge.

Sontag, S. (1976) 'Fascinating Fascism', in B. Nichols (ed.) *Movies and Methods*. Berkeley: California University Press.

Winston, B. (1984–85) 'The White Man's Burden', *Sight and Sound*, 54, 1, 56–60.

_____ (1995) *Claiming the Real: The Documentary Film Revisited*. London: British Film Institute.

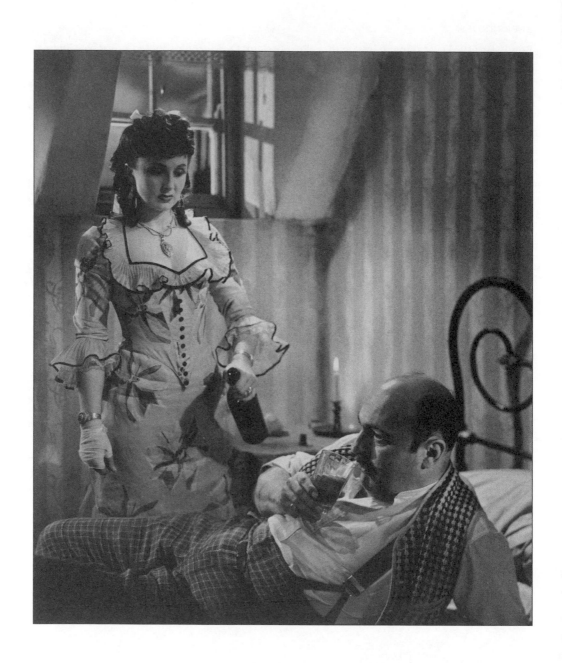

PINK STRING AND SEALING WAX

05

ROBERT HAMER, UK, 1945

A studio-bound melodrama about a woman, a murderess at that, is not the first paradigm brought to mind by the word 'Ealing'. Yet *Pink String and Sealing Wax* (Robert Hamer, 1945) is the work of a major Ealing director and contains one of Ealing's most striking performances. Significantly, Michael Balcon, Ealing's production chief, in his autobiography fails to mention it at all. Charles Barr's *Ealing Studios* gives the film somewhat scant attention though its scenario of repression and consequences might have been thought to fit the overall structure and thesis of his book; and George Perry's *Forever Ealing* allots it a mere paragraph, half of which is taken up with plot synopsis. A sympathetic feminist reading comes from Marcia Landy in *British Genres*, but in the now-prolific writing about Ealing it rarely achieves much notice. It is worth speculating on why it is not better known and more written about.

Melodrama was not a mode favoured by Ealing; this was Gainsborough's territory in the mid-1940s. And melodrama was certainly not looked upon benignly by the reviewers of the day, the concept of the 'quality' film being tied to the realist ethic valorised by its contribution to the wartime successes of British cinema or to the literary adaptation that brought such prestige to the industry from the mid-1940s. Only rare Ealing films such as *Cage of Gold* (Basil Dearden, 1950) exhibit melodramatic impulses in full cry, though there are traces in other of the studio's output, including *It Always Rains on Sunday* (1947), which reunites director Robert Hamer and star Googie Withers. Realism of setting, in comedies as well as dramas, became an Ealing trademark and helped to ensure its high critical place in post-war British cinema. And as for *Pink String and Sealing Wax*, its literary/theatrical antecedents have nothing more to boast of than a modestly popular West End thriller by Roland Pertwee. (Withers in 2003 recalled thinking it 'a dreadful play but when I saw the screenplay I thought, oh, they've done something with this'.) This is not Dickens or Shakespeare or even Rattigan, three of the names on which the 'quality' cinema of the 1940s rested.

The film takes its plot directly from the play. There are two main strands which it is the business of the narrative to fuse. First, there is a middle-class Victorian household in Brighton, presided over by stern paterfamilias, pharmacist and newly-appointed court analyst Edward

Sutton (Mervyn Johns), whose three older children are in varying stages of rebellion against his repressive regime. Older daughter Victoria (Jean Ireland) yearns for a singing career in which she is encouraged by none other than Adelina Patti, but father believes that, while singing is an acceptable 'social accomplishment' for a woman, it is very questionable as a career. Younger daughter Peggy (Sally Ann Howes) eggs Mary on and herself surreptitiously feeds the guinea pigs her chemist father is using for experiment. Most significantly, his eldest son David (Gordon Jackson) is bullied for writing verses to the object of his affection and reacts by getting drunk at the local pub. Here he falls for the publican's wife, Pearl Bond (Googie Withers) – and the second strand of the plot is introduced. Pearl is married to a drunken bully Joe Bond (Garry Marsh); she has an unreliable fancy man, Dan (John Carol), who keeps her jealousy-level high; and she uses David's infatuation as a taunt to Dan – and as the means for providing her with the strychnine with which she kills Bond. She tries to blackmail analyst Sutton not to find Bond's death the result of poison, implying that this will save David from hanging, and when it is clear he is not to be influenced she, with a magnificent boldness that owes much to the 1940s 'wicked woman' tradition, walks to the railing at the cliff's edge and throws herself over on to the rocks beneath. David on the other hand is seen in a wedding photo married to the very appropriate girl his now softened father has always wanted him to marry.

What unites the two strands of the plot is that, in their separate ways, they articulate aspects of the repressive nature of the society in which both the family life and the milieu of the public house are set. There is a sense of stifled emotion at work in both, and part of the film's triumph is the very airlessness of the atmosphere, an effect that Ealing's usual preference for location shooting would have dissipated. Even behind the opening credits, the Brighton-set melodrama is introduced with a deliberately painted backcloth. The film then cuts to the interior of a newspaper office in which the editor (Charles Carson) is dictating a local story about Sutton, who is about to appear in his first murder case. This is followed by a dissolve to the interior of Sutton's chemist shop where he is passing over to a lady customer (Amy Dalby) a parcel wrapped with the eponymous pink string and sealing wax. 'How very neat that looks', she says of the parcel's concealment of a cure for various bodily ailments, and it becomes a symbol of the way unpleasant or potentially disruptive matters are concealed beneath Victorian disciplines and decorums. In rapid narrative moves, the film dissolves to the courtroom in which the judge (John Ruddock) is pronouncing sentence on a barely seen murderess, while Sutton watches impassively, and a dissolve shifts the scene to an elaborately-set tea table, around which Sutton's family hovers anxiously. Victoria hopes 'they've decided to hang Mrs Jackson',

because that will put 'Papa in a good mood', and, therefore, perhaps more than usually receptive to her wishes. The Sutton household is registered as a model of Victorian repression, sexual and otherwise, recalling those stifling settings for the family melodramas of novelist Ivy Compton-Burnett – or, on another level, the old theatrical (and cinematic) warhorse, *The Barretts of Wimpole Street*. Sutton treats his son David's poetic effusions sarcastically ('Lord Tennyson will have to look to his laurels'), turns down his daughters' requests, telling Victoria she is foolish not to accept the well-to-do young man (Don Stannard) seeking her hand – and bullies David *out* of the idea of marriage. His wife, Ellen (Mary Merrall), who has had five children over an age range of no more than ten years, is depicted as a typically subdued Victorian woman whose role is wholly domestic but who has enough spirit to urge her husband to try not to make his children fear him: 'Every day they withdraw more and more into themselves … they have secrets I'm not allowed to share.' Sutton's is a narrow religion in which fear and love are confused.

But if Ellen and her daughters lead the severely confined lives of middle-class women, the women in the film's other main setting – the pub – seem scarcely freer from the effortless dominance of men. The tippling spinster Miss Porter (Catherine Lacey) has had forty-seven convictions for drunkenness and has been imprisoned more than once. The other women – Pearl, Louise (Pauline Letts) whose profession seems obvious, the mock-genteel Mrs Webster (Maudie Edwards) who owns an oyster bar – are all at the mercy of men, notably the egregious Dan whose eye is always to the main chance, and, in Pearl's case, of a bullying husband as well. Pearl has looks (and Stanley Pavey's camera does justice to the sensual beauty of Withers), brains and determination and she is utterly stifled in the ambience of the pub, whether in the bar downstairs or in the living quarters she shares with the disgusting Bond. The fact that David Sutton is putty in her hands both signifies her attractiveness and points to her limitation: she takes up with David merely to make Dan jealous. She is the victim of a society in which women *need* men for their own status and *amour propre*, just as Victoria Sutton is a victim of the society's class strictures that question a woman's right to the fulfilment of a career.

If the film often feels as if it is ahead of its times (both the time of its setting and the time of its production) in its sympathetic treatment of the strictures on the lives and aspirations of women, it relapses into the kind of ending one might expect of a 1940s film, even from Ealing, which often seemed more progressive than other studios in its attitudes. David is rescued from the clutches of a seductress and reclaimed for marriage to someone in whom the audience has not the slightest interest. The only concession is that Vicky seems to have embarked on her

singing career (ironically, she has sung 'Home Sweet Home' for her audition at the Royal College of Music), though the film chooses not, and probably has not time, to show us by what steps she has arrived at this point. But Pearl, pushed to murder by her circumstances and her utter helplessness to change them, is dead. The scene between Pearl and Sutton, in which she tells him, 'I've come to help you save your son from the gallows', is an arresting confrontation of two kinds of 'deceit': Pearl in her brazen, self-serving strength and Sutton's unconscious repression of so much of human life outside the range of his narrow probity, which (overtly) reduces Pearl to nothing. Pearl, deserted by the shoddy Dan, stops sobbing, pulls herself together and walks out to the street. The camera tracks her from the pub, through the (studio) street to the railing at the top of the cliff over which she hurls herself. The very length of this tracking shot imposes on the audience an admiration for Pearl's courage. It is arguable that no other contemporary British actress, and certainly not the two biggest box-office attractions, Margaret Lockwood and Anna Neagle, could have so risen to its challenge as Withers does, or that any other Ealing director would have given her this chance.

The screenplay is by Ealing's resident woman writer, Diana Morgan, and the writing credit bears the rider, 'Script contributions by Robert Hamer'. There does not seem to have been any conflict about this and in 1992 Diana Morgan recalled her pleasure in working with director Hamer: 'You can see from his films he was just awfully good at directing women – no other Ealing films give such parts to women. He was the only one who liked women, really.' Withers confirmed this in a 2003 interview, adding that Hamer 'was a good friend and interested in me as an actress'. This is worth stressing because the film is most remarkable as a vehicle for Googie Withers, perhaps the strongest, most commanding actress British films ever produced. And that last phrase is significant because, unlike most of her contemporaries in the 1940s, Withers was essentially a *film* star, claiming in 1990 that the reason she never looked like a stage actress on the screen was 'probably because I had no proper theatre training except as a dancer.' Her contemporaries included Lockwood and Neagle, already referred to, intelligent Phyllis Calvert, robust Jean Kent, elegant Valerie Hobson and ambiguous Ann Todd, and I shall come back to the latter two in a moment, but it is arguable that the body of Withers' work stands up best to the scrutiny of fifty years on. Withers and Hamer are the two ingredients demanding closest attention here, and during the mid-1940s they were associated on three major films and on a fourth that Hamer was involved with though he was not credited.

Hamer seems to have been the Ealing director least in tune with Balcon's idea/ideal of 'projecting Britain and the British character'. Hamer subverted any notion of a homogeneous

'British character' and was more concerned in his films to look beneath the accepted surfaces of British life, exposing elements of hypocrisy and repression with a rigour that makes his films stand to one side of the Ealing ethos. At Ealing, only Alexander Mackendrick's films come near to Hamer's dark insights, and there is a much more palpable sense of danger about Hamer. After working pre-war as cutting-room assistant at Denham, then as editor at Ealing in 1941, he did uncredited directorial work there on the realistic war film *San Demetrio London* (1943), taking over when director Charles Frend fell ill, and on the musical-comedy *Fiddlers Three* (1944), some of which Hamer reshot when former documentarist Harry Watt's work proved unsatisfactory. (Watt himself makes no reference either to the film or to Hamer in his 1974 autobiography, *Don't Look at the Camera*). Neither film gives any indication of the sort of work Hamer would subsequently do at Ealing. He directed Withers and Ralph Michael in the very alarming 'Haunted Mirror' sequence of the celebrated portmanteau film, *Dead of Night* (Alberto Cavalcanti/Charles Crichton/Basil Dearden/Robert Hamer, 1945). The 'Ventriloquist's Dummy' sequence, directed by Cavalcanti, has tended to dominate accounts of this film; however, Barr redresses the balance by concentrating on the 'Haunted Mirror' episode, in which the threat to the happiness of the smart young couple comes from an antique mirror she has bought for him: 'The mirror visions are an assertion, forcing their way up as though from his unconscious, of all that he represses...' Repression of various kinds is at the heart of *Pink String and Sealing Wax*, as it will be again, in diverse forms, in Hamer's two greatest triumphs at Ealing, *It Always Rains on Sunday* and *Kind Hearts and Coronets* (1949). In the former, Googie Withers plays Rose, a lower-middle-class wife whose unexciting domestic life with an older man (Edward Chapman) is disrupted by the return of her lover (John McCallum), now a criminal on the run, and by the reawakening of the passion that has been subdued in the 'safety' of her dull marriage. Ealing's values being what they endemically were, she settles gratefully in the end for lying in the bed she has made, thereby consigning her sexual energies to the past. In *Kind Hearts and Coronets*, Dennis Price appears to accept the lower-middle-class life to which his once-aristocratic mother's heartless family has condemned him, but in reality never ceases to plot his revenge, which he executes with exquisitely apt calculation. His mother may have suppressed her sense of callous ill-usage, but he does not. Like Rose, though, he will not finally be allowed to get away with the expression of his feelings, either of vengeance or sexual passion.

There is, however, in Hamer's Ealing films a powerful sense of his being less than persuaded by the dénouements forced upon him, and much of their individuality lies in the ways in which he subverts their overt agendas. Away from Ealing his career was patchy: there

PINK STRING AND SEALING WAX

were the elegances of *The Spider and the Fly* (1949), with Eric Portman and Guy Rolfe playing out a battle of wits teasing on several levels, and *Father Brown* (1954), with Peter Finch and Alec Guinness, as thief and priest-detective engaged in a not dissimilar tussle of wits; and the undervalued *The Long Memory* (1952), again exploring tensions between criminal and the law (John Mills and John McCallum). For the rest, *To Paris with Love* (1954) is distressingly full of ooh-la-la stereotypes of gay Paree, and *The Scapegoat* (1958), with Guinness, Bette Davis (chomping on a cigar, yet), Pamela Brown and Irene Worth, inevitably had its moments, but fails to develop the possibilities in the idea of a mild English school teacher involved in impersonating a French count of murderous intentions. One sees what might have attracted Hamer to this scenario of hidden selves but it is a meandering, lacklustre film. Sadly, Hamer destroyed himself with drink and was barely employable in his last years. His last directorial credit is on *School for Scoundrels* (1959), a trifling comedy based on Stephen Potter's 'One-Upmanship' sketches, and little more than a parade of cameos from reliable comic actors. Its star, Ian Carmichael, in 1989 spoke of the unhappy experience, describing how Hamer was propped up for some weeks by his American producer Hal Chester, who, after a disastrous night shoot in London, 'sent him home and himself directed that night's work and brought in a new director to finish the film … Cyril Frankel'. It is an inglorious end to one of the most potentially exciting careers in British film.

Withers' career in British film ended in the mid-1950s because she and Australian husband John McCallum returned to live in Sydney, commuting over the next few decades to work in the theatre and on television, but never to make another feature film there. This was loss indeed as there was simply no one like her in British films of the period: even as a very youthful ingénue in the 1930s, she always spiked her work with a wit and sexiness that made her stand out from her contemporaries. She had worked on 'quota quickies' in the 1930s, including four for Michael Powell, and she was very noticeable in the opening sequence of *The Lady Vanishes* (Alfred Hitchcock, 1938). Powell eventually gave her major dramatic chances as the Resistance heroine in *One of Our Aircraft is Missing* (1942) and the wife of the Dutch patriot played by Ralph Richardson in *The Silver Fleet* (1942, directed by Vernon Sewell for producer Powell). But it is at Ealing in the mid-1940s that she leaves an ineffaceable stamp on British cinema. Her first brush with Ealing was in a vat of beer with George Formby in *Trouble Brewing* (Anthony Kimmins, 1939), and next, like the rest of the theatrical cast, she was hired for Ealing's audacious version of J. B. Priestley's allegorical play, *They Came to a City* (Basil Dearden, 1944). However, the films that established her as a presence to be reckoned with

were the three for Hamer – *Dead of Night, Pink String and Sealing Wax* and *It Always Rains on Sunday* – and *The Loves of Joanna Godden* (1947), directed by Charles Frend, but again partly by Hamer when Frend became ill. There were a couple of striking roles away from Ealing: she is very vivid as the boldly sensual wife of gross nightclub owner Francis L. Sullivan in *Night and the City* (Jules Dassin, 1950), described by Kim Newman as 'arguably the best *film noir* made outside the USA'; and in very different vein is wholly convincing as the dedicated Dr Sophie Dean in *White Corridors* (Pat Jackson, 1951).

She was not afraid to play strong, seriously flawed women and managed to do so without losing sympathy for them. In fact, she said in 2003 that she felt she had to resist finding anything sympathetic in Pearl, who, she believed, has married Joe to get off the streets. There was nothing of the English rose type about Withers and while so many of them have wilted in the memory she remains as vivid as ever. In *Dead of Night*, her character is no worse than merely superficial, exuding a confident, complacent charm, finding however the reserves of strength to save her husband from a descent into madness. *Pink String and Sealing Wax* offers the most extreme case of her flawed women as we shall see, but her two following films for Ealing offer remarkable studies of women determined to exert some control over their destinies. In *The Loves of Joanna Godden*, a rare sustained example of the pastoral mode in British film, she plays a lady farmer who is determined to run the Romney Marsh property she has inherited from her father, at the cost of her own emotional life. 'I'd like to meet the man who wouldn't take orders from me', she announces, having taken on the running of the farm after her father's death, but, despite Ealing's proto-feminism in the characterisation of Joanna, she eventually throws in her lot with neighbouring farmer Arthur Alce (John McCallum). The film ends on their embrace and his saying that there are 'no bounds to what we can do'. In other words, Ealing has taken us so far in soliciting admiration for her independence but cannot quite carry the impulse through. Most movingly, in *It Always Rains on Sunday* she is made to opt gratefully at the end for a life devoid of passion, and one can only wonder at the kind of society that had made her settle for it in the first place. This ending may be construed as a reaction against the dangers of loving the criminally-inclined Tommy, and the film is so unsentimentally convincing about how she has adjusted to the demands of a dull, domestic life, awareness of her erotic needs heightened by comparison with the love affairs in which her stepdaughters are engaged, that one hardly wonders at the time whether there were not other options open to her. Withers creates a film persona so vivid and strong in these diverse films that it goes against one's grain to want to see her subsumed into something less exciting than she deserves. And in 2003 she paid tribute to

Hamer as 'a really fine director who would see what an actor could do and, if it was any good, he'd keep it in' and she rewarded him with several magisterial studies of women of character.

British films in the mid-1940s, like their Hollywood counterparts, reveal a popular generic sub-category: the 'wicked woman' melodramas. In the US these included Barbara Stanwyck in *Double Indemnity* (Billy Wilder, 1944), Joan Bennett in *Scarlet Street* (Fritz Lang, 1945), Lana Turner in *The Postman Always Rings Twice* (Tay Garnett, 1946) and Joan Fontaine in *Ivy* (Sam Wood, 1947). In Britain, Margaret Lockwood betrayed her friends in Leslie Arliss' *The Man in Grey* (1943) and *The Wicked Lady* (1945), adding murder and highway robbery to her crimes in the latter, and in Lance Comfort's *Bedelia* (1946), a murderess again, she oddly retains some grip on the audience's sympathies. Later in the 1940s were two more striking examples of notable British actresses involving themselves in murder while allowing us serious insight into the strictures experienced by women in Victorian England. These are Valerie Hobson in Mark Allegret's *Blanche Fury* (1947) and Ann Todd in Lewis Allen's *So Evil My Love* (1948), both of whom, like Pearl Bond, come to untimely ends, and both films were based on novels by Joseph Shearing (aka Marjorie Bowen).

Blanche is the poor relation of the Fury family who take her in as governess to the daughter of her widowed cousin, Lawrence (Michael Gough), whom she marries without loving him and with 'no intention, contrary to the fashion of our times, of being ordered about by my husband'. She is in this respect a woman for post-war England rather than for Victorian times. She falls passionately in love with another outsider in the Fury world, the illegitimate estate steward, Philip Thorn (Stewart Granger), and is ready to collude with him in the murder of Lawrence and Simon Fury, Lawrence's father (Walter Fitzgerald), but will not remain silent when he arranges the death of the child who is now the legitimate heir to the Fury estate which Thorn covets. Blanche is opportunistic; she is as tough as Pearl in her determination to have more than her life has so far offered; and Thorn is an obsessive with his eye on acquiring what he believes life has wrongly denied him. They are, as Robert Murphy has written, 'ambitious outsiders denied the position in society to which their talents entitle them'. It is not sentimentality that leads her to denounce Thorn at the end, but the resurgence of a lingering moral streak that enables her to recognise the child's innocence as mattering more than her own gratification. Valerie Hobson's patrician beauty and manner were rarely used to more affecting ends than here, as Blanche, in the film's court scene, confronts and exposes her own feelings.

Similarly, Ann Todd's exquisite blonde ambiguity of appearance and her watchful, faintly secretive demeanour were never better served than by the role of Olivia Harwood, the

missionary's widow, in *So Evil My Love*. She falls for painter and conman, Mark Bellis (Ray Milland), whom she meets on the ship bearing her back from the West Indies to genteel poverty in Victorian London. Shaking off her widow's black garments and literally letting her hair down, she poses for Bellis, who encourages her to infiltrate the home and life of her rich but hapless old school chum, Susan Courtney (Geraldine Fitzgerald), married to a thin-lipped bully (Raymond Huntley) and taking to drink for consolation. Olivia tries to blackmail Courtney whose death she brings about in ways that lead to Susan's being sentenced to hanging for his murder. Manipulated at every turn by Bellis, she kills him and in the film's last scene goes to the police station to give herself up for this crime – and for Courtney's death, thus saving Susan. Like Blanche, she has at last jibbed at her lover's self-serving cruelty: he has used her while maintaining relations with another mistress.

These three women – Pearl, Blanche and Olivia – are three of the strongest female characters in post-war British cinema. Each comes up against the frustrations of life as a woman in a society effortlessly dominated by men, especially by bullying husbands and by unreliable lovers; each manages to retain some sense of dignity; and each is dead by the end of the film. The heart of the films is in the discrepancies between these complex, forceful women and the men who exploit them and whom they repudiate: Pearl kills her husband and rises stronger when her contemptible lover abandons her; Blanche's husband is feeble and her lover dangerously oversteps the mark; and Olivia will do a good deal for her caddish lover but draws the line at sexual betrayal. And in none of these, I would insist, is the viewer meant to withhold all sympathy from the female protagonists. In the case of *Pink String and Sealing Wax*, I would take issue with Sue Harper's comments that it 'represented a stern retribution for erring females, who were shown to be implacably evil' or that it is 'fuelled by distaste for the beautiful and amoral heroine'. Pearl has an energy and intelligence more forceful than anyone else in the film; her tragedy is to find no outlet for them and the viewer's reward for emotional investment in her situation is to be far more moved by her finally taking charge of her own fate than by the ostensibly 'happy' outcome for the law-abiding Victorian family.

This account has concentrated on the contributions of Hamer and Withers, but there are other influential contributors at work here. Among the cast, Gordon Jackson's freshly youthful David suggests, in ways different from Pearl's, the sorts of characteristics that the repressive Victorian household aims to check. The film is too intelligent to settle for simplistic binarisms in its depiction of the Sutton home on the one hand and the pub on the other. In Duncan Sutherland's superb art direction, the house is rendered as stifling in its upholstered over-

decoration, but both David and Victoria make their small bids for freedom and Mrs Sutton is permitted a momentary censure of her husband's authority. The pub setting is by contrast raffish and brightly lit, but it is by no means the obvious antidote to the repressions of the Sutton home: it has a drunken bully upstairs and a gaggle of hard-done-by, tipsy women in the bar. In the way *Pink String and Sealing Wax* looks and sounds, in its evocation of place and period, in the alignment of its contrasting cast members, it establishes a strong claim to be considered the most resonant melodrama of the heyday of British cinema.

Brian McFarlane

REFERENCES

Barr, C. (1993, revised edition) *Ealing Studios*. London: Studio Vista.

Carmichael, I. (1997) in B. McFarlane, *An Autobiography of British Cinema as Told by the Filmmakers and Actors Who Made It*. London: Methuen/British Film Institute.

Harper, S (1994) *Picturing the Past*. London: British Film Institute.

_____ (2000) *Women in British Cinema*. London: Continuum.

Landy, M. (1991) *British Genres: Cinema and Society 1930–1960*. Princeton: Princeton University Press.

Morgan, D. (1997) in B. McFarlane *An Autobiography of British Cinema as Told by the Filmmakers and Actors Who Made It*. London: Methuen/British Film Institute.

Murphy, R. (1989) *Realism and Tinsel: Cinema and Society in Britain 1939-48*. London: Routledge.

Perry, G. (1981) *Forever Ealing*. London: Pavilion and Michael Joseph.

Watt, H. (1974) *Don't Look at the Camera*. London: Paul Elek.

Withers, G. (1997) in B. McFarlane *An Autobiography of British Cinema as Told by the Filmmakers and Actors Who Made It*. London: Methuen/British Film Institute.

_____ (2003) Interview with author.

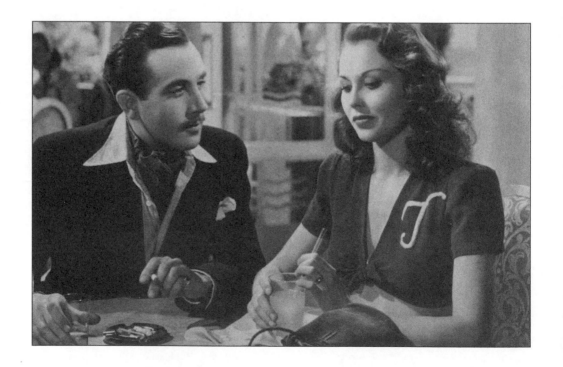

HOLIDAY CAMP

KEN ANNAKIN, UK, 1947

Reviewing *Holiday Camp* (Ken Annakin, 1947), the *Monthly Film Bulletin* (August, 1947) blandly and blithely described the film's story like this: 'The Huggett family – Joe, the missus, 16-year-old Harry and 21-year-old Joan – go to a holiday camp. Many things happen while they are there, the fates entangling them with a murder, two confidence tricksters and a number of pleasant harmless people. In the end, however, all ends happily for most of the characters.'

Here was a film about which no one in the industry, in advance of its release, seemed to entertain particularly high artistic hopes. Certainly not the Gainsborough production team of Sydney and Muriel Box, more associated at the time with the opulent melodrama of their big success, *The Seventh Veil* (Compton Bennett, 1946). In March 1947, after viewing early cuts of *Holiday Camp* and the psychological thriller *The Upturned Glass* (Lawrence Huntington, 1947), another Gainsborough product, the Boxes wrote in their production diary of their surprise that *Holiday Camp* was the better of the two. For the critics, the prospective film must have appeared just another product of the Gainsborough factory – the sixth such to emerge that year. But once the film was released, all doubts evaporated. Reviews were overwhelmingly positive, and the public took the Huggetts' holiday adventures straight to their hearts; within three months costs were recouped and the film moved into profit. Pressure mounted for Huggett sequels, and Gainsborough happily obliged, featuring their homely London family in three new Huggett adventures in 1948–49, some reworked from existing scripts. In February 1948 *Holiday Camp* successfully opened in New York; it was re-released to British cinemas in 1954.

When the film had originally emerged in London in August 1947, observers soon noted its singularity. 'They have made a social document illustrative of the tastes and manners of the age,' declared Campbell Dixon, film critic of the *Daily Telegraph*. Here, he wrote, were 'the twentieth century British islanders at play' – murderers apparently included. We need no longer imagine that the types paraded in the film form part of a 'social document'. They are script-writers' creations; cosy caricatures, on the whole, made to fit pigeon-holes. But Britain in 1947 clearly liked the distorted mirror image the film offered: the stereotypes had resonance. They do still: the film's fascination and importance remains rooted in its portrait of a country at play,

its social strands coming together with hopes and fears, and buckets and spades, and swimming suits, for a reviving communal experience.

The narrator's opening sentence in L. P. Hartley's novel *The Go-Between* states the truth: the past indeed is a foreign country. Over fifty years on, some context for the film and its subject matter may therefore be useful. Let us turn back the clock. Britain during the Second World War offered neither the time nor place for a rejuvenating summer holiday. Families were split up; coastlines were guarded and mined in case Hitler arrived; posters spread the Government slogan 'Is your journey really necessary?' But after the European war, recuperation and fresh air were much in the forefront of people's minds. The summer months of 1945 saw hordes of families and suitcases crowding railway stations trying to get on to trains: 'astonishing and sordid scenes', one reporter commented. The following year, an estimated thirty million people set out for holiday bliss – a number boosted by the demobilised returning from abroad, by the provision of workers' paid holidays (ensured in the 1938 Holidays with Pay Act), and by a new generation of young married couples with children and babies too young to ever have seen the sea.

For many of them, across the classes, the easiest practical answer to their holiday destination lay in the seaside camps offering for a set price chalet accommodation, canteen food and a rigid timetable of planned activities, indoors and out. Billy Butlin's camps dominated publicity and the public's favours. Camps at Skegness and Clacton had opened before hostilities began; the camp built at Filey, south of Scarborough on the Yorkshire coast, became fully operational in 1946, after having been commandeered by the RAF during the war.

The Filey site lay on cliffs overlooking the bay. The sea, the official statistics proclaimed, was a five-minute walk away. Hosts and hostesses, known by their uniforms as the Redcoats, were constantly on hand to serve, smile and cajole. Accommodation for 5,500 people. Two dance halls with three resident bands; licensed bars. As for games and sports, the guidebook listed 'Tennis, cricket, football, roller-skating, hiking, treasure hunts, putting, bowls, billiards, snooker, table tennis and darts.'

All that plus Godfrey Winn, popular columnist, women's magazine writer and champion of the Butlin camps – someone of whom *The People* newspaper later said he was 'as much part of the English scene as a cup of tea or fish and chips'. On 29 June 1946, over lunch with Sydney Box, recently appointed Gainsborough's new controller, Winn proposed a film using Butlin camps as a background. Box had been made to promise his Rank Organisation bosses twelve pictures a year; for a producer anxious about costs, and one with a taste for subjects with social

relevance, there were obvious attractions in a modestly sized, topical film with a built-in public appeal. The green light was given.

Winn, already booked to give a lecture at the Filey camp on 12 July, went on a field trip with the film's scheduled director Ken Annakin – chosen by Box for the warmth and verve of his wartime documentaries, many of them made for Box's former company, Verity Films. This was his first feature assignment. After this Filey foray, other hands helped turn Winn's resulting story into a viable screenplay. The list embraced Sydney Box and his wife Muriel; Mabel and Denis Constanduros (aunt and nephew), experts in lower-class comedy for the radio and stage; Ted Willis, stalwart of the left-wing Unity Theatre and the future television chronicler of *Dixon of Dock Green*; and Peter Rogers, who later pressed ahead in the popular vein with the *Carry On* comedies.

The subject matter became the film's title, *Holiday Camp*. Location photography at Filey, accomplished with a five-strong camera crew, was followed over the 1946–47 winter by studio shooting at Gainsborough's studio in Shepherd's Bush, London. 'Godfrey Winn has proved an utter pest since we agreed to work with him on the script,' Muriel Box wrote in the couple's diary on 22 December. Of Annakin she had better news: 'Ken Annakin is putting in some good work for a beginner in spite of certain setbacks.' The experienced and trusted Alfred Roome had been assigned as editor and instructed to guide Annakin on the set if need be; but little assistance was required. By 1 February 1947 the Box diary reported: '*Holiday Camp* nearly finished shooting – looking reasonable as far as rushes can show.' J. Arthur Rank saw the film on 14 March, and the film opened in London on 11 August, when Filey and the other holiday camps were in the middle of another bustling season. General release throughout Britain followed one month later.

The setting's fictional trappings were slim. Filey became changed to Farleigh. The camp was not Butlin's but Boddy's, the name spelled out near the beginning on the buses whisking the camp's new intake of holiday-makers from train to camp. You can easily spot the sequences filmed on location. There on celluloid, trapped like flies in amber, are the Filey holiday-makers of 1946: unpaid extras swimming, diving, stretching limbs in keep-fit exercises, bicycling, roller-skating, eating, dancing, singing along with the popular entertainer 'Cheerful' Charlie Chester, having fun in mass numbers. You can equally tell when the studio takes over, which it does constantly. Aside from the numerous chalet scenes, characters talk on the sand with back-projected footage unfolding behind their backs; or they perch on a studio cliff representing Flamborough Head, with a painted sea stretched out behind, moonlight glinting off strips

HOLIDAY CAMP

of tinfoil. Despite the delights of Filey and Annakin's strong documentary background, the finished film of *Holiday Camp* made relatively little direct use of either.

In fact, the film pursues several styles, just as it follows numerous characters and story threads. The acting contingent reflects this, with talent drawn from all parts of the entertainment spectrum. Flora Robson represents the higher echelons of the London theatre; she plays the upper-middle-class spinster Esther Harman, mulling over her lost love and opportunities as she watches a new generation of youngsters starting out in the post-war world. This character was the central figure in Winn's original story. Jack Warner, newly popular in films after *The Captive Heart* (Basil Dearden, 1946), had a background in radio and the variety stage; he was Joe Huggett. The young campers derived from repertory theatre and the London stage (Peter Hammond, Jeannette Tregarthen), the Rank Charm School (Susan Shaw), or the industry's own pool of juvenile leads (Jimmy Hanley, as the demobbed sailor Jimmy Gardner). Two of the younger leading players were already film stars in embryo. One was the attractive Hazel Court, cast as the Huggetts' plucky widowed daughter Joan. The other was Dennis Price, slithering suggestively through his lines as Binky, the RAF poseur and murderer evading police capture. And tucked away uncredited, Diana Dors undulated on the dance floor, annoying Ma Huggett (Kathleen Harrison) by catching Jack Warner's eye.

A crazy mix? No more perhaps than in any cast list for a British film of the era. But here the mix is significant. For *Holiday Camp* is a true melting-pot film, a jumble of characters, classes, modes and genres, and a film made at a crucial turning point in British film history. On the one hand the Second World War is breathing down the film's neck. You sense it in the experiences and hopes of the characters: Jimmy Hanley's sailor, Hazel Court's young widow, Yvonne Owen's chirpy WAAF, young men and women trying to 'make a go of it', all eager for their week of pleasure in testing times. You see it in the camp's regimented life and structure, with mass feeding, mass amusements, and the announcements of the loudspeaker voice, instructing, advising, above all controlling. The film's multi-strand format, though established enough with dramas like *Friday the Thirteenth* (Victor Saville, 1933) or (in Hollywood) *Grand Hotel* (Edmund Goulding, 1932), carries its own legacy of the war – a period when there was a specific propaganda point to dramas about layers of society joining together in a common cause.

At the same time, aspects of the post-war landscape of British cinema and popular culture stretch vividly before us. The domestic comedy of the Huggett family (bus driver, slightly nagging wife, children) points the way to the exploitation of 'ordinary' families in sentimental situation comedy and soap opera on British radio, television and cinema. If the Huggetts lived

up north, their address would doubtless be Coronation Street. Peter Rogers, for his part, saw a link with his own *Carry On* output: in both cases, he told Brian McFarlane in 1993, there was the fundamental audience attraction of 'ordinary people doing amusing things'.

Around the Huggetts at the holiday camp other and darker currents swirl. Here are ordinary people doing unamusing things, behaving badly, in one case to the point of murder. Compared to the black marketeers, loose women and other symbols of post-war malaise in contemporaneous films like *They Made Me a Fugitive* (Alberto Cavalcanti, 1947) and Gainsborough's own *Good Time Girl* (David MacDonald, 1948), the activities of card-cheaters Steve and Charlie may seem mild. (Playing pontoon, they take all of Huggett Jr's holiday money, £9.) Even so, in an epilogue to the novelisation of the *Holiday Camp* script prepared before the film's release, Godfrey Winn felt it necessary to remind readers that in Butlin camps 'in actual fact gambling is strictly taboo … so no one need be nervous of losing their shirt.'

With Dennis Price's serial killer Binky, hiding out with a bogus RAF identity, the film even enters, however briefly, the British cinema of lurid horror and unhealthy desire, of Hammer and *Peeping Tom* (Michael Powell, 1960), where hands strangle, screams ring out and the police always arrive too late. Winn's original story presented the Binky character as a show-off and a small-time crook, arrested at the end for petty larceny; 'he'd had his spree,' Winn told the novel's readers, 'at the price of his firm's petty cash.' Sydney Box knew he needed something stronger.

Current newspaper headlines supplied the solution. In September 1946 a man called Neville Heath was tried at the Old Bailey and found guilty of murdering two lonely, susceptible women; more victims were suspected. Heath, like Binky, used false names, including an unlikely RAF alias, Group Captain Rupert Brooke. Binky, in effect, became Heath's fictional stand-in. By the time of the first master script dated 22 October 1946 (four days before Heath's execution at Pentonville Prison) Mrs Huggett found herself reading a newspaper with a scare headline thrust at the camera's lens: 'SILK STOCKING MURDERER STILL AT LARGE'.

It is time to see how the various plotlines and characters of *Holiday Camp* intersect and play themselves out. The film begins with the chatter of incoming holiday-makers, and the settling into the chalets. The Huggett family is split up. Joe and Ethel Huggett share theirs with their baby granddaughter. Joan (Hazel Court) settles in with a chatty ex-WAAF, Angela (Yvonne Owen). Harry, the youngest Huggett (Peter Hammond), shares with sailor Jimmy (Jimmy Hanley), who quickly receives word that his girlfriend has jilted him. Jimmy prepares to abandon his holiday, but Joan persuades him to stay: 'I'm just going to be someone you know. The girl next door, OK?'

Dennis Price's Binky, alias Squadron-Leader Hardwicke, pursues romance much more aggressively. His chalet partner, Michael (Emrys Jones), a quiet music student, brushes off his breezy chatter; but any female gets an earful. Angela, out for a good time, is prepared to be amused; homely waif Elsie Dawson (Esma Cannon), who shares with Flora Robson's Esther Harman, is not averse either, and fantasises about instant romance and marriage.

Esther's story progresses alongside Michael's problems with his girlfriend Valerie (Jeannette Tregarthen), who shares a chalet with Susan Shaw's Patsy, another of the film's girls-next-door. The sensitive Valerie, in her late teens, lives with an aunt who disapproves. Her holiday with Michael is secret; her pregnancy is also secret, at least until she faints. This is the 1940s: the pair's marriage becomes essential. Valerie is in such despair that she proposes joint suicide by leaping off the studio version of Flamborough Head. Esther, always a hovering presence, waves a magic wand, and offers the couple future shelter.

Esther has been moved to act partly by the absence of love in her own life. From the beginning Esther has found the camp's loudspeaker messages disturbing; the voice reminds her of Alan, the lover stationed at Farleigh's World War One incarnation as an RAF base, and never seen since. Eventually, accompanied by subjective camerawork and special effects, Esther walks to the control tower, mounts the stairs, and finds Alan (Esmond Knight) at the microphone, his sight and memory lost in the war, but happy with a rebuilt life. They talk, but she leaves without identifying herself.

Other strands in the film are lighter in tone. Jimmy's friendship with the Huggett daughter Joan proceeds through initial attraction and misunderstanding to happy reunion. Harry, the son, loses his money playing pontoon with the card cheats; his father Joe gets the money back.

Binky's strand starts lightly enough but darkens as the film proceeds. He is given to sudden violence, twice grabbing Angela fiercely round the wrist. The brandished newspaper headline – the Silk Stocking Murderer has been renamed the Mannequin Murderer – gives the audience plenty of time to guess Binky's true identity. Even so, there is something shocking in the swiftness with which he strikes again, trembling, forcing his kisses on Elsie Dawson against the night sky, her murder implied but never shown. Esther reports her missing the next morning. But the authorities have already followed Binky's trail. As he packs his suitcase for departure, two detectives come to arrest him, for murders past as well as, presumably, the murder present.

'It's been lovely, hasn't it, Joe?' Ma Huggett chatters on the bus. 'Best holiday we've ever had. Roll on next year.' The cast list creeps up over footage showing the card cheats, having failed to hitch a lift, walking with suitcases down the road, backs to the camera.

In March 1947, in his epilogue to the film's novelisation, Winn reports that he had confessed to Butlin that the plot 'had got quite out of hand' since he wrote his original story. He meant, presumably, Binky the sex killer and the murdered Elsie. Butlin's reported reply was magnanimous: 'Don't worry, Godfrey. All my campers will know it couldn't have happened at Filey, and those who haven't been to one of my camps – well, to them it will be just another film.'

That may have been Butlin's mature attitude. Ken Annakin's autobiography *So You Wanna Be a Director?* presents another response. Shown the film as a courtesy by Box, Butlin immediately threatened to call lawyers and stop the film's release, a threat defused when Box relayed to Butlin information picked up by Annakin from a friendly Filey Redcoat. Seven drowned drunks, apparently, had been fished out dead from the camp's swimming pools; something Box was sure would interest the press.

Whatever Butlin's response, Binky the sex killer, roaming chalets and cliffs, is definitely the stone in the film's shoe, the ingredient that even now makes for awkward viewing and stops the jovial sentimental comedy of the Huggetts from taking complete hold. Into the family portrait of Britain enjoying the fruits of victory steps the psychopath, the disrupter of sunshine and harbinger of death: a character not only symbolising the worst of post-war malaise and disillusionment, but also suggesting with puritan disgust the horrible road to which having a good time could lead.

Binky's murder of Elsie, the working drudge, also carries class connotations. For all the sharing of chalets and the communal activities, class differences in the film are paraded like carving knives. The middle-class Michael loves the middle-class Valerie. Working-class sailor Jimmy teams with the working-class Huggett daughter Joan. Elsie, however, dreams outside the box and in her manhunt considers marriage to Binky, an RAF type with an upper-class drawl. Given the film's class structure and *dramatis personae*, she becomes the obvious murder victim.

To some contemporary reviewers the Binky strand, like the spinster's story, appeared a melodramatic ingredient unduly forced into the ordinary amusements of camp life. In addition, with the anonymous reviewer of *The Times* a whiff of disdain wafts off the page. The same week's releases included John Paddy Carstairs' *Dancing With Crime* (1947): 'another film,' the critic sighed, 'which illustrates the present preoccupation of British studios with … the more sinister and dubious ways of living indulged in both by ex-servicemen and those who never wore a uniform.'

The *Times* review also reflects a widespread feeling among the more intellectual Britons that holiday camps were definitely not the place for their own bucket and spade: the film, the

critic wrote, 'shows a community disciplined to a conception of pleasure forced on it from the outside, and that is what, to the detached observer, is so disquieting about it all.' The film, to its credit, appears aware of this. 'Sounds like a prisoner of war camp,' says Esther with a chill when Elsie mentions the camp's control tower. 'That's right,' chirrups Elsie, 'only we're the prisoners!'

This disdain was clearly not shared by Ken Annakin. Born in Beverley, Yorkshire, in 1914, his own background was lower middle-class. He entered films after serving as a flight mechanic in the RAF and began directing in 1942, speedily developing a reputation for lively, sympathetic documentaries. *London, 1942* was his first; *Turn it Out*, a particularly ingenious film on the need to boost exports released in 1946, was the last. *Holiday Camp* confines its visual documentary leanings to the location footage used in corners of scenes and linking material; but Annakin's roots and personality are well displayed in the sympathetic treatment of the 'pleasant harmless people' thronging the camp. The bulk of the characters are shot and framed in deft but conservative fashion. A more urgent, expressionistic style surfaces only on two occasions: when Esther is drawn towards the control's voice, walking in a daze among superimposed loudspeaker shapes and the smoke of dreams, and when Elsie meets her fate darkly at Binky's trembling hands.

Yet for all the alarming shadow that Binky casts, *Holiday Camp* stays the Huggetts' film; their warm bickering and the happy acceptance of a humdrum life hit the nerve with a war-battered public anxious to feel good about their own travails. One scene received specific approving mention both in reviews and public comment, a scene written by the Constanduroses. Joe and Ethel, visiting Flamborough Head, are sitting and musing about their lives. Surrounded by campers 'all poshed up', Ethel wonders if she is not getting 'a bit dowdy' for Joe. She need not have worried. 'Women who go larking about in a pair of pants and a blazer are OK at the seaside,' he admits. But then come the clinchers. 'Give me something plain in the home,' says Joe. 'Oh Joe, that's nice of you!' says Ethel, beaming with delight. One can imagine the Odeons capsising with laughter. Joe Huggett, it is clear, would not rush to support Women's Liberation; the Huggett spin-offs include similar lines that now raise more eyebrows than laughter.

Family entertainments became central to Annakin's subsequent career. He directed *Miranda* (1948), Gainsborough's popular mermaid comedy, and the wartime farce *Hotel Sahara* (1951). Further ahead lay big-budget extravaganzas, *Those Magnificent Men in their Flying Machines* (1965) and *Monte Carlo or Bust* (1969). Annakin also took charge, with dwindling interest, in the Huggett spin-offs themselves, films of equally dwindling quality. Jack Warner

and Kathleen Harrison stayed in their parental roles, triumphant; other actors came and went as circumstances dictated. *Here Come the Huggetts* (1948) and *Vote for Huggett* (1948) surrounded the family, back in London, with romantic and other family problems. *The Huggetts Abroad* (1949) improbably made them trek towards South Africa, bent on immigration, though the cast very visibly never left London. The family then decamped from cinemas to BBC radio, where *Meet the Huggetts* ran from 1953 to 1961.

How real were the Huggetts to their admirers in *Holiday Camp* and elsewhere? I suspect the family occupied a halfway house. They could be laughed at as caricatures of the ordinary working-class; with Joe's bluff cheer and Ethel's careworn commitment to home and hearth, they were also figures to identify with, even at the time to admire. But probably not by Mr and Mrs Vane Huggett, a real English couple who, it appears, made their own African trek, just like their celluloid namesakes in *The Huggetts Abroad*. Gainsborough was obliged to supply prints with a disclaimer notice at the end, separating fact from fiction: 'Since the name of the family was chosen it has been brought to our attention that a Mr and Mrs Vane Huggett and their family made a trek across Africa, subsequently returning to England. This film does not relate to Mr and Mrs Vane Huggett and their family and is not in any way based on their experiences...'

On the surface the notion that audiences in 1949 might have been confused about the Huggetts' identities is laughable. And yet Gainsborough in *Holiday Camp* peopled a film with authentic holiday-makers, pleasant and harmless, alongside the girl next door, the boy next door, the harried Cockney mother, the spinster eaten away with regret, the crafty card-sharpers, the mewling baby, the serial killer, the crowds on the dance hall, the Beauty Queen hopefuls: life, film, tinsel, reality, weirdly and gloriously mixed up.

Geoff Brown

REFERENCES

Annakin, K. (2001) *So You Wanna Be a Director?* Sheffield: Tomahawk Press.

Box, M. and S. Box (1946) *The Diary of Muriel and Sydney Box*, unpublished, British Film Institute Special Collections.

McFarlane, B. (1997) *An Autobiography of British Cinema as Told by the Filmmakers and Actors Who Made It.* London: Methuen/British Film Institute.

Winn, G. (1947) 'Postscript', in K. Porlock, *Holiday Camp.* London: World Film Publications.

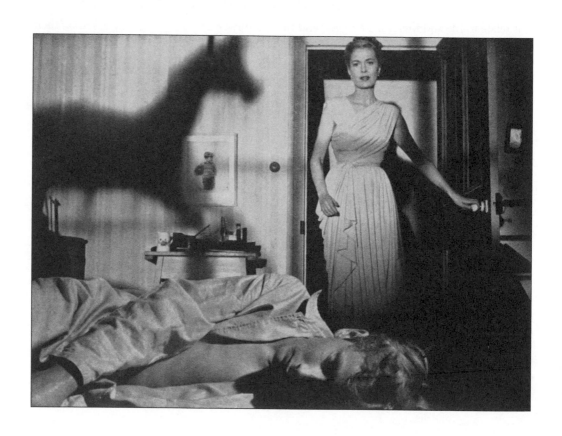

THE ROCKING HORSE WINNER

ANTHONY PELISSIER, UK, 1949

There was a woman who was beautiful, who started with all the advantages, yet she had no luck. She married for love, and the love turned to dust. She had bonny children, yet she felt they had been thrust upon her, and she could not love them. They looked at her coldly, as if they were finding fault with her. And hurriedly she felt she must cover up some fault in herself. Yet what it was she must cover up she never really knew.

The opening of D. H. Lawrence's 'The Rocking Horse Winner' establishes its tone of detached irony – a fairy story for adults told with a simplicity which belies the complexity of its ideas. The dilemma for a filmmaker confronted with such material is whether to find a way of transferring this distinctive style to the screen, or to use the story as a springboard for a radically different treatment.

The plot of Lawrence's short story is easily told. The husband of upper-middle-class Hester is unemployed and has gambling debts. To maintain her privileged lifestyle Hester borrows from her brother, Oscar, until he loses patience. The house is haunted by her unspoken plea 'There must be money!', which only the children hear. To ease her plight, her son, Paul, rides his rocking-horse to where there is luck, which means predicting the winners of horse races. He puts money on them, betting being handled by the handyman, Bassett. When Oscar discovers the extent of Paul's success, he arranges for a lawyer to give £5,000 to Hester under the guise of a bequest from a relative, while not neglecting to put his own money on the boy's choice for the next important race. Paul's final ride is to find the Derby winner. Afterwards he falls unconscious, rallying long enough to discover that his winnings amount to £80,000. Paul's last words to his mother are, 'I *am* lucky!'

'The Rocking Horse Winner' was written in 1926 for a volume of ghost stories edited by Lawrence's friend, Cynthia Asquith (sister-in-law of director Anthony Asquith). The inspiration was probably Cynthia's own troubled relationship with her autistic son. The film *The Rocking Horse Winner* was released in 1949 and was scripted and directed by Anthony Pelissier, the son of actress Fay Compton. This first screen adaptation of a work by Lawrence appeared

at a time when the author's critical and popular reputation was at low ebb. Rehabilitation came with the advocacy of F. R. Leavis, who dominated critical studies of Lawrence in Britain for two decades from the mid-1950s. His summary dismissal of the story may account in part for why the film is almost forgotten in Britain. This neglect makes two in-depth studies of the film from America all the more gratifying: Gerald Barrett and Thomas Erskine include the shooting script in addition to amassing an array of critical opinion. For good or ill it is almost impossible to separate the film from the Lawrence industry. Both film and story have generated commentary far in excess of the 6,000 words penned by Lawrence.

Pelissier was aware of the daunting nature of his task. This is made clear in a 1950 interview for the *New York Times* quoted by Jane Jaffe Young: 'Instead of following my first impulse of extending the surface areas of the story material … which would have been the easier way to write the screenplay, I decided it would be wiser and safer to dig underneath the surface. In this case, the adaptor leaned on Lawrence and rightly or wrongly believed that a sincere regard for the writer's integrity would carry both through to something approaching the desired result.'

This implies an overt element of interpretation rather than a literal translation from page to screen. If the risk of being over-reverent is not entirely eliminated, the practicalities of turning a short story into a feature-length film mean that additional material has to be added. Nor does reverence preclude other changes, including updating the action from just after the First World War to the late 1940s. Location shooting of the racecourse scenes may have been a determining factor: 1940s fashions would look incongruous in a 1920s drama. Pragmatism may also have dictated that only Paul (John Howard Davies) hears the whispered pleas for more money. Keeping to the original story in which his sisters also hear them would have required two small girls with considerable acting ability; as it is, Paul's sisters barely figure in the film. Bassett's role is expanded, but as he is played by John Mills, who was a bankable star as well as the film's producer, this is unsurprising. A crucial decision for any adaptor of the work is whether to view Paul as an ordinary boy drawn into a supernatural situation, or a boy possessed of unusual powers which are only waiting to be unleashed. In the writing and casting Pelissier opts for the latter, portraying a sensitive boy who is drawn into a dangerous relationship with his rocking-horse. It is natural in this situation that the whispers should emanate from the horse rather than from the house itself, as in the story. This emphasises the malign power of the toy horse, though it makes less sense of his plea to Uncle Oscar (Ronald Squire): 'It's the house, Uncle. It isn't getting any better – like we thought it would. It's getting worse.' Similarly, Bassett's comment that the house is an unhappy kind of place for the boy loses its impact.

Although the story is an example of Lawrence's move away from naturalism, many of the themes will be familiar to readers of his other works. The role of money in organising family relationships is explored in the story 'You Touched Me', while the return to a mother's love is central to the poem 'Piano'. The tensions between a weak husband, dominant wife and sensitive son thread through *The Rainbow* and 'England, My England': the relationship between Paul and Hester bears comparison with that of Paul Morel and his mother in *Sons and Lovers*. Paul in the story glimpses horses in the moonlit clouds before embarking on his final ride. The horse as embodiment of untamed elemental forces features in *Women in Love* and *St Mawr*. The moon appears in Lawrence's earlier novels during introspective moments, notably in *Women in Love*; its use as a symbol of destruction and regeneration was drawn from San (Bushman folklore), which coloured Lawrence's work in the 1920s. More intriguingly, 'The Rocking Horse Winner' was written in the same year as *Lady Chatterley's Lover* and there is a hint early in the film that Pelissier discerned similarities between the two works as Paul reveals his mother's hopes to Bassett: 'She said she only prayed to heaven you turned out all right.' When Hester visits the stables where Bassett has his quarters, she asks, 'Are you really sure you'd rather be out here than in the house? You'll freeze, my dear man. I shall be worrying about you all the time.' Fortunately for the censors and for J. Arthur Rank, who financed the film, this dangerous liaison is not alluded to again, though it casts a different light on the ending as Bassett burns the rocking-horse for Hester, but refuses her order to burn the money on the grounds that 'There must be some use for it; might be able to save a few lives with it – cost one to get it.' This is presumptuous behaviour for a servant. The incident is another departure from Lawrence's story in which Hester's realisation of what Paul has done for her has to be inferred. Is the change part of Pelissier's attempt to 'dig underneath the surface', or was Bassett voicing values which a 1940s audience expected to hear? According to Valerie Hobson who played Hester, 'I think it [the film] finished that way because Tony [Pelissier] and I both felt that we had to show Hester as not being made entirely of stone.' This accords with commercial practices of the period – both *Great Expectations* (David Lean, 1946) and *Brighton Rock* (John Boulting, 1947) were given upbeat endings. In a *Film and Filming* article a generation later (November, 1970), Margaret Tarratt attributed the change to the censors' disapproval of gambling, yet a film about winning the football pools (*Easy Money* [Bernard Knowles, 1948]) went on general release soon after. If the British Board of Film Censors only gave the latter film grudging approval, significantly the scenario report makes clear that gambling on horses was perceived as an upper-class activity and hence more acceptable. The Board

did stipulate that St Luke, chapter 17, verses 1 and 2 should be superimposed on the final shot of *The Rocking Horse Winner:*

> It is impossible but that offences will come: but woe unto him, through whom they come! It were better for him that a millstone were hanged about his neck, and he cast into the sea, than that he should offend one of these little ones.

Whether the verses were included when the film went on general release is not recorded, though they make clear what message audiences were expected to take away from the cinema.

Pelissier's debt to other films is analysed in the American studies. The opening shot of a model of the family's home, the first view of the child playing in the snow and the final shot of the burning on the rocking-horse echo similar moments in Orson Welles' *Citizen Kane* (1941). The stars were familiar to audiences from David Lean's Dickens adaptations: Mills and Hobson played Pip and Estella in *Great Expectations*, while John Howard Davies took the role of Oliver Twist in the 1948 film. Many of the qualities which characterised these performances were brought to *The Rocking Horse Winner,* though Julian Smith, in Barrett and Erskine's volume, finds Mills' performance closer to that of Bernard Miles' Joe Gargery in *Great Expectations*. Pelissier's faithfulness to the story's ironic tone and his attempt to find visual equivalents of the prose style with its alternating long and short sentences also receive detailed examination in the American literature, but the film's ending crystallises three topics which from an English perspective merit more attention: class, male friendships and luck.

Class divisions are made explicit by three scenes not found in the original story: urchin carol singers being given money by Paul's father, an extended sequence in which Hester goes to a poor district of London to sell her clothes (she seems to know the procedure) and the gathering of chauffeurs to swap racing tips during the charity ball attended by Hester and her husband. As well as pointing up the differing expectations and lifestyles of the social groups, these scenes emphasise that social mobility works two ways. While the family lives beyond its means, penury and social disgrace are never far away – a point underlined by the appearance of the bailiffs. As the ending makes clear, status counts for little when financial power resides in a child and a servant.

Class also provides a way of understanding the much-maligned Hester. In American commentaries on the film, words such as 'selfish', 'extravagant' and 'greedy' are much in evidence. Young is representative in calling her 'blatantly obnoxious, cold, self-centred'. Yet are

these comments really about the Hester of the film as distinct from the Hester of the story, and is the social structure of the household being overlooked? Inevitably the presence of a nanny in an upper-middle-class family formalises the relationship between mother and child, yet in spite of this the Hester of the film shows an empathic awareness that all is not well when she abandons the charity ball to go back to Paul, despite the nanny's reassurances over the telephone. Hester displays warmth and closeness towards Paul throughout the film, most noticeably when he accompanies her to an antique shop – another scene added by Pelissier. This is a mother and child enjoying each other's company with no hint of condescension or social constraint. At no time is Paul neglected, emotionally or physically. Tarratt is right in calling Hester 'loving, if somewhat thoughtless', instead of accepting the more damning verdict favoured by American commentators. Valerie Hobson's retrospective assessment, already noted, accords with that of Tarratt.

The vulnerable side of Hester is brought out in a scene introduced by Pelissier which appears in the shooting script, but is omitted from the film. Unbeknown to her family, Hester works part-time as a designer for a Soho dressmaker. She is seen antagonising both the owner of the workshop and the other staff. Here is a woman who feels that she is demeaning herself by working alongside her social inferiors. She tries to assert her status, but ultimately she cannot risk jeopardising her income. This Hester is far removed from Lawrence's self-obsessed spendthrift. Male friendships as much as shortage of money drive the plot. On first seeing Paul riding the rocking-horse and discovering the boy's interest in racing, Uncle Oscar begins treating him as an adult. As Hester leads her son from the room, Oscar remarks, 'Oh, what a shame. That promised to be one of the most adult and enjoyable conversations I've had for a long time. We'll have a really good talk tomorrow – when all these women are out of the way. Goodnight, old son.' Paul has left childhood and joined a club which excludes women. Paul, Oscar and Bassett are united by a shared interest which transcends social barriers. Honour is important in maintaining their secrets and is a word which frequently recurs. The rocking-horse represents a vestige of childhood, though when Hester accepts Oscar's advice to take Paul out of the nursery world and give him a room of his own, the rocking-horse goes with him. At the end of the film there is a reversion to childhood as she cradles the unconscious Paul after he has fallen from the horse on his final ride. The mother-child relationship is reasserted. To add to the complexity of the imagery, American commentators agree that the frenzied riding of the rocking-horse signifies masturbation. The British censor, Frank Crofts, evidently had the same suspicion, for his scenario notes specify that 'The urchin must not leer or by word or look show coarseness or

indecency.' Yet if masturbation is seen as a rite of passage, the rocking-horse assumes an adult role. In this sense the toy straddles two worlds.

Paul relies on 'luck' – another word which keeps recurring. The film exemplifies the confused British attitude to gambling. Betting was central to life in working-class Britain as the film *Love on the Dole* (John Baxter, 1941) illustrates vividly, yet it was perceived as corrupting by churchmen and legislators. Betting shops were not established until the 1960s and then they were subject to strict licensing conditions. To prevent the innocent from being lured inside, not only were these dens of iniquity required to offer the bleakest of environments, but the interiors had to be hidden from passers-by like the bars of Victorian pubs, which were subject to similar opprobrium. For the upper classes Hogarth's *A Rake's Progress* summed up the seamy side of gambling, with the rake being dragged down the social scale by his debauchery. *The Rocking Horse Winner* makes clear that Paul's winnings are tainted. One of the many ironies in the film is that wealthy Uncle Oscar is the gambler, while the spendthrift Hester is the wary one. As she confesses to Paul, 'We're inclined to be a gambling family, anyway, and you'll never know until you grow up how much damage it's done.' She might be referring to her husband's gambling debts, or perhaps there are other family scandals waiting to be revealed.

But luck goes deeper. It is an inscrutable force, ordering relationships and destinies. The dialogue in the antique shop encapsulates this:

Hester: If you're lucky you have money. That's why it's better to be born lucky than rich. If you're rich you may lose your money. But if you're lucky you'll always get more money.

Paul: Oh. Will you? Isn't father lucky?

Hester: Very unlucky I should say.

Paul: Why?

Hester: I don't know. No-one ever knows why one person is lucky and another unlucky.

Paul: Don't they? Nobody at all? Aren't you lucky either, Mother?

Hester: I used to think I was before I married. Now I think I'm very unlucky indeed.

If Hester is viewed as a caring mother instead of a Joan Crawford monster, this opens the way for Paul's final words, 'I *am* lucky!', to be an affirmation of his love, giving them an added poignancy.

Anthony Havelock-Allan's verdict on Pelissier is damning: 'Look at *The Rocking Horse Winner* – he certainly had many different talents, but none of them big enough to make a real impact.' It is easy to see what Havelock-Allan means. Pelissier directed seven films between 1949 and 1953 before turning to television. Aside from scripting *Over the Moon* (Thornton Freeland, 1937) and collaborating with Mills on another literary adaptation – H. G. Wells' *The History of Mr Polly* (1949) – Pelissier's work prior to *The Rocking Horse Winner* was in the theatre. Long stretches of dialogue betray the lack of a filmic imagination which is evident in a work using a short story as a springboard to something radically different: Hitchcock's *The Birds* (1963). This weakness in *The Rocking Horse Winner* puts a heavy responsibility on the actors, with much of the burden being carried on the shoulders of a young John Howard Davies. William Alwyn's music cannot make up for a lack of dramatic tension as Paul ascends the stairs to his final ride. Such blemishes did not stop the film from being judged by John Montgomery in 1954 as 'one of the most polished products to emerge from British studios since the war'. Desmond Dickinson's brooding photography contributed to this assessment. *The Rocking Horse Winner* recalls Dickinson's work on *Hamlet* (Laurence Olivier, 1948) as the camera prowls corridors and staircases and searches the shadows. There is always something to attract the eye. It is visual images which linger in the mind, such as the triumphant leer of the rocking-horse as it is consumed by fire.

In his autobiography John Mills assesses *The Rocking Horse Winner* as an artistic triumph, but a box-office disappointment. The tepid response of audiences seeking entertainment is understandable. The description 'ghost story' seems misleading. Whatever the merits of Lawrence's tale, it fails to send a shiver down the spine; with the exception of Valerie Hobson's performance so does the film, which remains resolutely earth-bound by comparison with *Dead of Night* (Alberto Cavalcanti/Charles Crichton/Basil Dearden/Robert Hamer, 1945) or *The Others* (Alejandro Amenabar, 2001). Equally understandable is the enthusiasm of critics and academics who can view the film as a pioneering adaptation of a modern literary work, a dissection of the upper-middle-class family or an English *film noir*. Interest resides in the gulf between audiences and writers on film as much as in the intrinsic qualities of a work which adds an intelligent and humane subtext to Lawrence's story. Perhaps Pelissier made his characters too sensitive for their own good. Villains are more interesting dramatically and the film seems peopled by victims. Just as thought-provoking are the cultural differences exposed by English and American responses to the film. Not for nothing has Lawrence been called an adoptive American. He explored the psyche with a directness which was alien to English cul-

ture at a time when expatriate Americans like Henry James and T. S. Eliot were embracing the more allusive English approach. Along with the Dickens adaptations, *The Rocking Horse Winner* is an early example of heritage cinema, bringing a literary vision of England to the screen. Its very Englishness is part of its appeal, yet this can be taken for granted by English audiences and critics because it is not stressed and because the vision is, in a sense, alien.

Some films eclipse their literary source: who reads James Hilton's *Good-Bye, Mr Chips* (1934)? If Pelissier's film has not superseded Lawrence's short story, it has outlasted three other film versions (Peter Medak, 1972; Robert Biermani, 1982; Michael Almereyda, 1997). It presents a well-mannered view of Lawrence, with a socialist edge and fidelity to the story's distinctive attitude to luck – both story and film were created in the aftermath of war and in war luck is equated with survival. At the opposite extreme is Ken Russell's visceral approach to *Women in Love* (1968), produced as traditional social structures were weakening, censorship restrictions were easing and a generation was growing up with no direct experience of war. Both films are of their time. We can only speculate which Lawrence would have preferred.

Philip Gillett

REFERENCES

Barrett G. and T. Erskine (1974) *From Fiction to Film: D. H. Lawrence's 'The Rocking Horse Winner'.* Elcino and Belmont, CA: Dickenson.

Havelock-Allan, A. (1997) in B. McFarlane, *An Autobiography of British Cinema as Told by the Filmmakers and Actors Who Made It.* London: Methuen/British Film Institute.

Hobson, V. (1997) in B. McFarlane, *An Autobiography of British Cinema as Told by the Filmmakers and Actors Who Made It.* London: Methuen/British Film Institute.

Lawrence, D. H. (1960) 'The Rocking Horse Winner', in D. H. Lawrence, *Love Among the Haystacks and Other Stories.* London: Penguin Books.

Mills, J. (1980) *Up in the Clouds, Gentlemen Please.* London: Weidenfeld & Nicholson.

Montgomery, J. (1954) *Comedy Films.* London: Allen & Unwin.

Young, J. J. (1999) *D. H. Lawrence on Screen: Re-visioning Prose Style in the Films of 'The Rocking Horse Winner', Sons and Lovers, and Women in Love.* New York: Peter Lang, 1999.

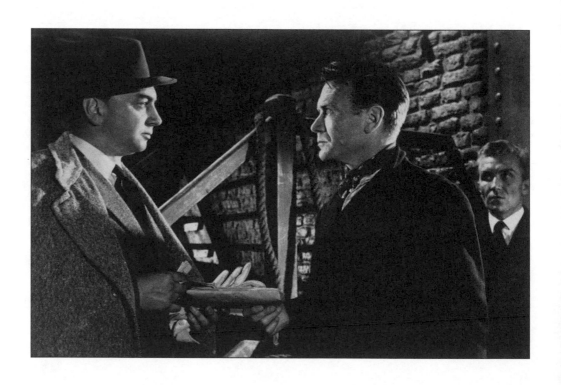

THE LONG MEMORY

ROBERT HAMER, UK, 1952

Some kind of habitation can be made of nearly any type of barge or lighter; you have only to build a roof across the stern-frame – an old tarpaulin will do, and I have seen it done with a few lengths of plank or corrugated iron. Spritsail barges are the best, however, for then you have it all complete with a cabin and bunks and even a kitchen stove. So until they fall apart or are pulled to pieces the hulks in Morocco Bay are mostly lived in by old men, watermen or bawley-men or lightermen, who, having no other home and being too old even to be nightwatchmen, have settled like hermit crabs in them and made themselves as comfortable as may be.

In his novel *The Long Memory*, published in 1951, from which the above quotation is taken, Howard Clewes conjures up a world, real enough then, now entirely swept away, of barges and lighters, of sea pilots and mud pilots, of huge freighters and nippy tugboats, of shrimpers and smugglers, of over-crowded shipping lanes and lonely creeks, of the tumultuous life of the great river Thames, the gateway to London. Back to this world comes Philip Davidson after serving seventeen years hard labour for murder. Holed up in a derelict barge he plots revenge against those whose lies led to his being found guilty of a crime he did not commit. He is watched by a reporter keen to get a good story and the policeman who was in charge of his case and who married Davidson's girl. It is a grim tale but a well-told one with Clewes effectively etching in the riverside background as a setting for his story of guilt, revenge and human frailty.

The film rights were snapped up by Hugh Stewart, an enterprising independent producer. His chosen director was Robert Hamer, whom he had worked with in the cutting rooms of Denham in the late 1930s. Stewart, whose editing credits include Hitchcock's *The Man Who Knew Too Much* (1934) and Victor Saville's *South Riding* (1937), served with the Army Kinematograph Service and went into production after the war, eventually finding major commercial success with the Norman Wisdom comedies of the 1950s. Hamer moved to the GPO Film Unit under Alberto Cavalcanti; and when Cavalcanti established himself as a producer/ director at Ealing Studios Hamer joined him there. He produced (and directed some

of) Charles Frend's *San Demetrio London* (1943) and Harry Watt's *Fiddlers Three* (1944), and made an impressive debut as credited director with the 'Haunted Mirror' episode of *Dead of Night* (Alberto Cavalcanti/Charles Crichton/Basil Dearden/Robert Hamer, 1945). He went on to direct *Pink String and Sealing Wax* (1945) and *It Always Rains on Sunday* (1947) and enjoy international success with *Kind Hearts and Coronets* (1949), the film for which he is still best known. Received wisdom has it that because Hamer's dark vision contradicted the cosy ethos of Ealing; or because he was too original an artist to survive in the drably conformist atmosphere of the 1950s British film industry; or because of his own inner turmoil over drink and his ambivalent sexuality, he was never again able to make a decent film. As with most myths, there is a small kernel of truth here, but this one is sustained by the lazy snobbery which insists that only a couple of dozen British films are worthy of critical attention, and the reality is more complex and more interesting.

Hamer found it difficult to find a follow-up project to *Kind Hearts and Coronets* at Ealing. He worked with Mark Benney, most famous for his criminal autobiography, *Low Company* (1936), on a script set in Soho; but it ran into censorship problems. His bold plan to cast Margaret Lockwood as Edith Thompson, who had been hanged in 1923 when her lover was found guilty of murdering her husband, was not received with enthusiasm; and his ambition to film Richard Mason's novel, *The Shadow and the Peak*, with Vivien Leigh in the starring role, was considered riskily expensive and too erotic. Consequently he took leave of absence to make a film for Mayflower Pictures, the company set up by Erich Pommer and Charles Laughton which had nurtured him in the 1930s. *The Spider and the Fly* (1950), set in early twentieth-century France, centres on the rivalry between a policeman and a master criminal who both love the same woman. Reconciliation seems possible when they come together to burgle a safe containing a list of German agents working in France. But one of the names on the list is that of the woman they both love and the film ends pessimistically. Hamer returned to Ealing to make *His Excellency* (1951), a potentially interesting film with Eric Portman (who had played the policeman in *The Spider and the Fly*) as a working-class trade union leader appointed a Colonial Governor and having to stand up to politically-motivated strikers. But the resulting film was a disappointment and Hamer severed his links with the studio.

John Mills, who gives an impressive performance as Davidson in *The Long Memory*, recalls it as: 'an extremely good thriller, which would have been even better if our director could have stayed off the juice … Twice, during night-shooting on a barge in the Thames he fell in the river walking backwards with a viewfinder glued to his eye.'

Mills is not the most reliable of sources but the flashback to the night-time events on the barge which lead to murder is too perfunctory. Hamer certainly had a serious drink problem and the patchy nature of *His Excellency* would support the idea that he was losing his grip. But overall, *The Long Memory* is beautifully composed, in terms of both images and narrative, and I would argue that it is an example of that very rare species, 'the lost masterpiece of British cinema'.

This is not a view shared by critics then or now. Most contemporary reviews were unsympathetic. *The Times* complained that Hamer's directing was 'fussy' and that he was 'a good deal too ingenious with his cutting'. The *Daily Worker* thought John Mills looked and acted like a sulky schoolboy and the *Manchester Guardian* found the film portentous and over-solemn. C. A. Lejeune of the *Observer*, who had been offended by the 'dreary round of squalor' portrayed in *It Always Rains on Sunday*, was surprisingly warm towards *The Long Memory*, though she thought the story too slow, 'rather like a plump old dachshund enjoying a constitutional'. Only Roy Nash in the now defunct London evening newspaper, the *Star*, offered unqualified praise; and only Dilys Powell in the *Sunday Times* made any comparison with the novel, pointing out that its main weakness as raw material for a film was the lack of 'a solid, convincing central figure'.

Reading the novel after seeing the film is a shock, not because the story is radically different, but because the central figure is not Davidson but Bob Lowther, the policeman who handles his case. In the period of Davidson's incarceration, Lowther rises in the hierarchy of the Metropolitan Police and marries Fay Driver, Davidson's girlfriend – a fact he conceals from his superiors lest it hamper his promotion prospects. The central moral dilemma of the novel is what Lowther should do about his wife – whom he has long suspected of perjury. Should he expose her to disgrace and imprisonment, sabotage his own career, and (as Fay argues) ruin the happiness of their young son? Or should he let sleeping dogs lie? The policeman's dilemma is interesting and Clewes handles it well, but it is too trivial to stand up to the intense scrutiny of a 90-minute film. Although Lowther is a satisfyingly real policeman, increasingly uneasy that justice has not been done but trapped by the inertia of everyday life, he is too compromised and too inactive to become the film's protagonist.

Hamer and his co-writer Frank Harvey – a talented playwright and scriptwriter whose play had been adapted for Walter Forde's Ealing comedy *Saloon Bar* (1940) – tighten up the plot. In the novel, Davidson, the respectable if slightly dreamy son of the owner of a fleet of tugboats, gets emotionally involved with Fay Driver, the daughter of a drunken bargee and is implicated (though only as an observer) in the criminal schemes of Spencer Boyd, who uses

the barge as a base for smuggling and other nefarious activities. Boyd and an escaped convict, Delaney, fall out. Davidson tries to stop Boyd smashing Delaney's skull, the barge catches fire, and Fay, her father, and Boyd's sidekick, Pewsey, escape in the dinghy, while Davison jumps overboard and is picked up by a river-police patrol boat. Only one body is found, which Pewsey and the Drivers confirm is Boyd's, and Davidson is tried and found guilty of his murder. Hamer and Harvey retain most of this but make it more plausible by having Pewsey and the Drivers agree to deny the existence of Delaney altogether, thus absolving themselves from any criminal activity and making Davidson's version of events seem like the fabrications of a fantasist.

More fundamentally, Hamer and Harvey shift the focus from Lowther to Davidson. The Davidson of the novel is almost as pathetic a creature as Frankenstein's monster, morbidly sensitive to the presence of others, immensely strong but poorly co-ordinated, driven by blind vengeance but incapable of planning ahead. Jim Phelan, an IRA gunman who himself spent thirteen-and-a-half years of a life sentence in Dartmoor and Parkhurst, reckoned that, in the grim prisons of the inter-war years, fourteen years was the maximum that a man could take without becoming seriously disturbed. Hamer and Harvey sensibly reduce Davidson's sentence from seventeen to twelve years, allowing Mills to play him as bitter and morose but intelligent and resourceful. Thus the Davidson of the film is a more active figure and a less strange one for the audience to identify with. This process is helped by the acting persona of John Mills – who was best known for the resilient Cockney 'Shorty' Blake in *In Which We Serve* (David Lean/Noel Coward, 1942) and for Pip in *Great Expectations* (David Lean, 1946), though he had also played a tap-dancing nightclub owner in *The Green Cockatoo* (William Cameron Menzies, 1937) and the protagonist of Roy Ward Baker's *The October Man* (1947), who is suspected of murder and doubtful of his own sanity.

Philip Kemp, one of the very few critics to write with any perspicacity about *The Long Memory*, picks up on thematic concerns that recur throughout Hamer's work and praises his use of landscape; but he argues that he 'needed a crueller actor than John Mills (James Mason perhaps?) for the lead. Mills does a staunch professional job, giving us the tenacity but missing the malevolence; the role calls for a cold, harsh venom that isn't within the actor's compass.'

Several contemporary reviewers also disliked Mills' performance. But the key to Philip Davidson's character in the novel and in the film is that essentially he is not malevolent: that he is a good and gentle man. In the novel the only person who is frightened of him is Pewsey, the cowardly and not very bright henchman who gives evidence against him; Fay laughs at the idea of being afraid of 'poor Philip' – though in the film, where she is a more vulnerable figure, she

is terrified when he succeeds in confronting her. But his rough appearance and rude manner seem to provide no protection against the kindness of strangers. Jackson, the scavenger of the mud-flats, refuses to be rebuffed and plies him with cups of tea and practical advice; Craig, the reporter sent to write a piece of cheap sensationalism, provokes Davidson to violence but becomes convinced of his innocence; Elsa, the Polish waif from the riverside café awakes him to pity and little by little opens his heart to love. Jackson, old and frail despite his chirpiness; Craig, the world-weary reporter; and Elsa, the persecuted refugee, all recognise a fundamental humanity in Davidson which the bitterness distilled by years of injustice has failed to dissolve. The ambivalence that an actor like James Mason (or Richard Attenborough or David Farrar) could have brought to the part would be out of place here. Paradoxically in a film which consciously echoes Marcel Carné's *Quai des Brumes* (1938), it is the essentially English mix of dignity, aloofness and decency which Mills brings to the part that makes him so effective.

Shifting focus from policeman to wronged man might seem a too easy way to tauten the narrative and heighten dramatic tension, but Hamer succeeds in making the film more resonant and sophisticated than the novel. The emotional centre of the film becomes the issue of whether Davidson is so eaten up by the desire for vengeance that he will willingly destroy himself in his bid to destroy those who wronged him, or whether he still has the capacity to rebuild a life for himself.

In *Get Carter* (Mike Hodges, 1971), another film entirely concerned with revenge, Jack Carter's vengeance is not for himself but for others. His brother's death is a matter of family honour, and, though he is touched more deeply when he realises that the catalyst for his murder is the girl he reluctantly acknowledges is his own daughter, the film is structured around the unravelling of a mystery and the confronting and defeat of powerful adversaries. In *The Long Memory* there is little mystery and Davidson's adversaries are characterised by petty self-interest rather than Machiavellian evil. Vengeance is a chimera which Davidson has to overcome before he can return to a semblance of normal life. When he does confront his enemies – the shambolic Pewsey, the suburban housewife Fay, even the back-from-the-dead Boyd – he gains no satisfaction. As he tells Fay: 'When you came to the door just now it suddenly hit me. All the time I was in prison I've been nourishing this hatred against a great villainess and I suddenly saw just a tawdry little coward.'

The moral centre of Hamer's film is Elsa (played by the Norwegian actress Eva Bergh, though she comes across as convincingly mid-European). As Christine Geraghty points out, 'Her candour and frankness in love turns into a self-surrender; an abasement in which she

takes nothing for herself. She is twice filmed on her knees, scrubbing the floor, and she offers to "keep things clean for you, cook for you". When Davidson demands "Why should you think I want you here?" she replies: "I did not think you would want but I thought perhaps you would not mind." On her first night at the shack, with Davidson mute and angry by her side, she nevertheless declares: "Tonight – I've been happier than I ever remember.'"

Joyce Howard in *The Night Has Eyes* (Leslie Arliss, 1942) and Ann Todd in *The Seventh Veil* (Compton Bennett, 1946) play women who are sadistically humiliated by a charismatic but damaged man played by James Mason. Essentially awestruck adolescents, they persist in believing that he will be redeemed by their love. Elsa's self-abasement is different. She knows that Davidson's harshness is a mask, that despite his gruff hostility she is safe with him. What she is drawn to is kindness not cruelty. 'You are not a cruel man.' She tells him. 'I have seen too much cruelty not to know.' Happiness in a broken-down barge with a vengeful ex-convict might seem like a dangerous delusion. But Elsa, far from being a victim of fantasy has a strong sense of reality rooted in her experiences of the brutality of war – a war which has passed the incarcerated Davidson by. Lowly she might be, but in a world of suffering she can speak with knowledge and authority and she is able to woo Davidson away from his futile quest for revenge and bring him back to wholesome life. 'You're the person I always knew you were', she tells him when he returns from confronting Fay.

The film could end here, but Clewes provides an extra plot twist which is even more effective in the film, where it is in a sense gratuitous. Davidson, now happy with Elsa and eschewing any further desire for vengeance, accepts a job from the owner of the riverside café. He has simply to deliver a parcel to a warehouse in Shad Thames, on the south side of Tower Bridge. He delivers it and recognises that the recipient is Boyd, the man he is supposed to have murdered. He goes back to confront him and begins to beat him up, but breaks off in disgust, telling him, 'It's not worth it. It's funny, when you come to the point revenge isn't worth it. You plan it and plan it and then when you start it makes you feel as filthy as the other person.' But Boyd is determined to kill him. A chase ensues, all the way along the river from Tower Bridge to the mudflats of Morocco Bay. The police arrive too late to be more than passive observers and it is old Jackson, who has adopted a proprietorial friendship towards Davidson, who appears like an avenging scarecrow to save the day. The film ends with Davidson, Elsa and Jackson – a trio of outsiders – steadfastly turning their back on the respectable and corrupt world.

The Long Memory contradicts not only the idea that Hamer made nothing worthwhile after *Kind Hearts and Coronets*, but also that 1950s British cinema suffered from a dearth of

creativity. One can certainly read auteurist concerns into the film, but *The Long Memory* is also a genre film which is the product of a highly-skilled team of collaborators. Cinematographer Harry Waxman had already shown his flair for atmospherically *noir*ish visuals on *Brighton Rock* (John Boulting, 1947) and *Waterfront* (Michael Anderson, 1950). Here, much of the action is outdoors, in bright, bleak spring daylight. As in *Brighton Rock*, Waxman creates a world which is vibrant and familiar but at the same time sinister and threatening. Art Director Alex Vetchinsky – who had also worked on *Waterfront*, as well as *The Seventh Veil*, *The October Man* and *Hunted* (1952), a non-Ealing film made by Charles Crichton with a similar downbeat ethos to that of *The Long Memory* – designs interiors such as the Davidsons' barge, the shabby café, the prim suburban home of the Lowthers, and the grimy shadow-strewn warehouse where Davidson discovers Boyd, which evoke a world as solid and real as those created by the British New Wave films which emerged at the end of the decade. Contemporary reviews tended to blame (and sometimes credit) Hamer for the way in which the film was edited, but producer Hugh Stewart was himself an accomplished editor, and the film's editor Gordon Hales, who had cut *The Seventh Veil*, *Hunted* and Ralph Thomas and Betty Box's *noir*ish *The Clouded Yellow* (1950), was something more than an anonymous technician and he is likely to have made a significant contribution.

Two sequences stand out and are worth looking at in detail for their masterly combination of direction, cinematography, design and editing. Davidson traces Pewsey to Gravesend. The police are already there, as is the reporter, Craig. The attempt to warn Pewsey is complicated by the fact that he has left his wife for a cinema usherette. Davidson, Craig and Lowther all track him down and watch and wait. Meanwhile Mrs Pewsey (Thora Hird) turns up at her rival's house to rub camphorated oil into Pewsey's chest, accurately gauging that he will be afflicted by his seasonal attack of bronchitis. Davidson's decision to act coincides with the harassed Pewsey's acquiescence to his shrill mistress's demand that he put the cat out. He opens the door to see Davidson coming up the garden path and has time to bolt back inside and barricade the door. Nothing happens. Davidson continues to watch the house; the police continue to watch Davidson. When day dawns Pewsey sneaks out and surrenders himself into police custody, confessing that his evidence at the trial was inaccurate. Davidson goes home, a beautifully composed dissolve taking him from a narrow town street back to the bleak expanses of the mud flats. Pacing, composition and lighting combine to make a sequence which might have been disappointingly dull (we are denied a full confrontation between Davidson and Pewsey) into a meaningful juxtaposition of farce and tragedy.

The other sequence comes soon after the Pewsey episode. Davidson has reluctantly agreed to let Elsa stay with him for a brief period and returns at night to find the cabin clean and tidy, flowering bamboo blossom in a jar on the table, and Elsa lying in one of the bunks. She tells him that 'Tonight, lying here, I have been happier than I ever remember', as he lies down on the other bunk, his head at right angles to hers. The camera tracks into a medium close-up of their faces as she tells him that good people should try to be happy together. A dissolve takes us to the Lowthers' bedroom, where Fay sits at the dressing-table combing her hair as her husband tells her that she will have to go in to Scotland Yard to answer some questions. There is a cut to a medium shot disturbingly reminiscent of scenes from Hamer's episode in *Dead of Night*, as Fay, watching Lowther in the mirror, asks him if this is going to be 'very awkward for him'. Back on the cramped barge Davidson tosses and turns and Elsa gently questions him about what is troubling him and suggests that, 'Perhaps it is not worth it to hurt people back.' He grimly insists that it is and we cut to a big close-up of Lowther's face in the darkened bedroom as he accuses Fay of lying at the trial. She admits that he is right and tells him the whole story. The sequence ends with a close-up of her sad face.

Again what could have been banal and contrived is moving and revelatory. The shallow Fay of the novel becomes a tragic figure contorted by guilt and fear. But the juxtaposition of her confession – where the falsity on which her comfortable, respectable life has been built is exposed – with the raw honesty of the emotions expressed by Elsa and Davidson in the crude discomfort of the barge, reminds us not to allow the guilty suffering of the wrongdoer to eclipse that of the victims of evil and cowardice.

Richard Winnington, most perceptive of the post-war newspaper critics, points out that: 'Whatever else it may be Hamer's new film, *The Long Memory*, is certainly his greatest tribute of love to French film art. An almost agonising effort has been made, but without any of the vital materials, to reshape Marcel Carné's *Quai des Brumes* into basic English.' Similarly, Philip Kemp, generous and perceptive though he is about *The Long Memory*, is unable to escape the shadows of *Quai des Brumes*. Hamer was undoubtedly influenced by the French poetic realist films of the 1930s – in *Pink String and Sealing Wax*, *It Always Rains on Sunday* and *The Spider and the Fly* as well as in *The Long Memory* – but he adds nothing to Frenchify Howard Clewes' parochial English story set very specifically along the Kentish banks of the Thames. Like *It Always Rains on Sunday*, *The Long Memory* combines an affection for those consigned to the lower depths, and a robust use of melodrama taken from the French, with a feel for English idioms and English locations. There is also a visual flair in both films – in *It Always Rains on*

Sunday this is particularly apparent in the final bravura chase through the railway shunting yards ending in the death of the escaped convict Tommy Swann – which relates it to contemporary British films like Carol Reed's *Odd Man Out* (1946) and *The Third Man* (1949), Boulting's *Brighton Rock*, Cavalcanti's *They Made Me a Fugitive* and Ralph Thomas' *The Clouded Yellow* in what might be seen as a British *noir* tradition.

The look of the film in terms of lighting and production design, the intelligent economy of the script and the cleverly organised editing make *The Long Memory* an absorbing and satisfying film. The performances make it convincing and enjoyable. Mills is irascible enough to be authentic, decent enough to command our sympathies; John McCallum – who had played the desperate Tommy Swann in *It Always Rains on Sunday* – is ironically but effectively cast as Lowther; Elizabeth Sellars transforms the superficial Fay of the novel into a brittle, edgy and quintessentially English femme fatale; the young stage actress Eva Bergh makes the improbable Elsa believable; and the usual array of British character acting talent – most notably John Slater and Thora Hird as the Pewseys, Vida Hope as the frowsy café proprietress and Michael Martin-Harvey as old Jackson – enliven the most mundane scene.

The Long Memory is a good example of the invisibility of British cinema. Contemporary critics thought little of the film, but contemporary reviews of Tourneur's *Out of the Past* (1947) or Sirk's *All That Heaven Allows* (1955) or Hitchcock's *Vertigo* (1958) were equally dismissive. It is the failure to look back with eyes unblinkered by preconceptions which is to blame. If one does, then it is possible to see – as several other chapters in this collection show – a cornucopia of cinematic riches.

Robert Murphy

REFERENCES

Geraghty, C. (2000) *British Cinema in the Fifties: Gender, Genre and the 'New Look'*. London and New York, Routledge.

Kemp, P. (1995) 'The Long Shadow: Robert Hamer after Ealing', *Film Comment*, May–June, 71–8. Revised and re-printed in I. MacKillop and N. Sinyard (eds) (2003) *British Cinema of the 1950s: A Celebration*. Manchester: Manchester University Press.

Mills, J. (1980) *Up in the Clouds, Gentlemen Please*. London: Weidenfeld & Nicolson.

Winnington, R. (1953) 'Close-Up', *News Chronicle*, 24 January.

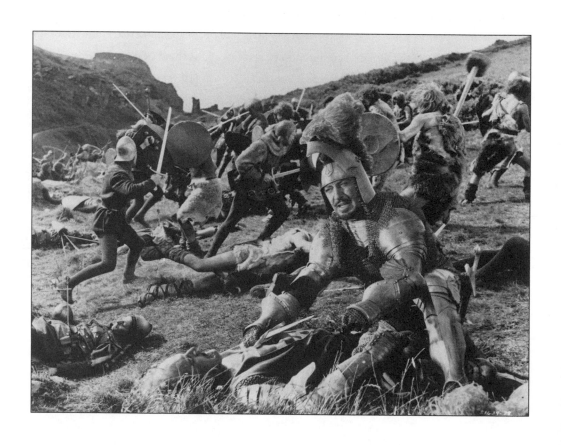

KNIGHTS OF THE ROUND TABLE

RICHARD THORPE, US/UK, 1953

Based on *Le Mort d'Arthur*, Sir Thomas Malory's fifteenth-century compendium of the legends of King Arthur, *Knights of the Round Table* (Richard Thorpe, 1953) focuses upon Arthur's struggle to become and remain King of Britain in the face of dissent and treachery led by his enemy, Modred, and on the love triangle between Arthur, Queen Guinevere and Lancelot, Arthur's staunchest friend and ally.

A film financed by a major Hollywood studio, directed by an American, and featuring major Hollywood stars Robert Taylor and Ava Gardner, may appear to be a strange choice for a collection of essays on British films. *Knights of the Round Table*, however, is a good example of a strand of cinema which becomes increasingly important in Britain and other European countries during the 1950s and 1960s – the Hollywood 'runaway' production. Americans had been closely involved in the British film industry since the 1890s in one way or another: equipment supply, distribution bases, production subsidiaries, personnel exchange, and so on; and the post-Second World War period saw an intensification of this involvement particularly in terms of production financing. Although the American influence on British cinema is often spoken of in terms of regret, the advent of the 'runaway' production did enable British filmmakers, British actors and British subject matter to play a significant role in the big-budget spectacular filmmaking of the post-war period and to bring British cinema to the attention of a wider audience. Indeed, *Knights of the Round Table* – a medieval epic shot in the innovatory widescreen CinemaScope format – offers an alternative version of the British film of the 1950s, contrasting dramatically with the understated war films, the parochial crime pictures and the Ealing comedies that are often regarded as definitive of post-war British cinema. This chapter examines *Knights of the Round Table* as an example of 'runaway' production but also pays attention to other important contexts for the film including the introduction of CinemaScope and the development of the medieval epic genre in the American cinema.

Hollywood companies have a long history of British-based production and as early as 1920 Paramount had set up a studio at Islington. Following the quota legislation of 1927, which required US distribution firms to include British-made films in their offerings to exhibitors,

other studios set up British subsidiaries to make what became known as 'quota quickies' – cheaply-produced films designed to fulfil quota requirements. MGM, as befits a studio with an opulent image, did things slightly differently, setting up a British subsidiary in 1936 with a commitment to the production of 'quality films' as opposed to the low-budget films characteristically produced by the British arms of companies such as Fox and Warner Bros. Revised quota legislation in 1938 encouraged bigger budgets and MGM-British made three films at Denham Studios, including *Goodbye, Mr Chips* (Sam Wood, 1939), which enjoyed considerable success both in Britain and America as A-grade pictures. Production was interrupted by the war but in 1944 MGM acquired their own studio at Borehamwood and the company's British-based production was resumed in the late 1940s. Although MGM clearly had planned to continue their pre-war strategy of making films in Britain, there were new factors that encouraged such a policy. The resolution of the Anglo-American trade dispute of 1948 included an agreement which prevented the US majors from remitting the whole of their British distribution profits back to America, and required a percentage of such earnings to be spent in Britain on activities such as film production. 'Runaway' production, then, is, in part at least, a consequence of this; it was a way for the majors to use their 'frozen coin' as *Variety* called it. There were also further economic incentives such as lower labour costs, but one of the key factors in Britain from the early 1950s onwards was the availability of production subsidies from the British Film Production Fund ('Eady money') to US-owned subsidiaries like MGM-British. The fund was designed to help the British film industry but the legislation defining a British company was framed loosely enough to allow the subsidiaries of the Hollywood majors to benefit from the extra financing available.

It was in such a context that MGM-British began the production of *Knights of the Round Table* in the summer of 1953 using the new CinemaScope format together with Perspecta sound, a versatile stereophonic system. A 'flat' conventional version was also shot simultaneously indicating perhaps some uncertainty about the long-term potential of CinemaScope but also in recognition of the fact that it would take some time for cinemas to be re-equipped with new wide screens and stereophonic sound systems and that there would still be a demand for films shot in the Academy ratio in the immediate future. In the summer of 1954, MGM's *Knights of the Round Table* – a spectacular, lavishly budgeted, star-packed, widescreen picture – took its place in a somewhat low-key, parsimoniously-financed British cinema of indigenous, parochial genres. In the first half of the 1950s British 'runaways' often meant big-budget costume pictures such as *Captain Horatio Hornblower R. N.* (Raoul Walsh, 1951) and *Ivanhoe* (Richard Thorpe,

1952); from 1954 onwards it also meant widescreen images and stereophonic sound, and was a trend which continued on a more inflated scale into the 1960s with historical epics such as David Lean's *Lawrence of Arabia* (1962) and *Doctor Zhivago* (1965), and *Khartoum* (Basil Dearden, 1966).

Knights of the Round Table was one of the earliest films made in CinemaScope – the new widescreen process developed in 1953 by the Twentieth Century-Fox Company – and was the first CinemaScope feature film to be made in Britain. It was released in America late in 1953 hot on the heels of Fox's initial CinemaScope titles, and, though made in Britain as a 'runaway' production, it was the first film in the new format from Hollywood's leading studio, MGM. The story of CinemaScope, of course, is basically American though its origins lay in Frenchman Henry Chrétien's invention of the anamorphic cinematographic process in the late 1920s and the brief flurry of widescreen production in Hollywood in the early 1930s. The success of *This is Cinerama*, filmed in the ultra-widescreen three-camera process and launched from outside the studio system in September 1952, prompted Hollywood companies to explore alternatives to the conventional Academy screen ratio. Twentieth Century-Fox led the way with CinemaScope, a somewhat less cumbersome process than Cinerama, and one which required less adjustment for the industry in terms of cinematographic and projection technology. The company's aim was to install it as the widescreen norm for the industry and to establish 'CinemaScope' as a readily identifiable brand-name, 'something like Cadillac or Frigidaire', as one of their executives was quoted in *Variety* (9 September, 1953). Of the other majors, MGM seems to have been the most interested in the process entering into a licensing agreement for CinemaScope with Twentieth Century-Fox in March, 1953; most of Hollywood fell into line subsequently with the notable exception of Paramount which developed an alternative non-anamorphic wide-screen process – VistaVision. The films which launched CinemaScope were *The Robe* (Henry Koster, 1953) (the first release in the format), *How to Marry a Millionaire* (Jean Negulesco, 1953), *Beneath the 12-Mile Reef* (Robert D. Webb, 1953) and *King of the Khyber Rifles* (Henry King, 1953) from Fox, and *Knights of the Round Table* from MGM – the only film from another studio. All premièred and began their first-runs in the USA between September and the end of December 1953. *The Robe* was first shown in Britain in November 1953, but *Knights of the Round Table* did not reach its British audience until May 1954, several months after its American debut and only a week or two before the only other British CinemaScope production of the time, *The Flight of the White Heron*, a documentary from British Movietone News recording the Royal Tour of the Commonwealth.

MGM-British produced films in many genres but in 1952 *Ivanhoe* had achieved massive success at the American box office and *Knights of the Round Table* was an attempt to repeat the success using the same star – Robert Taylor – in the same generic mould but exploiting more thoroughly the enhanced colour and spectacle available with the widescreen format. Both films can be set in the wider context of Hollywood's return to the big-budget film after the rather more austere production values of the 1940s. In the summer of 1951 *Variety* had identified Cecil B. De Mille's *Samson and Delilah* (1949) as an early example of this trend and as an effective and persuasive demonstration of the way in which a single spectacular film can stimulate interest in the industry as a whole. *Samson and Delilah* indeed became the biggest money-maker in Paramount's history to that point. There followed a spate of expensive, spectacular films drawing upon a number of historical epochs including biblical times, the ancient world of Greece and Rome, the medieval period broadly conceived to range from the Arthurian era to the fifteenth century, the regency period, the Napoleonic wars, and so on. It was in the context of this trend that MGM embarked on a programme of historical costume films with many, though not all, scheduled for foreign production. These included the Roman epic *Quo Vadis?* (Mervyn LeRoy, 1952), shot largely at Rome's Cinecittà studios, and continued with a number of British-made titles, including the three medieval epics – *Ivanhoe* and *The Adventures of Quentin Durward* (Richard Thorpe, 1955) as well as *Knights of the Round Table* – and the Regency-set *Beau Brummell* (Curtis Bernhardt, 1954). The schedule also included titles produced at MGM's Hollywood studio such as the Ruritanian tale *The Prisoner of Zenda* (Richard Thorpe, 1952), *Scaramouche* (George Sidney, 1952) set during the French revolution, and *Young Bess* (George Sidney, 1953) based on the early life of Elizabeth I.

Many of the historical films were in CinemaScope and it was exactly this kind of film that was considered ideal for the new more expansive widescreen formats which were better suited to the spectacular display of costume and scenery, of action and casts of thousands, compared to the relatively cramped dimensions of the conventional screen. Yet the trend towards the spectacular was there already, dating at least from *Samson and Delilah* in 1949. CinemaScope, of course, accentuated it, providing an additional impetus for a trend already popular with a public, which had flocked to the MGM films *Quo Vadis?* and *Ivanhoe* in 1952 pushing them to second and third respectively in the *Variety* top box-office performers list for the year.

Knights of the Round Table was part of a medieval-epic strand of the historical film along with a number of titles from other studios. Some were made in Britain, some in Hollywood, and titles include Disney's *Robin Hood and His Merrie Men* (Ken Annakin, 1952), Twentieth

Century-Fox's *Prince Valiant* (Henry Hathaway, 1954) (based on Hal Foster's long-established Arthurian comic serial), Warner Bros.' *King Richard and the Crusaders* (David Butler, 1954), Universal's *The Black Shield of Falworth* (Rudolph Maté, 1954), Columbia's *The Black Knight* (Tay Garnett, 1954), and Allied Artists' *The Dark Avenger* (Henry Levin, 1955). Within that strand the film was one of a small number deriving from the Arthurian tales. In 1950 Columbia released a 15-episode serial *The Adventures of Sir Galahad*, and *Knights of the Round Table* was followed by *Prince Valiant* and *The Black Knight*.

The first CinemaScope films were anticipated with foreboding with critics such as Gavin Lambert, editor of the influential British journal *Sight and Sound*, anticipating that a lengthy period of artistic settlement would be required before the new widescreen process developed its own aesthetic principles. In such a context, the critical responses to early titles such as *Knights of the Round Table* tended to focus as much on the CinemaScope process itself, with most reviewers and commentators pronouncing on its advantages and disadvantages, as well as on the films themselves. Some of the early titles were seen as gaining in power and spectacle from the widescreen format and *Variety* (23 December 1953) commented that *Knights of the Round Table* would have been impressive in the conventional Academy format but that 'in C'Scope, it's immense'. MGM's film, along with other spectacular CinemaScope films such as *The Robe* with its pageantry of Ancient Rome and the Holy Land, and *Beneath the 12-Mile Reef* with its impressive underwater sequences, were deemed 'natural for CinemaScope' by *Variety*. However, there were fears about the versatility of the wide image and the stereophonic sound, with some critics seeing the magnification of sound and image as a threat to the presentation of more personal, intimate drama, which would be overwhelmed by the magnitude of the new system. Bosley Crowther, the distinguished critic of the *New York Times*, expressed this well in a review of *The Robe* in which he suggested that 'an unwavering force of personal drama is missed in the size and length of the show, and a full sense of the spiritual experience is lost in the physicalness of the display' (quoted in *Variety*, 23 September 1953).

The British critical reception of *Knights of the Round Table* was delayed until May 1954, when the film had its première in London at the Empire, Leicester Square. By that time, CinemaScope was no longer a novelty and though critics did make reference to the spectacular scenery, the castles (both real and studio-constructed), the pageantry and the battle sequences with scores of extras, there was more room for other issues to be raised. Although made in Britain, the film's runaway status meant a preponderance of Americans in the production team. These include the director, Richard Thorpe, an experienced Hollywood professional whose

credits stretch back to the 1920s, stars Robert Taylor, Ava Gardner and Mel Ferrer, and though the scenario was based on an English work – Sir Thomas Malory's *Le Mort d'Arthur* – it was written by experienced Hollywood screenwriters Talbot Jennings, Jan Lustig and Noel Langley. Certain key figures were British including Freddie Young, the cinematographer, but some of the critical comments reflected concerns about the cultural identity of a film based on a venerated classic and dealing with a potent national legend, but made largely by an American creative team. Some critics were disturbed by the 'anachronism of the American voice' (*Daily Worker*, 15 April 1954) delivering dialogue intended to capture Malory's medieval Britain and specifically 'a King Arthur who speaks in the orotund tones of a US Senator'. A number of critics saw the picture as a covert western, a point noted previously after the film's US release in the American journal, *Saturday Review* (16 January 1954). Its critic lamented that 'all the wonderful body of Arthurian legend and romance, including Malory's *Le Mort d'Arthur*, had been compressed by busy screenwriters into something suspiciously close to the format of a large-scale western'. At least one British critic agreed, suggesting that the film 'is basically a "tinned western" with Picts instead of Indians and armoured Art and his boys hitting the trail for Camelot' (*Star*, 14 May 1954). The reviews were mixed with some praising the film for its scenery and spectacular action, and some agonising over its mixed provenance as a runaway. Both the American and, a few months later, the British audiences responded positively however. Though the critical reception of the early CinemaScope films was mixed, all of them were successful at the box offices in both countries, to a lesser or greater extent. Indeed, *The Robe* was the most successful film at the American box-office in 1953, and was second in the list of all-time top grossers compiled by *Variety* in 1954, and *Knights of the Round Table* reached the number eleven slot in the American top-grossers list for 1954. The mixed, somewhat lukewarm response of the critical community ran counter to the enthusiastic popular reception of the new style of film presentation.

Knights of the Round Table is an early CinemaScope film, made in Britain as a runaway production for the mighty MGM company, and part of a cycle of spectacular historical films made from the late 1940s onwards. Such contexts affect the form and style of the film. We have noted the forebodings with which critics and commentators anticipated the first tranche of CinemaScope films. During the fifty-year history of the narrative film prior to CinemaScope the Hollywood film had evolved a broad, flexible stylistic approach, balancing analytical editing with visual display, subordinating overt style to the demands of clear and effective narration. Some commentators feared a shift in the balance between editing and display and predicted

that dramatic sequences would be shot in a theatrical manner in long takes with minimal analytical cutting. At the beginning of the film, Arthur (Mel Ferrer) and Merlin (Felix Aylmer) meet Modred (Stanley Baker) and Morgan le Fay (Anne Crawford) and they dispute the right to rule a Britain divided into warring provinces. The sequence is shot in relatively lengthy takes with the four characters standing in a line across the screen in the shallow playing zone for actors permitted by the early anamorphic lenses with their limited capacity for depth of field. While there is some alternation of shots which include only two of the characters at a time, the overall strategy depends upon what David Bordwell calls 'the clothesline staging principle'. This kind of set-up is repeated throughout the film in sequences of character interaction. Yet despite the technical limitations, some sequences indicate that it was possible to incorporate conventional dramatic cutting. Though he is unaware of her identity, Lancelot rescues Guinevere who has been imprisoned by the Green Knight while on her way to Camelot for her wedding to King Arthur. Lancelot returns unexpectedly to attend the wedding and a relatively flat medium-shot presentation of his meeting with Arthur is punctuated by close-ups of the three characters involved in the romantic triangle – Arthur, Guinevere and Lancelot. The developing relationship between Lancelot and Guinevere is simply signalled through an exchange of close-ups which pick up force from their previous anonymous meeting. To some extent the film bears the imprint of early CinemaScope in its flat staging, but it also breaks from that to cross-cut between the protagonists at various points, belying the fears expressed by some commentators that the CinemaScope process would eliminate the close shot and cutting for effect. Spectacle, though, was the primary rationale for the introduction of the new processes and *Knights of the Round Table* with its battles, tournaments and jousting sequences certainly provided plenty of visual bravado. Critics, in particular, singled out the major battle sequence for praise. The wide format certainly made for a more spectacular exploitation of the hundreds of horsemen in full medieval regalia charging across the wide expanse of the screen providing the film with a sense of vastly increased space compared with its predecessors and, in particular, with *Ivanhoe* which deployed knights on horseback in a much more limited manner.

Runaway productions were frequently criticised for their tendency to flatten cultural specificity in favour of a generalised and unsatisfactory 'mid-Atlantic' flavour, as it was termed during the 1960s. *Knights of the Round Table* features American actors in the main roles of Lancelot, Arthur and Guinevere, and derives much of its character from the performances of Robert Taylor, Mel Ferrer and Ava Gardner all of whom were familiar faces to British audiences. However, runaways also characteristically featured actors from the host production

country or countries in their casts as well, though usually in supporting roles. *Knights of the Round Table* had a number of British actors including Stanley Baker and for some British critics Baker's scowling performance as the evil Modred stole the show from the Hollywood stars, illustrating that the mix of different nationalities can at least make for some interesting acting chemistry. The other British name on the credits which should be mentioned is Freddie Young, the cinematographer. Young had worked for MGM-British from 1949 and already had a substantial record dating back to the 1920s; he had worked on the company's prestigious productions such as *Edward My Son* (1949) and *Mogambo* (1953), and he was nominated for an Academy Award for *Ivanhoe*. Subsequently he was to win Academy Awards for his work on *Lawrence of Arabia* and *Doctor Zhivago*. As the top cinematographer in the industry he was an appropriate choice for the first CinemaScope film to be made in Britain. Whatever might be said about the cultural identity of the film, the acting, the dialogue, the narrative, its visual splendour particularly in the numerous outdoor sequences remains as a testimony to the technical expertise of Freddie Young.

The other quality of runaway productions worth commenting upon is the specificity they derive from location shooting. Indeed, Darryl Zanuck, the production head at Twentieth Century-Fox, claimed that overseas shooting by his company was not motivated by economics (lower labour costs, access to frozen funds) but rather by the desire to provide authentic settings for films set in foreign parts. Though Hollywood set designers were adept at constructing vast sets representing all parts of the globe, and a range of times from the past, setting a medieval British drama amongst real medieval castles and their environs was seen as an appropriate merging of the travelogue tendency of the new widescreen formats and the demands of verisimilitude. To this end, *Knights of the Round Table* was partially shot in Devon and Cornwall though the battle sequences were filmed in Ireland and the court of Camelot was constructed on the back lot at Borehamwood. Whether the pragmatic mixture of studio and locations (Ireland was chosen because of the availability of horses and extras in abundance) ensures a greater authenticity than a shoot at Culver City may be debated, but part of the rationale for runaway production lay in the use of what was frequently dismissed as 'local colour'.

Knights of the Round Table, though technically a British film, can be absorbed into the history of the American film in the 1950s. As a 'runaway' production it is a symptom of a significant change in Hollywood's filmmaking practices, a geographical shift in the production base in which countries such as Britain, France, Italy and Spain became hosts and collaborators with the US industry. As an early CinemaScope film released a couple of months after *The Robe*

it can be regarded as 'experimental', evidence of the initial understanding of the impact of the new aesthetics of widescreen on narrative cinema, and a film which provides British cinema with a small foothold in the development of the new widescreen film. As a medieval epic, it is a contribution to a key Hollywood cycle of the period based in part on British historical and cultural material.

Maybe there is less to say about its place in the history of the British film, despite its characteristically British subject matter, the Arthurian legends, a key element in this country's culture and literature since the Middle Ages. The film certainly contrasts dramatically with the small-scale comedies, the social problem pictures and the war films, which form its native cinematic context. Yet the phenomenon of the 'runaway', as many writers have pointed out, did, at least, provide employment and experience for British film workers of various kinds mainly in the middle and lower echelons – craft-workers for example. Occasionally, as happened in *Knights of the Round Table*, key creative personnel were drawn from the host country – in this case cinematographer Freddie Young. Runaways also provided opportunities for indigenous actors and Stanley Baker, for one, certainly boosted his career with his energetic and unsmiling performance as Arthur's great enemy. Indeed, runaways, for all the discussion of their threat to an indigenous cinema, did provide a wider international platform for British cinema and, according to George Perry, 'were recognised in the course of their wide release in America as British, thus conditioning audiences towards a more general acceptance of British films'.

Tom Ryall

REFERENCE

Perry, G. (1975) *The Great British Picture Show*. London: Paladin.

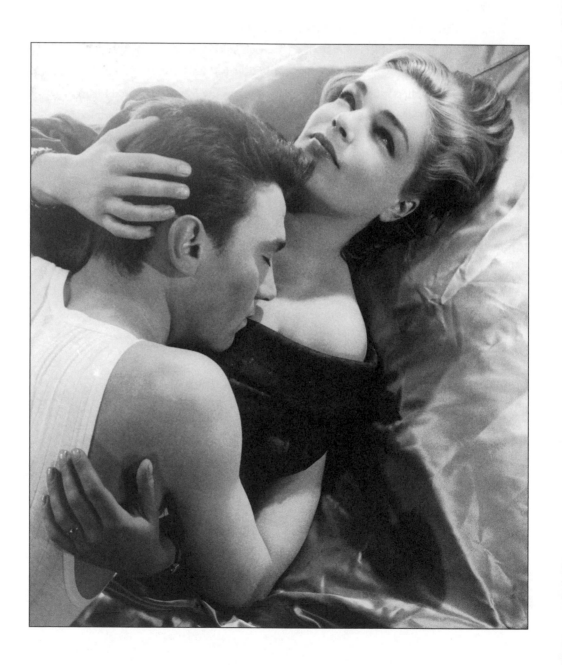

ROOM AT THE TOP

JACK CLAYTON, UK, 1959

Based upon John Braine's best-selling 1957 'Northern Realist' novel, Jack Clayton's *Room at the Top* (1959) turned out to be a huge popular hit at the British box office. Among contemporary critics, Dilys Powell spoke for many when she wrote, 'It gives one faith all over again in a renaissance of the British cinema.' But if the 'new wave' of 'social realism' heralded by *Room at the Top* proved pretty short-lived, lasting until just 1963 when it peaked with Lindsay Anderson's *This Sporting Life*, there is no doubting the force of John Trevelyan's twinfold argument that Clayton's considerable screen success was 'a milestone in the history of British films' as well as 'the history of British film censorship'. Trevelyan should have known, after all, given that he took over as secretary of the British Board of Film Censors (BBFC) two months before *Room at the Top* passed through its vetting process for award of a film certificate. The following account of the fate of *Room at the Top* in the BBFC's hands, however, depends principally on the original documentation for the film which James Ferman, then BBFC secretary, kindly provided in 1982.

Room at the Top posed special problems for the BBFC from the start. It was, to begin with, a Remus production for Romulus Films. Both companies were owned by John and James Woolf, two highly respected producers. John Woolf, the business brain in the partnership, was also an influential figure at the British Film Producers Association (BFPA), and served on its executive council in the 1950s and 1960s. He was, for instance, a member of its high powered delegation to see the BBFC in March 1955 over the question of 'X' certificate films and the matter of pre-production censorship of scripts. James Woolf worked in publicity for Universal in Hollywood before the Second World War and returned to Hollywood at the war's end to join Columbia. He had 'the flair for "production" more commonly found there than in Britain', Alexander Walker comments, and 'he was an obsessional filmmaker, loving the wheeling and dealing'. A 'midwife for talent', James Woolf spotted Laurence Harvey and Heather Sears in early roles and put them both under contract.

The Woolfs had started their own company in 1948. They immediately engaged a roster of burgeoning production-line talent, including Jack Clayton, who was used on six consecutive pictures before being granted his directorial debut with *The Bespoke Overcoat* in 1955. Though

a short film, it was given a general release and won an Academy Award. The Woolfs' output was varied and eclectic. It ranged from routine domestic comedy employing British directors – Gordon Parry for *Sailor Beware* (from Philip King and Falkland Cary's farce), Maurice Elvey for *Dry Rot* (based on John Chapman's play) and Ken Annakin for *Three Men in a Boat* (from Jerome K.Jerome's novel), all in 1956 – to large, expensive co-productions employing Hollywood directors and international actors – two in 1953 with John Huston's *Beat the Devil* and *Moulin Rouge* (starring, respectively, Humphrey Bogart and Jose Ferrer), and one in 1957 from David Miller, *The Story of Esther Costello* (with Joan Crawford and Rossano Brazzi).

Several of the Woolfs' productions, furthermore, encountered considerable problems with the BBFC, notably Henry Cornelius' *I Am a Camera* (1955), because it had intended broaching the abortion theme evident in its original sources (Christopher Isherwood's story and John van Druten's stage play) and Gordon Parry's *Women of Twilight* (1952), because it was based on Sylvia Rayman's controversial all-women play about 'baby farming' and 'unmarried mothers'. *Women of Twilight*, indeed, enjoyed the unique distinction of becoming Britain's first film to be granted an 'X' certificate after introduction of the category in 1951. The 'X' certificate sought to initiate a category of film classification which not only limited cinemagoing audiences to persons over 16 years of age but was also meant to promote the production of British films that were construed as 'good adult entertainment'.

The Woolfs' experience of the industry, then, was considerable. They were born and bred in the business, unlike many of those running 'new wave' companies like Woodfall Productions, where Tony Richardson and John Osborne were imports from the theatre. And they were shrewd, commercial producers. Though thwarted in their attempts to buy the rights of Osborne's *Look Back in Anger* in 1956, they were plainly intent on exploiting the potentially rich seam of new British writers coming to the fore. John Braine soon proved an obvious candidate. His book, *Room at the Top*, was published in March 1957. Braine's interview with Woodrow Wyatt on BBC's *Panorama* on 8 April 1957, which reportedly added a further 12,000 copies to sales, was seen by John Woolf. An abridged serialisation of the novel in the *Daily Express* for ten days from 22 April doubtless further enhanced its popular appeal.

The Woolfs proceeded to acquire the film rights for £5,000. The experienced Scot, Neil Paterson, was bought in as scriptwriter, but much of the production company was recruited in-house, with Jack Clayton being given the director's job. Although at the outset James Woolf apparently favoured using the film as a vehicle for the talents of husband-and-wife team Stewart Granger and Jean Simmons, the brothers sensibly agreed that Braine's characters needed flesh-

ing out in a different way. In addition, they had their own contract players to consider. Thus, they gave the comparative newcomers, Laurence Harvey and Heather Sears, two of the leading roles as Joe Lampton, the protagonist, and Susan Brown, the industrialist's daughter. Simone Signoret was brought in at Clayton's suggestion for the part of Alice Aisgill, Joe's mistress. In one obvious respect, therefore, changes were immediately required of Braine's original novel as Alice became French and was provided with a new social background. Nevertheless, Clayton promised, when announcing to the trade press that location shooting would start in June 1958, the film 'will remain remarkably true to John Braine's bestselling novel'.

Clayton's promise, allied to the automatic recognition by reviewers that Braine was 'a leading member of the new school for young writers', not to mention the reputation his novel quickly acquired in the popular press for its relatively frank depiction of sex, should have been sufficient to alert the BBFC to the fact there would be problems over the film. These problems were inevitably compounded, however, when the Woolfs chose not to tender a script for advance scrutiny in the time-honoured fashion that traditionally obtained. Pre-production censorship of scripts as well as post-production review of completed films, before the award of a release certificate, had been instituted and maintained since the 1930s.

Instead, their film was submitted for BBFC consideration close to 'final cut' stage and in almost finished state. Given the troubles encountered at the BBFC before Trevelyan took a firm grasp at the helm, what better time for the Woolfs to test the new waters? The alternatives posed for the BBFC were obvious. It could reject the film outright, though that was unlikely bearing in mind the costs that had been incurred by the production company (to the tune of £280,000) and the furore such a move would arouse at a moment when relations with the industry were already strained. Or it could allow it through virtually untrammelled with the prospect, at best, of a modest amount of amendment here and there to achieve their desired effect.

There were risks involved for all parties, to be sure: if the BBFC took any exception to the film and even minor changes were required, the Woolfs must hope they would be technically feasible and relatively straightforward – with no loss in continuity or characterisation, for instance, and incurring little further expense; the censors, for their part, must not be seen to lose credibility in the face of such an obvious attempt to present them with a *fait accompli*. Certainly, Trevelyan's latitude in the matter appeared to be severely curtailed. In the event, he made the most of a distinctly tricky situation and turned it to advantage.

What the censors viewed, then, on Thursday 2 October 1958, was a copy of *Room at the Top* at 'fine cut' stage (with separate picture and magnetic soundtrack, to accommodate last-

minute editing before marrying the two into a final show print). Little wonder, perhaps, that the producers got away with as much as they did – not least, as Arthur Marwick has observed, 'with rather more "language" than the Board of Censors would have wished for'. Nevertheless, the BBFC was adamant about several things that were subsequently expressed in meetings and correspondence. Some were easy to effect, others proved more difficult. Thus, the word 'lust' in the line 'Don't waste your lust', and 'bitch' in 'You're an educated and moral bitch' were changed respectively to 'time' and 'witch' by the simple expedient of having the actors re-dub the words for the soundtrack. The BBFC also asked that the word 'scalped' be deleted from the reported description of Alice Aisgill's death in a car crash and a new line substituted, again by voice-over. Trevelyan's considerable reservations about how graphic the dialogue might be were made clear in a letter of 13 October: 'We still feel that the lurid descriptions of Alice's death are overdone and hope that some way can be found of reducing them. Most of the description is spoken off-screen when Joe's head and shoulders alone are visible, so cutting should not be difficult … Incidentally, we all thought that some reduction in this verbal description would be an artistic improvement, but you may think differently.' John Woolf's reply the very next day revealed the extent to which they had sought to accommodate the censors' expected misgivings in advance by simply having Alice's death reported and not actually shown: 'I must say that I am concerned that Alice's death in the film should not be toned down too much. Dramatically, it is of course terribly important and I should have thought too that the fact that she met a violent end is morally right from the censorship point of view. As I mentioned to you, we had at one time thought of shooting the scene itself but when we decided against that, it certainly did not occur to us that just having it talked about by other characters would be likely to raise censor-ship problems.' In the event, a suitable voiced-over compromise was inserted and 'scalped' was dropped. But the biggest problem, finally, concerned a post-coital scene between Joe Lampton and Mavis, a working-class girl with whom he enjoys a brief, flirtatious encounter in a wood-yard scene towards the end of the film. The scene required changes to alter the 'implication' – so that it 'gets rid of the idea that he has made love to her'; revised dialogue to make it altogether more 'acceptable'; and, clearly, some measure of reshooting.

At the end of the day, however, all parties declared themselves satisfied with the results and the film was given an 'X' certificate. It came as no surprise and advertising for the film announced 'A Savage Story of Lust and Ambition – The Film of John Braine's Scorching Best Seller'. The meetings and correspondence between the producers, director and BBFC secretary had proved nothing if not harmonious, after all, even distinctly amicable. 'It is a great pleasure

to me to meet someone with the sensitivity not to allow the dramatic content of a scene to be destroyed by purely arbitrary rules of censorship', Jack Clayton wrote on 6 November 1958; 'I'm happy that we have found a solution to all the original objections which is mutually agreeable.'

Trevelyan replied on 2 February 1959, congratulating Clayton on 'the outstanding success' of the film and urging him to get on and make more. 'It was a pleasure to discuss things with you because you so readily took the point of my comments', he continued, then added: 'Some reviewers seem to be rather surprised that we should have passed the film as it was without cuts, but we still think that it is perfectly acceptable for the "X" category, and indeed the sort of film that we would like to see in this category.' It was a revealing statement. 'I have been enthusiastically praising your whole attitude to films to every journalist or interested person that I have met', Clayton replied, on 13 February 1959, while passing yet more compliments: 'I believe it is a wonderful thing for our industry to have a Censor who wishes to help and encourage the making of adult films.'

Despite the mutual congratulations, however, Trevelyan obviously had doubts over *Room at the Top*, not least since he knew how far he had been something of a hostage to circumstances and the producers. He decided therefore to send two BBFC examiners along to early public screenings to observe audience response – an innovation introduced by the Board in the early 1950s but rarely used. In addition to providing an insight into contemporary class attitudes, their reports reveal how carefully, if impressionistically, the BBFC monitored cinema-goers' reactions. They constituted, in short, a modest attempt at market research.

Trevelyan, of course, now had to answer for BBFC policy. It helped him a lot to have some idea what audiences thought. It helped a lot more when the film in question turned out, as this did, to be a considerable popular success. One examiner saw the film at an afternoon showing in the Plaza cinema within a week of its release on 22 January 1959, and stated:

Balcony packed, so stalls probably ditto. On the whole, a silent, sensible audience of real adults, not Teddy Boys. But there was the inevitable, odd burst of inane laughter at some of the more outspoken lines. One man hurried out in the middle and said to an attendant at the balcony exit 'This is a disgusting film', which made several people giggle … I think the 'shock' appeal of the film rests mainly on the personality of Simone Signoret, who always carries about with her the climate of a sultry foreign 'X', to which the patrons of English-speaking 'X's are not accustomed. People were probably also interested to hear the words 'whore', 'bitch' and 'bastard' which still

has the charm of novelty for the cinemagoing public. The love-making was certainly fairly hot for those who are not accustomed to foreign 'X's, but it looked to me fairly easy to defend. I expect the film will produce a few cross letters in its passage round the provinces, but there was nothing in it that I personally was surprised or worried to see or hear in an 'X' film.

Another examiner viewed the film on 4 February 1959 and commented:

> I saw this at the Carlton. I should say that in a packed house, about 80% of the audience were people of 30 or over – many from the 'provinces' ... I have seldom seen an audience more gripped by or more sympathetic to any other British film (except possibly *Kwai*). This was partly due to the extraordinary but unobtrusive realism of the photography and to a high standard in direction. Simone Signoret's performance deserves an Oscar. She has never been so good. I am not surprised that people have talked about the frankness of the dialogue – certainly the most 'adult' we have ever allowed in a non-continental film. But I thought the visuals were discreet enough. It is interesting to note that after most of the tricky scenes, i.e. the seduction of Susan, there were little touches of wry or ironical humour which made the audience chuckle and helped to remove any shock or offence which the audience might otherwise have felt. I only heard one lot of female gasps. That was when Wolfit referred to Signoret as 'that old whore'. This, I think, was partly due to the unexpectedness of the remark and partly because I think most of the women in the audience were so much in sympathy with Signoret's predicament ... The Board has done the right thing with this film. But I'm glad that we allowed the frankness and the visuals to go no further. How easy it would be if all tricky scripts were made by such a good technical team.

Not everybody, however, was enamoured of *Room at the Top*. When it came before the Commonwealth Film Censorship Board, for instance, the chief censor in Sydney wrote enquiring of the BBFC 'whether the version sent to Australia may possibly vary somewhat from that passed by your Board'. He queried several matters which had raised a few eyebrows among his members, including lines of dialogue which still remained in the film, such as 'You constipated bitch', 'You bastard, you bastard, you filthy rotten bastard', and 'I'll slit your bloody gizzard'.

Trevelyan affirmed that it was the same version and that the BBFC had allowed the lines. 'The dialogue in this film is admittedly strong', he continued, 'but the Board considered it was acceptable for the "X" category in a film that was clearly made with sincerity.' His concluding sentence, nevertheless, laid down an important caveat: 'Such dialogue would not necessarily be accepted in other films.' There were still limits to what would be permitted in 'new wave' cinema and they applied, principally though not exclusively, to 'language'. Given that British 'new wave' cinema was rooted in stage and literary adaptations for the most part, with only an occasional original screenplay in evidence, it is no surprise that this turned out to be a major cause of concern for the censors.

For all the reservations expressed by the Australian censors, Jack Clayton and John Trevelyan had every reason to feel pleased. *Room at the Top* was a box-office hit and revealed, according to most reviewers, that British 'adult' films had arrived. 'Whether they praised its realism, or condemned its sordid qualities', Arthur Marwick has pointed out, 'the critics were unanimous in recognising *Room at the Top* as something new and stunning in British film-making.' Among contemporary critics, for instance, Frank Jackson singled out the importance of the film's 'sincerity' (first advocated by Trevelyan, of course) when writing in *Reynolds' News* on 25 January 1959): 'At long last a British film which is truly adult. *Room at the Top* has an "X" certificate and deserves it – not for any cheap sensationalism but because it is an unblushingly frank portrayal of intimate human relationships.'

Trevelyan, for his part, shared in the praise for allowing the film but was credited most with settling an issue that had been paramount in BBFC thinking since the 'X' category was introduced and had long proved the source of much concern in relations with the industry – how best to promote British adult films of 'quality'. The criteria applied by Trevelyan to *Room at the Top* substantially set the parameters in this respect and helped, moreover, to determine the critical consensus that existed across the film industry when judging British 'quality' cinema thereafter.

Tony Aldgate

REFERENCES

Marwick, A. (1984) '*Room at the Top*, *Saturday Night and Sunday Morning*, and the "Cultural Revolution" in Britain', *Journal of Contemporary History*, 19, 1, 127–51.
Trevelyan, J. (1973) *What the Censor Saw*. London: Michael Joseph
Walker, A. (1974) *Hollywood, England: The British Film Industry in the Sixties*. London: Harrap.

TUNES OF GLORY

RONALD NEAME, UK, 1960

Ronald Neame's *Tunes of Glory* (1960) 'is one of the ten best films ever made', so Anthony Burgess was once informed by his companion in a lift at Claridge's. The companion in question was none other than Alfred Hitchcock, coincidentally Neame's mentor when he had entered the film industry as a young assistant cameraman on *Blackmail* (1929). It is hard to imagine a higher accolade, so it is curious that the film rarely finds a place in the established canon of great British films. In a poll conducted by the British Film Institute in 1999 to discover the hundred best British films of the century, *Tunes of Glory* was one of the most conspicuous absentees. In attempting to rehabilitate the stature of a film which seems to me a major achievement by any criteria, I would like also to suggest some reasons for its comparative critical neglect.

Based on the debut novel of James Kennaway, first published under the title of *Jock* in 1956, *Tunes of Glory* concerns a Scottish regiment in peace-time thrown into turmoil by the conflict that develops between its two senior officers, Jock Sinclair (Alec Guinness), a fiery Scot who has risen through the ranks, and the new Colonel who has replaced him, Basil Barrow (John Mills), an old Etonian who has progressed via Sandhurst and Oxford and whose grandfather had been a former head of the regiment. The social and national differences are exacerbated by a contrast of temperament and manner. Jock's boisterous style of leadership, where an alcohol-induced camaraderie has often substituted for discipline, now has to give way to a more gentlemanly but rigid regime. Things come to a head at a regimental cocktail party open to the local community, where the rowdy behaviour of Jock and his cronies rouses Barrow to an embarrassing explosion of rage before the assembled gathering. A more serious incident occurs later that evening, when Jock discovers his daughter Morag (Susannah York) in the pub with a young piper from the regiment (John Fraser) and angrily knocks him down. The offence warrants a court-martial. Should Barrow pursue the matter with the full rigour of the law, leaving himself open to the accusation that he has been motivated by personal malice? Or should he deal with the matter internally, preserving the name of the regiment through the avoidance of bad publicity, but perhaps giving the impression of capitulating to the wishes of Jock's supporters? The decision he makes will have tragic consequences.

During the early script stages, the film looked as if it were to be made at Ealing studios, with Michael Relph as producer and with Jack Hawkins in the role of Sinclair and Alec Guinness as Barrow. In a memo to the head of the studio, Sir Michael Balcon, Kenneth Tynan, who at that time was a script-reader for Ealing, expressed the view that Kennaway's first-draft screenplay had 'too much army-worship in it', a view also shared by the director Alexander Mackendrick, later to become a close friend of the writer. By the time Kennaway had made the necessary adjustments, Ealing had gone cold on the film and Hawkins had become unavailable, but the property had now been acquired by the independent producer, Colin Lesslie, who had interested John Mills in the project.

There are different accounts of how the leading roles were cast. Mills has said that he and Guinness tossed for it, whereas Guinness' recollection was that he was originally offered the role of Barrow but expressed a preference for Sinclair. Nowadays the casting seems so right that it is hard to imagine either of them in the other's role; and the critics have tended to be divided on the question of who was the victor in this acting 'duel'. 'If Mills is good for Guinness', commented Dick Richards in the *Daily Mirror* at the time, 'Guinness is certainly good for Mills,' punning neatly on the drink's famous advertising slogan but also reflecting a feeling that Mills might perhaps have shaded the contest (he was to win the *Films and Filming* vote for the year's best performance by an actor and also the best actor award at the 1960 Venice Film Festival). Guinness' preference for the role of Sinclair, I suspect, was due to his perception that Colonel Barrow might seem a little too close to his role as Colonel Nicholson in *The Bridge on the River Kwai* (David Lean, 1957), a performance for which he had won an Academy Award but which he had found extremely taxing. His Jock Sinclair seems in some ways an anti-Nicholson characterisation, Guinness revelling in the role of a man who is actively antagonistic to the idea of going by the book.

If Guinness' Sinclair seems an example of inspired casting against type, John Mills' Barrow is an equally imaginative example of casting within type. As Jeffrey Richards has shrewdly noted in *Films and British National Identity*, it is a mistake to see Mills' screen persona simply in terms of stiff-upper-lip restraint. Some of his most memorable screen moments occur precisely when this restraint breaks down and gives way to violent emotion. Richards cites his performance here and his role as the amnesiac struggling to retain his sanity in Roy Ward Baker's *The October Man* (1947) as exemplifications of that; and one could add, for example, his Pip in Lean's *Great Expectations* (1946), reduced to delirious collapse by the pressure of events, and most of all, his performance in J. Lee Thompson's *Ice Cold in Alex* (1958) as an officer whose

neurotic alcoholism sometimes endangers the whole mission. (Or, in comic vein, in *Tiara Tahiti* [Ted Kotcheff, 1962] as another misfit imploding with a sense of ill-usage.) In *Tunes of Glory*, the moment when he blows his top at the party is an electrifying display of emotional mania. In dramatic terms, it has been carefully prepared. We have seen already unexpected flashes of anger from him when his decisions have been queried: this is not a man at ease with himself or prepared to listen to others. Despite the advice of his adjutant Jimmy (Gordon Jackson) to deal with the matter after the party rather than make a public scene, he will not be restrained ('Don't argue with me!' he barks at Jimmy). The camera closes in on him as the noise swells and his anger rises, and Mills now pulls out all the stops: eyes wild and tearful, as if before them is his worst nightmare; hands clenched so tightly, you feel they could break glass; in particular, an uncontrollable twitching eyebrow, that here and later betokens an inner turmoil close to nervous breakdown. Ironically, the noise dips at precisely the moment when he is screaming at his loudest for the dancing to stop, so that his rage sounds across the civilities of the occasion with an even more hysterical edge, and allows Sinclair to respond with a mock innocence bordering on insolence: 'You called me, Colonel?'

In talking of this scene, Mills has said that he asked Neame if he would try and film it in one take. Before shooting had begun, Neame had promised him that if the actor produced a moment of magic, he would be sure to catch it. (In Brian McFarlane's *Autobiography of British Cinema*, Gordon Jackson attributed this confidence to his experience as a former stills man and cinematographer who knew exactly how to cover a scene and record it to the actor's advantage. When Maggie Smith was worrying about her performance in one of Neame's biggest successes, the 1969 film, *The Prime of Miss Jean Brodie*, Jackson could reassure her with this example.) In his 1981 memoir *Up in the Clouds, Gentlemen Please*, Mills pays tribute to Neame's work on the film, but oddly seems to think that this was his first film as director. It was, in fact, his ninth and indeed, at that time, he had made more films with Alec Guinness than any other director. It is a strange mistake, perhaps deriving from Mills' previous experience of working with Neame as producer of *Great Expectations*, but more particularly from the way his directing career has been upstaged by that of the more illustrious David Lean – a process painfully marked by their last working experience together on *The Passionate Friends* (1949), where Lean's wresting of the directing reins from Neame's grasp had left the latter in a state of near-suicidal despair.

Certainly Neame's work has been marked more by versatility than by self-expression. It encompasses the genial comedy of *The Card* (1952) and *The Horse's Mouth* (1958); the suspense of *Take My Life* (1947) and *The Odessa File* (1974); musicals such as *I Could Go on Singing* (1963)

and *Scrooge* (1970); disaster movies like *The Poseidon Adventure* (1972) and *Meteor* (1979); and much else besides. His confidence that he could be relied on to catch the best moments of his cast is certainly borne out in *Tunes of Glory*, where the acting in depth is outstanding: quite apart from Guinness and Mills, redoubtable performers of the calibre of Gordon Jackson, Dennis Price, Duncan Macrae and Allan Cuthbertson are as good as they have ever been on screen, whilst reliable supporting players such as Percy Herbert (as the punctilious Riddick) and Richard Leech (as Rattray, the truculent trouble-maker amongst Jock's crew) excel themselves, not to mention Susannah York making a glowing screen debut. A self-effacing stylist, Neame nevertheless is a consummate craftsman, and *Tunes of Glory* cannot be faulted for its pacing, its compositional sense, and its narrative flow. There is very little in the direction that draws attention to itself but there are any amount of small touches to cherish: Sinclair's first greeting of Barrow in a close-up that seems calculatedly intimidating, as if testing the mettle of the man; the way the camera records his throwing his whisky into the fire after the uncomfortable first conversation and the sudden flare of the flames, expressive both of Sinclair's anger and the sparks to come; the smooth fade from the comedy of the dancing practice in the parade square to the initial elegance of the dance itself at the party; the way Barrow tends to have his back to the action before moments of high drama as if needing to steel himself for confrontation; the low-angle shots of Barrow at times of dramatic crisis to suggest a character nervously staring into an abyss. Mainly the direction has that typical quality of British reserve. 'He resisted the temptation to show what a brilliant technician he was,' Mills wrote, 'his direction was smooth and unobtrusive; the highly dramatic scenes that Alec and I had to handle were therefore much more effective.'

Why, then, has the film fallen out of the frame when great British films are mentioned? Even at the time, it was only a modest commercial success, its military background perhaps unappealing after the recent ignominy of British military adventurism over Suez. The film's complex sympathies might also have dismayed both sides of its potential audience, for, if Kenneth Tynan had thought the early draft pro-Army, the War Office was wary of what it saw as its critique of military life, a sensitive issue at a time when the future of National Service was under review. (In the event, the War Office was less than totally co-operative, insisting that Irish rather than Scottish soldiers be used as extras and that no tartan worn could be identified with a particular regiment, and refusing to allow permission to film at Stirling Castle, which had to be reconstructed as a studio set.) In terms of film history, it came at an awkward time, too late to cash in on the popularity of 1950s films about the British forces (its post-war set-

ting and its downbeat tone put it slightly out of line, anyway) and being upstaged by the gritty working-class realism of the British New Wave, whose subject-matter and style made the traditional virtues of *Tunes of Glory* seem slightly old-fashioned. Jack Clayton's *Room at the Top* (1959) might have been set in the 1940s but it speaks very much to the changing values and attitudes of a decade later; *Tunes of Glory* is set in 1948 – very obliquely indicated in the film – but seems curiously out of time, with only Jock's bad language nudging it towards the era of anger and permissiveness. 'I daresay one is wrong by looking too hard for social reflections,' said Dilys Powell at the time. 'Lucky enough to find a film that has life in it.' But other critics were looking for social reflections, and some voiced reservations, particularly about the ending. It is appropriate, then, to return to the original material and the adaptation of it for the screen by the novel's author, James Kennaway.

At the time of his death in 1968 when only forty (he died of a heart attack while driving home from London after a meeting with Peter O'Toole about their forthcoming film collaboration, *Country Dance*), Kennaway had already established a considerable reputation as a novelist which has never diminished. Even after his death, his work continued to attract filmmakers, most notably his incomplete, posthumously published novel, *Silence* (1972) which Jack Clayton was particularly anxious to film: the last-minute cancellation of the project contributed to the director's suffering a serious stroke. (The unpublished draft screenplay by Michael Cristofer is one of the best film scripts I have ever read.) In ten years, he had also amassed significant writing experience for the cinema: he had worked on two films for Basil Dearden, *Violent Playground* (1958) and *The Mindbenders* (1963); collaborated with Alexander Mackendrick on an eventually aborted project on Mary Queen of Scots; done some work on Neame's *Mr Moses* (1965) and Michael Anderson's *The Shoes of the Fisherman* (1968); co-written Guy Hamilton's *Battle of Britain* (1969); and had even been offered the opportunity to write the screenplay for *The Birds* (1963), a further indication of Hitchcock's admiration of *Tunes of Glory*. For all the criticism of the film for what *Halliwell's Guide* calls its 'underdeveloped screenplay', it is this film for which Kennaway is principally remembered as a screenwriter and it was the screenplay which secured the film's only Academy Award nomination.

It is a fine example of skilled adaptation. While retaining the strengths of the original, notably the sharply-etched characters and lively dialogue, he markedly improved the dramatic structure. In the film, for example, the daughter's romantic involvement with Corporal Piper (John Fraser) is established at the outset rather than revealed in the middle of the narrative, as in the novel. One effect of this is to given an early frisson of irony and tension when Sinclair,

after the drunken evening that precedes Barrow's takeover, starts quizzing him about his love-life ('You got a lassie? Tell me, are your intentions strictly honourable?') Similarly, Jock's teasing of his best friend, Charlie Scott (Dennis Price) in the mess, when his fate is still in the balance, has more humour and tension in the film than in the novel, because here he has already learned of Charlie's treachery in supporting the idea of a court-martial. Even tiny details are sharpened. In the novel, Barrow puts himself immediately at odds with Sinclair by requesting a brandy and soda rather than the traditional whisky; in the film, he asks for a soft drink, and Sinclair invests the line, 'a lemonade for Colonel Barrow' with all the disdain he can muster.

Above all, whereas in the novel Barrow's suicide comes like a bolt from the blue, leaving the reader to guess at the ultimate motive, in the film his actions at this point are characterised with great care. He has gone to talk things over with Sinclair and stops off at the changing rooms to ask Sinclair's whereabouts; Simpson (Allan Cuthbertson) is deferential, whilst Rattray is typically rude, but what is most noticeable is the way Barrow hovers at the door after leaving the room to catch what they say: not the action of a confident man. In the confrontation with Sinclair, he tries to persuade him of how much the regiment means to him: 'I've eaten, slept and dreamt this regiment since my first toy soldier.' But such a disclosure only plays into Sinclair's hands: would not a court-martial bring dishonour upon the regiment Barrow loves? Curiously the novel never discloses the moment when Barrow gives way but, in the film, after Sinclair promises his loyalty, Barrow almost imperceptibly concedes the advantage. 'You mean you're not going to press charges?' Sinclair asks, for clarification. 'That's what I seem to have said,' Barrow responds, sounding for all the world like Conrad's Lord Jim after his ignoble jump from what he mistakenly thought was a sinking ship ('I had jumped, it seems'). After he has exited, Sinclair grins to himself and mutters, 'Toy soldier', a recollection of Barrow's earlier disclosure and also, one feels, Sinclair's estimate of the man. The dissolve from that to Barrow's face in the mess that evening, where he sits isolated from the others with the exception of Jimmy and with the raucous laughter sounding like a contemptuous rebuke, is truly painful. The eyebrow starts twitching; sound is subjectively distorted to suggest Barrow's unstable mind; even the click of the balls from the snooker room as he comes out of the mess seems to suggest something in him has snapped. A brief conversation with Charlie Scott only confirms his worst fears: the decision has been seen not as strength but weakness, not as evidence of his judgment but of Sinclair's will. Coming out of the snooker room, he pauses only to look up at the portrait of his grandfather to convince himself of how far he has fallen from the standards of his forbears, before going upstairs to kill himself. In the film, the stages by which this drastic action is taken

seem entirely plausible. One would not need to look very far in recent history to find a parallel case of a public servant taking his own life when a lapse in behaviour and the pressure under which he has been put has destroyed his sense of self-integrity, the guiding principle by which he has lived.

The final scene, where Sinclair orders a funeral for Barrow with full military honours, has been even more roundly criticised. For example, Terence Kelly in *Sight and Sound* (Winter 1960/61) called the ending 'inexcusable' and added: 'Neame and Guinness are not, to put it mildly, at their ease in portraying Sinclair's own mental breakdown, and the scene is far less one of tragic remorse than gauchely contrived emotionalism … the final message is seemingly the value of charitable loyalty, as the officers, repenting their treatment of Barrow, gently escort the weeping Sinclair home.' Far from sensing unease, I find it hard to imagine how Neame's visual and aural dramatisation of Kennaway's conception could be bettered, and it is on record that Guinness' performance on set of this scene was so powerful and poignant that it reduced his co-star, Gordon Jackson, to tears. Moreover, contrary to Kelly's assertion, there is no evidence that the other officers 'repent their treatment of Barrow': indeed, all of them seem to regard Sinclair's funeral plans as bizarre, out of scale and inappropriate. In the novel at this point, Kennaway writes: 'They had turned their eyes away from him, much as boys do when one of their number begins to cry.' In the film, as Sinclair seems to slip into a self-communing trance and is alone in hearing the tunes of glory inside his own head, the men desert him, filing quietly and unobserved out of the room. At the end, Sinclair's only listeners are the sentimental Jimmy, who was formerly Barrow's confidante, and the sly, saturnine Scott who, at crucial moments, has betrayed both his superiors. It is a hardly ringing endorsement, then, of this hollow gesture of regimental grandeur that seems designed less to honour Barrow than to assuage Sinclair's guilt; and the futility of it hits even Sinclair at the end, by now mad, unmanned and sobbing into his beret like a baby. If the two are 'gently escorting' Sinclair home, it should be remembered that the home he is returning to is now chilly and unwelcoming, bereft of a darling daughter whom he has utterly alienated. This is not my idea of a sentimental ending.

However, this is not to deny that there is something enigmatic about the ending and about the overall impression left by the film. One can certainly empathise with its observations on what can happen in any organisation when a new broom is sent in to sweep away old habits. It also makes shrewd and interesting points about contesting masculinities. This occurs at every level of the characterisation, though being seen with particular intensity in the rivalry between Sinclair and Barrow. There is rugged Scot versus regular Englishman but, on a deeper

level, much is made of the difference of their war experiences: while Sinclair was performing heroically at El Alamein, Barrow was being tortured as a prisoner of war, an experience that might well have broken his spirit even before his traumatic term as Colonel. It can also be seen in their private lives: Sinclair has a daughter and a racy relationship with the actress Mary (Kay Walsh), whereas Barrow is left to muse morosely on his loneliness and confide to Jimmy about his failed marriage, a melancholy confession amplified discreetly by the mournful wail of a train whistle in the distance. Yet Sinclair sulks when cross, mimics his superiors, plays naughty, disobedient games: there is a sense in both of arrested development, of men who, at their core, have remained either 'old *boys*' (a recurrent refrain) or '*toy* soldiers'.

But what is the core of their antagonism? They are polar opposites, but why does one sense, almost from their first meeting, that they seem destined to be the nemesis of each other? I think there is something Conradian in this confrontation, as if, in looking at their ostensible opposite, they see something they fear in themselves. Sinclair compels Barrow fatally to confront his own weakness and it is an image of himself he literally cannot live with. More unexpectedly, Barrow compels Sinclair to confront the uncouth excesses of his own nature that just occasionally appals the tolerant Jimmy, disgusts the cynical Scott, and will drive his daughter away from him, perhaps permanently. Even as he professes to despise Barrow, there is a side to him he secretly envies, subtly disclosed in that overwhelming final scene when, for the first time, he even starts speaking like him ('Colonel … I prefer to be addressed as Colonel').

If the conflict is so keenly felt, the reason might be that Kennaway was working out a similar tension in his own personality, indicated in the very title of the book about him, *James and Jim* by his biographer, Trevor Royle. The conflict, according to Royle, was between man and artist, wild boy and introvert: in other words, the Jock and Barrow sides of his own personality. While the film can be appreciated as an enthralling human drama in which two great actors thrillingly lock horns, one could also see it in more universal terms as one of the screen's most satisfying treatments of the eternal struggle between the Apollonian and Dionysiac sides of the human psyche.

Neil Sinyard

REFERENCES

Kennaway, J. (1956) *Tunes of Glory*. London: Puttnam.

McFarlane, B. (1997) *An Autobiography of British Cinema as Told by the Filmmakers and Actors*

Who Made It. London: Methuen/British Film Institute.

Mills, J. (1981) *Up in the Clouds, Gentlemen Please*. London: Penguin.

Neame, R. (2003) *Straight from the Horse's Mouth: An Autobiography*. New York; Scarecrow Press.

Richards, J. (1997) *Films and British National Identity*. Manchester: Manchester University Press.

Royle, Trevor (1983) *James and Jim: A Biography of James Kennaway*. Edinburgh: Mainstream Publishing.

NO LOVE FOR JOHNNIE

RALPH THOMAS, UK, 1961

When Wilfred Fienburgh, the sitting MP for North Islington, died in a car crash in February 1958, he left behind the manuscript of a novel he had been working on. *No Love for Johnnie*, published posthumously in 1959, provided a startling insight into contemporary political life, and more specifically, the creeping malaise in Fienburgh's own Labour Party. The novel begins with the train of thought of its protagonist, 42-year-old up-and-coming Labour MP Johnnie Byrne, upon pulling into a Northern railway station for a party fundraiser: 'I wish I were a hundred miles away from this railway carriage, thought the Member of Parliament. The speech I am going to make is stuck in the back of my throat, I am choked by the dry dust of a thousand speeches. I am weary of words and hand-shaking and smiling at people and screwing myself up to mouth platitudes. There is nothing new to say. The whole damned business is as mechanical and meaningless as a formal tribal dance. I am body-sick and mind-sick of the whole bloody business.' After opening with his jaded dismissal of shameless politicking, *No Love for Johnnie* goes on to explore in more detail precisely what has caused Johnnie to feel so despondent. We soon discover that he has come to an uncomfortable juncture in his career. He has not been offered a job in the newly-elected Labour government, as he had expected, and is deeply wounded by his omission. Reeling from the blow to his (considerable) ego, he tries to repair the damage by opportunistically joining an extreme left splinter group (described by one of his colleagues as the 'revolution-by-Wednesday brigade') whose aim is to discredit the new Prime Minister.

In Johnnie's private life, things are equally turbulent: Alice, his wife of twenty years, has just left him, citing her disgust at his narcissism and wavering commitment to socialist principles as the spur. After a short tryst with Mary, the girl who lives upstairs and is infatuated with him, he meets a pretty young model called Pauline at a party and begins a serious relationship with her. The two halves of Johnnie's life, the personal and the professional, come into direct conflict when he should be making a vital speech against the Prime Minister in the Commons but instead decides to foreswear left-wing agitation to stay in bed with his new lover. However, their romantic idyll is brief because Pauline soon breaks off the affair, disquieted by the age gap

between them and Johnnie's lack of interest in having a family. Shortly afterwards, Alice offers Johnnie a reconciliation, and having exhausted all other romantic options, he decides to go back to her. However, at this point, the Prime Minister offers Johnnie his longed-for ministerial post, informing him that the only reason there had been no offer previously was Alice's involvement with the Communist Party: now the couple are estranged, there is no bar to Johnnie's promotion. Given a final choice between political advancement and personal fulfilment, Johnnie opts for his career over his wife, and the novel closes on a bleak note as the ruthlessly ambitious MP tears up his wife's telephone number and makes himself comfortable on the front bench: 'He was one of them, now, one with Fox, Pitt, Gladstone, Disraeli, Lloyd George, Churchill, sitting as they had sat, indolently, idly listening, his feet on the table of the House. It was a natural and inevitable position to assume ... For this brief segment of time John Roderick Byrne, MP, Assistant Postmaster-General, was happy. At long, long last he was content.'

Tony Benn, a young Labour MP at the time, noted in his diary that *No Love for Johnnie* was the subject of 'long and bitter discussion in the Smoking room' of the House, as well as much speculation about who the character of Johnnie Byrne might be based upon (one of the frontrunners was future Prime Minister Jim Callaghan). However, some were not able to shrug it off as harmless fodder for the Westminster gossip machine. In his column for the *Daily Mirror*, senior Labour politician Richard Crossman argued that its 'nauseating caricature of Labour politics' would serve as 'a windfall for the Tories' and guessed that if Wilfred Fienburgh 'had survived to see the earnings of his pen coming to look uncommonly like the thirty pieces of silver, he would have bitterly lamented his success'. Privately, Crossman noted with dismay that not only was *No Love for Johnnie* being serialised in the *Evening Standard*, but 'the BBC has bought television rights and I think we can assume it will be filmed as well'. The next year, Crossman's worst fears were to come true as *No Love for Johnnie* went into production for the Rank Organisation, with a screenplay by Nicholas Phipps and Mordecai Richler that adhered very closely to the structure of Fienburgh's novel. The lead role of Johnnie Byrne would be played by Peter Finch, fresh from his BAFTA-winning performance as the eponymous wit in *The Trials of Oscar Wilde* (Ken Hughes, 1960). Mary Peach ('and that is her real name', stated the publicity material for the film somewhat unctuously) would play the object of Johnnie's affections, Pauline, while Rosalie Crutchley and Billie Whitelaw would play the other women in his life, Alice and Mary. Meanwhile, the rich and varied world of Westminster would be peopled by an impressive roster of familiar British character actors, among their number Stanley Holloway, Geoffrey Keen, Donald Pleasence and Paul Rogers.

No Love for Johnnie was brought to the screen under the aegis of Betty E. Box and Ralph Thomas, the most durable and consistently successful producer/director partnership in the history of British cinema, who made over thirty films together over a 25-year period. The team had many box-office hits but were probably best known for their immensely popular medical comedy *Doctor in the House* (1954) and the equally successful series it subsequently gave rise to. The popularity of the *Doctor* films might easily have pigeon-holed Box and Thomas, and as Betty Box later recounted, 'every time we took a new script to Rank, they said, "Oh make another *Doctor*". It got very boring.' However, it was the reliable (and very large) income generated by the *Doctor* films, and the fact that Box and Thomas were the keepers of the goose that laid the golden eggs, that actually enabled them to make more varied films. They cleverly used their commercial clout as a way of negotiating with Rank to make the films that they wanted to make, on the proviso that they would produce another *Doctor* film now and again. As Ralph Thomas baldly put it: 'We used to make them as a bribe.' It was this arrangement that enabled them to make more personal or risky projects such as their thoughtful adaptation of Dickens' *A Tale of Two Cities* (1958) and the moving wartime drama about an Italian convent harbouring Jewish refugee children, *Conspiracy of Hearts* (1960), which actually became one of the most successful films of its year.

Yet, even given their special arrangement with Rank, Betty Box was surprised when she and Thomas were permitted to go ahead with *No Love for Johnnie*. Politics had not often been the subject of British films, being generally regarded as box-office anathema. There had been biopics of revered Prime Ministers such as Disraeli and Pitt the Younger, and a film scripted by Betty Box's sister-in-law Muriel, *The Years Between* (Compton Bennett, 1946), had used Commons life as the backdrop for feminist melodrama, but the more usual approach to the depiction of any kind of party political activity was to use it as a source of humour, from the knockabout comedy of *Old Mother Riley MP* (Oswald Mitchell, 1939) to the frisky satire of *The Chiltern Hundreds* (John Paddy Carstairs, 1949) – in which an elderly Earl resigns from his parliamentary seat to find that his son is standing as the Labour candidate and his butler as the Tory - or *Left, Right and Centre* (Sidney Gilliat, 1959) – in which candidates from opposing parties fall in love and overcome their ideological differences. In subsequent years, and through the newer medium of television, serious studies of the troubled soul of the Westminster Left would be more frequent, from Dennis Potter's *Vote Vote Vote for Nigel Barton* (1965) to Trevor Griffiths' 1976 series about lecturer-turned-MP *Bill Brand*. But when *No Love for Johnnie* was being made, the last film to take a Labour politician seriously had been *Fame is the Spur*

(Roy Boulting, 1947), a thinly-disguised portrait of the first Labour Prime Minister, Ramsay Macdonald. In fact, the two films have a lot in common: both focus on socialist politicians who have allowed their commitment to the cause to be compromised by their pursuit of personal glory. Both also locate an authentic Labour politics firmly in the past, although, interestingly, they use different historical moments to denote their golden ages (Peterloo and Chartist riots of the nineteenth century for *Fame is the Spur*; conscientious objectors and suffragettes of the Edwardian period for *No Love for Johnnie*), implying that a sense of inexorable decline, a feeling that an age of guts and glory has forever vanished, to be replaced only by milksops and turncoats, has perhaps less to do with historical reality than it has to do with the psychopathology of the Labour movement. It is symptomatic that the only truly honourable Labour MP in *No Love for Johnnie*, who was 'just good … never heard him say a malicious word about anyone' according to the Prime Minister, is one that we never actually meet and who only has six months to live.

Otherwise, Labour is evidently racked by what might be described nowadays as 'authenticity issues', with frequently-voiced complaints against 'toffee-nosed lawyers and university lecturers' taking over the party and Johnnie having to defend himself against accusations of embourgeoisement from the ill-tempered Welsh veteran Charlie Young (Mervyn Johns): 'My family was as working class as yours … it's twenty years since you've done an honest day's work at the bench.' The film nicely evokes a parliamentary milieu which is half clubby congeniality and half Darwinian brutality: even during the new Prime Minister's first address to his MPs, even while they laugh at his jokes and sing 'For he's a jolly good fellow', we can see the subtle nods and winks that signify the formation of the splinter group to bring him down. Perhaps it is the portrayal of the Labour Party as a scheming bunch of backstabbers that allowed *No Love for Johnnie* to come to the screen. Betty Box later speculated that the film was only made because the dissolute politician concerned was Labour and not Conservative, a distinction that the right-wing boss of the Rank Organisation, John Davis, heartily approved of. Raymond Durgnat perceived a form of sly 'pro-Conservative propaganda' at work in the film, drawing particular attention to a scene in which a Tory MP makes an impassioned plea on behalf of the beleaguered fishing industry while the Labour members are 'smugly indifferent to the issue of the debate, delighted with their personal pre-eminence'. However, Betty Box's former membership of the Communist Party and involvement with the Unity Theatre slightly complicates the notion that the film was inevitably a slur on the Left from the Right.

Even so, Johnnie Byrne comes to stand as the incarnation of a 'new Labour' party which is Machiavellian and media-savvy, and the film manages to make some neat comments on

the imbalance of image and substance in mid-twentieth-century politics at his expense. For instance, Johnnie is drinking at a bar when the political interview he had recorded earlier that day suddenly comes on the television behind the counter. Some of the punters stop to gaze up briefly, taking some notice (albeit grudgingly) of what he has to say but utterly failing to notice that the real man who made those comments is no more than a few feet away from them. Evidently the physical self pales in comparison with the phantom self projected through the modern media. The growing importance of personality politics is suggested in a telling exchange with a photographer (played by a reliably waspish Dennis Price) who Johnnie encounters when he pursues Pauline to one of her modelling assignments. The photographer mistakes handsome, mature, distinguished-looking Johnnie for the model in a whisky advert he is about to shoot, and tells him that if he ever wants an alternative career he would be 'a good type for middle-aged men of the world'. The spheres of politics and modelling, which should by rights be diametrically opposed, have edged ever closer, as policies appear less important than the ability to look charismatic on a poster.

Aside from its political subject matter, *No Love for Johnnie* was a departure from the usual run of Rank productions in another way: it was to be the company's first 'X' certificate film. It fell into this category because of its steamy love scenes, quaintly described as 'torrid mattress capers' by *Kine Weekly* (19 January 1961), as well as a visit to a prostitute, the presentation of a striptease and some moderate swearing. The Rank Organisation had hitherto held out against the rise of more adult-orientated cinema in favour of a commitment to providing wholesome 'family entertainment', a decision mainly motivated by J. Arthur Rank's strong religious convictions. However, by the early 1960s this policy was becoming increasingly difficult to sustain. As Ralph Thomas said in 1966, 'What once appealed no longer appeals. Tastes change. They change overnight and the filmmaker must be one jump ahead, ready to cater for that change.' *No Love for Johnnie* therefore marks a decisive moment in British film history when even the most conservative elements of the industry had to acknowledge a growing permissiveness in society and concomitant changes in audience preferences; when, according to Vincent Porter's formulation, Rank's Methodism had to give way to the demands of the marketplace. The film's publicity material reveals a slight ambiguity about moving into 'X' territory, rather over-emphatically insisting that 'although there is an "X" certificate, this is a strong human drama that can't help but appeal to all your adult patrons'. Nonetheless, Rank seem equally determined to make the most of the cachet the 'X' bestows: the film's pressbook has a special section entitled 'X-ploiting the "X"' which suggests using the slogan 'X-tremely

X-citing X-ceptionally X-clusive entertainment' to publicise the film – hardly hiding its light under a bushel.

No Love for Johnnie might be considered as Rank's reaction to the success of the British New Wave, and its own attempt to make a film in that style: it was compared variously in reviews to *Room at the Top* (Jack Clayton, 1959) and *Saturday Night and Sunday Morning* (Karel Reisz, 1960). However, *No Love for Johnnie* differs from them in dealing with the moral and sexual progress of a Northern male protagonist who is in his forties, rather than in his twenties like Joe Lampton or Arthur Seaton. Johnnie belongs to a different generation, and comes from a more puritanical background, and both factors affect his behaviour. Although William Whitebait described Johnnie in the *New Statesman* (17 February 1961) as a lothario 'for whom bed is what bricklaying was to Churchill', the character is not sexually liberated in the manner of the New Wave roaring boys. Rather, his sensuous impulses are only just beginning to surface after long repression throughout an ascetic upbringing dominated by 'Moses in the bulrushes on Sunday, politics the rest of the time' and early marriage to a childhood sweetheart who has never shown any sexual interest in him: '42 and never been kissed' is how he describes himself in the novel. As Robert Murphy puts it, there is 'an appalling vulnerability beneath the polished exterior' in Johnnie that is partly due to his professional anxieties but also due to personal insecurity. One of the leitmotifs of his relationship with Pauline is her frequent encouragement to him to take off his jacket or remove his tie, as if sensing how far Johnnie uses his image as respectable pillar of the community as a shield to hide behind. It may be a little far-fetched but one might see in the progress of Johnnie from former Methodist Sunday School teacher to *homme moyen sensual* a fitting metaphor for the changes occurring in the Rank Organisation at this time, as it eschewed its founder's moral convictions in favour of a more liberal attitude to filmmaking.

Throughout the film, we are told that Johnnie Byrne is 'the most unmitigated, grasping and self-important bastard I have ever met in a lifetime's politics' (the words of the Prime Minister's Private Secretary), but the harsh appraisal never quite seems to fit the character, and this is undoubtedly because of the decidedly sympathetic performance of Peter Finch as Johnnie. Finch is an interesting figure in the landscape of post-war British cinema; superficially quite similar to such sturdy British chaps as Jack Hawkins, Richard Todd, John Gregson and Kenneth More, while standing at one remove from their brand of s(t)olid masculinity. His looks were an interesting combination of ruggedness and delicacy: his friend, novelist George Johnston, described Finch's face as 'young-old eroded' with 'sharp deep-set eyes and gaunt cheekbones' topped off with a 'spiky tangle of hair', but he also noted the voluptuous mouth that dominated

his features and that Finch's biographer Trader Faulkner described as 'large [and] sensual ... like a tulip'. His difference from his peers in 1950s British cinema came partly by virtue of his 'Australian-ness' (although he was actually British by birth, he had spent most of his formative years in Australia), underlined by his frequent essaying of Australian roles in films like *A Town Like Alice* (Jack Lee, 1956) and *The Shiralee* (Leslie Norman, 1957). But perhaps it also derived from the fact that he was given the chance to play more complex, haunted characters than the 'chaps' were usually permitted: although the likes of Hawkins and More have more depth than they are usually given credit for, it is impossible to imagine any of them convincing as Oscar Wilde in the same way as Finch. In *The Battle of the River Plate* (Michael Powell/Emeric Pressburger, 1956), he is superb as the doomed introspective Captain Langsdorff who prefers suicide to the ignominy of defeat, and in the underrated *Passage Home* (Roy Ward Baker, 1955) his ironically-named character Lucky Ryland is a thoroughly absorbing portrayal of a formerly upright man collapsing into alcoholism and sexual obsession. Although he is probably best known for winning a posthumous Academy Award for his role in the extravagant American media satire *Network* (Sidney Lumet, 1977), as the unhinged newscaster urging viewers to stick their heads out of window and scream 'I'm as mad as hell and I'm not going to take this anymore!', it was in British films that he did almost all his best work. He achieved the unique accolade of winning the BAFTA for Best Actor four times, the third time being for his role in *No Love for Johnnie*.

Elaine Dundy argues that Finch 'plays Johnnie full out, revealing rather than concealing, with the result that there is something ingenuous, even sympathetic about the transparent but strenuous conniving Johnnie goes in for to keep on the right side of the power factions in Parliament, regardless of what the issues are'. Crucially, his performance steers the film away from being solely about political ambition and allows us to see that Johnnie's endless striving is a symptom of the character's personal torment, or more specifically, a warped and frustrated yearning for love. He is supremely touching in his scenes with Mary Peach, as the character's reserve and bombast start to drop away and something closer to the real Johnnie emerges for the first time. He confesses to her how difficult it was to lose his Yorkshire accent: 'I worked hard to kill it ... For six months in the mess all I said was "Pass the marmalade, please".' Finch also uses a particular facial expression to suggest Johnnie's deepening love and the charlatan's surprise at the sudden unexpected authenticity of his feelings: a gentle smile accompanied by a slight raise of the eyebrows, summarised by Dundy as 'a spontaneous click that registers his instant recognition of what he was later to call "human frailty", glimpsed either in himself or

in others'. It is a smile he uses to great effect throughout his career: it occurs as he talks direct to camera about his failed love affair in *Sunday Bloody Sunday* (John Schlesinger, 1971); it appears after he has announced that he will blow out his brains live on TV in *Network*. The character of Johnnie also fits into an emerging pattern in Finch's career; that of playing men who fall in love with someone significantly younger than themselves, and who suffer because of the experience, as in early films such as *Passage Home* and *The Trials of Oscar Wilde*, as well as later films such as *Girl with Green Eyes* (Desmond Davis, 1963), *Far From the Madding Crowd* (John Schlesinger, 1967) and *Sunday Bloody Sunday*. In each role, he brings exactly the right combination of romantic self-deception and rueful realism to his characterisation of someone falling in love despite his better judgement.

The characterisation of Johnnie Byrne is structured around the duality of outward confidence and inward fear, and this is explored most fully when Johnnie is threatened with a vote of no confidence from his constituency party who think he spends too much time on television and has become 'too big for his boots'. He hurries back up to his Northern seat to try and placate the members, but with little success. His jokes fall flat as the camera slowly pans across the deadpan faces of the crowd gathered in the shabby committee room who finally decide to give him a second chance. Johnnie attempts to give a gracious speech of thanks but is overwhelmed by nausea and has to rush to the lavatory to be sick – ironic in view of the fact that his first piece of advice to a new MP had been to find the Commons' lavatories. So intense is Johnnie's horror at his countrymen's rejection of him that the expression it takes is violently visceral. In this scene, more than any other in the film, we witness the power of 'the return of the repressed', in the shape of Johnnie's humble origins coming back to haunt him.

No Love for Johnnie suggests that its hero is a man who has sublimated his need for human warmth into his political ambitions to such an extent that he is no longer able to recognise the difference between love and self-aggrandisement. There is a chilling moment earlier in the film when he leaves a restaurant with Pauline on his arm and catches sight of the pair of them in a series of mirrored tiles that run along the wall. He pauses to contemplate the image before remarking that they make a 'handsome couple'. Even now, when he is supposed to be hopelessly in love, it seems that the image-conscious politician has not quite departed. It prompts us to wonder how far Johnnie's love for Pauline is predicated on the fact that having an attractive young model on his arm makes him look good. As Johnnie surveys the image of the 'handsome couple', so does the film's audience, but we notice that this supposedly perfect image is actually fragmented, broken up by the distorting divisions between the tiles, perhaps

presaging how the couple's unity will founder on his vanity and solipsism. This scene is part of a whole pattern of mirror imagery throughout the film that is used, along with television images and political posters, to suggest a man permanently at one remove from himself. At his lowest ebb, after having been abandoned by Pauline and upbraided by his constituents, Johnnie makes an unsuccessful pass at Mary, and when she rejects him, he clings on to her and begins to weep uncontrollably. 'Nobody wants me. There's nobody anywhere', he sobs desperately, but the rest of his sentence, significantly, is unclear, muffled by Mary's body. Does he say 'I just wanted to be someone' or 'I just wanted to be with someone'? It hardly matters: for Johnnie, the two have become tragically interchangeable.

No Love for Johnnie had its West End première on 9 February 1961, followed by a party at the Dorchester Hotel to celebrate Ralph Thomas and Betty Box's eighteenth collaboration. The film received warm, though not ecstatic, reviews (although Dilys Powell in the *Sunday Times* described it as 'a film which does us credit' and Alan Dent in the *Sunday Telegraph* found it 'practically flawless') but excellent reviews in the trade papers *Kine Weekly* and *The Daily Cinema* which called it 'box-office dynamite' and 'an outstanding bet'. However, it did not perform as well as predicted, and one wonders if the reason was the implausibility of the film's central situation – an illicit love affair between a senior politician and a young model. However, just a few months after *No Love for Johnnie* hit the screens, war minister John Profumo would encounter Christine Keeler for the first time, naked beside the swimming pool at Cliveden, and the stuff of fiction would become incontrovertible fact.

Melanie Williams

REFERENCES

Box, B. (2000) *Lifting the Lid*. Sussex: The Book Guild.

Dixon, W. W. (1996) 'Interview with Ralph Thomas', *Classic Images*, 249, 34–43.

Dundy, E. (1980) *Finch, Bloody Finch: A Biography of Peter Finch*. London: Michael Joseph.

Durgnat, R. (1970) *A Mirror for England: British Movies from Austerity to Affluence*. London: Faber and Faber.

Faulkner, T. (1979) *Peter Finch: A Biography*. London: Angus & Robertson

Murphy, R. (1992) *Sixties British Cinema*. London: British Film Institute.

Porter, V. (1997) 'Methodism versus the Marketplace: The Rank Organisation and British Cinema', in R. Murphy (ed.) *The British Cinema Book*. London: British Film Institute.

80,000 SUSPECTS

VAL GUEST, UK, 1963

In October 1960 the British magazine *Films and Filming* published an article by Val Guest, the prolific producer, director, scriptwriter, ex-actor and ex-journalist. In it, he recounts how in 1953 he gave himself five years to become financially viable in the film industry. He recalls that, in 1958, having succeeded in this task, he decided to 'stop "playing safe" and take a few chances'. The first film of this change of tack was *Yesterday's Enemy* (1959) and its success convinced him that he could 'now make pictures the way I felt I should make them'. In a later interview, Guest cited *The Day the Earth Caught Fire* (1961) as 'my favourite' and added two other films of this newfound freedom, *Expresso Bongo* (1959) and *Jigsaw* (1962) along with *Yesterday's Enemy* to the list of those films he particularly liked. *Hell is a City* (1959) was another film he was proud of. However one looks at it, the period 1958–64, the period best known now for the cinema of the British New Wave, was an extremely productive one for Guest and in it he made a number of films which look back to the ethos and assumptions of the 1950s with a sensibility which is beginning to feel like that of the 1960s.

80,000 Suspects, released in September 1963, came towards the end of the period. Guest's screenplay, based on Elleston Trevor's book, *The Pillars of Midnight*, deals with the outbreak of an epidemic of smallpox brought to Bath by a ship steward on holiday from the 'Indian run'. The film deals with the battle to contain the disease by health and local government professionals and meticulously records the complex plan drawn up and implemented – the tracing procedures, the inoculation queues, the isolation and disinfection practices – as well as the physical and mental strain all this places on those involved. At the same time, the film examines the crisis in the marriage of one of the doctors, Steven Monks and his wife Julie, an ex-nurse who responds to the call for volunteer helpers and catches smallpox herself. Their marriage is clearly under strain and it emerges that Steven has had a brief affair with the sexually promiscuous Ruth, the wife of his dedicated colleague, Clifford. Steven and Julie move tentatively to a resolution which will allow them to stay together but the climax of the film is provided by Ruth. As the authorities bring the smallpox under control, they are alarmed when a new carrier is identified outside the city. It turns out to be Ruth, who, in order to prevent further transmission

of the disease, isolates herself in an abandoned hotel. A desperate call to Steven to say goodbye brings the authorities but the hotel has already caught fire and Ruth is killed.

The film was made in black-and-white CinemaScope, with impressive location photography by Arthur Grant who had worked with Guest on *Hell is a City* and *Jigsaw*. The main parts of Steven and Julie were played by Richard Johnson and Claire Bloom, with Guest's wife, Yolande Donlan, taking the role of Ruth. A strong supporting cast included Mervyn Johns as Buckridge; Cyril Cusack as the priest, Father Maguire, who tries to help the marital couple; Michael Goodlife as the saintly Clifford and Kay Walsh as a formidable Matron. The film's press book highlighted acting as one of the attractions of the film emphasising the theatrical pedigree of Johnson and Bloom and a change of role for Donlan who had previously played lighter comedy roles. Johnson had indeed worked largely with the Royal Shakespeare Company in the 1950s but had television experience and a Hollywood film, *Never So Few* (John Sturges, 1959) behind him. In interviews, he explained frankly that he was moving into films to make money and he established an image in the 1960s of a debonair man about town with a string of wives and girl-friends. Claire Bloom, who had made her name as Juliet for the Royal Shakespeare Company in 1952, was also an experienced film actress whose films included *Limelight* (Charlie Chaplin, 1952), *The Man Between* (Carol Reed, 1953) and *Look Back in Anger* (Tony Richardson, 1959). In a 1962 interview, she expressed frustration about the kinds of roles she was offered in the 1950s: 'The only parts I was ever offered were WREN officers. And then for a long time it was Biblical roles.' As an English actress in Hollywood, she added, she was cast as 'a lady' though *The Chapman Report* (George Cukor, 1962), based on a notorious study of sexual behaviour, gave her the chance to break away from that type. Bloom thus brought to *80,000 Suspects* the mark of quality associated with British theatre but with glamour sufficient to make her one of the stars featured in the long-running Lux soap advertisements.

The trade paper *Kinematograph Weekly* was moderately hopeful about what it described as a 'personal drama seething through a documentary record of a smallpox outbreak'. It felt that the film lacked 'really big star names' but might get by on the established popularity of 'hospital and medical ingredients'. It commented though on the lack of unity between the 'two branches of the drama'. Raymond Durgnat argued in *Films and Filming* (September 1963) that the melodramatic elements of the plot, particularly the finale which 'would seem pure Lyceum on paper', had been made to seem 'quietly real', but the *Monthly Film Bulletin* (September 1963) felt the reverse and commented that 'a veneer of authenticity … is effectively smothered by the collection of appallingly stock characters and situations'. *Variety* (August 1963) also suggested

that 'the documentary and fictional elements do not entirely jell' but praised the film for a 'a professional know-how that rarely flags'. The film in fact proved a failure at the box office and did worse than any other film on the Odeon circuit that year.

In analysing *80,000 Suspects*, I want to focus on the generally recognised interaction of melodrama and documentary which framed the initial response and has been picked up on by later critics like Robert Murphy who argues that the film combined 'an almost documentary interest in the attempts to control the epidemic' with 'a highly-wrought melodrama about a doctor … his disillusioned wife … and ex-mistress'. I want to suggest that the division between them is not so simple (epidemic equals documentary, marital discord equals melodrama) and that the film also provides a documentary-style analysis of its central relationship, the marriage of Steven and Julie. In doing so, it puts on screen an unusually uncomfortable depiction of middle-class, married love, which, while it may be one of the reasons for its commercial failure, may also indicate something about attitudes to sex and marriage in the society in which it was made.

This is not to say that the documentary element is not extremely strong in the handling of the smallpox situation. Guest was committed to this approach in films more usually thought of as fantasy; he recalled that he had agreed to do *The Quatermass Experiment* (1955) on condition that he could 'shoot it as a newsreel – as though *Panorama* had told me to go out and cover the story'. For the crime thriller, *Hell is a City*, he had tried for 'newsreel qualities' and 'documentary touches' and applied the same approach to *The Day the Earth Caught Fire*, with critical and commercial success. So this was an approach that appealed to Guest and was highly appropriate to the social problem element of *80,000 Suspects*. Some of the most striking and moving shots in the film are images created through setting the drama in locations which have a lived reality and history: the cold breath and white steam on a cold New Year's Eve in the Roman baths; the façade of a medieval church with pigeons flying across; the fires burning in braziers at night as if the plague had indeed returned; the mass of people in the queues for inoculation recalling wartime hardships; the army lorries, bulky and out of place in the historic town and in the countryside around, a contrast recalling the tropes of wartime cinema; the piles of snow pushed up on the roadsides, a temporary nuisance in the face of greater hardship represented by the ambulances driving through. In such images, we can see not only the 'original (or native) scene' which John Grierson commended but also something of André Bazin's sense of the stubborn 'concrete density' of reality. Such images work because they have a specific sense of place which grounds the plot and because their use draws unpretentiously on a tradition in British

filmmaking of invoking experiences embedded in the fabric of national history. Guest has gone some way to fulfilling Grierson's dictat that documentary 'must master its material on the spot, and come in intimacy to ordering it'.

That ordering goes beyond the use of 'raw' material in a fiction film. Raymond Durgnat's review, linking the film to the traditions of John Grierson and Free Cinema, argued that it succeeded where the documentarists had failed in depicting 'a sense of society' in which people find 'a modest, real dignity' in helping others. In the response to the epidemic, Guest carries out the Griersonian function of showing British civil society, in all its complexity and detail, to the people it is meant to serve. In this case, it is the intermeshing of the police, hospital services and local authority health services which is exposed to the audience offering the health inspector as the unlikely hero, the public servant as defender of our care. What seems to be an impossible task – the tracing out of the contacts and carriers among the 80,000 suspects whom Davis might have met – gradually becomes a matter of names, lists, checks and procedures efficiently mapped out in meetings between the Town Clerk and the Medical Officer of Health, the Chief Health Inspector and the newspaper editor. Although the strain shows, these local government authorities remain in control – the army and police, and indeed the media, take on tasks as directed. In a film which visually emphasises locality and place, local civic order is tested but not broken.

A similar sense of detail and procedure can be seen inside the hospital. Steven's identification of the first case, after visiting the patient on New Year's Eve at Clifford's request, leads into scenes which lay out the disinfection procedure which Steven must undergo in order to leave and the isolation process which will now apply to the staff and patients in the hospital. It is, again, not a question of improvising in the face of the unknown but putting pre-existing plans into order. The importance of this routine implementation of preventative measures is reinforced at the end of the film by Matron's insistence on procedures. Almost inevitably, the role of Matron is accompanied by the kind of jokes and complaints which were the mainstay of many hospital comedies but, in this instance, Matron's control is essential. In her fever, Julie wants to rebel against Matron but admits that she admires her. 'I admire competent people' she mutters, a sentiment the film, in its public service mode, endorses.

But the hospital is a more complex place than the town hall because it is also a space in which personal relationships are made and tested. At first glance, personal relationships in the hospital are subject to the demands of public order. Job roles have a specific place in a hierarchy, with porters and attendants acting almost as servants for the consultants, paying off waiting

taxis and running the shower in the disinfectant room. The working-class characters feature only as patients: the initial victim and the original carrier come from a working-class family. Gender relations appear also to be firmly controlled with the female nurses and sisters attending on and supporting the male doctor; the nurses are professionals in their own right but in an established order. Even Matron's bossiness towards Steven occurs when he is in his role as patient's husband rather than consultant and it is significant that Julie left her job as nurse in the hospital when she married Steven and took on a different role as his wife.

The organisation of the hospital is thus laid out in the documentary mode of the film as a place where dedicated professionals care for the citizens of the welfare state. But the hospital can be understood rather differently as an institution which makes too many demands on the personal lives of its employees. As Julie points out in the first scene, it is the place where she and Steven first met, indicating a barrier which has been breached and might be so again. Ruth blames the hospital for keeping Clifford away from her, redefining his dedication as a fastidious refusal to get involved in his marriage. It is stressed also that Steven has been working too hard there; hence the planned holiday which is in fact prevented by the epidemic. And the crisis in Steven and Julie's marriage is brought to a head when she turns the tables and volunteers not only to help but also to stay in the quarantined hospital. Thus, the hospital not only has a significance in the maintenance of public order; it also has a symbolic function as a source of dissension in the marriages which are under scrutiny in the more melodramatic side of the plot.

Nevertheless, it is when relationships are taken outside the hospital that the trouble starts. A lengthy opening scene, filmed in a series of mobile long shots, lays this out as hospital staff celebrate New Year's Eve in the Pump Room. A jazz band plays 'Auld Lang Syne' as Steven and Julie fail to keep to the rhythm together and Ruth is revealed standing alone and drunk in the dancing crowd. As Steven and Julie move into a waltz together, a blonde nurse leans between them to say 'Happy New Year, Doctor' to Steven, breaking the barriers of work and coming briefly between the married pair. As the scene develops, Ruth is clearly established as sexually active, dangerous and lonely but the willingness of the houseman to be led astray, the sexual undertone of the sparring between Steven and Julie, the jokes of the other doctors and the boisterous behaviour of the off-duty crowd sets up an edgy, sexualised atmosphere which pervades the film. It will reappear in the sulky sensuality of the teenage daughter in the Davis family; in the model who wants to be vaccinated on her thigh rather than her arm; in Steven's flirtatious attempt to make up to a nurse he has shouted at moments before. And it appears in the

running commentary on the difficulties of marriage and the possibilities of adultery that run through the film. 'Have fun' says a nurse to the couple as Steven takes Julie for a respite from the makeshift inoculation clinic. 'With her husband?', Steven responds satirically, as if an enjoyable evening were an unlikely event for a married couple.

Personal relationships are thus set up as dangerously outside public order and, as critics pointed out, when the film turns to examining them, it tends to turn to melodrama. Ruth is the character who operates most fully in this mode. Her character is established with bold strokes and, as *Kinematograph Weekly* commented, Donlan 'lets fly with an extrovert performance'. Donlan here has something of Shirley MacLaine's ability in American melodramas such as *Some Came Running* (Vincente Minnelli, 1958) to generate sexuality and pathos. Ruth is childish in her inability to control her emotions, to keep adult secrets and in her demands for the instant satisfaction of her needs for alcohol, sex and love. Although it is tempting to see her as another example of a sexual woman punished, the film is not entirely unsympathetic to her. Donlan gives warmth to her voice and the humour helps to avoid self-pity. There is a strong hint that in returning to her former lover Ruth has genuinely found what neither her husband nor her other lovers could give her. In addition, Clifford's devotion to his work and his emotional repression are not treated as exemplary; instead, his severe control is set in a melodramatic contrast to the excessive, messy emotionalism of his wife. As Steven comments to Julie, 'that marriage is beyond help'.

The melodramatic elements reach their climax in the connection made between Ruth and the disease. Ruth is not the source of the smallpox but a clear link is made between her sexual behaviour and the epidemic. When Steven talks of his affair with her, his language seems to invoke the disease: 'It came upon me while I wasn't watching', he comments, 'then I was in it up to my neck.' Having escaped Bath before the quarantine, Ruth infects her lover, Bradley, who dies first, and then herself becomes the last victim. In these final scenes, the gothic setting of the gloomy staircase in the abandoned hotel; the strong contrast between light and darkness in the lighting scheme; the ghastly scabs on her face and the fragility of her connection, via the telephone, to the modern world all contribute to the melodramatic ending. Ruth becomes a frightened victim and the fire which she causes, destroys the hotel and thus finally cleanses the district of disease. It is an act of self-immolation which, with melodramatic economy, unites the plague and sexual infidelity.

This clear identification between Ruth and disorder is the culmination of the critique of marriage which she drunkenly delivers when Julie takes her home after the New Year's Eve

dance. At this point, Julie and Ruth appear to have much in common. Both are wives abandoned, on the last night of the year, by their dedicated husbands who are at the hospital; both are childless, returning to well-to-do but empty homes; neither works and their status appears to depend on that of their husbands. The clarities of melodrama have not yet separated them and Julie responds to Ruth's complaints about lack of a purpose in life with her own question: 'Being a wife won't do?' Ruth oscillates here between lamenting her own failure at femininity – 'I'm not even a woman, just a nothing' – and a wholesale critique of marriage. Given her affair with Steven, she knows more about the state of the Monks' relationship than Julie herself but, although she criticises Julie for being 'smug' and 'wifey', she broadens the attack into a cartoon parody of traditional marriage: 'The human race is practically extinct and so is marriage. Me big game hunter. Bring back bear for little Olga.'

This conversation has a narrative purpose since, as she later tells Father Maguire, Julie finally picks up the hints about Steven's affair with Ruth. But despite Ruth's drunkenness, her denunciation of marriage and her scepticism about Julie's confidence in her relationship with Steven act as a springboard for the detailed examination of the Monks' marriage that follows. Despite the tendency of the critics to associate the stories of marital discord with melodrama, the analysis of this marriage is not handled melodramatically but adopts the painstaking, documentary mode with which the epidemic is handled.

The film starts with Steven and Julie dancing out of step and they continue to do so almost to the end. The two are continually out of synch with each other's moods in small ways as well as large and the film traces out the repetitive movements towards and away from each other that mark this modern marriage. At the dance, when Julie wants to go home, Steven wants to stay; when she wants to drink and unwind, he decides to take responsibility for Ruth and then goes back to work at the hospital. When he rings from the hospital, her response is light and flirtatious but he cuts her off. When he is dedicated to his work, she presses a holiday on him but he is most determined to go on holiday when she decides to stay; 'I need you with me. You owe this to me.' They cannot even agree on whether they are having an argument. 'This isn't a bust-up' he protests as they discuss whether to stay or not; 'For you it is' she responds. Even after her illness has brought home to Steven that he loves her, he remains puzzled and cross when faced with her exhilarated, tremulous pleasure at still being alive and leaves her alone to weep.

The film details the painful process of an apparently disintegrating marriage by emphasising the many small failures and fallings-out rather than a definitive explosion. Although

Julie grasps the fact of the affair from Ruth's drunken hints, she keeps that knowledge from Steven. Neither is the audience given access to the internal battle she is having, which she later describes to Father Maguire: 'If he'd really wanted Ruth, not me, he would have gone to her.' Instead, we observe the marriage from the outside and it is the lack of successful communication or decisive action which is striking. Julie consistently refuses Steven's attempts at confession. Thus, when Steven appears reconciled to her decision to stay in the hospital and comes to see her at work, Julie rejects both his offer of a meal and his wish to discuss their problems. Similarly, when Julie becomes ill, the two share a loving scene in the hospital at which he tries to tell her of his affair but she deflects him again. But Steven is not consistent and angrily resists revealing himself when, in a long scene in the decontamination room shortly afterwards, he discusses his infidelity coldly with Father Maguire and argues that his wife need not be told since, if she does not know, she is not affected.

Underpinning this inability of the pair to be open with each other is a bitter self-analysis which is largely conducted separately, thus giving a rather implausible role to the priest who acts as an unofficial confessor. In Julie's case, what emerges is an unfocused dissatisfaction with what her life has become because of marriage. Unlike Ruth, Julie is the traditionally good wife but she continually berates herself for being 'a dull drab … a drear and a bore'. But what is hinted at here is that it is the role of 'the perfect wife' itself which is empty and unrewarding, that being a good wife cannot bring personal fulfilment. The value of competence in the public sphere, is not replicated when Julie tries to act it out in the private sphere of her marriage, making the notion of the perfect wife itself problematic. The return to her professional role as a nurse can in this context be seen as a response to something even more damaging than the plague – dissatisfaction with her married life.

In parallel, Steven is conducting an equally damning self-analysis. Significantly this is not framed expressly as the desire to be a good husband but as the desire to feel. 'I wish I knew what I felt' he tells Father Maguire at the beginning of a long dialogue in the decontamination unit, 'I don't register anything.' He is sceptical about the priest's recommendation that emotions should be expressed and shared. When Father Maguire presses him to tell Julie, he resists, arguing that this would remove 'the natural reserve of privacy that exists between two people that spend their lives together … I think the idea of complete intimacy between two human beings is undignified and insufferable.'

Clifford criticises him for lack of compassion while Steven suggests that Clifford has too much. 'Why are you always sorry for people?' he asks Clifford when he expresses sympathy

for Bryant. And Julie recognises that he is a private person but stresses her need to get through to him.

The ending suggests a tentative reconciliation within this marriage, an ending less flamboyant than Ruth's dramatic death. The resolution is, to some extent, sexual as Steven enters the decontamination unit during the women's session and finds Julie, naked, in the shower. But if this indicates a sexual urge that even this careful couple cannot deny, the film also attempts a more considered resolution of their marital problems as they walk away from the fire which has killed Ruth. Steven's story has a clearer ending in that his problem – lack of feeling – is identified and the beginnings of a solution found. Steven acknowledges his lack of openness with his wife – 'There was so much I wanted to say' – and then, as the pair move away from the fire, expresses feeling:

Steven: I'm sorry for Clifford.
Julie: There was a time when you couldn't feel anything for Clifford.
Steven: That was a long while ago. It was before I heard you were going to be all right.
 All new things began from there.

For Julie, the resolution is not so clear-cut. She wants her marriage to continue but, naked in the shower, she still accuses herself, this time of being 'cowardly'; 'martyrs sometimes follow the wrong cause' she suggests, placatingly. She asks for forgiveness because 'I should never have left you' and, in the final lines, seeks reassurance from her husband:

Julie: We're going to be all right aren't we Steven?
Steven: Yes, we're going to be all right.

But the film cannot provide an answer to Julie's earlier question of Ruth: 'Being a wife won't do?' And it is not clear how Julie is to return to being a good wife without turning once again into the 'dreary wife' she despises.

In some senses then, *80,000 Suspects* is working with familiar 1950s figures, the perfect wife and the unemotional man, and doggedly follows the minutiae of their marriage. In this story, there are no innocent parties and no fixed positions; decisions made are then unmade and inconsistent attitudes adopted. The performances and modes of filming the couple are similarly restrained compared with those associated with Ruth's story. *Kinematograph Weekly* com-

mented that Johnson and Bloom 'are pretty British in their attitudes to personal tragedy', suggesting a stiff-upper-lip approach which had become a cliché from British war films. Johnson gives a rather monotonous performance in which the gloom that accompanies Steven's work on the epidemic also marks his more emotional exchanges. It is significant that there are several attempts to inject emotion or significance into the performance by the use of strong lighting and camera movement to provide a close-up as if the acting is not quite delivering what is required. Bloom, however, provides a more varied performance. Her gestures and expressions are calm and composed when, for instance, she is dealing with Ruth. She puts on a mask in her exchanges with Steven after she has learnt about his affair but her face relaxes into a more open, trusting expression when she expresses joy at still being alive. This quickly changes to anxiety when she speaks quickly and hysterically to Steven in order to block off the possibilities of his revelation. Bloom thus performs the mannerisms which Julie adopts because she can trust nothing to be what it seems. The overall effect is one of brittleness and unease, the reverse of the instinctive quality which Donlan brings to her playing of Ruth. Bloom's acting fits the observational documentary mode used in the treatment of the marriage but it may well have led to the popular failure of the film in that it holds back identification with the emotional feeling of the situation.

But maybe Julie's situation could not quite find expression at this point. B. Toker suggested that 'Val Guest treats his characters in a "sociological" manner – in other words without taking them out of their context', and *80,000 Suspects* justifies this comment. It is not just the Swedish furniture and the holiday in Le Toquet which make Julie and Steven a modern couple. Their relationship, with its sexual frustrations and deliberate misunderstandings, signifies something beyond itself. The films of the New Wave had achieved their success by expressing their rebellion through the young, finding ways of rendering in film an expression of feeling which was already present in plays, novels and music of the late 1950s. The rebellion at which *80,000 Suspects* seems to hint was more difficult to give imaginative life to, though, in the same year, *The Very Edge* (Cyril Frankel, 1963), with a script by Elizabeth Jane Howard, also seems to be reaching for it. The answer to Julie's question was found elsewhere, again in the same year, with the publication of Betty Frieden's *The Feminine Mystique* who identified the 'problem that could not be named' and demonstrated, as *80,000 Suspects* had suggested, that 'being a wife won't do'.

Christine Geraghty

REFERENCES

Grierson, J. (1979) 'First Principles of Documentary', in F. Hardy (ed.) *Grierson on Documentary*.
 London: Faber.

Guest, V. (1960) 'British films were never that bad', *Films and Filming*, 7, 1, 34.

_____ (1998) *Filmfax*, June–July, 67, 100–6.

McFarlane, B. (1997) *An Autobiography of British Cinema as Told by the Filmmakers and Actors
 Who Made It*. London: Methuen/British Film Institute.

Murphy, R. (1992) *Sixties British Cinema*. London: British Film Institute.

Toker, B. (1964) *Meanwhile 8*, publication of London School of Film Technique Film Society.

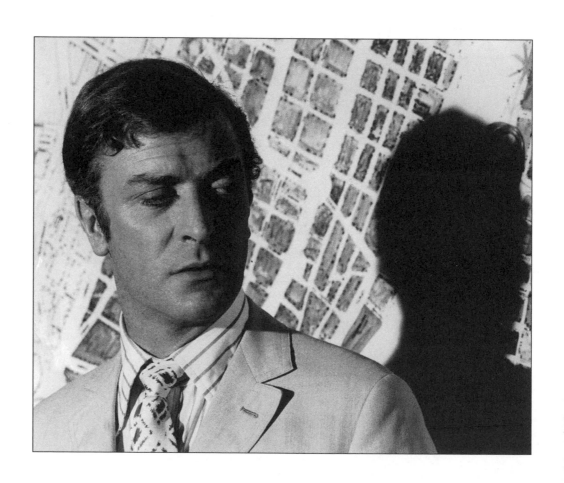

THE ITALIAN JOB

PETER COLLINSON, UK, 1969

> For he might have been a Roosian
> A French, or Turk, or Proosian
> Or perhaps Itali-an!
> But in spite of all temptations
> To belong to other nations
> He remains an Englishman!
>
> – W. S. Gilbert, *H.M.S. Pinafore* (Act II), 1876.

The Italian Job (1969) is really a war film … not a lot of people know that. Peter Collinson's tall tale of English villains who carry out an audacious bullion robbery in Turin is usually thought of as a high-1960s crime caper; but the planning, preparation and execution of the raid conforms precisely to the generic conventions of the 'special operation' behind enemy lines depicted in countless films about the Second World War. As in Collinson's film, the operation is based on intelligence about the enemy; it is the brainchild of a bright young officer, it is licensed by a supreme commander; it is the responsibility of a daring, diverse but disciplined group of comrades with a charismatic leader; it involves the deployment of specialist technology; and it requires cunning, skill and courage to ensure success against the odds. If there remains any doubt that *The Italian Job* is a war movie in disguise it should be dispelled when we realise that the next film by its writer, Troy Kennedy Martin, was *Kelly's Heroes* (Brian G. Hutton, 1970) in which a disreputable platoon of American soldiers, with a resourceful leader (Clint Eastwood) steels gold bars from a bank in Nazi-occupied France. Does the plot sound familiar?

Of course, *The Italian Job* was not the first film to adapt the successful formulas of the Second World War picture to tell other kinds of stories, especially the planning and execution of spectacular heists. In England, even before the Great Train Robbery captured the public imagination in 1963, black-and-white crime films like *The League of Gentlemen* (Basil Dearden, 1960) and *Prize of Arms* (Cliff Owen, 1961) had depicted the staging of big-money robberies, conceived as military operations by ex-servicemen. Subsequent films had been influenced by

the more lighthearted spin given to the caper movie by the successful cycle of American heist pictures that began with *Ocean's Eleven* (Lewis Milestone, 1960). Michael Caine, the star of *The Italian Job*, had played opposite Shirley MacLaine in the comedy thriller *Gambit* (Ronald Neame, 1966); but the immediate precursor of Collinson's film was Michael Winner's *The Jokers* (1968), a zany London caper involving an attempt to steal the Crown Jewels. Both films squeeze the remaining drops of madcap frivolity from the husk of 'swinging London', but *The Italian Job*, in particular contains intimations of a more sombre diet to come. The film might be a tongue-in-cheek tale of lads larking in foreign fields; but it would leave an impression of Britain poised on the edge of something precipitous. This is not to suggest that *The Italian Job* rejects the upbeat rhythm of its times. On the contrary, the mood of the film is as sprightly as the cars that are its stars, and suggests that there is still plenty of fuel in the 1960s tank. Even the ending finds humour in misfortune. But there is a hint of desperation in its *joie de vivre*, a sense that the good times might not last, the party might be closed down. Just around the S-bend was World Cup defeat, Tory government, IRA bombs, and an oil crisis; not to mention the collapse of the indigenous British car industry. The film's images of British industrial products careering to destruction down foreign slopes were more prophetic than most appreciated at the time.

The Italian Job may look as 1960s as Carnaby Street, but its action draws on a tradition of English combat that dates back many centuries to an earlier Elizabethan age. Good Queen Bess legitimated the practice of armed entrepreneurship that allowed privateers like Sir Francis Drake to plunder the wealth of other nations in the interests of the beleaguered English State, and to lay the foundations of Empire. In the sixteenth century, it was the Spanish who were the enemy, threatening to draw England into Europe; but in the late 1960s, it was the burgeoning economies of continental countries like Italy that exerted an irresistible pull. In *The Italian Job*, the kind of privateering that built the British Empire is again called upon to restore national pride and bring home the Euro-gold, this time in the days of the Empire's dissolution.

The plot of the film is a relatively simple one. On his release from Her Majesty's prison, Jack-the-lad Charlie Croker (Caine) is met by his girlfriend Lorna (Maggie Blye) in a stolen diplomatic car. Croker visits his tailor and collects his Aston Martin before attending his coming-out party at an hotel where Lorna lays on a rich selection of girls for his pleasure. But Croker also has his mind on his next job, and, at an assignation with the widow of an Italian mobster friend, he is willed the plan for a robbery spectacular enough to make him an underworld star and guarantee the patronage of its unchallenged leader, Mr. Bridger (Noel Coward). At first, when Croker breaks back into jail to pitch his plan, Bridger punishes his

impudence by sending heavies to Croker's Portobello pad to beat him up. Later, the *grande dame* of British crime becomes convinced that the robbery will scupper an Italian/Chinese manufacturing deal and provide a fillip for the national balance of payments. His plan green-lit, Croker works with Bridger's lieutenant, Camp Freddie (Tony Beckley), to assemble an unlikely cross-section of the classes to outwit the Mafia and lift the gold bullion from a security van in the centre of Turin. The scheme is timed to coincide with a football match between England and Italy in the city, and involves disguising the robbers as England fans. It also requires the assistance of a sex-obsessed boffin, Professor Peach (Benny Hill), to sabotage Turin's traffic computer and bring the city to a standstill. On the way to their target, the robbery team is ambushed by the Mafia and loses its high speed cars. However, the Brits are undeterred and put their faith in the ingenuity of their plan and the versatility of their three red, white and blue Mini Cooper runabouts. The robbery and subsequent getaway scenes are a *tour de force* of stunt driving and remain a testimony to the brilliance of L'Equipe Remy Julienne driving team. Equally memorable is the ending: a literal cliffhanger in which the getaway coach is left balanced on the edge of a sheer drop, the gold at one end and the robbers at the other as counterweights.

This was not the ending originally envisaged by Troy Kennedy Martin, best known as the creator of BBC television's gritty police drama series *Z Cars*, but of *The Italian Job*'s producer, Michael Deeley, a former production manager of Woodfall Films. In fact, Kennedy Martin had conceived a very different film: a more realistic underworld story with undertones of social and political criticism, more in sympathy with the contemporary rage on the streets of Paris than the patriotic chanting on the terraces of Wembley. In posing a challenge to the reactionary *ancien régime* represented by Bridger, Charlie Croker was to embody the spirit of anarchy that was so much a part of youth rebellion in 1968. Ironically for a film which would glorify the British automobile, Kennedy Martin had wanted his movie to make a statement against the excesses of consumerism by conspicuously destroying a string of luxury cars. However, as a Mini-owner himself, he exempted the 'classless' little vehicle from his general condemnation of motor manufacturing. Clearly, the allegorical intentions of the film were present from the beginning; but the tone in which they were handled would change considerably in the transition from script to screen. Collinson would play up the satire of English chauvinism already evident in the screenplay, and add a dose of camp excess that was not entirely to the author's taste. As the sexual proclivities of characters like Croker and Professor Peach were exaggerated for humorous effect, Kennedy Martin's critical drama became Collinson's comic book.

One might have expected this to spell disaster for the film, but instead, it gave *The Italian Job* a symbolic quality that would allow it to be of its time, and yet of all times. Right on the historical cusp between the Imperial and the post-Imperial, Collinson's treatment captured something essential, something vernacular, just as an Ealing comedy like *The Lavender Hill Mob* (Charles Crichton, 1951) had before it: Englishness in a bottle. Granted, it might be bottled myth, and for some it might smell like sweet perfume, while for others it might stink like stale urine, but it is there for all to sample.

Collinson's film transports us to a parallel universe in which 'everybody in the world is bent', and England is once again a rogue piratical state, reigned over by a lionhearted queen – this time played by Noel Coward. Her sea dogs are now road racers, their ships of oak are Mini Coopers; and their ruffs and rapiers have become jump suits and pick-axe handles. Cadiz harbour is now the centre of Turin, and the beards to be singed belong to the Cosa Nostra. Collinson's treatment of the script as a modern-dress swashbuckler was entirely in keeping with his personality and buccaneering attitude to life, as his widow, Hazel, has recalled in an interview included on *The Italian Job* DVD: 'He was like a pirate, full of risk-taking, full of fun … If he wasn't on the edge, it wasn't worth living.'

The director had been brought up in the Actors' Orphanage where Noel Coward had taken on the role of his Godfather, mentoring a career in cinema and television interrupted by National Service during the Malayan Emergency (1954–56). Some of the trauma of Collinson's early years was evident in his first film, *The Penthouse* (1968), a Pinteresque study of menace and deceit. Neither this, nor his second picture, *Up the Junction* (1968), was an obvious qualification for handling the lighter and more expansive *The Italian Job*, but the executives at Paramount were sufficiently impressed by Collinson's talent to offer him the opportunity to direct his mentor, Coward, and the rising star, Michael Caine. Deeley and Stanley Baker, the partners in *The Italian Job*'s production company, Oakhurst, would have preferred to see Peter Yates in the director's chair. Both had worked with him on the heist film *Robbery* (1967), and Yates was a dab hand at car chases as *Bullitt* (1968) demonstrated. As so often in the 1960s, it would be American dollars that would bankroll a film as British as the Union Jack, only to see it crash and burn at the US box office. The film's failure in America would be almost guaranteed by a wildly inappropriate advertising campaign. Paramount would wait over three decades before reclaiming the story for the Stars and Stripes; setting a remake in America, but in homage to the original, retaining the nippy little Minis.

The Italian Job is now hard to imagine without the Minis. It remains the vehicles' own finest hour and their enduring advertisement, but their complacent manufacturer completely failed to grasp the significance of the film for its products. The Mini became the mechanical star of the film in spite of the indifference of the British Motor Company (BMC) and the unprecedented co-operation given to the film by its rival Fiat. Thanks to a personal approach by Lord Harlech to the Head of Fiat, Gianni Agnelli, the production was given the run of Turin and of the Italian car giant's test track on the roof of its factory. Never has a commercial organisation contributed so enthusiastically to its own humiliation, and the very real disruption of its home city. The traffic jams in the centre of Turin were completely genuine. Thus the conditions of the film's production themselves contribute to the myth of effortless English superiority propagated on screen. The whole enterprise can be seen as a big con-trick worked on American financiers and Italian hosts by a bunch of self-serving British wide boys; confirming the judgement of the film's Mafia Commander that the English 'are not as stupid as they look'.

In the film, the criminal underworld represents the Eurosceptic flip side of Britain, the vein of patriotic isolationism that runs deep beneath the surface of an island race. It keeps alive a tradition of international relations that the State – with its policies of overseas aid, diplomatic bridge-building, economic co-operation, tariff and trade agreements, and independence for its dominions – has abandoned. This truly is a 'self-preservation society', determined to be independent, distrustful of 'Johnny Foreigner', and ready to exploit his weaknesses. As a distorted mirror image of the formal social organisation of power, the underworld has an alternative establishment with its own Royalty and courtiers. Moreover, it incorporates those social transformations that had enlivened the cultural elites of the 'swinging sixties'. It is a melting pot in which issues of class, race and sexuality are largely subordinated to questions of professional expertise. Of course, this vision of the new enterprise culture retains some well-worn stereotypes – the well-hung black bus driver (Big William); the effeminate shirt salesman; and the academic with a penchant for plump women (Professor Peach) – but it also encompasses a world in which a young working-class man with fresh ideas (Croker) can make good; a gay man in a cerise suit (Camp Freddie) can be the managing director of a bent corporation; and a 'dolly' in a mini-skirt (Lorna) can be a professional car thief. However, it is clearly not a world progressive enough to allow women full participation in a dangerous mission, as Lorna is eventually deemed a 'liability' to the Turin robbery and packed off to Geneva to await the conquering heroes.

At the centre of this topsy-turvy underworld is the figure of Coward's Mr Bridger, imprisoned but in charge. On set, Collinson insisted that Coward was referred to as 'the master', and all that really is required of him is that he play an exaggerated version of himself. The ageing star was even looked after by his real-life partner, Graham Payn, who took the part of Keats, Bridger's fawning courtier. In the film's distorted lens, Bridger represents the traditional ruling elite of Britain. He demands and receives that which the British are practiced in giving: deference. Even the prison officers owe him allegiance, ensuring his toilet ritual is private and his time on the 'throne' is undisturbed. Beneath its frilly pink lampshade, his cell is plastered with family photos – the royal family, that is. His appearances are accompanied by versions of 'The British Grenadiers' and 'Rule Britannia', adapted for a chamber orchestra in a way that suggests repressive power overlaid with a refined gentility. He is clearly officer class, but just as clearly, his tired regime needs the transfusion of energy and initiative that an enterprising subaltern like Charlie Croker can provide. Appropriately for a young man keen to break free of the restrictions of the past, Charlie lives above an antique shop. The relationship between Bridger and Croker is effectively an allegory of class relations in Britain in the preceding century. It begins with a humble petition met with a violent response, and ends with an uneasy class alliance in the face of a foreign challenge. Bridger is outraged to find his toilet ritual interrupted and his throne usurped by the audacious young Croker whose response to the rejection of his robbery plan is to contemplate offering it to the more innovative Americans, people who 'recognise young talent and give it a chance'.

Mr Bridger's British underworld, with its quirky agglomeration of gentlemen and players, is defined against a caricature of the Italian Mafia that owes much to fascist militarism. The Cosa Nostra presents a more regimented variation of the state-within-a-state. Unlike its inclusive and meritocratic British counterpart, the Mafia is exclusive and governed by a hereditary hierarchy. It is characterless, uniform, serious and ruthlessly efficient; whereas England's criminal commandos are irreverent, cheeky, eccentric, unruly, but effortlessly effective. They not only know how to get the job done, but how to do it with style and humour. The contrasts have their origins in an unashamed British chauvinism, but, in the same way that the Second World War film often exhibits a respect for the German military, *The Italian Job* has a sneaking admiration for its own antagonists. From the opening titles in which we follow that pinnacle of Italian automotive design, the Lamborghini Miura, snaking sensuously around the Alpine bends, we are aware of the grace of a culture for which good taste has become second nature. The British may drive on the 'right' side of the road, but they cannot hope to match the Italians'

apparently innate ability to make sound aesthetic judgements, that casual appropriation of beauty that is so evident from faded frescos to palatial piazzas (all immaculately displayed in Douglas Slocombe's compositions). Even the Mafia soldiers, strikingly arranged against the skyline, recall the statuary that is so much a part of Italian civic design.

However, it is also clear that Italy is a somewhat decadent and complacent culture, less adaptable than the new post-Imperial Britain. The new Brits are quick-witted, light on their feet and still blessed with the devil-may-care attitude to danger that helped to build the Empire in the first place. Now freed of the burdens of Imperial responsibility they are able again to indulge their piratical impulses by mounting the sort of hit-and-run raid usually associated with the resistance of power rather than with its exercise. All this, of course, is symbolised by the nimble, unpretentious Mini Cooper, able to dodge and weave between the monumental structures of Italian civic pride. Cheeky and irrepressible, the patriotic Minis are the mechanical projections of Britain's 1960s' spirit, literally swinging their way through Turin's sewers. The car driving into the tunnel is a subliminal symbol of sexual penetration, and there is a distinct impression that Croker's smash and grab raid is a violation of Italian virtue and of the bodily integrity of one of Italy's beautiful cities. It is rape by a stranger under the very noses of a fiercely protective (Mafia) family or, to put it in terms of the film's dominant discourse of sporting competition, it is the taking of the home end by away-team football supporters.

Football, like criminality and product design, is one of the film's key sites of Anglo-Italian competitiveness. The 'people's' game had been central to Italy's prestige during Mussolini's dictatorship when the national team became controversial world champions at the 1934 World Cup. Italy then were the home side, just as England were when they lifted the trophy by beating Germany in 1966. If that game was a ritualised commemoration of the war against fascism, so too is *The Italian Job*'s Italy vs. England international, fought out between two old adversaries. The English victory in the foreign football stadium is the twin of the successful bullion raid in the same city. Both are 'a result', not simply for the nation, but for the class associated most strongly with soccer and with crime. Croker's robbers, who wear matching blue overalls, connoting both team membership and blue-collar work, bring these associations together. Ironically, blue is also the colour of the Italian football team jersey. When Bridger accepts the credit for the heist by regally descending the prison stairs to the rhythm of plates beaten by an army of men in overalls, it is the England football chant that echoes round the jail. For many fans of the film, the triumphant scene is given poignancy by the knowledge that English patriotism has now itself become an imprisoned tradition, granted only limited parole during sports competitions.

The contradiction between jingoism and irony and the ambivalent responses it elicits are at the heart of the film's fascination for modern viewers. A film largely conceived as a critique of patriotic prejudice remains open to appropriation as a celebration of national superiority. The point, however, is that even in 1969 nationalistic fervour was already a subordinated emotion, evidence of an uncool Britannia, and relegated to representation by an underworld of villains. This is *The Italian Job*'s master inversion, crucial to its popular appeal as a view from below. It is sustained throughout the film. For example, the Mafia, rather than the Italian police or government, is pictured as the holder of power in their country. They guard the mountainous approaches and issue dreadful warnings to invaders. It is a tradition of representation familiar from the Imperial Adventure film: the gallant British column or scouting party ambushed in the hills by hostile tribesmen. But the irony is that, if this is bandit country, it is the Brits who are the bandits. It is they who refuse to bend the knee to authority, they who are the saboteurs rather than the soldiers. This reversal is in keeping with the film's gentle satirising of the gentlemanly virtues of Britishness. 'Fair play' is not a phrase which slots easily into the vocabulary of *The Italian Job*'s protagonists: in his Captain Croker persona, Charlie quips that he used a machine-gun to shoot tigers in India, while his girlfriend Lorna has no compunction in stealing the car of the Pakistani Ambassador. The old protectorates have clearly become ripe for plunder. The virtue of moderation fares no better: Charlie eschews choosing between the girls Lorna has assembled for his prison-release party, and opts for them all. Loyalty is shown scant respect when Charlie beds the widow of his recently deceased friend, Beckerman; while democracy is lampooned when Charlie asserts that it means 'doing everything I say'.

Nevertheless, if the rhetoric of *The Italian Job* suggests a break with past traditions, it also emphasises their relevance. The spirit of Britain's 'finest hour' is, as ever, present as the red, white and blue on the streets of Turin. At the bogus funeral that allows Mr Bridger out of prison, he addresses the robbery team before their mission like Queen Elizabeth I wishing Godspeed to the nation's defenders against the Spanish Armada. He also evokes the memory of the Empress Victoria when he effectively dedicates the robbery to the memory of 'Great Aunt Nellie' who 'brought us up properly and taught us loyalty'. As Croker's team sail away from the white cliffs of Dover we hear the strains of 'Rule Britannia; and when facing annihilation by a superior force of Mafiosi, Croker responds with a classic piece of Churchillian bravado, surviving by promising to 'fight on the beaches': 'There are a quarter of a million Italians in Britain, and they will be made to suffer. Every restaurant, café, ice-cream parlour, gambling den and nightclub in London, Liverpool and Glasgow will be smashed. Mr Bridger will drive them into the sea.'

Thus, by manipulating resonant patriotic symbols and memories and reassigning them to a subordinate cultural group, *The Italian Job* is able to successfully address a new British post-Imperial identity: a Britain whose prestige is no longer based on heavyweight military might, but on native skill, courage and cunning. Britain's 'greatness' can no longer be attributed to the vast size of her possessions, but to the spirit and enterprise of her subjects. Despite poking gentle fun at the legacy of Empire and Etonian values, the film can still reassure its native audience that, though times have changed and glories may have passed, there is every reason to be confident that Britain still has what it takes to outfox and outmanoeuvre other nations. The Elizabethan wheel, it announces, has turned full circle. The sea dogs are back in business.

Steve Chibnall

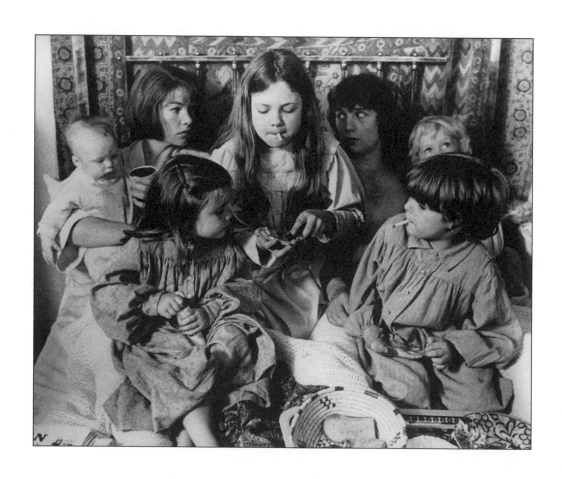

SUNDAY BLOODY SUNDAY

JOHN SCHLESINGER, UK, 1971

Expatriate South African actor Antony Sher recalls in his autobiography 'how the elegant decadence of *Darling*', John Schlesinger's take on 'swinging sixties' London, 'beckoned me towards England; and how I learned about a certain look through that film – the *Darling* look.' Anyone anywhere who saw that film when it was first released in 1965 will immediately know the kind of look he means: a mix of glazed *ennui* with unappeasable yearning and a campily-cocked eyebrow. And anyone like me who was growing up at the time in an even more remote outpost of the old British Empire, suburban Melbourne, will readily confirm the siren-like power of that look. Yet if it was especially seductive, it was not uniquely so. In differing ways, probably most English films from the outset of the industry have exercised some such enticements for us 'colonials'.

No one could better attest to this than the editor of the present volume, who was an English teacher at my Melbourne school in the 1960s but already an extraordinary aficionado and proselytiser of British cinema. As well as running a film society for the boys (where we cut our *cinéaste*'s teeth on early Hitchcock and Ealing comedies) he had taken a class to see an earlier Schlesinger movie, *Billy Liar* (1963), when it was showing in Melbourne; and it was there one was first captivated by *Darling*'s star, Julie Christie, playing a much nicer girl on this occasion, and in the distinctly *inelegant milieu of a northern English town, but radiating irresistible cool in every frame. She was to crop up again, as beguilingly, in a later Schlesinger film, his adaptation of Thomas Hardy's *Far From the Madding Crowd* (1967), filmed this time in deepest Dorset and set in the nineteenth century. Schlesinger, you began to realise, was a master at evoking a varied range of Englands, and it was not just the charisma of Christie that attracted you to each of them but also his own discreet posture of wry reverence. He was undoubtedly wedded to England and English ways – these had comprised the subject matter of all his films to date. Whatever its sources in Schlesinger's own case – and these may lie partly in his religious background (Jewish) and sexual orientation (gay) – his ambivalence about his homeland was bound to chime with that of many a child of England's former colonies, caught between being outsider and insider. There was the added attraction in *Far from the Madding*

Crowd of the presence of Peter Finch, English-born, but partly raised in Australia, and a much-loved actor there before he also yielded to the beckoning finger of the motherland and its rich theatre and cinema culture.

My first trip to England was not until the end of 1969, and my own first dip into that culture was going to see Ken Russell's *Women in Love*, starring Glenda Jackson, at the Prince Charles Cinema off Leicester Square in London. On the surface Jackson and Christie might be thought to be as like as a pickled onion and a peach but that is partly why you can take equal relish in both of them. Such diverse delectations aside, there were lots of things about living in England during 1970 and directly observing it from an outsider's viewpoint that made me more ambivalent about the place than I had been when I first embarked on the trip. Little did I know that during this period another Schlesinger film was being brought to fruition that would team Peter Finch with (or, in one sense *against*) Glenda Jackson and provide not so much a beguiling invitation to partake of England's varied charms as a crystallisation of one's own ambivalent feelings towards the country. The film in question was *Sunday Bloody Sunday* (1971).

The title itself conveys ambivalence of various sorts. It is unlikely that many in the film's audiences around the world would have been attuned to the past political resonances of the phrase 'Bloody Sunday'. This had been the name given to an infamous episode of street violence in London involving police and socialist demonstrators back in November 1887, and it was also the nickname of one of the anarchist characters in G. K. Chesterton's novel, *The Man Who Was Thursday*, published in 1908. The phrase would be used again in a political context some months after *Sunday Bloody Sunday*'s release to name the day when thirteen civilians were killed by British paratroopers during a protest march in Northern Ireland, but nothing so specific or so turbulent is even hinted at in the film or by its title. As it happens, the action starts on a Friday and covers two whole weekends together with all the days in between. There is a political subtext to the action, figured neatly on the soundtrack by news broadcasts on a car radio announcing wage blow-outs, threatened strikes and an imminent crisis in foreign exchange rates; 1970–71 was an unstable period in British politics with the bowing-out of a long-term Labour government and the return of the Conservatives bent on limiting the legal powers of the trade unions. But if there is a sense in the film that the best of times in the nation's political history is now past, there is nothing to suggest that this is yet the worst of times.

Certainly, as evoked by the costume and set design, the world inhabited by the major characters and most of the minor ones is supremely comfortable, bordering on plush; and this is part of its beguilement for the film's audience – and for its makers. The cushionings of this

world are suggestive at the same time of its complacencies and perhaps of the precariousness of its supports, though what disruptions occur in its inhabitants' lives do not derive from any conventional political quarter. Implying his distance from other prominent or rising British directors of the day (Tony Richardson, Karel Reisz, Lindsay Anderson, Ken Loach), Schlesinger remarked in a 1991 interview: 'I'm not a particularly political animal ... If they [the audience] have learned a little more about other people, that's fine.'

A yet more apt 'background' is provided by the music on the soundtrack: recurrent snatches of the trio 'Soave sia il vento' from Mozart's opera, Cosi fan tutte. Schlesinger remarked of this bewitching and plangent song in a 1993 interview with Jeremy Isaacs, 'It is about waving goodbye, and ... about having a calm and safe trip.' More significantly, it is enmeshed in a plot about lovers' games, masquerades, betrayals, and if there is anything substantially political in Schlesinger's film, it is within this realm of emotional politics and the intricate diplomatic interplay of personal and family relationships. Interestingly, there is a reprise of this trio in the score of Closer (2004), Mike Nichols' film on related themes.

The bloodiest thing to happen in Sunday Bloody Sunday – and it does take place on a Sunday – is the running over of a dog by a lorry. The dog belongs to an upper-middle-class English family, who have come out for a leisurely walk. Though the disruption to this serene spectacle is in no way political, it is at least partly attributable to the complacencies of that class. What precipitates the accident is not any error on the part of the lorry driver but the heedlessness of the young daughter in the family (Kimi Tallmadge). Precocious Lucy imagines she is somehow above conventional class categories and expectations. Her liberal intellectual parents, the Hodsons (Vivian Pickles, Frank Windsor), have gone away for the weekend, leaving her in the care of their best friends, Alex Greville (Glenda Jackson) and Bob Elkin (Murray Head). 'Are you a bourgeoise?' Lucy teasingly asks of Alex when Alex expresses mild surprise at finding the Hodson children smoking pot. Joining in the game, Bob, a kinetic sculptor who also likes to place himself outside regular categories, explains that 'she has a bourgeois father who's very grand and owns a lot of banks'.

The irony here is that Alex has been pressing beyond the conformities of marriage represented by the Hodsons and her parents (Maurice Denham, Peggy Ashcroft) in embarking on an affair with Bob. He is blithely bisexual and having a simultaneous relationship with a Jewish doctor, Daniel Hirsh (Peter Finch). A business efficiency expert, Alex too is not above indulging in another sexual liaison – with one of her clients (Tony Britton). She would hardly have recognised herself as typical of the species of female eunuch identified by Germaine Greer

in the book of that name, first published in the year the film was being made. But neither is Alex any trailblazing liberationist. Lucy's instincts are shrewd. Alex's dalliance with her client could well be a case of the bourgeois lady protesting too much her sexual independence from Bob, trying to live by his insouciant philosophy ('We're free to do what we want') while continuing to suffer from his more sustained two-timing ('Other people', she tells him, 'often do what they don't want to do at all').

Bob's other lover, Daniel, similarly suffers the frustrations of this unconventional twist on the eternal triangle, though what protests he registers are purely verbal and then fairly muted. He has not entirely denied himself the measure of freedom opened up by the recent decriminalisation of homosexual acts. There is a brief, subtle suggestion of his sexual past – the narrative of the whole film is built on a succession of such deftly-economical vignettes – in a night scene set around Piccadilly Circus, in which Daniel, stopping his car at a traffic light, is accosted by a drunken young Glaswegian (Jon Finch) with whom it emerges he once had a one-night stand. 'Are we going back to your place, then?' the Glaswegian expectantly asks of Daniel. 'No, we are *not* going back to my place' comes the firm reply this time. It is clear that Daniel is now committed to his relationship with Bob – frustrated by its limits and contingencies but stoically content. He still cannot bring himself to tell his conservative Jewish family about it, however, and all too stoically tolerates, as he deflects, their attempts to marry him off: 'I have not found the right person yet,' he tells a particularly pushy aunt (Marie Burke) at his nephew's barmitzvah. It is not so dissimulating a statement (at least he refrains from saying 'the right woman'), and right at the end of the film we hear him, in effect, reiterating this statement and applying it specifically to Bob, who has now left both him and Alex to further his career in America. But Daniel's tone remains stoical, uncomplaining except about those who might presume to judge he is better off without his 'half a loaf': 'All my life I've been looking for someone courageous and resourceful, not like myself, and he's not it … But something. We were something. You've no right to call me to account…'

This epilogue is also a monologue, delivered by Finch straight to the camera. It is the last Sunday evening in the film and perhaps the aptest moment for such quiet reflection, with its admonitory, slightly sermonising coda (while it may not be Daniel's sabbath day, he is as much an Englishman as a Jew, like Schlesinger himself). But the monologue packs a special punch here because nearly all the preceding scenes have been fairly realistic conversation pieces, if sometimes involving just a single character in shot talking on the telephone. One artful pre-echo of this final scene is the 'Anglican epilogue', as the script calls it, that we see flickering from

a television screen being watched by Bob and half-watched by Alex in one of the earliest scenes, set on the first Friday evening. For all the easily mockable tone of this tele-vicar's sentiments (and mocking them is precisely how Bob responds) their burden is not dissimilar to that of Daniel's admonitions: 'Christ doesn't take sides. He doesn't judge. He cheers for you as much when you win as when you lose…' The big difference in Daniel's case is that there is no one else in sight watching or listening to – or mocking – his exhortations to non-judgmentalness: we, the film audience outside the frame, appear to be the only palpable audience he is addressing. An alienation effect that is also deeply involving, it makes for a powerful cinematic moment, all the more arresting for being so against the grain of the whole.

As well as impressing on the film's audiences the seriousness with which his exhortations are to be taken, Daniel's monologue by its very form underscores his loneliness – and, by implication, Alex's. As the two immediately preceding scenes have revealed, Bob has flown the coop that afternoon, leaving his pet toucan with her. A Sunday full of promise for him as he jets off to a new life in America betrays its promise for her and Daniel. Just nine days earlier, at the Hodsons, she had been able to look forward to 'the chance of a whole weekend together' with Bob. That prospect was already disappointed by the following day when he could not resist dropping over to Daniel's, though he does return to her for the Sunday. By the following Sunday such prospects, let alone any longer-term ones, are dashed for both Alex *and* Daniel. It is likely now that Bob will never return.

As the vaunted serenity of Sundays cannot be insured against sudden and violent disruption, so their freedom from the preoccupations of the working week may contain the seeds of desolation as much as of joy. Facilitating the closest intimacies, they can also foster a deep loneliness or sense of aloneness. Schlesinger's picture graphically documents the possibilities for loneliness, the frequency of aloneness, in a big, glamorous, proudly progressive cosmopolitan capital replete with cultural diversions.

It is not *just* a Sunday thing, of course. A recurrent motif throughout the whole film, one of the main threads connecting its individual vignettes, is a telephone answering service presided over by a faintly prurient, all-too-knowing operator (Bessie Love). Yet its very existence is a testimony to the continual *disconnections* or missed connections between the main characters, who seem to spend more of their time on the phone talking to this suburban sphinx than to each other. There are two particularly affecting vignettes, set on a Saturday and a Monday respectively, that show (or report on) the deep loneliness within even long-established relationships. In one of these a patient of Daniel's (June Brown), during a routine consultation in his

surgery, opens up to him about the deep bleakness of her marriage – the result in part of her own sexual squeamishness. In the other, Alex's mother, at the end of a family dinner, delicately adverts to a similar problem in the Greville marriage, though in this case it is her husband who seems to have lost his sexual spark. The camera lens, as it roves among the mahogany and silver of the Grevilles' dining-room, consorts with the dimly-flickering lighting to capture the starched opulence of this world – its enticements and its oppressiveness.

While it is true, perhaps, that Sundays – in the Western world – have a peculiar power to distil confused emotions in concentrated form and to accentuate states of loneliness, there remains a defiant rather than a desperate tone to the phrase 'Bloody Sunday'. Although none of the characters actually use the phrase, it is in this spirit of confronting, transcending, getting over and not giving in to the sense of desolation the day can embody that most of them will manage to go on surviving at least, if not move on in fresh directions. Daniel advises his woman patient: 'Sometimes people survive better apart.' It is what he realises about himself by the time he comes to deliver his monologue at the end. Having planned a holiday in Italy with Bob, he will still go on his own now Bob's left him. 'Bugger the conditional,' he declares in a moment of exasperation with the Italian grammar he is trying to learn from a record in preparation for the trip. Those words are as much a declaration of his new independence from the equivocal Bob – and, at a yet more subliminal level, a curt summing up of the unsatisfactory dynamics of their past relationship: fully and vigorously sexual but lacking in comparable emotional commit-ment or security. The screenplay – officially credited to Penelope Gilliat, though the dialogue was partly re-written by David Sherwin – is full of such subtle verbal layering.

Alex, a few scenes earlier, has also bravely dismissed Bob from her life. He has idly asked her to come and visit him when he goes to America, pleading that 'Nothing's changed.' To which she retorts: 'That's the trouble … All this fitting in and shutting up and making do … I don't want to live like this any more. I *can't* come over … We've got to pack this in…' She is also implicitly rebelling here against the advice that her complaisant mother has given her: 'Darling, you keep throwing in your hand because you haven't got the whole thing. There *is* no whole thing. One has to make it work.'

Reviewing *Sunday Bloody Sunday* in the *New Yorker*, Pauline Kael, while handsomely applauding its 'intelligence and skill and conviction', rather oddly took Mrs Greville's admoni-tions as a 'message' of the film and represented this as symptomatic of a 'certain bloodlessness' about the whole enterprise. In her use of this term was she artfully resisting the film's own title – or momentarily forgetting it? One might ask the same of another illustrious critic of

the day, Kenneth Tynan. In the privacy of his diary a few months earlier, he had berated the 'new world of bloodless ambiguities' represented by *Sunday Bloody Sunday* and a recent crop of other, mainly English, films or plays. While apparently allowing for more mixed or complex 'messages' than Kael could see in the film, in essence Tynan's apprehensions were the same as hers, and much less forbearing in tone. Whatever he meant by 'ambiguities' (and this he never spelt out), he reduced the emotional stances and strategies adopted by the characters in the film to what he called a 'so-British acceptance of the mystique of making the best of a bad blow-job' and spoke of 'the gloomy ruefulness with which … the hero and heroine squander their affection and regard on a cool and uncaring erotic object – the boy'. There are some suggestive half-truths in these first impressions of the film, but suggestive as much in what they miss as in what they capture of it. While it is unmistakably 'British' (or English), in emotional tone as in location, this is not necessarily a constricting quality – nor just a monotone.

Like its director, its scriptwriter was born and bred in England, and it inevitably contains strong if disguised reflections of or on their own lives there. A note on Gilliat at the back of the published script says that 'she went to school in London during the blitz' – an experience directly echoed in a flashback sequence depicting (or re-enacting in the character's memory) Alex Greville's anguished London childhood during the same traumatic period. Though the publisher's note on Gilliat also says that 'she first thought of this film script on a train in Switzerland', an account by Schlesinger of the film's genesis vigorously challenges this 'lie', protesting the film's homegrown English origins and its personal/autobiographical perspectives in the same breath. Prompted by Brian McFarlane's observation and query, '*Sunday Bloody Sunday* seems to me one of the handful of best British films ever made. How do you rate it?', Schlesinger declared: 'Very highly. It's the most personal of all my films. I'm an openly gay director … and I'd had a relationship with a much younger man that was funny and enjoyable. It didn't last for that long … but we're still great friends and … I thought, "There's a film in there." … While we were editing *Far From the Madding Crowd*, I spent days with Penelope, talking very freely about each other's personal lives. Out of this came the film…'

Between *Far From the Madding Crowd* and *Sunday Bloody Sunday*, Schlesinger had made his first film in America, *Midnight Cowboy*. Gilliat, too, had been carving out another career for herself as none other than Pauline Kael's fellow-film-reviewer at the *New Yorker*. (They divided the year's cinema between them, covering six months each at a time.) Professionally speaking, at least, America clearly offered a prospect of wider spaces and horizons for both Schlesinger and Gilliat, and that is indirectly reflected in young Bob's hopeful decampment there at the end

of *Sunday Bloody Sunday* as well as in some off-the-cuff remarks of their own. In a film review published in August 1970, Gilliat opined: 'The spoken language of England, especially working-class England, is full of sad, vengeful could-haves, miles from the possible'. Years later, in his interview with McFarlane, Schlesinger recalled how, when filming *Midnight Cowboy*, he had 'loved the experience of working with American actors, who were freewheeling in a way that I hadn't found to quite the same extent in England. We are more reserved and kind of held-in'.

In such remarks Gilliat and Schlesinger partly confirm Kael and Tynan's diagnosis of the wilfully frustrated, frustrating nature of English sensibilities but they also suggest there's rather more variety or tension involved. Gilliat indicates that the sense of thwartedness or repression is of differing degrees, dependent partly on social class. It is still pretty general, they both acknowledge, but as Schlesinger knows from his own experience it has also been possible within those general confines to be 'openly gay' and have sexual liaisons that are 'funny and enjoyable'. This is as much a matter of differences between generations as between classes or individual temperaments. Gilliat and Schlesinger do not say as much in their remarks, but their film is richly suggestive of the newer, wider, emotional and sexual opportunities available to members of their own and subsequent generations.

Through such recent developments as the decriminalisation of homosexuality or the invention of the contraceptive pill, Daniel and Bob and Alex and the generations they represent are freer than their parents or other elders were to discover, explore, test possibilities within themselves, especially their sexual selves. Of course there had been many British films, from at least the early 1960s on, that touched in various ways on these generational changes in sexual mores – and that, in broaching the subject through a popular medium such as cinema, may have done much to abet the changes or facilitate public discussion of them. Pertinent examples include *The Trials of Oscar Wilde* (Ken Hughes, 1960), where Finch playing the title role was given his first opportunity of straying from his accustomed heterosexual territory; *Victim* (Basil Dearden, 1961), regarded as the first commercial film to deal expressly with homosexuality in a contemporary setting; and Schlesinger's own *Darling*. But *Sunday Bloody Sunday* was in advance of all of these movies perhaps – and certainly in advance of any American movie of the same period – in the way it 'normalised', refused to exoticise or make a pathology of, its central characters' behaviour and feelings.

Pauline Kael at the time recognised in Finch's role 'possibly a movie first – a homosexual character who isn't fey or pathetic or grotesque'; and in a later biography of the actor, *Finch, Bloody Finch*, Elaine Dundy recorded the shockwaves produced – not only in the film's initial

audiences but also among the older generation of the crew that made it – by his first on-screen encounter with the character of young Bob. The two men exchange a deep hug and then a protracted, sumptuously passionate kiss. *Pace* Tynan (Dundy's former husband, as it happens), there could be nothing more full-blooded for its day, nothing more confronting and *de*mystifying about a certain form of human sexuality, than this embrace. According to Dundy, it had that sort of effect on people because of its 'very casualness'; and she cites the suspicion expressed by the actor who played Bob that 'what really disturbed them about it was that it could happen with such *ease*'.

If this scene has lost much of its power to shock – popular television fare such as *The Bill* does not flinch now from the spectacle of male-to-male snogging – that is a tribute in itself to the original breakthrough made by *Sunday Bloody Sunday* and to the breakdown it sought in barriers of sexual understanding. Much of the *mise-en-scène* has the look today of a period piece (for one thing, that sphinx of the message bank could no longer ply her trade in the era of automated answering machines and mobile phones); but the emotional tenor of the film is still far from quaint, and it retains an enduring curiosity for those of us who witnessed the frustrations and the promises of the milieux it represents as well as for subsequent generations who wish to see something of the roots of their present identity and condition.

Ian Britain

REFERENCES

Dundy, E. (1980) *Finch, Bloody Finch: A Biography of Peter Finch*. London: Michael Joseph.

Gilliat, P. (1971) *Sunday Bloody Sunday*. London: Corgi.

____ (1976) *Unholy Fools: Wits, Comics, Disturbers of the Peace*. New York: Viking.

Hacker, J. and D. Price (1991) *Take 10: Contemporary British Film Directors*. Oxford: Oxford University Press.

Isaacs, J. (1993) 'John Schlesinger: Face to Face'. London: BBC. On-line. Available htpp://www.bbc.co.uk/bbcfour/cinema/features/john-schlesinger.shtml

Kael, P. (1973) *Deeper into Movies*. Boston: Atlantic Monthly Press.

Lahr, J. (ed.) (2001) *The Diaries of Kenneth Tynan*. London: Bloomsbury.

McFarlane, B. (1997) *An Autobiography of British Cinema as Told by the Filmmakers and Actors Who Made It*. London: Methuen/British Film Institute.

Sher, A. (2001) *Beside Myself: An Autobiography*. London: Hutchinson.

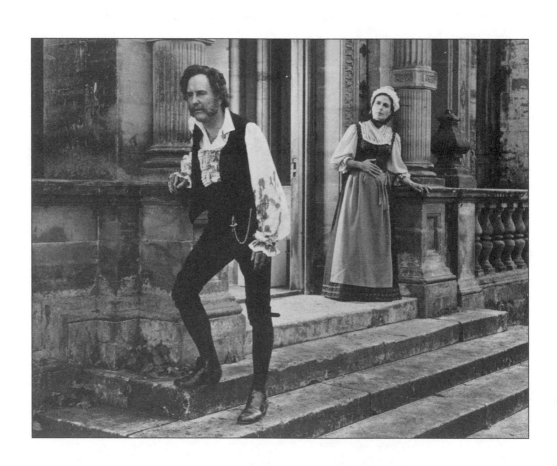

DEMONS OF THE MIND

PETER SYKES, UK, 1972

Demons of the Mind (Peter Sykes, 1972) has yet to receive proper recognition. Its relative neglect stems from an unfortunate set of circumstances. Not only, for reasons that will be examined in detail, did the film make little impact when first released, but it also dates from the 1970s, the most reviled and critically neglected period of British cinema history. In addition, the film is a late Hammer, made during a period when the studio is conventionally described as being in terminal decline. Had *Demons of the Mind* been made in the Golden Age of Hammer Gothic (1957–65), it would be much better known. However, it is very much of its moment, one of the best and most complex films made during a brief but vigorous period of generic revisionism in which English Gothic cinema was being rethought and redefined, both visually and thematically.

Demons of the Mind is set in a remote part of Bavaria in 1830. Baron Zorn (Robert Hardy) lives in a Gothic castle with his adult son Emil (Shane Briant) and daughter Elizabeth (Gillian Hills), his manservant Klaus (Kenneth J. Warren) and sister-in-law Hilda (Yvonne Mitchell). His children are the result of his marriage to a peasant woman, Liese, in the hope that her pure blood could remove the taint of hereditary insanity that plagues the Zorn line. However, Liese committed suicide and the children, weakened by drugs and bleeding, are virtual prisoners in the ancestral home, kept separate in order to frustrate the incestuous closeness that Zorn believes has developed between them, which he takes as evidence that they have inherited the family curse. Elizabeth has been sent to the sanatorium of a radical physician, Dr Falkenberg (Patrick Magee) in Vienna, but escaped. She has a brief affair with a medical student Carl Richter (Paul Jones), but is captured by Klaus and Hilda and forcibly returned home.

The local villagers are frightened by the disappearance of several young women, which they believe is the work of a mythical forest demon. Zorn, who knows that the women have been raped and murdered by his son, brings Falkenberg to Bavaria to find a cure. Falkenberg's experiments reveal Zorn's responsibility, but he consents to Zorn's demands to find an instant cure for Emil involving a dangerous procedure, in which Inge, a village woman, is offered as a substitute for Elizabeth. This only mystifies and enrages Emil, who kills Inge. The villagers see

Zorn disposing of Inge's body in the lake, and, believing him to be the murderer, march on his house, led by the itinerant, self-styled 'priest' (Michael Hordern), who bears a flaming cross before him. Convinced he must destroy his own family to cure 'the evil in my blood', Zorn shoots Falkenberg and stalks his two children, who escaped following Emil's murder of Hilda. Emil is killed, but Zorn hesitates before shooting Elizabeth and is surrounded by the villagers. The Priest stakes him with the fiery cross. Carl tries to comfort Elizabeth who rakes his face with her nails in a frenzied attack: she has inherited the 'curse'.

The above synopsis might make *Demons of the Mind* appear to be standard horror fare, with clear echoes of Hammer's 'Dracula' cycle. However, screenwriter Christopher Wicking has argued that it was necessary to emphasise the conventions of the genre in order to subvert them. David Pirie identifies Wicking as part of a new generation of 'ardent *cinéastes* with a fascination for American cinema' who tried to rejuvenate the horror genre because they saw in it a creative tradition that was capable of change and was also popular. The impact of the *cinéastes* on the genre was marked by an increasingly complex visual and narrative style, and thematic reflexivity, which demonstrated a highly developed knowledge of the genre it sought to critique. Wicking established a reputation as a horror writer through his scripts for American International Pictures (AIP) including *The Oblong Box* (1968) and *Cry of the Banshee* (1969), both made in Britain and directed by Gordon Hessler, which use the motif of the family curse. After creative frustrations at AIP, Wicking moved to Hammer Films, which was undergoing a period of radical change caused by the retirement or disaffection of a number of key staff and relocation to Elstree, which ended the stable regime at Bray that Hammer had enjoyed for fifteen years. The move was insisted upon by Hammer's new partners, Anglo-EMI, which had undertaken to fund Hammer's films after the collapse of its arrangements with American partners, part of a more general withdrawal of American finance from the British film industry. Hammer was now working in a highly competitive marketplace in which new companies – Amicus and Tigon as well as AIP – were making Gothic horrors in a period which saw a glut of horror films: 95 films were released in the period 1970–74. These volatile conditions made Hammer receptive to new ideas and in Michael Carreras, who became Managing Director in January 1971 after the retirement of his father James Carreras, Wicking found another radical spirit, prepared to support *Demons of the Mind*, as Julian Petley commented, 'because he saw it as a move in a new direction, which is what he wanted'.

Wicking was in partnership with independent producer Frank Godwin, with whom he shared a common interest in myth, legend and history. Godwin, who had interested James

Carreras in 1970 with his idea of a film about lycanthropy, a subject that Hammer had not used since *The Curse of the Werewolf* (Terence Fisher, 1960), went into co-production partnership with Hammer to make *Demons of the Mind*. Godwin was determined, despite a modest budget of £200,000, to create a distinctive film, aiming 'to get the sincerity and atmosphere achieved in the early German films'. It was Godwin and Wicking, the latter acting as an uncredited co-producer, who made the key decisions about cast, crew, and so on, and spending an unprecedented (for a Hammer film) length of time on location. A full week of the film's six-week shoot took place at Wykehurst Place, Bolney, East Sussex, designed by Pugin in 1770, using both the ground floor rooms and the surrounding estate in order to ensure that *Demons of the Mind* looked very different from a conventional Hammer production.

Godwin brought with him his own art director, Michael Stringer, and accepted Wicking's suggestion to employ Peter Sykes as director. Wicking had worked with Sykes on *Venom* (1971), and had been impressed by the young Australian's ability, enthusiasm and knowledge of legends. Wicking felt he would contribute a more innovative visual style than the more established, and therefore more predictable, Hammer directors such as Roy Ward Baker or Terence Fisher. Sykes also contributed to the film's intellectual project by suggesting that Falkenberg, an ordinary doctor in the original script, become a near-portrait of Franz Mesmer (1734–1815), acknowledged as the founder of modern psychotherapy, thereby giving the role more substance and historical weight. *Demons of the Mind* is also a meticulously researched production, its details as authentic as possible, including an original scarificator with which Hilda bleeds Elizabeth.

Godwin was determined to cast the film differently: 'We didn't want it to be just another Hammer film, so we didn't want to use [Peter] Cushing or [Christopher] Lee.' He persuaded Yvonne Mitchell, with whom he had worked on *Woman in a Dressing Gown* (J. Lee Thompson, 1957), to come out of retirement, and her presence induced other luminaries to sign up: Michael Hordern, appearing in horror for the first time, and Patrick Magee playing the now crucial role of Falkenberg. The quality of their performances is a crucial factor in *Demons of the Mind*'s success. Sykes persuaded pop singer turned actor Paul Jones to play the hero, Carl, having directed Jones in his first film, *The Committee* (1968); but he was not able to get Marianne Faithfull, who had to be dropped at the last minute because insurance could not be obtained for a known drugs user. She was replaced by Gillian Hills, who had just appeared in Stanley Kubrick's *A Clockwork Orange* (1971) and the psychological thriller *La faute de l'Abbé Mouret* (Georges Franju, 1970). The discovery was newcomer Shane Briant, whose role as Emil was enhanced

when the early rushes revealed the strength of his performance. The problematic casting was Zorn. Sykes had worked with Peter Brook and tried to interest Paul Scofield who declined, as did James Mason. Eric Porter was mooted, but was lost to a rival Hammer production, *Hands of the Ripper* (Peter Sasdy, 1971). Eventually Robert Hardy, a noted Shakespearean actor, took the part, and his performance was to prove problematic. This difficulty delayed the film's production for five months.

At the heart of *Demons of the Mind*'s revisionism is the clash between different systems of belief. Wicking noted that the film 'is like a werewolf story, but one that looks at the reality behind the legend'; and that reality was 'a human psychopathic condition that wouldn't have been understood by the medicine of the time'. This confrontation is focused in the central scene where Falkenberg experiments on Zorn, which was, according to the Press Book, 'studio-designed after the style of the great Mesmer's own equipment of the eighteenth century. A circular wooden trough [the *baquet*] containing iron filings, mercury and bottles filled with magnetised water is the focal point of the hypnotic healing session. Iron rods point at the patient under hypnosis, while an adjacent revolving candle, throwing off sinister shadows, adds dramatic tension to the scene.' These authentic details, so different from the usual bubbling beakers in Frankenstein's laboratory, are used creatively to lend a disturbing resonance to Falkenberg's actions. Dressed in rich purple robes, Falkenberg is an ambivalent figure, at once the priest demanding unquestioning faith in his new 'religion' and the modern scientist whose apparatus is the triumph of Enlightenment rationalism. Gently rubbing Zorn's temples to induce the trance as he gazes fixedly at the revolving candle, Falkenberg espouses his doctrine: 'The basic principle of my work assumes the existence of a universal fluid, a force uniting all living things which this magnetic apparatus can harness to bring your innermost secrets to the surface, make them comprehensible allowing us to act on them.' Mesmer argued that disease resulted from a disequilibrium of the fluid within the body, a condition which could be cured by the physician who through his apparatus could place patients into a trance-like state and provoke a 'crisis' that would reveal the problem and hence a cure could be found.

Zorn reaches his 'crisis', a terrified admission of his appetites: 'I relished the thought, the very idea of blood. Like my ancestors before me, I saw myself an evil demon of the forest lusting to kill and that I would die a ritual death as they did. But still my desires were violent, obscene. Shapes waving, not fur, not fur, hair flowing, blood, flesh.' As Zorn speaks, the camera moves closer and closer until the whole screen is filled with Zorn's eyeball, on which we see, optically fogged, a naked, blood-daubed woman caressing herself in erotic abandonment. Zorn is not

recounting an ancient curse, but his own wedding night in which he sees his pure wife writhing in sexual ecstasy: 'Her virgin blood flowing. Crying out in pain yet not wanting me to stop. Wanting me to go on despite the pain, the blood. It disgusted me.' These images echo an earlier, baffling moment when Zorn stared distractedly into the flames flickering in the fireplace, but which can now be interpreted by Falkenberg as his 'dreams of sexual fear repressed through guilt. You were incapable of carrying out these fantasies and now your children share these impulses. They are the key.' Thoughts of his children bring the 'crisis' to its head. The images reveal Liese's horrific death, slashing her wrists and neck in full view of the children while Zorn confesses that he drove her to madness and suicide and screams loudly.

Falkenberg's smug pleasure in his success reveals the cold hubris that often undermines the man of science in Gothic fiction and, as the action develops, his insights serve only to accelerate the catastrophe. Although he understands that the children are the victims of Zorn's tyranny and Hilda's misplaced protectiveness, he cannot reach them. They are silent when he experiments on them in a scene that is dominated by Emil's restless and terrified eyes, sensing in Falkenberg another oppressor, deaf to their needs. *Demons of the Mind* is characteristically ambivalent about whether the children's love is incestuous, a recurrence of the 'curse' that blights the family as Zorn believes, or, as Falkenberg diagnoses, a perfectly natural cleaving together in such desperate circumstances. But Falkenberg, ever the careerist, accedes to Zorn's desperate urgency – fuelled by Carl's visit and the increasing restlessness of the peasants – to provide an instant solution. His scheme to provide a substitute for Elizabeth in the peasant girl Inge (Virginia Wetherell) provokes a crisis that Falkenberg neither anticipates nor controls. As the baffled Inge flees in terror, pursued by Emil who cannot understand why 'Elizabeth' should be so hostile, Falkenberg looks on in horror. Seeing Zorn deliberately release Emil, he realises the true depths of the Baron's sickness, understanding that Emil has become 'the instrument of your lust … He did what your fears and dreams made you want to do, but which your conscious mind could not do.' In a highly creative reworking of Jacobean revenge drama which Wicking strongly admired, Zorn had made Emil the means by which his morbid disgust and fear of women has turned into vengeance on the whole sex.

Falkenberg's Freudian insight can neither prevent the final catastrophe, nor his own death. Zorn shoots him unceremoniously, a brutal, shocking act that is merely the prelude to the full horror of Zorn's pursuit, as the ultimate revenger, of his own children in a desperate attempt to cure the 'evil in my blood'. Zorn's own death, staked by the mad priest at the head of the peasant revolt, was a generic cliché that seemed to echo countless Dracula films. However,

the film's depiction of the peasantry is radical. They are not the 'rhubarbing' villagers beloved of Hammer productions, but, as Wicking argues, a substantial presence, given a significant amount of screen time and dialogue. Their customs and beliefs, including the pagan exorcism ritual they perform, 'Carrying Out Death', are authentic, documented in *The Golden Bough*. This seriousness, in which the peasants are groping towards a rational explanation of the 'demon', was meant to give their revolt a believable social context and socialist message. Their dawning understanding of their situation, is confused by the presence of the priest, superbly played by Hordern, who embodies another set of beliefs: God's divine if inscrutable purpose. He too, can do nothing to save the children. Their third would-be saviour, Carl, often shown riding a white horse to symbolise his purity and goodness, is also ultimately powerless, unable to reach Elizabeth's damaged mind and, like so many heroes of Gothic melodrama, rather insubstantial. In retrospect, Wicking regretted that he did not show Carl as being caught up in the madness that grips all the other characters.

Roy Skeggs, Hammer's resident production adviser, thought *Demons of the Mind* had 'the highest production values of any Hammer film', a striking comment given the quality of many of the company's films. They stem, in part, from Stringer's intelligent production design, which, as in the Mesmerism scene, blend authenticity with evocation. Stringer helped create the oppressive atmosphere of 'Castle Zorn' by his use of narrow rooms with sloping ceilings, barred windows, griffins supporting gargoyles, torn, fluttering curtains and spiky shadows against gaunt walls. He favours asymmetrical compositions in which space is fragmented by shafts of light and masses of shadow evoke both *film noir* and German Expressionism; our first glimpse of Emil's cell echoes *The Cabinet of Dr Caligari* (Robert Weine, 1919). The lighting is equally important, and the film benefited from the work of Arthur Grant, photographing what was to be his last Gothic horror before his death in 1972. It was Grant's experience and ability to work very rapidly – he had joined the industry as a camera operator in the 1930s and shot his first Hammer Gothic, *The Curse of the Werewolf*, in 1961 – which ensured that *Demons of the Mind* looked very handsome despite the tight budget. Many of the exterior shots – the sun glinting through the trees, the sinister tranquillity of the lake – have a breathing naturalism that was unusual for Hammer. Grant's interior work, as in the Mesmerism scene, is equally subtle, an ability to use low lighting levels that give a haunting beauty that is more subtle and subdued than conventional Hammer. The rich colours of the costumes are picked out against the generally sombre interiors, as are the stained-glass windows that Stringer added to the actual staircase at Wykehurst Place.

Sykes' direction is boldly innovative – within this genre – in his use of unusual composi-
tions, often photographing an interior scene in long shot to create the sense of Zorn's mansion
as an alienating, cavernous space with bare, comfortless and gloomy décor, in which the occu-
pants struggle to make contact. Sykes uses extreme angles, hand-held subjective camerawork
and rapid cutting to create a disorientating effect in several key scenes. Emil's pursuit and kill-
ing of Inge is rendered by a montage of fast cuts and extreme angles and tilts, which capture
the bewildering frenzy of his aggression. The chase is viewed through the house window, ver-
tiginously from the top of the tower, interspersed with the brooding silhouette of the heraldic
stone eagle figure. The hand-held camera follows Emil and the increasingly despairing peasant
woman, cutting between the two, victim and killer, building the horror until Emil strangles
Inge in slow-motion. His actions are intercut with shots of Elizabeth who grasps her own throat
in a sympathetic mimicry of her brother's actions, which recalls several earlier occasions. This
startling juxtaposition is the boldest example of a device used throughout *Demons of the Mind*,
which often uses a shock cut to shift from Zorn to the peasants and vice versa. This deliberately
restless, unsettling direction complements a story about the ambiguities of desire and guilt and
creates a powerful atmosphere of neurosis and paranoia. The concluding freeze-frame echoes
Witchfinder General (Michael Reeves, 1968), another innovative Gothic horror which also
demonstrates the impossibility of eradicating the horror that has been unleashed.

Harry Robinson's symphonic score shows both his classical training and his commercial
nous: 'If the public heard a big wash of sound and sonority, they would believe they were watch-
ing a "big" movie.' However, the film's slow-moving, lush and romantic melody is punctuated
with eerie harp music, as during Inge's death, which lends an oneiric, haunting quality to the
most dramatic moments. Randall Larson notes the use of 'a Moog synthesiser – a rarity at the
time – to give the score an appropriately unusual and cerebral tonality'.

After the relaxation of censorship regulations in the late 1960s and the raising of the age
threshold for an 'X' film to 18 in 1970, it became *de rigeur* for horror films to make increas-
ingly explicit use of sex, nudity and graphic violence. However, *Demons of the Mind* did not
pass through the censors' hands unscathed. The British Board of Film Classification were quite
prepared to tolerate Inge's full-frontal nudity as she is being dressed as Elizabeth, but were con-
cerned about the film's graphic depiction of violence. The examiners' report dated 8 December
1971 noted that although 'we quite realise that this is the same old Hammer hokum as before',
they had four specific objections to the violence: the flashback scene in which Zorn's wife is
seen with gashes on her body and cuts her own throat; Emil's killing of Inge in which he stuffs

earth into her mouth; the savagery of his killing of Hilda; and the dismembering and staking of Zorn at the film's climax. After a meeting with the Board's Secretary, Stephen Murphy, Godwin wrote on 17 December detailing the changes that were to be made to meet these objections. The most important of these were the changes to the flashback sequences, which Godwin stated were 'at a preliminary stage. It is our intention to change drastically the relationship of the images of the superimposed nude figures over the close-up of the eye, making the eye much more predominant, and, at the same time also reducing the effect of the blood by "bleeding" the colour'. The mother's suicide was to be 'greatly minimised ... by shooting through diffused optical glass, superimposing a burning fire effect, and proportionately reducing the strength of the images'. He also noted that the makers wanted 'the effect of the sexual and other images' in these scenes to be 'a subtle one'. He reminded Murphy that 'in this particular subject we have intentionally refrained from exploiting opportunities for gratuitous violence and horror, but it is vital that when the drama is played out, the impact is not watered down to an unrealistic level'. The Board found the changes 'tolerable', but required further toning down of Hilda's death before passing the film on 21 December.

However, this was not the only hurdle that *Demons of the Mind* had to face. Its release was delayed both because Hammer had a backlog of films, having over-produced, and because, despite Michael Carreras' strong support, it was thoroughly disliked by EMI's hierarchy. Although Hammer's films were ostensibly to form a major part of the assault of Anglo-EMI on the world market, the Head of Production at Elstree, Bryan Forbes, was unsympathetic, believing that 'the Hammer genre was coming to the end of its natural life'. When finally released in November 1972, *Demons of the Mind*, like most other horror films in an overcrowded marketplace, became one half of a double-bill without a West End première or a trade screening. As was customary, it ran on the EMI circuit for one week in North London followed by a further week in South London, after which it largely disappeared. It was particularly unfortunate in being paired with the low-brow pseudo-American shocker *Tower of Evil* (Jim O'Connolly, 1972), which received appalling reviews. Wicking also felt that its title further blighted its box-office chances, as anything to do with the mind is a big turn-off for audiences. Its working title, *Blood Will Have Blood*, an allusion to Shakespeare's *Macbeth* and a line used by Zorn in the film, was, Wicking thought, a characteristically enticing audience bait, but it was changed by Hammer's marketing department, which thought there were too many bloods in the title! In addition to these specific difficulties, the genre itself was undergoing a radical transformation with films such as *A Clockwork Orange*, *The Devils* (Ken Russell, 1971) and *Straw Dogs* (Sam

Peckinpah, 1971). Hammer's attempts to revivify Gothic horror could not compete. The foreign marketplace, always crucial to Hammer's fortunes, was also changing. The American audience for horror films was now typically under-18 and therefore the more explicit and 'adult' material that Hammer introduced into its new raft of Gothic productions was difficult for American distributors to place. And, as Hammer no longer had a specific tie-up with a distributor, the film had a very limited American release in 1973 in a double-bill with another Hammer horror: *Fear in the Night* (Jimmy Sangster, 1972).

As 'just another' horror hokum, *Demons of the Mind* received virtually no reviews. David McGillivray's for the *Monthly Film Bulletin* (November 1972) which reviewed all British films, was disappointingly hostile and strangely obtuse, failing to recognise the critical spirit in which the film mobilises familiar conventions: 'although it is made with style … the content is meagre, and unfortunately the days are past when a string of horror-film clichés … could stand in lieu of plot … The film's principal distinction is its violence, mostly gratuitous and, in the case of the final bloodbath, thoroughly unpleasant.' On its second American release in 1976, it was very positively reviewed by *Cinefantastique*, whose reviewer, Jeffrey Frentzen, saw it as 'a clear defiance of what Hammer has stood for' in its critique of the usual conventions and praised its 'sense of wonder [that] transforms a vision of horror into poetry'.

Ironically, as Jonathan Rigby notes, *Demons of the Mind*'s release coincided with, 'the beginnings of a tentative critical acceptance' of Hammer's films. However, being associated with Hammer's terminal decline, it has not featured strongly in the retrospective rehabilitation of the company's *oeuvre*. And, although it has been grouped with several other films which it resembles thematically – a reinterpretation of madness as psychological rather than 'evil'; an emphasis on generational conflict and the monstrous father; and a concern with the damaged young man – the film's distinctiveness has not yet been fully appreciated. Most commentators follow Pirie's lead who judged *Demons of the Mind* 'strange and compelling – although flawed'. His deprecation of Hardy's performance has been frequently echoed. Sykes admitted to having difficulties 'reining him in' and Hardy's expansive, theatrical performance, while superbly effective in the 'big' scenes, fails badly in the quieter moments. Several commentators have found the film thematically dense to the point of opacity; Denis Meikle judged it flawed by 'a fog of pseudo-psychological preoccupations' where 'the weight of its guilt-ridden sexual obsessions ultimately submerges interest. Recent studies admire the film but misperceptions persist, as in Harvey Fenton and David Flint's *Ten Years of Terror* that describes *Demons of the Mind* as 'well-made, brilliantly directed' but that it succeeds 'despite the corny (not to mention reactionary) finale'.

As I hope to have demonstrated, *Demons of the Mind*'s ending is consistent with its thoroughgoing revisionism which remains contemporary because of its postmodern sense of the absolute relativity of knowledge, refusing to privilege one form over another. Disarmingly beautiful in almost every frame, the film re-examines, rather than merely subverts, its Gothic conventions, questioning their ethical and historical basis and engaging with profound issues of death, sexuality and belief. It is an uncompromising, allusive, cerebral film, relentlessly downbeat, which its makers thought genuinely horrific – 'real horror' – not the usual scary but ultimately uninvolving spectacle. Its courageous, intelligent radicalism deserves recognition now, and *Demons of the Mind* should take its place as one of the genre's triumphs, on a par with *Witchfinder General*.

Andrew Spicer

Author's note: I should like to thank Claire Thomas in the Special Collections section at the British Film Institute for locating *Demons of the Mind*'s post-production script (dated March 1972) and the Press Book; I am most grateful to Edward Lamberti, Information Officer at the British Board of Film Classification, for providing a copy of the Board's file for the film.

REFERENCES

Fenton, H. and D. Flint (2001) *Ten Years of Terror: British Horror Films of the 1970s*. Guildford: FAB Press.

Frentzen, J. (1976) '*Demons of the Mind*', *Cinefantastique*, 5, 1, 29.

Larson, R. D. (1996) *Music from the House of Hammer: Music in the Hammer Horror Films 1950–1980*. Lanham, MD and London: Scarecrow Press.

McGillivray, D. (1972) '*Demons of the Mind*', *Monthly Film Bulletin*, 39, 466, 229–30.

Meikle, D. (1996) *A History of Horrors: The Rise and Fall of the House of Hammer*. Lanham, MD and London: Scarecrow Press.

Petley, J. (1998) 'Interview with Christopher Wicking', *Journal of Popular British Cinema*, 1, 142–50.

Pirie, D. (1973) *A Heritage of Horror: The English Gothic Cinema 1946–1972*. London: Gordon Fraser.

Rigby, J. (2002) *English Gothic: A Century of Horror Cinema*, second edition. London: Reynolds & Hearn.

Wicking C., P. Sykes and V. Wetherell (2002) Commentary on *Demons of the Mind*, moderated by Jonathan Sothcott; Widescreen DVD release. Michigan. Anchor Bay Entertainment.

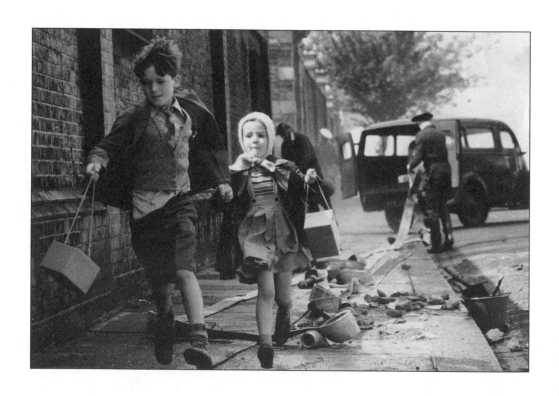

HOPE AND GLORY

JOHN BOORMAN, UK, 1986

Hope and Glory (John Boorman, 1986) begins on the first day of the Second World War, 3 September 1939, when Bill (Sebastian Rice-Edwards) is six years of age and, along with his younger sister, Sue (Geraldine Muir) is playing in the garden of the family house on the borders of Surbiton and Carlshalton. It ends five years later, in early September 1944, with the birth of a son to his elder sister Dawn, the destruction of the school he detests by a stray bomb, and his being able to 'steal' an extended summer holiday. (In reality, the school was hit by a V1 Vergeltungswaffen/Reprisal Weapon which was a German small, guided jet-propelled rocket-plane that flew on a pre-determined course at 400mph, carried a ton of explosives and detonated on impact.) It is a visual crystallisation of incidents and episodes that matured in Boorman's imagination over forty years and moulds the story of an unexceptional family into a form that gives it an extraordinary meaning.

Moments after we see Bill and his sister in the back garden, there is silence and Neville Chamberlain, the Prime Minister, announces over the wireless that, as the Government has received no response from Berlin to its ultimatum over Poland, Britain is at war with Germany. No other scene in the film can be dated as precisely and Boorman claims to 'remember every detail of that hour' and to have 'tried to render it' on the screen. Bill's parents Clive (David Hayman) and Grace (Sarah Miles) stand apprehensively, in an intimate domestic scene, as Chamberlain speaks and Dawn (Sammi Davis), his 15-year-old sister fixatedly searches for her stockings. 'For both my parents it represented the possibility of deliverance', Boorman writes in his 'Memoir' accompanying the screenplay, 'My father couldn't wait to join up. It was a blessed escape from … his clerical job and perhaps vague and unformed dissatisfactions with his marriage and his street.' Boorman's mother was liberated from a marriage in which, although deeply fond of her husband, she did not love him; she had always loved her husband's best friend, Mac (Derrick O'Connor), Herbert Brooks in reality, and was now thrown closer to him. At Clive's urging, Mac watched over the family while he was away; his mother worked part-time in his factory and he would drive her home after work. In itself, this is the cornerstone of a melodrama, but *Hope and Glory* is not *Brief Encounter* (David Lean, 1945). Its characters are not

subject to ridicule or disapproval; they are portrayed tenderly and without criticism. When Molly, Mac's wife and Grace's friend, briefly runs off with a Polish airman, she might simply have been shopping a while for all the disquiet it creates in Boorman's recollections.

Hope and Glory is deeply personal and ambitious in combining the myths of Boorman's own family with those of England and of the Second World War. It is a complete film without the viewer needing to have extra-textual knowledge of the war or of Boorman's other work, but the published screenplay and his sly, elegantly written autobiography *Adventures of a Suburban Boy* reveal something else: Boorman's concern with the ways that the act of remembering is transmuted into mythology. It is a process that requires not only the consolidation of memories, but also the forgetting and the suppressing of them. Boorman is drawn to forms in which past and present meld, where his own family appear as real or fictional figures in the past and where history and the here-and-now coalesce. His films, most noticeably in *Hope and Glory* and *Excalibur* (1981), draw on such sources to develop the myth of a family that is a simulacrum for one of England.

If some incidents from childhood lingered in Boorman's mind and provided the direct inspiration for *Hope and Glory*, there are many others that were sieved out. The imprimatur of authentic detail is entirely missing; there are no newspaper headlines to suggest the progress of the war; there is no mention of Britain's allies, the United States or the Soviet Union; although there are two 'Careless Talk' posters at the Canadian Army base where Dawn's lover is stationed, there are none questioning whether your journey is really necessary or for Squander Bug campaigns. Although elements of the film, such as the family living-room, are accurately and precisely reconstructed, others, such as the 'endless, dead straight street' of the treeless Rosehill Avenue where he lived, turned out to be misremembered, 'such are the composites of movies and memory.' Yet he did not correct it, make his memory square with reality; he left it as it was and remained with his imagination. Nostalgia, an attempt to evoke the past, is completely missing; the film takes place in the present, that is as Boorman remembers his childhood in 1986 when Margaret Thatcher was in her second term as Prime Minister. The first image in *Hope and Glory* is of a 1939 newsreel item, 'Crisis', which refers not only to the threat of war, but also to a current concern, Thatcherism.

When, in *Hope and Glory*, the fire engine clangs into Rosehill Avenue during the first bombing raids of 1940, it is impossible for an audience, informed by extra-textual knowledge of British wartime cinema, not to see it through the shadow of Humphrey Jennings' iconic *Fires Were Started* (1943). Boorman does not quote nor copy it; it is part of the culture's collective

memory and a reminder of the potency of cinema itself. 'Jennings,' he writes, 'used ordinary people to convincing dramatic effect in his wartime films ... I was drawn to this style of poetic documentary and would later practice it in my own work.'

Boorman is far from a Howard Hawks or a Joseph H. Lewis, unaware of the underlying themes of his work. He is, it turns out, a self-consciously ambitious filmmaker who has, out of necessity, divided his career between America and Britain. Although his first feature film, *Catch Us If You Can* (1965), featuring the Dave Clarke Five, was made in England, others such as *Point Blank* (1967), the celebrated thriller starring Lee Marvin, and his biggest commercial success, *Deliverance* (1972), were directed in America. Some of his films, like *Leo the Last* (1970) and *The General* (1998) were critical successes but commercial failures, while others, notably *Exorcist II: The Heretic* (1977) pleased no one at all.

It was while working on the *The Emerald Forest* (1985) with the Kamaira tribe in Xingu, 'the origins of human society' as he wrote in 2003, that he came to reflect on his own links to his beginnings. *Hope and Glory* is 'an attempt to look at a family, up and down the generations, backwards and sideways'. But there is concealment. The names of family members are changed: Boorman is called Bill, his mother Ivy becomes Grace; Wendy, his elder sister, is called Dawn, and his father George is given the name of Clive; it is a reminder that we are watching an imagined family and a created past, one that existed but is simultaneously a fiction.

The script, Boorman writes, derives from incidents that had hung in the memory, but he continues, 'film has its own imperative' and he invents scenes between Mac, 'who was my father's best friend and the man my mother had loved all her life', and embroiders his sister's relationship with her lover, a Canadian soldier, although in this case 'some [episodes] turned out to be true.'

A Christmas celebration at the family home culminates in a bravura scene where his maternal grandfather George (Ian Bannen) rises to his feet to make his annual tipsy toast: 'I've seen half the wonders of the world, but I've never laid eyes on a finer sight than the curve of Betty Browning's breast.' It is sparklingly funny, but Boorman has transferred an experience of his own national service days, when he was courting a nurse, to a memory of his grandfather's. There is no mention of his paternal grandfather, Henry, whom Boorman remembers clearly as the essentially 'happy-go-lucky' inventor of the washing machine who started a factory to make clockwork toys, but lost his fortune in the aftermath of the First World War. 'When he died', Boorman recalls, 'he left nothing but his laughter ringing in our ears.' In the film, there is nothing of him at all. There is, though, something of other members of his family: Charley

Boorman, his son, plays the Luftwaffe pilot who bails out of his aeroplane, lands just behind the house and cockily flirts with Dawn as he is taken into custody by a police constable armed solely with a truncheon; Katrine, his daughter, plays Charity, one of his aunts; Telsche Boorman, his late daughter, was drama coach to the children in the film. (Telsche Boorman [1957–1997] appears uncredited, as the Lady of the Lake in *Excalibur* and with his other two daughters, Daisy and Katrine, in Boorman's *Zardoz* [1974].)

As with most first-person stories, the narrator is passive; Bill observes but rarely comments. He frequently watches his mother through the landing banisters arguing with Clive or reprimanding Dawn; he sees that she and Mac are having intimate conversations, but can only guess at what is being said. His strongest recall is for his feelings, his sense of embarrassment at finding himself unable to join in and look down the knickers of Pauline, a young, unpopular neighbour, and a slowly developing shame at his origins. He recalls his awareness of the vague gentility that his parents' affected, their appalled response when the Local Authority built housing estates close by, and their dyslogistic concern when his sister came home 'talking "common"' or with scabies. There were, he notes, four million houses similar to theirs built between the wars, with names like Gladroy and a Ford 8 or a Vauxhall 12 in the garage, characterless, semi-detached properties that were 'half-way houses to respectability'. While the academics, the politicians, and the upper classes worried about socialism and fascism, Boorman writes, 'the cuckoo had laid its egg in their nest and Margaret Thatcher would hatch out of it'. He was humiliated at seeing his mother 'dig anxiously into her purse and sniff, seeking both money and sympathy … It was worse when she was sniffing out money to buy *me* something.'

From the beginning of his feature-film career, Boorman has negotiated the treacherous path between commercial and personal cinema. He writes of a British film industry that collapsed after the heyday of Ealing comedies, David Lean, Carol Reed, Powell and Pressburger, and has never recovered. He laments the way a filmmaker's life is squandered working on 'movies that we fail to make' and the choice for a British director that has become 'to stay at home and do small pictures, or to go to Hollywood and make big ones – or to do a bit of both, as I have done.' There is feeling of exhaustion, of the struggle not in the end justifying itself. Yet, at the time of writing, Boorman has a film set in post-Apartheid South Africa, *Country of My Skull*, in post-production, in which the themes that preoccupy him appear to be again central.

He writes endlessly about the difficulty of setting up a film, sometimes, as in the case of *Where the Heart Is*, of the impossibility of doing so. His book, *Money into Light*, is mostly about the seemingly endless struggle to finance *The Emerald Forest*, much of which was filmed

in Brazil. The go-ahead comes almost at the moment when Boorman is about to throw in the towel. His autobiography and the published script of *Hope and Glory* also provide rare opportunities to read first-hand accounts of the complicated pre-production and post-production processes for a film that came within a hair's breadth of not being made. On the basis of his first draft script, *Hope and Glory* was budgeted 'at around $10 million to the shock and horror of some studio assessors who had the impression of a rather small intimate picture'. Finally, an agreement came from André Blay at the video company, Embassy Home Entertainment, but there was still a financial hiccup to come. Blay needed the approval of Coca-Cola, which was being sold in a management buy-out led by him, but who for a fortnight more, still owned Embassy. Boorman's team were already building the huge set of Rosehill Avenue over fifty acres, 'which is probably the largest set built in Britain since the war', on a deserted airfield at Wisley. The blow came; Coca-Cola decided, after all, not to sell Embassy to Blay and his associates and the flow of cash suddenly stopped. With less than twenty-four hours before the film was to be closed down, Coca-Cola finally agreed to go ahead. Boorman does not give us the film's final budget, but Columbia, which Coca-Cola owned and had David Puttnam as its chief executive, distributed the film theatrically in the United States, provided the film with full backing, and took over the UK distribution rights. It was not a new ordeal for Boorman. *The Emerald Forest* and other films had also come close to not being made at all.

The struggle to attract the financial support and create a film is for Boorman not dissimilar to battles that have been fought in Britain before, against seemingly hopeless odds. They are made, as the 'Battle of Britain' was won in 1940, or as the Arthurian legends show, only with magical or seraphic intervention. In *Hope and Glory*, there are moments when such affecting things occur: the deliverance of fish after grandpa has despatched Bill and his sister Sue in a rowing boat under strict orders not to return until they have caught some. Just as they are about to give up and return empty-handed, a stray German bomber off-loads a spare bomb to explode in the river; within seconds, dozens of fish stunned by the blast are floating on its surface. As the children's' family stare astounded at the food-laden boat, his grandmother observes, 'It's like the feeding of the five thousand. It's a miracle.'

The mysterious and magic blend effortlessly in *Hope and Glory*. Immediately before war is announced, Bill is playing with his lead figures of Merlin and a knight 'riding through an emerald forest'. In Boorman's version of the Arthurian legend, Merlin, the superhuman and precocious court magician, guides the destinies of both Uther Pendragon and his son Arthur to forge a nation with one king. Uther, who is Chief of the Britons, misuses his power by having Merlin

transform him so that he can seduce Arthur's mother Igrayne, the wife of Cornwall. Merlin then enables Arthur, their offspring, to become king at the age of fifteen by drawing a sword that is lodged in a rock. With it, he defeats the heathen to create a single country with a single king. The myth of the national struggle in *Hope and Glory* and the 'People's War' is embodied in the voices of the two successive Prime Ministers, Neville Chamberlain and Winston Churchill. Chamberlain, the man of Munich, the 'appeaser' of Hitler, and Churchill, the man of destiny, who announces that he has formed a government of all parties and 'Now, one bond unites us all.'

The myth unfolds in Boorman's own family as well, not only in the triangular relationship of his father, mother and his father's best friend as the Arthur, Guinevere and Lancelot relationship, but also in the way in which the game of cricket is represented. Clive has signed on in the army, hoping to reclaim the status and excitement he had found in the First World War in which he ended as a Captain in the Indian Army commanding Gurkhas and was opening batsman for its cricket team. He and Bill are throwing a cricket ball to each other and playing around, when he suddenly pauses, wanting to entrust his seven-year-old son with a confidence. 'You're old enough now.' It is an intimate moment and, for a second, it seems to be about sex. Instead, Clive confides, 'Your hand is too small to master it, but not to start practising. Anyway I'm going to pass on the secret now, father to son, in case something happens to me.' He unfolds the mystery of the googly, a delivery in cricket, that wrong-foots the batsman, by appearing to be a leg-break, while actually being an off-break. It is a considerable moment in Bill's life, as significant as anything Arthur learnt from his stepfather, and later at Shepperton, under his grandfather's Merlin-like influence, he uses the knowledge to defeat his father.

After the family house is burnt out and Grace and her family deposit themselves on her father's home, Grandpa George, who has witnessed Bill's cricketing skills first hand, challenges his father, home on leave, and Mac to a cricket match: Clive and Mac against Bill and Grandpa George. Grandpa mischievously suggests that Bill sends down a googly. It completely deceives his father and bowls him out. Clive is dumbfounded, but in another exquisite moment intensely proud. When Bill had described the delivery as 'like telling fibs', he had responded, 'That's it. When you tell a lie, you hope to get away with it. When someone else does, you want to find them out. A good batsman will spot a googly. A good bowler will hide it. Always remember that son.' Grandpa George delights in their triumph. Like Merlin himself, he has guided and forged the development of the family. 'It's the law of life,' he guffaws, 'Cruel, isn't it.' The grandson he deeply loves has fulfilled his promise, just as he had returned triumphant when despatched to find food on the river.

It is not the end of the grandfather's Merlin-like achievements. He drives Bill in his school cap, holding his satchel and gas mask on his first day back to school after the summer holidays. Bill sulks beside him, neither wanting the end of the summer holiday nor to return to Rosehill Avenue. Grandpa is unhappy too, glares at Bill, and calls him a 'miserable little tripehound. I'm the one who should be fed up, sacrificing my last sup of black-market petrol to take you to school.' He puts him down, hurling abuse at the half-crazed headmaster as he passes by. As Bill enters the playground, it is mayhem; the children are deliriously celebrating the destruction of the school, which a bomb has hit an hour before, throwing their caps in the air and cheering. 'Thank you, Adolf', says one of Bill's friends, looking up at the sky. Bill rushes back to the car and Grandpa, who bursts into a 'barking' laugh that is almost out of control. It is a God-given moment of delight and the film returns to Boorman's narration.

Boorman has been fascinated with the Arthurian legends since childhood and steeped himself in them. Although modest about his work (for example, not attending the American Academy Awards ceremony in 1972, when his film *Deliverance* was nominated for Best Picture, Best Director and Best Editing. He considered Francis Ford Coppola's *The Godfather* 'a better picture' and was sure it would win), he is not without his own streak of precociousness. When at the age of eleven, an aunt bought him *Man and Superman* thinking it was a comic, he and his friend David digested George Bernard Shaw's scathing views on Christianity and 'fancied' themselves as Fabian Socialists. By that time he was introduced to John Cowper Powys' version of the Grail myth, *A Glastonbury Romance*, and 'had read Eliot's *The Waste Land* with enormous excitement … The deeper Arthurian England – an England that lay under the numbness of suburban life – held me in its thrall, alerted my imagination, and promised deliverance … In his notes, Eliot refers to Jessie L. Weston's "The Grail Myth and Romance" and I studied her theories as well. These Arthurian stories, "The Matter of Britain", were passed down in an oral tradition, shaping the psyche of Europe … Thomas Malory was commissioned by William Caxton … to write an English version of the "French Book" … Yet his *Morte D'Arthur* must certainly have drawn heavily on the stories he knew from the oral tradition. It also differs from the German version, Parzival [sic], by Wolfram von Eschenbach. It is remarkable how these three versions reflect their several national characteristics. Malory's is eccentric but practical … Eschenbach's is about an idiot savant's destructive quest for spirituality.'

Boorman's research does not stop there. He follows the legend through other arts. He visited Bayreuth with his daughter Telsche to see the *Ring Cycle*, 'whose Germanic myth has many elements in common with the Grail legend'. Wagner's music 'insinuated' its way into *Excalibur*,

Boorman's own version of the Arthurian legends, with the prelude to *Tristan and Isolde* used to 'underscore the tryst of Lancelot and Guinevere' and the prelude to *Parsifal*, becoming the motif for the quest for the Grail. His deep attachment to the legends is highlighted in his providing the foreword to a recent edition of Thomas Malory's *Le Morte D'Arthur*.

Apart from the thread of Arthurian legend that underpins the narrative of *Hope and Glory*, there is another strand: that of the cinema's influence on memory. In an early scene, Boorman, as narrator, remarks that, for all the talk about war, nothing happened, but the Hopalong Cassidy films of Saturday morning cinema, 'Now, that was the real thing.' The potency of cinema that the young Bill recognises is in its super-reality and is especially valued by the young. His dreams of the war adopt the qualities of cinema; they are in black-and-white, stylised and clichéd, internalised variations of the films he knows. One night, he falls asleep while listening on his crystal set to a news reporter broadcasting from France, and dreams that he is searching for his father on a battlefield strewn with dead bodies. The cinema not only provides the plots of his dreams, it modifies the way in which he sees he world. When the family home is destroyed by an unexplained fire, Bill rescues the tin in which he stores his lead toys and opens it to find them melted, a single mass, like the dead of his dream. It is a crucial moment; Grace understands it as a punishment for her infidelity; Bill feels that his world of imagination and fantasy has been ruined as a punishment for his killing a kingfisher with an airgun. It was an exchange of elements, fire for water.

The grail for Boorman is the cinema itself. Boorman's ancestor in British cinema is Humphrey Jennings, who combined poetry, sound and image into metaphors for British courage of the period in *Fires Were Started* and *Diary for Timothy* (1945). *Hope and Glory* echoes *Listen to Britain* (1942) when, the morning after an air raid nearly kills Grace and two of her children, she sits down at the piano and plays first 'Begin the Beguine', then moving on to Chopin. As she does so, Mac, Molly, Dawn and a couple of neighbours are suddenly framed around her, totally without movement. Boorman's memory of the moment has been modified and transformed by the experience of cinema, so much so that it has become a simile. When the young Bill wanders to school collecting shrapnel after the first of the German bombing raids on the Croydon area, the devastated houses behind him are now a landscape of wreckage reminiscent of a Paul Nash painting, *Totes Meer Dead Sea* (1940–41), which is based on photographs of wrecked German aircraft in a field taken by Nash, an Official War Artist in the Second World War renowned for his landscapes recording the impact of aeroplanes. As in his pictures of the Western Front of the First World War, in works like *We are Making a New World* (1918), Nash reaches beyond

the simple documentation with a hushed surrealism that suggests death. Likewise, Boorman suggests life rumbling beneath the image but Bill's first concerned thoughts when he hears groans in the debris, that someone is trapped and injured underneath, turn to embarrassment as it dawns on him that it is a couple making love in the ruins from the night before. The soulless street set in the middle of a characterless Metroland is Boorman's equivalent of Luis Buñuel's image of the tree-lined avenue that is inexplicably stranded in the open countryside of *Belle de Jour*: 'It perfectly suggested the idea of these people coming from nowhere and going nowhere and will always be with me.'

Hope and Glory is a family narrative that exists inside the broader accounts of a nation at war and of the Arthurian legends; it is a living memory, shaped by the unconscious processes of remembering the past. It embodies myths on the forging of England, the fight for nationhood during the Second World War, the search for the grail and Boorman's feelings in the present. The triangle of his mother's love for his father's best friend is the family's renewal of the Arthur, Guinevere and Lancelot legend, part of the story of England. The pangs of jealousy that his father felt, as his mother cared for the man she loved in his final illness, are suggested in *Excalibur* when, with Merlin's help, Guinevere nurses Lancelot back to life and abandons her spouse, Arthur, for the man she loves. Boorman merges the myth of Malory's Arthurian legends, of the forging of the nation, of chivalry, and the search for the grail into those of his own family and those of 'the people's war' and underpins them with folk memory, popular song, photography, art and especially cinema. In Moscow, in 1977, he visited the museum that was once the home of the Soviet film director, Sergei Eisenstein, sat at his desk, and saw Eisenstein smiling at him 'out of the many photographs crowding the walls. It was an epiphany', writes Boorman, 'it was if [Eisenstein] was saying, "You must keep going. You have to make your transcendent movie."' The transcendent movie, 'that elusive grail', is for Boorman a film that transcends film. If *Hope and Glory* is not it, one wonders what Boorman had in mind.

Kevin Gough-Yates

REFERENCES

Boorman, J. (1985) *Money into Light: The Emerald Forest: A Diary*. Faber and Faber, London.
_____ (1987) *Hope and Glory*. London: Faber and Faber.
_____ (2003) *Adventures of a Suburban Boy*. London: Faber and Faber.

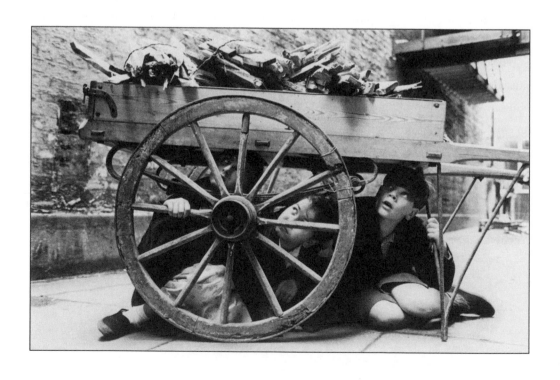

DISTANT VOICES, STILL LIVES

TERENCE DAVIES, UK, 1988

<div style="text-align:right">

18

</div>

'The British never were very gifted filmmakers.' With this one sentence, the French film direc-tor Jean-Luc Godard, in conversation with Colin McCabe in the early 1990s, dismissed the very notion of British cinema. Or nearly did so, for he admitted a single exception: *Distant Voices, Still Lives* (Terence Davies, 1988). And while we must allow for a degree of prejudice on Godard's part – as the existence of this volume clearly illustrates – that this particular film should have been singled out in this manner provides an indication of the huge impact it had across the world on its release, and of the high regard in which it continues to be held.

Distant Voices, Still Lives is Terence Davies' second film and, along with the *Trilogy* which preceded it (*Children* [1976]; *Madonna and Child* [1980]; *Death and Transfiguration* [1983]), and *The Long Day Closes* (1992) which followed, it forms part of the wide-ranging autobio-graphical project that dominated his work across these years. Davies was born in Liverpool in 1945, the youngest of seven surviving children in an Irish Catholic working-class family, and his autobiographical films explore both the magic world of childhood and the bullying, prejudice and misery that constitutes its darker side. In particular, the opposing influences of his gentle, loving mother and abusive, psychotic father constitute the main source of the tensions around which all his autobiographical films and, arguably, his life and character are structured.

However, although *Distant Voices, Still Lives* can be firmly slotted into this autobiograph-ical context, it nevertheless differs radically from the other films listed above. For instance, despite being autobiographical and, therefore, intensely personal and intimate, it contains no alter ego, no direct representation of Davies himself. Moreover, the majority of the events it depicts occurred before he was born, or while he was still very young. Instead of articulating his own memories and experiences, Davies is remembering the stories that he had been told throughout his childhood by his mother and older siblings (Eileen, Maisie and Tony), for so vivid were they that they seemed part of his own past. The role of story and myth in the crea-tion of individual identity is a fascinating aspect of memory, and its treatment here accounts for much of the film's originality and structural complexity, not least its multiple viewpoints and shifting tenses. As Davies' camera weaves in and out of the memories, terrors and fan-

tasies of the various characters, he creates a film of extraordinary power and beauty, in turn lyrical and unbearably painful, a film that continues to haunt the viewer long after leaving the cinema.

Distant Voices, Still Lives is actually composed of two distinct, yet entirely interrelated films, which were made in 1986 and 1988 respectively. It focuses upon Davies' family in a period which, in *Distant Voices*, ranges from 1940 to the mid-1950s, and in *Still Lives*, concentrates on the 1950s. Each of the two parts loosely chronicles the rituals of traditional family life: *Distant Voices* centres around Eileen's wedding, which is tightly interwoven with the funeral of the father, while *Still Lives* opens with the birth and christening of Maisie's daughter, and ends on the evening of Tony's wedding day. However, there is no conventional narrative development, and the film's meanings are created by its form and structure rather than by any chronological plot. Davies explains that this is because the film is about memory, and memory does not move in a logical or linear way but shifts constantly back and forth through time in response to triggers and events occurring in the present. He himself likens the film's complex patterns to ripples spreading out across the surface of a pond when a pebble is thrown in, one memory leading imperceptibly into another in circular and repetitive movements that reflect the emotional importance of events, not their chronological sequence. Thus, rather than simply depicting scenes from the past, this film sets out to recreate the very processes of remembering, and this is one of the features that accounts for both its striking originality and its emotional intensity.

Distant Voices, the first half of the film, was made in 1984, with financial backing from the British Film Institute Production Fund (set up to enable talented young British directors to make experimental low-budget features). The BFI and Channel 4 found this short film so outstanding that they were eager to fund Davies to make the second part that he had always planned, not least because a feature-length film was a far safer commercial prospect than a short. In May 1988, the complete version, *Distant Voices, Still Lives*, was screened to tumultuous acclaim in the Directors' Fortnight at Cannes where, as one contemporary reviewer put it, 'it outshone almost every other movie'. The International Critics' Prize at Cannes was just the first in a string of prestigious international awards, and the film quickly achieved the cult status that it retains today. It was therefore *Distant Voices, Still Lives* that brought Davies' work to the attention of a wider national and international public, and helped to establish his reputation not only as Britain's most exquisitely gifted filmmaker, as Philip Horne suggests, but as one of the most exciting and innovative of all contemporary directors anywhere.

One of the great strengths of the film is its unsentimental and unflinching examination of both the suffering and the joy of family life. The images throughout are beautifully composed and textured, and Davies recreates the bleak atmosphere of the time by filming with a coral filter, removing all primary colours (apart from red lipstick and nail varnish) from the sets and costumes, and processing the film using a complex bleach bypass technique. The resulting print thus reveals desaturated colours that are reminiscent of the hand-tinted photographs of the period, as well as perfectly capturing its atmosphere and mood. Davies' obsession with detail marks every aspect of the film, from the authentic costumes and sets to the naturalistic acting, and outstanding performances by Pete Postlethwaite as the father and Freda Dowie as his long-suffering wife are supported by a powerful and entirely convincing cast. One of the film's innovative features is the role it accords to music, especially popular songs of the period, which are heard for half of the film's running time. The songs are used less as a source of nostalgia than as one of the main ways in which Davies creates meaning.

Despite its immediate international success, *Distant Voices, Still Lives* gave rise to widespread critical debate, much of which centred on the difficulties of defining such an unusual film. Disturbing scenes depicting the father's violence are starkly realistic and these, along with the detailed depiction of working-class family life in post-war Britain, encouraged certain critics to situate it within the British documentary or realist tradition, particularly since it exemplified the defining characteristics of realism: deep focus, long shots, location filming, social subject matter, northern working-class setting, lack of stars, and so on. In these terms, Davies' working-class background was seen as proof of the film's particular, and unusual, authenticity.

However, any attempt to define *Distant Voices, Still Lives* as an example of realism is forced to take account of the film's extreme self-consciousness and formal complexity, which are the attributes of the so-called art-house films that are traditionally perceived as the antithesis of realism. While some critics therefore suggested that the film's formal concerns diluted its authenticity and lessened its value, others argued, no less passionately, that the source of the film's power was not its 'realism', but its striking textures and images, subtle rhythms and innovative camera work. Such critical wrangling is pointless, for to understand the film it is essential to recognise that it is both social document and aesthetic composition, both complex and easily accessible, and that it combines both the British documentary and the European *auteur* traditions.

It is important to view *Distant Voices, Still Lives* within a wider European context, not only because of its status as an *auteur* film evoking widespread comparison with the work of

directors such as Bergman, Bresson, Kiéslowski and Tarkovskii, but also because it fits into the category of autobiographical, first-person memory narratives that flourished across Europe in the 1980s and early 1990s. Given that autobiography is hard to classify in terms of form or genre because it is both realistic and fantastic, intensely personal and yet universal in its appeal, it is clear that many of the problems in defining *Distant Voices, Still Lives* disappear altogether if its autobiographical status is acknowledged. But what makes this particular film so fascinating, and what distinguishes it so clearly from most other autobiographical films is Davies' desire to explore memory by recreating the very processes of remembering. In *Distant Voices, Still Lives*, therefore, it is not possible to separate form and meaning, and pointless to attempt to distinguish between realistic content, on the one hand, and self-conscious formalism on the other. Significantly, Davies is one of a small number of directors for whom the composition of film most closely resembles music, and, if the fluid camera and complex patterns of *Distant Voices, Still Lives* are neither chronological nor plot-driven, they may instead be recognised as musical and harmonic. Unravelling some of the implications of this notion, as well as noting the innovative role that Davies accords to music throughout, will perhaps provide the clearest indication of the film's freshness and originality.

To illustrate Davies' originality, I have chosen to examine a single sequence from *Distant Voices, Still Lives*. The sequence, depicting a childhood Christmas, lasts just four minutes and, at first glance, appears straightforward and insignificant; however, closer analysis reveals its ability to create and develop multiple layers of meanings in ways that afford insight into the composition of the film as a whole. It occurs some thirteen minutes into the film, immediately following scenes which interweave shots of Eileen's wedding with shots of the father's funeral. The sequence is unusual to the extent that it marks one of only two occasions when the father is depicted in a positive light. Why this should be so, and how this new viewpoint modifies or reinforces our earlier understanding of the family dynamic, will constitute one of the objects of the analysis here. The sequence divides into two distinct sections: the first, occupying all but the last ten seconds, gives a nostalgic portrayal of Christmas as a joyful family occasion, but this picture is completely undermined in the brief second part, whose brutal and disturbing images confront the viewer with fundamental questions about the (un)reliability of memory, the instability of viewpoints, and even the nature of truth and reality. This brief sequence therefore provides an example of Davies' directing at its most economical and its most devastating.

It opens with a Christmas carol, that most nostalgic of sounds, as a solo voice sings the familiar opening lines of 'In the Deep Mid-Winter', and it is this carol that both motivates and

structures the events that follow. (The carol here replaces the popular songs that perform a similar function elsewhere in the film because its nostalgic impulse specifically targets Christmas.) When we first hear the carol, the screen is still showing Eileen and her husband on their wedding day as she sobs disconsolately for her dead father. But as the carol continues, the camera moves away from the couple and begins a long, slow track from right to left. While the slow track to music is a characteristic of Davies' work, in film language, of course, camera movement from right to left across the space of the screen generally indicates a parallel movement back in time and, indeed, when we next see Eileen and the others they are once again children. That the Christmas carol should provide the impetus for a return to the past is part of its function as nostalgia, and Davies knowingly exploits its power to draw us, the viewers, emotionally into the sequence. As the camera tracks through the darkness, we see the exteriors of the buildings it passes, their lighted windows alone indicating the unseen dramas going on inside. One of the clear messages that the film portrays through its detailed focus on the inner world of Davies' family is the extent to which domestic life, concealed behind the walls and net-curtained windows of the terraced streets, is isolated, troubling and secret, and this feeling is intensified here as the camera slips past a succession of such private spaces. At one moment, passing the pub, we hear distantly the voices inside, but even that world is closed to us. Perhaps Davies is suggesting that nostalgia, for all its powerful evocation of the past, only shows us what we want to see, so that access to other areas of memory, particularly painful or uncomfortable areas, is denied. Moreover, given the extreme self-consciousness of all Davies' work, it is not unreasonable to see in the lighted windows that the camera slowly passes a reference to the frames in a spool of film, each of which potentially has any number of powerful stories to relate. Equally, Davies may be commenting here on the whole notion of film as a vehicle for exploring and (re-)creating the past.

As the first verse of the carol draws to a close, with the line 'In the deep mid-winter, long ago' (with the musical emphasis on '*long* ago'), the tracking camera reaches, or seems to discover, a bank of lighted candles surrounding a statue of the Virgin Mary. In front of the statue, the entire family is gathered, lighting candles and folding their hands in prayer, in what appears to be a nostalgic and sentimental evocation of the spirit of Christmas past. The carol continues, as does the camera's slow track for it passes the family without a pause, but as we move into the street where the Davies family lives, a choir replaces the solo voice. As if in response to the carol, the lighted windows now contain symbols of Christmas: a star, a garland or a string of tinsel. At this point, nostalgia literally transforms the landscape of memory, for the lyrical soft-

focus of the camera is intensified by the Christmas-card snow which magically softens the hard contours of street and houses, transforming a simple wooden fence with a glittering layer of snow, or a window with intricate patterns of frost. The camera reaches the window of Davies' house and through it, softly framed by snow, we can see the father as he carefully decorates the tree. This is the first time in the sequence that we have been permitted a glance into a domestic interior, and it is at this point too that the first cut in the sequence occurs. The cut transports us inside the house where, for the first time, the camera pauses. We watch the children, standing close to their mother, as they wish their father goodnight. He turns to them (and us), smiles, and replies 'Goodnight kids'. The next cut moves us into the children's bedroom as the father enters with exaggerated care to hang up their bulging stockings. From what appears to be the father's point of view, we see the children as sleeping cherubs, cutting to a medium shot of his face as he stares lovingly at them and murmurs 'God bless, kids'. There is a close-up of his hands as he tenderly hangs the stockings at the foot of the bed, and a fade to black as he closes the door behind him. The carol then transports us, directly and without warning, into the next scene in which the children and their father are sitting around the table which is laid for Christmas tea. The setting is somewhat theatrical, in that the chair in front of us is empty, so that the father, at the head of the table, faces us directly, with the children on either side. The carol stops abruptly, and in the frozen silence that replaces it, the children watch their father, first apprehensively and then with increasing terror, as he sweeps the cloth and all the food and dishes off the table in a sudden rage, screaming for his wife to clear up the mess. Christmas is over, and the following scene will reveal the father in hospital as we move into different memories and times.

I began by suggesting that this sequence is basically simple, and indeed, as we have seen, it contains relatively few actions and does not really serve to propel the narrative forwards. It is not particularly dramatic, and it might be tempting to confuse its knowing nostalgia with sentimental naïveté. Nevertheless, its impact on the viewer is considerable, and its subversion of time and space, its insistent foregrounding of music, and its contradictory viewpoints already indicate something of the film's innovative techniques. Furthermore, the sequence reveals how Davies creates meanings not only from the images that are shown, but in the tensions and spaces between them, and through their shifting relationship with music. For all its apparent simplicity, the real complexity of the sequence pinpoints the power of Davies' directing.

As we have seen, the sequence divides into two parts of unequal length. It is important to note that the duration of the first part, with its nostalgic images of an ideal Christmas, is actually determined by the length of the carol that we hear in its entirety. We have already identified

the carol as a source of nostalgia, for it leads back to the past, while the mobility of the camera articulates memory as process, as a form of time travel. When the carol ends, it is replaced by silence, as we observe the frozen family tableau. In that silence, the camera too is static, for trauma, it is known, blocks remembering, and Davies portrays the stasis that results as the antithesis of music, as well as the denial of movement, change and hope.

If, in this sequence, music performs both as narrative impetus (for it is the carol that creates the nostalgic return to the past), and as structuring device, it also creates and develops fundamental layers of meaning. Through the opposition between silence and music noted above, Davies is able to explore the processes of memory and the stasis of trauma, without having to explain or illustrate these openly. And because our response to music tends to be instinctive and powerful, we, the viewers, approach these memories from within, emotionally involved even as the conflicting realities that confront us require an intellectual response. This technique, specifically the stark opposition between those moments when music is heard and those when it is not, is used in a similar way throughout the film. In general, the father's presence on screen is marked by his inarticulate violence but also by the oppressive silence that heralds such violence, whereas songs and music occur almost only when he is absent, and almost always in association with the mother. Thus the dialectic between maternal nurture and paternal violence is expressed by the form of the film as much as through its narrative content. As a result, the function of music is never merely supportive since it is at least as vital to our understanding of the film as other, more traditional signifiers such as dialogue or action.

The first part of this sequence is one of only two instances in which the father's presence on screen does coincide with music, as well as being one of the only two instances in which his image is not entirely negative (the other shows him whistling as he grooms the horse that pulls his rag-and-bone cart). Hearing music as we observe his loving treatment of his children, we might be tempted to revise our earlier understanding of the father as brute and bully. However, to do so would require us to accept as reality events that Davies clearly represents as nostalgia. Moreover, the silence of the second part, along with the frozen family tableau and motionless camera, quickly reinforces our previous understanding of the father as source of violence and trauma, making us doubt the events that we have witnessed in the first part, and its viewpoint. It is certainly not that of the director, for Davies makes no bones about his continuing hatred of the father and, in any case, we know that the memories that form this narrative are not his own. The immediate context of the sequence suggests that we may be seeing Eileen's idealised and emotional memories but this would contradict the experiences portrayed in the rest of the film,

so the first part of the sequence remains highly problematic and causes us to question whose memory shapes the second part.

Significantly, this sequence which was initially seen as a simple, romantic evocation of Christmas, not only provokes disturbing questions, but also explores further the father's influence. In shots of the family group assembled on Eileen's wedding day, for example, the screen is dominated by a black-and-white framed photograph of the father, positioned on the wall in such a way that it occupies a central position in the family group, reminding us that his influence continues, even though he is dead. In the second part of the sequence, however, in which the father is still alive, he actually occupies that central position, while on the wall immediately behind him hangs a mirror which reflects the back of his head. Mirrors are generally used in films to reveal something about a character's search for identity, but here it serves as a powerful metaphor for the two conflicting versions we have seen, and the problematic nature of the father's personality.

By using the same carol to link these two very different scenes, Davies allows nostalgia to develop freely and then to be attacked and destroyed from within. Thus he clearly demonstrates that childhood was never perfect, even at Christmas, and within this new reading, the actual words of the carol acquire new significance. This mid-winter world is indeed bleak, icy and frozen. It is in fact the embodiment of stasis and despair and, if anything, the antithesis of the 'reality' depicted in the first part of the sequence, coloured by the potent nostalgia of the remembered music. In this way the sequence acquires deeper resonances with each new interpretation, and given that similar processes are going on in and between all the sequences that structure *Distant Voices, Still Lives*, something of its complexity can be glimpsed. Rejecting the rules that dominate mainstream narrative, Davies embraces ambiguity, and his film repeatedly poses open-ended questions to which there are no right or wrong answers.

Distant Voices, Still Lives reveals Davies to be one of the most original and challenging of all contemporary directors but, as I have attempted to show, it also reveals him to be one the most empowering. In his demands for the emotional, intellectual and, above all, creative involvement of the viewer, he creates a film that does not tell a story so much as provide each of us with the possibility of telling ourselves a story, or indeed a range of different stories. It is true that, like a piece of music, the film weaves its meanings through its shifting tones and harmonies, its rhythmic contrasts, and its intervals and silences as much as through its haunting images and this might suggest a daunting complexity. However, the layers of potential meanings that the film offers allow individual viewers the freedom to discover their own meanings,

to tell their stories, and thus the film is never obscure or pretentious. Indeed, all the time that critics were striving to unravel its complexities or to define its form, its generic identity, or its techniques, Davies was receiving letters from people all over the world telling him that the film had somehow unlocked their own childhood memories and had spoken directly to them. That power, or that empowerment, is surely its greatest legacy.

Wendy Everett

REFERENCES

Davies, T. (1992) *A Modest Pageant*. London: Faber and Faber.
Horne, P. (2000) 'Beauty's slow fade', *Sight and Sound*, 10, 10, 14–18.

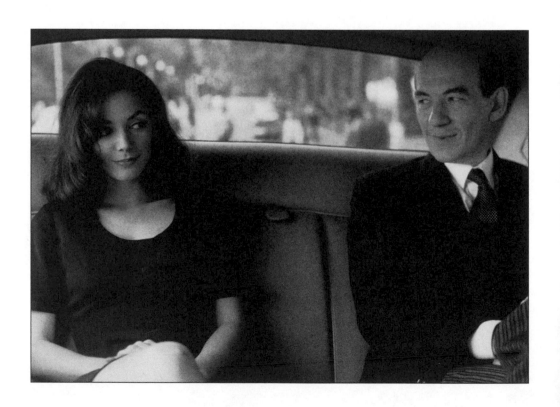

SCANDAL

MICHAEL CATON-JONES, UK, 1989

To begin with, a handful of symmetries, intended or serendipitous as the case may be. *Dance With a Stranger* (Mike Newell, 1985), the film about Ruth Ellis, the last woman executed in Britain, has a moment set in the 'hostess' club that Ruth manages, where her young lover creates an embarrassing scene. Ruth tells a girl who has been coolly looking on, not to take it seriously. The girl replies, 'I don't take any of them seriously. They've still got their mother's milk running down their faces.' Younger, fresher than Ruth (Miranda Richardson), she is also harder, less vulnerable. This cameo was acted by Joanne Whalley who, four years later, played Christine Keeler in *Scandal* (Michael Caton-Jones, 1989). *Dance With a Stranger*, though it cannot have foreseen Whalley's later role, nevertheless brings into fleeting relationship (wholly mythic, since Keeler was a child in 1953) the two iconic figures of Ellis and Keeler by naming what might easily have been a nameless part – Christine – which, I suggest, reads inevitably as Christine *Keeler*, even without the emphasis given by Whalley's later characterisation. That the later film is clearly conscious of its predecessor is shown by its adopting that scene's background music (Guy Mitchell's 'She Wears Red Feathers and a Huly Huly Skirt' [1953]) and turning it into the stage number in Murray's nightclub where Stephen Ward (John Hurt) first sees Christine Keeler. There she straddles a dolphin which is also a bicycle that she pedals, skirt riding high, as he watches her, invoking the narrative's opening where Ward gazes with sensuous appreciation at a girl cycling by (repeated with another girl just before his arrest).

These moments also recall images from *Wish You Were Here* (David Leland, 1987), in which the dissatisfied teenage heroine Linda (Emily Lloyd) provocatively rides her bike in a repeated motif of frustrated liberation. It has been noted by John Hill that *Wish You Were Here* is 'loosely based upon the early life of Cynthia Payne, whose subsequent career as a brothel keeper also inspired the film *Personal Services* (Terry Jones, 1986)'. Though there the heroine's surname distortedly reminiscences its source (Payne to Paynton), her Christian name slides from Cynthia to Christine, as if this film too is eager to join the earlier woman of scandal to the later. In *Absolute Beginners* (Justin Temple, 1986), a musical version of Colin McInnes' novel of 1950s teenage subculture, the hero's promiscuous mother is acted by a

real-life Profumo affair player, Mandy Rice-Davies. A last related intersection: John Hurt who plays Stephen Ward in *Scandal* also played Timothy Evans, the victim of *10 Rillington Place* (Richard Fleischer, 1970), American-directed, but quintessentially British in its cast, setting and fascination with institutional injustice and the dingy trappings of literally murderous frustration and sexual crime.

Such intertextualities declare not only the Profumo Affair's continuing fascination, but also *Scandal*'s self-conscious placing of itself in a line of 1980s films which replay the 1950s (and just before and after) as distinct from the periods favoured by 'heritage' cinema. Noted by some reviewers at the time, this was later reformulated by Hill in his *British Cinema in the 1980s*. There (following Fredric Jameson's observation that '*ideas* of facts and historical realities' predominate over 'facts or historical realities') the critic notes two dominant retrospective meanings for the 1950s – the first, a nostalgically perceived lost stability; the second, an era of repression containing, however, incipient if defeated revolt, 'the harbinger of things to come': 'It is this version of the 1950s which the films of the 1980s primarily invoke.' He cites *Scandal, Dance With a Stranger, Wish You Were Here, Personal Services, Chicago Joe and the Showgirl* (Bernard Rose, 1990), *The Krays* (Peter Medak, 1990) and *Let Him Have It* (Peter Medak, 1991) – all, more or less, biopics. To them might be added other films that are – *10 Rillington Place* (as a significant earlier predecessor) and *Prick Up Your Ears* (Stephen Frears, 1987) – and others that are not – *Absolute Beginners* and *A Private Function* (Malcolm Mowbray, 1984). Significantly, Hill further writes that 'the treatment of these characters is less governed by biographical or sociological accuracy than the symbolic value which they seem to possess. This mix of criminals, deviants and social misfits seems to offer a set of characters who are in protest against the drabness and conformity of the society around them.'

Whether particular viewers accept such 'symbolic value' over fact depends, of course, on many variables. Here it is worth emphasising that the question is hardly new. *Scandal*, like its siblings, is not only a 'true story' but a historical film, even though the period reconstructed is very close – as Edmund White's statement, that his *A Boy's Life*, written in the 1980s about the 1950s, is a historical novel, recently underlines – and therefore part of the genre, if we add film to the novel and drama, addressed by Georg Lukacs in his famous work *The Historical Novel* (1960 [1937]). Lukacs, whose primary points of reference are Shakespeare, Scott and Goethe, defends – as long as certain conditions of historical significance are met – the distortion of historical fact, especially in the drama (film?) where, with the mode's propensity for foregrounding real historical protagonists rather than placing them in the margins as is the

novel's tendency, such contradictions occur more prolifically. Lukacs, for whom the art work embodies not so much 'the complex, actual historical causality' of a situation as 'the human collisions which spring necessarily and typically' from it, thus defends Goethe turning the historical Egmont 'from a married man with a large family into a radiant, captivating youth with no family at all'.

The parallel in *Scandal* is the central couple's softening. It downplays, for instance, Ward's interest in prostitutes and the more toadyish aspects of his social climbing, mediating his vices through John Hurt's 'ruined boy' looks and compelling voice into the actions of a largely benign Professor Higgins of the sexual revolution. And it mitigates his Eliza's hard emptiness through Joanne Whalley's vulnerability until she appears something very different from Ludovic Kennedy's contemporaneous report: 'It was a terrifying little face, vacant yet knowing; and it belonged not to a girl of twenty-one but to an already ageing woman.' The change is most vividly dramatised in Whalley being pressed against a wall by the rapacious press, the opposite of Bridget Fonda's infrangible Mandy Rice-Davies, whose cheerful hardness revels in the theatre of publicity. The other related invention is the love plot between Ward and Keeler, albeit an odd, hyper-romantic romance, platonic and unconsummated, at the centre of a world of promiscuity and sexual experiments which both of them notably indulge in, with others. This is especially explicit when Christine tells the policeman pushing her towards betraying Ward that Stephen is the only man she has ever loved; in her visiting him during the trial, in her unanswered phone call as he slips into a nembutal-induced coma, and in the metamorphosis of Ward's much-documented interruption of Mervyn Griffith-Jones' cross-examination of Ward himself to protest at the prosecution's low-life witnesses, into his selfless condemnation of his defence lawyer's interrogation of Keeler: 'This is unfair.'

Are such fictions comparable to Lukacs' instances from Shakespeare, Goethe and Balzac? Viewers must answer this for themselves. We may, however, note that the romanticisation of the social-climbing voyeur-pander and the party girl/prostitute is at one with the rest of Hill's neutral statement on the 1980s revisionist films, that 'even in those cases where crimes were actually committed, the offences are often seen in metaphorical terms – as forms of social and sexual transgression as much as criminal acts'. Further complicating the question of *Scandal*, this romanticising does not delete but exists in relationship to more unideal, if often still softened elements – Ward's voyeurism and perversity, Christine's hardness and self-deceiving assertions that she is not a prostitute (the camera literally foregrounds the two banknotes Profumo [Ian McKellen] leaves for her mother), and the pair's betrayals of each other. Presumably if we jus-

tify the major distortions, such workings of the reality principle are fundamental, since without them the story would lack the appeal of its perversities as well as becoming the less interesting story of two innocent victims rather than that of two far from innocent exploiter-victims of the society which eventually destroys them.

Scandal was still a controversial project in the mid- to late 1980s. Its final form was as the debut film of Michael Caton-Jones, a Scottish-born director, who, on the back of its success, left immediately for a still-continuing Hollywood directing career of films, without, excepting Rob Roy (1995), reference to British subject matter. These hardly impel an auteuristic reading of Scandal, towards which there seem more fruitful approaches, especially considering that Caton-Jones' direction is the last link in a complex genesis, which began with a projected television mini-series originally to be directed by Stephen Frears. There is much evidence that this ran into top-level opposition both at the BBC and ITV and that the decision to abandon it for a feature film was the result of considerable obstruction. The film's makers milked at least some of the controversy surrounding its making, though the notoriety that helped sell the film also impinged on the text, inasmuch as considerations of libel affected it in various ways (for instance Douglas Fairbanks Jr threatened action if portrayed, so that Trevor Eve's amusing American star who has troilistic sex with Keeler and Rice-Davies was finally called David Fairfax Jr). There were influential if ineffectual calls to abandon a film unfair to a rehabilitated Profumo, and a minor furore when it was discovered that the Conservative government had, inadvertently, indirectly part-funded the film.

Prior to production there was much exploitation of interest in who were to impersonate notorious real-life figures. (Emily Lloyd was chosen to play Mandy Rice-Davies – another intersection to add to those with which this chapter began – but was unavailable, and was, with an eye on the American market, replaced by Bridget Fonda.) The film's release was surrounded by major publicity, in which those of the real-life principals (who obviously did not include Ward for one reason and the Profumos and the police for others) who were willing, joined. Keeler indeed reworked her previous memoir into an edition released to cash in on the film. Some newspapers ran retrospectives of the affair. Highlights included coverage of afternoon tea between Christine Keeler and her impersonator and Keeler attending the première with her son. By 3 March 1989, according to The Guardian, the film had already taken £1.5 million, with Palace Pictures providing a paradigm for the British film industry by striking two hundred prints for saturation release. Reviewing of the film was widespread and prominent and basically divided between poles of approval – vindication of Ward, condemnation of the establishment

– and disapproval – dislike of the film's perceived softcentredness and superficiality. It is probably true that *Scandal*'s reputation has diminished while that of other films linked to it (*Wish You Were Here* and *Dance with a Stranger* in particular) has increased. My own sense is that *Scandal* remains more interesting than its diminished reputation suggests, and what follows tries to indicate why.

Centring on Ward and Keeler's relationship, visualised through the filters of romantic softening and the symbolic values already mentioned, the narrative largely replays the known facts, selected from manifold documentary sources. Governed by the temporal economy of a film rather than mini-series, *Scandal* of course omits much (sometimes for legal reasons) but often appeals to the cognoscenti by allusion – for example the photos of the corgis at Cliveden suggesting Ward's contacts with royalty, the song 'Goodness Gracious Me' insinuating Dr Savundrah, much mentioned at the trial, and Ward's cloying way of addressing Keeler as 'little baby' deriving from Keeler's autobiographies. In line with the couple-centred format, the narrative all but begins as Ward meets Keeler at Murray's nightclub, pursues her, and then grooms her for success. Through Ward she and Rice-Davies enter a world of privilege and orgies, and Keeler sleeps with both Ivanov, the Russian naval attaché, and John Profumo, the War Minister, simultaneous attachments that, when revealed, cause the notorious security and sex scandal. Her concurrent low-life affairs with the West Indians Lucky Gordon and Johnny Edgcombe spiral into violence, which threatens Ward's reputation and causes him to break with her. She, as the Profumo scandal threatens to surface, sells her story. Despite attempting to help his friends Profumo and Lord Astor (Leslie Phillips) suppress the affair, Ward suffers the establishment's revenge. Dropped by his friends, including Lord Astor, abandoned by MI5 for whom he has done some amateur surveillance of Ivanov, he is brought to trial on trumped-up pimping charges, and his protégées pressured to incriminate him. Ruined, he commits suicide before the guilty verdict is brought in, though his lonely demise is aureoled with the love bond of Keeler's unanswered phone call.

Neither a courtroom drama (the trial is only briefly staged), nor an inquiry into Ward's guilt (he is plainly innocent of the charges), *Scandal* drastically simplifies the case's politics, with not a sign of the Labour opposition anywhere, let alone the roles played by such as the MPs George Wiggs and John Lewis. We briefly glimpse a stand-in for Macmillan in the Commons, but none for Wilson. Such omissions stylise the narrative less into a realistic political situation than a collision between reaction (anti-pleasure, or pleasure for the upper classes alone) and liberalisation, with the former contracted into the unnamed Tory MP played by James Villiers

(noted for portraits of hyper-civilised brutality and upper-class arrogance such as Captain Midgeley in *King and Country* [Joseph Losey, 1964] and Lord Langham in *Nothing But the Best* [Clive Donner, 1964]). His Scotland Yard phone call, later denied, begins the persecution and his interview with Ward, based on a meeting Ward had with Macmillan's private secretary, embodies both supercilious disdain and deceptively bland threateningness.

All this further argues that the film is most significantly seen in the context of the gains and losses of the sexual revolution, with Ward and Keeler elevated into (unlikely, flawed) harbingers of change, even unconscious martyrs for the faith. It is this, plus a large quotient of unexpected comedy (such as the troilism scene with Christine, Mandy and the American star; Christine and Mandy's battle for predominance in the 'Runnin' Bear' cabaret number, Ward's speculation that marijuana's effects might be like 'a stiff Pimms') that produces the film's largely optimistic feel – a transgressive phoenix rising from the crematory ashes of Ward's plummeted cigarette ash, the film's final image. 'No one turned up' one of the film's postscripts notes, to Ward's funeral, but the present audience would know better. Many of the early episodes cultivate a lighthearted feel, as in the following exchange:

Ward: You'll be happy here with me … and my friends.
Keeler: You make it sound like a dare.
Ward: Oh, do I? Well, perhaps I do. Never say no to a dare, Christine. You never
 know what you might miss.

That sense of transgressive 'daring' tends to outweigh what might otherwise be interpreted only pejoratively, the interclass mixings as merely another version of upper-class buying of lower-class bodies, the interracial minglings as merely privileged white slumming. The point is not that the film denies such realities; for instance, Christine, though she appears to obtain more pleasure from her black lovers and drugs than from her higher-placed consorts (at one point she yawns while having sex with Profumo), is quick to abandon Johnny when he threatens her social climbing – but that it projects the feeling, pronounced if often interstitial, of the flawed contacts symbolising more positive potential class and racial trans-shiftings, in this case as much carried by the partying music (as the DJ says 'The young sound of Jamaica, I love it') as by the action.

A brief examination of *Scandal*'s opening three sequences will suggest in more detail how such, often implicit, meanings are produced. It should be noted that an alternative opening

exists in some prints, prefacing what is outlined here with a preview of Keeler exiting the Old Bailey to be assailed by the press, a sequence occurring towards the end of the film. But this does not alter what is suggested below, only adding further to the sense of the character's victimisation.

1. The titles/late 1950s montage: Frank Sinatra's recording of 'Witchcraft' opens the film, first as sound alone, then over a collection of slow-motion images representing the late 1950s. This establishes a thematic of the allure of sexual desire, or, rather, a male celebration of female sexuality, wittily demoting a host of implicit theological and moral views into terms of secularised pleasure – 'witch' (''cos there's no nicer witch than you'), 'wicked', 'witchcraft', 'conscience' 'although it's strictly taboo') and a call not to resistance but to action: 'proceed with what you're leading me to'. This plays throughout the following newsreel, or in one case, fake newsreel, images: (i) Macmillan and Eisenhower, circa 1959; (ii) toffed-up boys and girls ballroom dancing; (iii) schoolboys playing on an improvised roundabout; (iv) older girls laughing together (echoing the sexual separation of the previous image); (v) the curious insertion of an image of Jeroen Krabbé as Ivanov swigging Kruschev-like from a bottle at a banquet – rationalisable as the first instance of the film's switchings between its own diegetic world, real newsreels and imitation newsreels in which the actors portray the historical figures caught by television and photographs; (vi) at some Royal Navy exhibition an audience watches a boy trampolining; (vii) a youth kisses his girlfriend, lifting her moped helmet to do so; (viii) a girl is watched by another audience as an instructress helps her toss a pancake; (ix) the comedian Ken Dodd mugs at the camera, a policeman in the frame; (x) another audience, all children, laughing at, the cut suggests... (xi) large men in kilts locked in a Highland wrestling embrace; (xii) the laughing children again; (xiii) finally, mysteriously, a waiflike boy (guiltily?) hurries away clutching a parcel, looking back at the camera as he goes. Out of the possible meanings that might be generated from the song's and images' interplay, one predominant thread is the presence of children (from pre- to post-adolescents) as both actors and audiences framed by Ike and Mac as the (seemingly asexual) father figures of a (repressive?) age. These innocent seeming pre- and post-adolescents of circa 1959 have become, I take it, the relatively youthful 1989 audience addressed by *Scandal*, invited to review their beginnings, and to see the narrative events that follow as, to use the word again, 'harbingers' of the socio-sexual changes of their world. These images of 1959 may be viewed critically (as repressive), or nostalgically (embodying a lost innocence), or both together, but they represent a foreign country, which, however, the narrative shows in transition, so that, while the historic children probably only laugh at the clumsy comedy of the

wrestlers staggering against each other, their selves in the later audience have the perspective to note the image as made ribald by homosexual connotations and knowledge of the cultural importance of the homosexual parts of the 1957 Wolfenden Report. The final image of the waif resists complete explanation, but perhaps suggests something carried (stolen?) from past to future where, beneficent or Pandora's box-like, it will be opened.

2. Stephen Ward introduced: A bus traverses a London street in newsreel monochrome which turns into colour (prefiguring many other colour/monochrome swiches between diegetic reality and media versions of it in the film). On a spring or summer's day in 1959 ('Bliss was it in that dawn to be alive') Ward buys a newspaper from a vendor who comfortably calls him 'guv', and then watches with pleasure a tartily overdressed girl promenading her dog. But then his eye is caught by, and he watches even more pleasurably, a younger, less artificial girl riding her bike, evoking memories of Linda/Emily Lloyd in *Wish You Were Here*. The juxtaposition not only suggests Ward's interest in the natural and untransformed as object of his transformations, but also implies retrospectively, and less optimistically, that the second might turn into the first. Elsewhere sequences based on the confrontation of naturalness with artifice trouble simpler lines of meaning, as where, at Ward's behest, Christine emerges from the bathroom (echoing Kim Novak in Hitchcock's *Vertigo* [1958]) her fake blonde hair replaced by a more natural colour, and Ward then removes her false eyelashes, yet we cannot but be aware that the transformation has the sheen of a hair rinse. Another striking scene, where (to the Shadows' 'Apache') Christine and Mandy, in a riot of fetishistic fragmentations of body parts, doll up for a night on the town, seems, beyond its quota of satire, as much celebration as denigration of artifice.

3. Ward meets Keeler at Murray's nightclub: Cut from Ward on the pavement to male singer and chorus girls performing 'She Wears Red Feathers and a Huly Huly Skirt'. Though the number has elements of ironic critique – comic *faux-naif* exoticism, denied by the silver and white costumes of the dancing girls, with not a grass skirt in sight – its bouncy geniality, like that of the later stage number 'Runnin' Bear' and the music organising other montage passages – for example 'Roll Out Those Lazy Hazy Crazy Days of Summer' for the Cliveden sequence and 'Let's Do the Twist' for the newsreel sequence bridging 1961 with 1962 – casts an indulgent aura over the club's 'knocking-shop' aspects. The lyrics, with their respectable London banker escaping to the music hall where he is smiled at by 'a pearl of a native girl' – like those of 'Runnin' Bear' with its story of frustrated love among opposed Indian tribes – comically inflect the prevalent thematics of liberation and denial. The sequence around the

number has less savoury aspects – one of Keeler's young Arab boyfriends is transformed into a seedy older Arab, the questions of Ward's 'eye' and 'wickedness' (the latter developed in a later brief encounter with Rachman) are ambivalently raised, and Keeler, in words that foreshadow the film's interest in the media's creation of hollow celebrity, appears both stupid and vulgar as she dances with Ward and insists of his partner of the evening 'She's on the telly in't she?' to which he replies 'When she's not flat on her back.' However, the centre of the sequence is where Ward watches Keeler on stage in an epiphanic extended moment of slow-motion, subjective sound and the mythological overtones of her dolphin-riding (cycling), surrounded by the fire of the sparklers held by her attendants while Ward, transfixed, watches her, until, after his head jerks out of his hypnotised state, he lights the cigarette at his lips, the flame of his lighter echoing the sparklers (and, no doubt, the desired but malign fires of the photographers' flashes to come).

At the election-night Conservative victory party near the film's beginning, which does much to establish its historic moment, the MC prefaces Macmillan's 'You've never had it so good' with the comedian Tommy Trinder's catchphrase 'You lucky people'. Like much in *Scandal* this works ambivalently, satirising materialist desire (the boorish MC, the fat cats and chorus girls), but also signalling the film's characteristic intersecting of politics with comedy, as well as acting out, socio-linguistically, class trans-shiftings (Trinder's demotic address notched up several classes, Macmillan's sign-of-the-times assumption of the populist notching down several). Last, but not least, there is also the significance of the MC's *double entendre* where having 'it' and being 'lucky' have meanings less economic than sexual (at the very least the two together). The moment, like others discussed above, is characteristic in its mixture of satire, documentary and comedy, and in the way, within the satiric moralism that is the obvious register for the subject, other 'structures of feeling' infiltrate, even at times dominate the film.

Bruce Babington

REFERENCES

Hill, J. (1999) *British Cinema in the 1980s: Issues and Themes*. Oxford: Clarendon Press.

Keeler, C. (1989) *Scandal*. London: Xanadu.

Kennedy, L. (1964) *The Trial of Stephen Ward*. London: Gollancz.

Lukacs, G. (1960 [1937]) *The Historical Novel*. Harmondsworth: Penguin

White, E. (2003) 'More History, Less Nature', *Times Literary Supplement*, 25 July, 11.

THE MIRACLE

NEIL JORDAN, IRELAND/UK, 1991

Neil Jordan is the most versatile and prolific of artists; as well as being Ireland's leading film director, he is an award-winning short story writer, a novelist, scriptwriter and film producer. Similarly, as a director, he refuses any tight classifications. He has worked within varied production contexts, both in terms of budget and of the very different film industries of Ireland, Britain, the USA and France. His films have ranged from big-budget spectacles – *High Spirits* (1988), *We're No Angels* (1989), *Interview with the Vampire* (1994), *Michael Collins* (1996), *The End of the Affair* (1999) and *In Dreams* (1999) – to medium-sized projects – *Mona Lisa* (1986), *The Crying Game* (1992) and *The Butcher Boy* (1997) – to the small-scale yet culturally rich films of *Angel* (1982) and *The Miracle* (1991), both of which, like *The Crying Game, Michael Collins* and *The Butcher Boy*, were made in, and in dialogue with, his native Ireland. Thematically, his work has varied from Irish politics placed within the messy realities of human romance, personal responsibility and imagination (*Angel, The Crying Game, Michael Collins*); to fairytale and often grotesque and murderous fantasy such as in the adult re-working of 'Little Red Riding Hood' in *The Company of Wolves* (1984) which, in its celebrated transformation sequences, draws on elements of body horror, the visually superb psychosexual thriller *In Dreams*, and the critically-acclaimed *The Butcher Boy*; to the realm of horror proper with the commercially successful adaptation of Anne Rice's novel *Interview with the Vampire*; to the more subtle period piece of *The End of the Affair* which also focuses, though differently, on the supernatural; and to the playful and intelligent postmodernist re-visiting of Jean Pierre Melville's popular *Bob le Flambeur* (1955) in *The Good Thief* (2002). Nevertheless, the sensibility that informs these disparate worlds remains the same.

The films, like his literary work, which delights in the sensuous, seem to focus on the notions of transgression, perceived normality and appearance. Put simply, Jordan allows his characters to explore and challenge borders so that they may be comfortable with their own identity. These borders are most often of a sexual nature, but are necessarily social and cultural. Moreover, such investigations are played through a slippage between one state of reality or identity and another, which is most explicit in *The Company of Wolves, The Crying Game, The*

Butcher Boy and *In Dreams*. Often originating from a realist perspective, his books and films find their way into the irrational or the other, or as he put it himself, 'I like to take stories that have a realistic beginning, that start from the point of realism and go to some other place that is surrealistic.' Such 'an impatience with reality,' he suggests, is also to be found in the fantastic within Irish literature, and something he has characterised as particularly 'Irish'. These elements are certainly visible in much of his work, as is the consistent re-visiting of the oedipal triangle whether in its most basic form of the son falling in love with his mother and rivaling the father, as in *The Miracle*, or more subtle variations on the theme, such as in *Michael Collins* or *The End of the Affair*. Indeed, the love triangle, whether it involves two males or two females, as in *Mona Lisa*, is a central feature of his work, but then, as Rose in *The Miracle* explains to Jimmy, it is the complications of the desire that A, B and C have for each other that not only makes a story interesting, but possible. There's no story at all if everything is resolved, and the film ends with A loving B, and B loving A.

Neil Jordan began his career as a writer for children's theatre, radio and television, but it was as a short story writer with the collection, *Night in Tunisia and Other Stories* (1976), which won the Guardian Fiction Prize in 1979, that he found international acclaim. Of all his written fiction, this collection is the one which continues to be singled out for praise and indeed includes many themes and motifs that inform his later work. This is also true of his novels which include: *The Past* (1980) in which a character seeks to discover the identity of his father (is it the father or is it the son?); *Dream of a Beast* (1983) in which a man becomes estranged from his wife and more generally from conformist society, and literally transforms into a beast, until finally he rediscovers joy and love with his wife; and *Sunrise with Sea Monster* (1994) which includes a woman having a relationship with a teenage boy but marrying his father. While elements and images from these are reworked and cited within all of his films, perhaps the single most intertextual work in terms of Jordan's own creative output is *The Miracle*. Yet this richly textured piece, which is at once a universal tale, 'the oldest story' in Rose's words, and an Irish story that operates within an Irish cultural framework, has received little critical attention.

Fittingly, given how the *Night in Tunisia* stories resonate in his film work, it was this collection's visual richness which brought Jordan to the attention of film director John Boorman. An Irish resident since the early 1970s, and promoter of a commercial Irish cinema since becoming Chairman of the nationalised Ardmore Film Studies in 1973, a policy which put him on a collision course with many of the more culturally acute indigenous Irish filmmakers, Boorman became

engaged with Jordan on a number of projects. One of these had him direct the documentary on the making of *Excalibur* (1981). More importantly, he was executive producer of Jordan's first feature *Angel*, which was made with money from Channel 4, the balance being provided by the recently-established Irish state agency, the Irish Film Board, of which Boorman was a member. This became the subject of controversy and led to some resentment from those involved with film production in Ireland who felt that Jordan had not yet proven himself as a filmmaker.

Angel was the first Channel 4 film to receive a theatrical release and this put him in contact with exhibitor and producer Steve Woolley, whose recently-formed production company, Palace, would become one of the engines of British film production in the 1990s. Palace was the producer of Jordan's second feature, *The Company of Wolves* (also the name of Jordan and Woolley's film production established in the late 1990s) based on Angela Carter's short story. While the film was well-received in Britain and Ireland, it faltered in America owing to inappropriate promotion in which it was cast as a mainstream blood-and-gore movie. This was followed by the well-received though very different film, the British *noir* thriller *Mona Lisa*, for which Bob Hoskins won the Best Actor award at Cannes. Lauded by critics, it was described as 'the perfect recipe for a British thriller', not least because it pulled 'off the difficult trick of seeming to work to an American dynamic while having obviously imported nothing', a comment which bemuses Irish readers. It was precisely Jordan's distance from British culture that allowed him to bring his phantasmagorical Irish sensibility to London (and Brighton) to create one of the key 'British' films of the decade.

Following the positive response to *Mona Lisa* in America, Jordan was offered a big-budget project, the filming of his script of the comic gothic *High Spirits*. However, this experience in the American film industry was a traumatic one, as his original conception was changed radically by the producers, who were more interested in producing an 'Oirish' *Ghostbusters* than an ironic and intelligent re-visiting of the Irish gothic tradition. Though disillusioned, he accepted a director-for-hire job, his only one, of David Mamet's version of *We're No Angels*, the original of which was directed by Michael Curtiz in 1955. Nevertheless, the film, which stars the unlikely (and unsuccessful) comic talents of Robert de Niro, and features Sean Penn and Demi Moore, contains key Jordanesque elements such as a concern with appearance and reality, borders, and the nature of belief and spirituality. The consequence of these bruising encounters with American cinema was ultimately positive as it led to a creative return to his roots that resulted in *The Miracle*. It was designed as a small-scale and personal project with 'integrity', and as a way to expunge the negative American experience.

Jordan's return to 'home' in the film is literal (much of it was shot near his then home in the seaside town of Bray), artistic (the film draws on his early writing) and symbolic (the story is an oedipal one concerned with origins). (Incidentally, Bray is also home to Ardmore Studios, now privately-owned, and Ireland's only feature film studios, which was opened in 1958 and primarily services international productions.) However, because of the poor state of the Irish film industry at the time and the lack of state support, it was, like most of Jordan's films, funded by the British and American film industries. Indeed, during this period the Irish Film Board, whose policy generally favours small-scale indigenous films, was dormant. Reactivated in 1993, the Film Board has been at the forefront of the renaissance in Irish filmmaking, which developed rapidly in the 1990s through a combination of state investment and generous tax reliefs on film investments. This scheme attracted many international productions, including *Michael Collins*, which it helped finance. After the success of *The Crying Game*, for which Jordan was awarded an Academy Award for Best Original Screenplay, he was appointed to the Film Board and served on its Board of Directors for four years in the mid-1990s, during which time he also acted as a script reader for the Board.

If artistically *The Miracle* returns to 'Night in Tunisia', it nonetheless also draws on themes from other stories in the collection, such as 'Mr Solomon Wept', in which a father/son relationship is explored against the backdrop of an absent mother and a tawdry seaside town, and, most notably, 'A Love', in which a boy consummates a relationship with a woman old enough to be his mother and to whom his father is attracted. It also looks back to *The Past* and forward to *Sunrise with Sea Monster*. In *The Miracle*, two 17-year-olds, Jimmy (Niall Byrne) and Rose (Lorraine Pilkington), hang out together in Bray and invent stories about people they see. Jimmy's father, Sam (Donal McCann), who has reared his son since his mother's apparent death, is a musician who invites his saxophone-playing son to join his jazz band for the summer. Jimmy and Rose become intrigued by the arrival of a glamorous blonde, Renée Baker (Beverly D'Angelo), but soon Jimmy loses interest in Rose's story game as he becomes infatuated with the mystery woman who turns out to be starring as Frenchy in a theatrical production of the musical western *Destry Rides Again* and with whom he begins tentative relations. Rose, now jealous of his interest in Renée, becomes involved with elephant-trainer Jonner, and later has sex with him. Renée manages to rebuff Jimmy's sexual advances, telling him she is too old, but when he sees her with his father his jealousy and confusion grow. Sam asks her not to tell him that she is his mother and warns his son to stay away from her, which Jimmy interprets as the father fancying Renée for himself. Playing detectives, Rose and Jimmy

visit Renée's dressing-room and she agrees to hear him perform. However, when she arrives at the ballroom, she becomes disturbed when she sees Sam and Jimmy playing together and leaves only to be followed by Jimmy. At his home, he again tries to seduce her, and Renée leaves hurriedly, her handbag still in the kitchen. In it he finds a photograph of Sam and her, thus revealing the identity of his mother, something later confirmed to him by the inarticulate Sam. The following night on the beachfront, Jimmy again attempts to make love to Renée who seems unable to tell him the reason they should not, but as she explains her teenage pregnancy and life with Sam he cannot contain himself and rapes her. Distressed, Jimmy falls asleep in a church, where earlier he had gone with Rose to ask God to help him seduce Renée. When he awakens he finds an elephant there, perhaps the sign from the divine, but part of Rose's plan. Teaming up again with Rose, who has released all the circus animals, the pair stroll on the promenade and invent stories as the animals run wild. Renée, his mother's ghost, has left Bray to return alone to America.

Though not unique to Ireland, the oedipal fantasy seems much favoured in Irish literature. There seems to be a predilection for such a scenario in the post-independence period in particular, and it can be argued that in a colonised or neo-colonised state, where the land is not the father's to give to the son, the resolution of the oedipal crisis is frustrated. The historical basis for such a crisis of paternity may lie in nineteenth-century Ireland, where sexually mature adults were forced to live in the parental home as children until both obstacles (i.e., the parents) in the way of fulfilment (through marriage) were removed (ideally dead). The alternative was emigration. While Irish literature explored this trope throughout the twentieth century, it was only with the advent of regular commercial feature films in the 1980s that the ineffectual and castrated Irish male makes frequent appearances on the screen, epitomised perhaps by the eponymous *Cal* (Pat O'Connor, 1982). 'Celtic Tiger' cinema of the 1990s also contains such representations (or its mirror, the tyrannical father). Conceivably, this may be related to the emergence of a strong woman's voice in Irish culture and the overwhelming presence within public discourse of the visuality of women's bodies and women's issues which emerged from the mid-1980s onwards.

Jimmy and Sam's relationship is dysfunctional from the beginning, with their mutual loss of the mother/wife tarnishing their relationship with resentment and hatred. With Sam abdicating his parental responsibilities through heavy drinking (coding for the Irish sublimation of sexual desire), his crisis is ultimately his lack of respect for the patriarchal order. Sam's refusal to follow the patriarchal law, and to explain to Jimmy his origins or give to him even an

image of his mother, can only lead to erasure and death, something made clear in one of Sam's dreams in which his death is predicted. Time, it would seem, is running out. Other dream narratives, though by Jimmy, confirm Sam's symbolic death. In one, a photograph of Sam burns, and later Jimmy imagines him as a dead fish, with the hook still hanging from his mouth. Sam's refusal to be a proper father thus condemns Jimmy to an existence outside of history/time, and only after Jimmy finds the photograph and rapes his mother can he be reinserted so that he can embark on an adult male life with Rose as his lover. Jimmy's unlocking of the bonds of history is just one of the many miracles that the title may refer to.

As in 'Night in Tunisia', which takes its title from a Dizzy Gillespie composition as played by Charlie Parker, Sam's and Jimmy's troubled relationship is filtered through music. More generally, music is an important element throughout Jordan's work which not only adds to the films' aural texture but is integral to their meaning, whether as ironic counterpoint or as straight articulation of the character or event. It is no accident that four of his films take their titles from songs (*Mona Lisa*, *The Crying Game*, *The Butcher Boy*, *In Dreams*), while *Angel* was initially conceived as a musical. Unsurprisingly, then, *The Miracle* delights in full-length performances that are central to understanding the various characters. For example, when Renée sings 'Stardust' it becomes more than a soulful rendition of the classic jazz number, but resonates with the reality of lost love that is hers and Jimmy's, just as when she plays Frenchy, she becomes Frenchy. Reality, imagination, past and future, all blend. Similarly, for Sam and Jimmy, their sexual identities are expressed through their ability to play jazz, a musical genre resonating with the body and natural rhythms. The association of music and the body is made explicit in the image of the phallic saxophone that Jimmy fetishistically works on. This is also seen in *Angel* through Danny (Stephen Rea in the first of eight appearances in Jordan's films), but later he swaps the saxophone for the gun, which plays only one tune, in this case political assassination. While such a combination of sex, music and performance is visible throughout *The Miracle*, not least as the central characters are performers, the climactic scene of Jimmy 'raping' Renée, intercut with the legs of couples dancing to Sam's performance, and a bored Rose, who is underneath a thrusting Jonner, perhaps most elegantly sums it up.

In the first instance, *The Miracle* is an oedipal story which follows Jimmy's psychosexual development and loss of innocence. It returns him to the oedipal moment when the boy's love for the mother becomes sexualised and the father becomes a rival. The resolution of this triangle is usually through the threat of punishment (symbolic castration) by the father, which leads the child to reject his mother and identify with the father. The child then accepts and becomes part

of the male world of the symbolic and is free to love other women. Because of his mother's absence, Jimmy is denied access to this first developmental stage, and is thus unable to love other girls. Since he is unable to reject that which he never had – his mother – he is also unable to identify with his father and is thus incapable of embracing Rose. They are, as Rose tells Jimmy, 'Too friendly to be lovers, too close to be friends, together they lived in the twilight zone.'

Nevertheless, *The Miracle*, like many of Jordan's other films – most notably *The Company of Wolves*, *Mona Lisa*, *Interview with a Vampire*, *The End of the Affair*, *In Dreams* and *The Good Thief* – operates as a commentary on storytelling; or, makes explicit the nature and process of storytelling, writing and performance; or, as is the case of *The Crying Game*, allows the characters to understand themselves through narrative such as the parable of the scorpion and the frog. In *The Miracle*, it is Rose who plays at being author, with Jimmy her assistant, but it is his personal narratives that overwhelm the 'story'. Only when he has unravelled his family's complex history does power return to Rose, who had already written the plan for a narrative that would become hers and Jimmy's future.

Such *mise-en-abyme* is not limited to the creative process of writing, but is also found in Jordan's use of the *Destry* musical which becomes a playground mirror to the triangle of Sam, Jimmy and Renée. Indeed, Renée becomes the fated Frenchy who, as Jimmy observes, dies 'well' in the show, but who, with his father, he helps to kill in real-life. Of course, such play is doubly layered. While the original narrative that Jimmy created for the out-of-place glamorous mystery woman was that she was a French widow who killed her husband and is now looking to claim her inheritance, it becomes translated into a type of reality that envelops him. His fantasy in a sense becomes his own story, which almost threatens to engulf him.

In this regard, the use of photography in Jordan's writing and film work serves as another layer of commentary on representations, as his extensive quotations from films, from *Angel* to *The Good Thief*, testifies. Indeed, *The Past* is in a sense a meditation on photography, with references to Edweard Muybridge's visit to Dublin; it is the career of one of the book's central protagonists; and it is a recurring feature of Jordan's work in general. Many have laid stress not so much on the narrative power of his prose writing, but on its visual power. In fact, *The Past* is largely devoid of dialogue and Jordan has described it as being 'entirely composed of visual description', adding that he felt he was 'writing himself out of the form entirely'. He regarded it as 'pointless to continue writing just to describe what things look like'. As a result, he became a filmmaker. For Jimmy, the photograph is both the means of returning to his origins (even though he is absent from the image of his father and mother together), but it serves as the

mechanism for a counter-memory of himself as an infant gazing up at the mother from his pram, the image over which the film's opening credits play.

The town of Bray, one of Jordan's many seaside homes since childhood, is yet another instance of the director's use of the sea in his work. Indeed, he has said that he cannot finish a film without reaching the sea. In *The Miracle*, the sea becomes more than a backdrop to the events; it becomes the site of fantasy. It is where Rose desires to be; where Renée continually gazes towards; and various sensuous, violent or romantic encounters happen by the seafront. The seaside is also the dominant trope in the *Night in Tunisia* collection of short stories, where it features in seven of the ten stories, as well as in *Mona Lisa, The Crying Game, The Butcher Boy. The End of the Affair* and *The Good Thief*. Water and the seaside are the *mise-en-scène* of desire and sexual liberation, so that it becomes a metaphor for the ultimate desire, which is a return to the maternal waters and total plentitude. However, the seaside holiday town is usually a tawdry place, a location of mechanical desire and pleasure, impersonal and empty. The encounters with the seaside tend to be unsatisfactory – such as young Francie Brady's retracing of his parents honeymoon in *The Butcher Boy*, or Brighton where Bendrix and Sarah in *The End of the Affair* appear to be happy until it is revealed by her husband that she has six months to live.

While *The Miracle* in many ways belongs to late 1980s/early 1990s Ireland, it celebrates images and sounds of the 1950s. Nonetheless, it refuses to endorse the promise and exoticism of the past – the Night in Tunisia, so to speak – but points to its emptiness and pain. Perhaps the power in the rejection is that Jimmy 'kills' the (1950s) mystery by raping his mother, and seems in the end to take Rose as a (modern) lover, who, unlike Renée, is finally allowed by Jimmy to control her own representation. As such, *The Miracle* is not a 1950s coming-of-age film of the type Irish cinema produced in the 1980s and 1990s, which included *My Left Foot* (Jim Sheridan, 1989), *All Things Bright and Beautiful* (Barry Devlin, 1990), *Circle of Friends* (Pat O'Connor, 1995) and *Dancing at Lughnasa* (Pat O'Connor, 1998), where a sometimes self-consciously plastic image of Ireland is presented which imagines, in an uncritically nostalgic mode, a past figured in terms of tradition, family, the landscape, Catholicism and conservative moral values, but with nationalism and its attendant reality of political violence avoided.

Jordan has come in for criticism over his representation of women. This was most acute in discussions of *The Crying Game*, where the only real woman is rendered as a monster. It is important to point out that Renée is not simply the bad, promiscuous mother, who 'knew' them all, Sam included. She is also the heroine who returns to save her boy and help him discover the truth. She is at once the hard callous mother who left him and the woman of his (and

Sam's) dreams, whose screen image is signaled by the sultry and sensuous saxophone. Sam, on the other hand, is unequal to the task demanded of him and instead becomes an all-too-Irish father: an ineffectual drunk. Nevertheless, in its defilement of the mother's body through rape, it is unquestionably an attack on the family, the basic unit of the Irish state according to the 1937 Constitution. In this way it continues the work of the first wave (1975–87) of contemporary Irish filmmakers who, as part of a corrective or alternative vision of Ireland, proffered a version of the family where it became the site of repression and instability. For the first time it could be seen as a fragile construct subject to abuse, oppression, hypocrisy or divorce. Part of the achievement of these films was the deliberate complication of Ireland's emotional and psychosexual landscape, and *The Miracle* exists in this framework.

While *The Miracle* did not prove to be a commercial success, that opportunity came shortly afterwards. *The Crying Game*, with its brilliant marketing in the USA by Miramax, was the most successful non-American film released there to that date, as well as garnering an Academy Award for Jordan. This was followed quickly by the international hit *Interview with the Vampire*, which cleared the way for Jordan to make his long-cherished biographical picture about the Irish War of Independence leader, *Michael Collins*. Like *Angel*, which was ostensibly concerned with political violence in Northern Ireland, Collins' real historical setting of the 1916–22 period also focused on the way in which violence affected the individual rather than explored the historical or political processes, in this case, the triangular relationships of Collins (Liam Neeson), his friend Harry Boland (Aidan Quinn) and their lover, Kitty Kiernan (Julia Roberts). Made for Warner Bros., though hugely popular in Ireland, the film was not a success in America but it provided Jordan with the opportunity to adapt Patrick McCabe's best-selling novel, *The Butcher Boy*. This film tapped into, and helped de-romanticise, the nostalgia that has surrounded representations of the 1950s and early 1960s in Ireland. Focusing on a dysfunctional smalltown Irish family, it is set against the background of the Cuban Missile Crisis of 1962, and, in effect, destabilises and deconstructs earlier representations of the period.

The Miracle and *The Butcher Boy*, while on the surface apparently very different films, stand out in 1990s' Irish cinema as films that challenged received official views, while exploring the troubled nature of the Irish family and the abuse which is at its core. Despite their dirty secrets, they remain powerful and sumptuo us pieces of cinema that are all too rare both at the local and international level.

Kevin Rockett

ORLANDO

SALLY POTTER, UK/RUSSIA/FRANCE/ITALY/NETHERLANDS, 1993

Sally Potter's 1993 film *Orlando* is a captivating and provocative adaptation of Virginia Woolf's equally challenging 1928 novel. Both trace the experiences and emotions of the fictional Orlando – across the span of four hundred years, across the vicissitudes of love, sex, geography, politics and class and, most notably across the divide of male and female. In the case of Woolf's text, the character of Orlando can be described as both an ironic biography of and a love letter to Vita Sackville-West. Woolf intersperses photos of Vita at various ages with aristocratic portraiture in order to construct her fictionalised life of Orlando as he/she grapples with issues of art, class, sexual politics and orientation. This playful and erotic tribute to Sackville-West is inevitably less prominent in Potter's version of the narrative. Rather, the film builds upon the earlier text to explicitly weave a wider – although no less fanciful – commentary upon the conventional roles of the sexes throughout the ages, exploring the hitherto unimagined possibilities for being female *and* active in the context of an Englishness which is literally corseted by ideologies of patriarchy, imperialism and the economies of class.

Both novel and film take up the story of Orlando as an aristocratic young man, a favourite of the fading Gloriana, Queen Elizabeth I, who exhorts him to stay young forever and thus provides the imaginative possibility of his 'immortality'. As well as creating the rich spectacle of a panoply of history from the Elizabethan age through to the twentieth century, this device of Orlando's agelessness foregrounds the complex and fundamental question of what constitutes individual identity, reformulating the nature/nurture debate. What *is* it that makes a person? Which factors are most influential? Is it *when* they live? The values and ideologies of their historical moment? The place and position in life in which they find themselves? Whether they are born male or female? And/or does Orlando carry something that is intrinsically him/her irrespective of these external influences of time, place and opportunity?

Informed as it is by the iconoclastic ideas of feminism and postmodernity, Potter's film in particular moves across both sides of this debate. For instance, the manuscript that Orlando (Tilda Swinton) toys with in the opening scene is literally carried, dog-eared by centuries of wear, through to the film's conclusion; like the oak tree itself after which it is titled, one

might argue that this textual voice – where literature is seen as the articulations of the self in history – suggests that there is indeed something which is consistent, although always evolving, throughout all the differences which Orlando experiences. At the same time however, Orlando, like all of us, is also a creature of his/her time, in many senses *becoming* the very roles which are expected or imposed upon him: from the luminous youth whom the Queen admires, to the foppish 'dabbler' the poet Nick Greene (Heathcote Williams) describes, to the ambassador sweating in his wig and robes in a foreign land, through to the woman who is as constrained in her roles as in her cumbersome clothes, or, as we see her in the Victorian era framed against topiary cups and saucers, caught within the ideology of the domestic, the sphere of nurturer and homemaker.

The film's narrative might thus be said to be 'about' the colourful tapestry of English history, especially the history of aristocratic class, privilege and colonialism – but it is equally the story of the individual at work within those wider cultural streams, in particular, the individual who is drawn to the linked paths of intense perceptions and emotions and the desire to articulate them. In this sense, as an often playful yet cynical study of the would-be artist in the making, *Orlando* balances a critique of individuality and the social, while also ironically commenting self-reflexively on the role of its own author/director and the inevitable juggle with the socio-historical and the ideological which finally produces the artistic text.

Coming from a background in dance, performance and the visual arts, Sally Potter already had a reputation as a feminist, independent filmmaker when she made *Orlando*. Her first feature film *Thriller* (1979) was a stark feminist revisioning of the classic tale of Puccini's opera *La Boheme*, unstitching the seemingly inevitable narratives of what Adrienne Rich has referred to as 'compulsory heterosexuality' which lie at the powerful heart of western romance. The film's *mise-en-scène* is minimalist and it is anti-realist in its refusal of the structures of conventional narrative. *The Gold Diggers* (1983), for which she used an all-woman crew, continued the themes of the relation of women to the twinned pillars of power across different eras – patriarchy and capitalism – exposing the ways in which this social structure keeps women apart from each other, their desires masked and/or co-opted. This film too offers a radical reworking of prior narratives: here, the tropes and genres of Hollywood storytelling are themselves destabilised and refracted through a specifically feminist perspective. However, owing to their uncompromising political and aesthetic styles, neither of these films brought Potter any significant commercial or critical success. She did produce a comedy, *The London Story* (1986), and was also involved in two documentary video projects for television focused

upon the range of human emotions, *Tears, Laughter, Fear and Rage* (1987). In 1988 she also produced for television a study of women filmmakers in the USSR, *I am an Ox, I am a Horse, I am a Man, I am a Woman*.

Orlando was a film on a much grander scale and its commercial success moved her decisively from the exclusively art-house and much closer to the mainstream. Significantly, although the critical and box-office success did link *Orlando* with a more commercial market, the film also retains a strong connection to the work of other art-house directors of the period. Tilda Swinton was an actor much used and admired by avant-garde, gay film director Derek Jarman, whose films such as *Caravaggio* (1986) also explored the fluidity of sexual identity in the context of a non-linear, very painterly, tableau-driven style. (Swinton also appeared in the following Jarman films: *The Last of England* [1987], *L'Inspiratione* [1988], *War Requiem* [1989], *Edward II* [1991]. In addition, in *Orlando*, Potter worked with various costume designers and art directors who had also worked with Jarman.) Similarly, the influence of Peter Greenaway's avant-garde films, perhaps particularly *The Draughtsman's Contract* (1982), can be seen in *Orlando*, especially as the character moves, impelled by the urgency of the soundtrack, from the eighteenth to the nineteenth century through the regimentations of the garden maze, across water features and lawns stamped and shaped by the dominance of culture and aristocratic class. In dedicating *Orlando* to Michael Powell, Potter also explicitly acknowledges his personal and aesthetic influence – in his role as a prolific and iconic British director, and perhaps particularly in his interests in sexuality and desire, as seen in films such as *Black Narcissus* (1947) and *Peeping Tom* (1960), in the collisions of youth and mortality in *The Life and Death of Colonel Blimp* (1943) or *A Matter of Life and Death* (1946), and in his merging of the cinematic with other art forms, such as ballet in *The Red Shoes* (1948) and opera in *The Tales of Hoffmann* (1959).

Made by Potter's own company, Adventure Pictures, in conjunction with the film's producer Christopher Sheppard, *Orlando* was also partly financed by the Russian film industry, with sequences shot in Uzbekhistan and St Petersburg, and was ultimately a co-production of the UK, Russia, France, Italy and the Netherlands. Significantly, while it is in some ways so concerned with the phenomenon of 'Englishness', and the individual's relationship to that dominant and imperial culture, *Orlando* is not an exclusively British film, not financially, visually or politically. As Potter discusses in conversation with Penny Florence, as with any hierarchical system, only a very few actually *belong* in the central, privileged place of Englishness; the vast majority are in some way marginalised, do not measure up, and are 'on the outside looking

in'. Such a position offers a unique perspective, echoing the same kinds of insights a writer such as Virginia Woolf was able to bring to English society, as a woman always literally and metaphorically on the edge of sites of masculinised power – forbidden the grass as well as the superior college in *A Room of One's Own*, excluded from the pomp and power of the judiciary and the military in *Three Guineas*. Dislocated from the benefits of privilege, the sexual or class fringe-dweller often has more ability to see and critique the centralised structures of power, to recognise the operations of ideology even as they tangentially influence the self.

Orlando also appeared in the context of a number of other adaptations of Virginia Woolf – Colin Gregg's television version of *To The Lighthouse* (1983), Eileen Atkins' stage play and television recording of *A Room of One's Own* (1992), and the play *Vita and Virginia* (1992), based on the writers' correspondence and starring Atkins and Vanessa Redgrave – a collaboration which was later to spawn the adaptation of *Mrs Dalloway* (Marleen Gorris, 1997). All these representations grapple, more or less successfully, with the translation of Woolf's very fluid and suggestive style, and the many voices and nuances which characterise it, as well as the transliteration of the purely literary into the sphere of the visual text with its different array of signifying possibilities. In many ways, Potter's film builds explicitly upon Woolf's radical use of the idea of a stream of consciousness – of the rising and falling of words, ideas, images according to the intertwined logics of both the conscious and the unconscious mind. The momentum, both in the film, as indeed in the genre-stretching novel, is not that of the purely linear narrative which proceeds according to objective causality, although it does clearly borrow from that especially within the various spatio-temporal vignettes which structure the more nebulous images and emotions: 1600, 'Death'; 1610, 'Love'; 1650, 'Poetry'; 1700, 'Politics'; 1750 'Society'; 1850, 'Sex'; and undated, 'Birth'. Rather, the unexpected, or unexplained linkages between sections, the sometimes dream-like sequence of events or situations or the bizarre details, such as Orlando's week-long sleeps, let alone his metamorphosis into a woman, signal a clear move away from realism and the demands of the genre of the historical costume drama – and into the sphere of the imaginative, the pulse of partially submerged desires that operate subliminally upon individual and cultural surfaces. As Potter herself comments in interview with Penny Florence, 'the premise of *Orlando* is that all history is imagined history and leaves out all the most important bits anyway'.

Unlike many of the other adaptations of literary texts which were popular at the time (for example the television series *Brideshead Revisited*, 1982; *A Room with a View* [James Ivory, 1985]; *Maurice* [James Ivory, 1987]; *Henry V* [Kenneth Branagh, 1989]; *Howards End* [James

Ivory, 1992]; *Where Angels Fear to Tread* [Charles Sturridge, 1991]), Potter's *Orlando* is not concerned with either 'real history' or a nostalgic evocation of an idealised, static England achieved through the verisimilitude of a lavish *mise-en-scène* and the slavish 'fidelity' to a canonical literary 'original,' with all the adherences to hierarchical class values that this implies. The film, even more so than the novel, is concerned with the history of *representation*, of how social structures have reproduced themselves for the vested interests of some, and not others, of how power and identity are coded through key indexical signs – in particular how one is *seen* from a dominant perspective. The emphasis upon the visual, so readily available to the cinema, is both a source of seduction for the viewer and, through the extravagant use of costume in particular, emphasises the ways in which clothing expresses and constructs the individual according to various roles and expectations. This can be seen for Orlando as male – for example the way in which his English garb hampers him in Khiza – but most particularly for Orlando as female, as she awkwardly manoeuvres her crinoline about the furniture or is condemned to long hours corseted, dressed and prepared for the masculinised gaze of society.

While Potter has certainly chosen to adapt the work of an important English writer, I would argue that her work avoids the conventional hierarchies of original and copy, of superior and inferior; rather, *Orlando* enacts the notion of adaptation as a dynamic process of fluid intertextuality. 'An adaptation has to be a transformation', Potter claimed in discussion with Scott MacDonald. We see traces of this transformative element in some of the structural elements of the film. Importantly, the direct gaze and address which Orlando gives the camera, from the very first scene and at key points throughout, crucially undermines the notion of an omniscient author/director. *This* narrative invites active, interpretative engagement from the spectator, just as it prevents Orlando him/herself from ever operating, as Laura Mulvey has argued, as the passive bearer of a conventionally masculinised gaze. The film is also transformative in relation to its use of casting. To use Tilda Swinton, a woman, as Orlando throughout immediately confounds any clear sense we might have of a fixed gendered identity. Significantly, it is not the kind of body that hides beneath the folds of clothing which is at issue here – and the film in general challenges the extent to which this, in the end, really matters. Most importantly, *Orlando* poses the question of how the *idea* of the sexed body is produced – by costuming, by sets of gendered behaviours – within any given socio-historical moment. This issue is further emphasised by the superlative casting of Quentin Crisp as Queen Elizabeth. A very recognisable face of the gay movement, the visual impact of Crisp as 'Queen' and Swinton as the male Orlando implicitly takes us across any rigid divide of male/female, masculine/

feminine, working to destabilise this apparent pillar of identity and social explicability. In this sense, the film is very much about thinking beyond rigid categorisations of sexual identity and orientation, catapulting the viewer into an uncertain, yet exciting set of potentials.

Potter's text also enacts some key narrative changes from the novel. For example, Potter's Orlando eschews the use of violence, retreating from the implied link between masculinity and aggression that Woolf identifies and abhors in her later text, *Three Guineas*. Significant also is Potter's refusal to finally marry Orlando to Shelmerdine (Billy Zane) and produce the male heir that would have allowed her to retain her property. In the film, Orlando takes a lover, not a husband, and the child that is born from that illicit and erotic coupling is female. In the final, almost utopian sequence, Orlando, beautiful and androgynous in appearance, delivers her centuries-old manuscript to the publisher (Heathcote Williams, again) in the late twentieth-century city sky-scraper, to then ride with her daughter (Jessica Swinton) on a motorbike, reminiscent of Woolf's 1920s, through a city under construction to visit her former home, now swathed in preserving drapes by the Heritage industry. Only a tourist now, she may be dispossessed from the mainstream position of power which the house and its traditions implies, yet having let the past go in this way, she is also unconstrained, able to operate from a position of difference – free to sit under the oak tree again, free to be observed by the camera lens held by her daughter, free to see the 'vision' of the angel through the leaves, as Jimmy Somerville, contemporary gay rights activist, and the counter tenor who first sang for the arrival of Crisp's Queen Elizabeth, now sings 'I am coming across the divide to you … we are one with a human face.'

Of course, Potter's film, released in 1992, is as much a part of its historical moment as Woolf's novel is of hers. The film extends the modernist, iconoclastic impulses of the earlier text, exploring further possibilities and refusing closures, engaging in the open-ended play and cross-referencing associated with the strategies and instabilities of postmodernity. It also actively engages with contemporaneous debates within theoretical feminisms, such as those regarding the ways in which 'sex' might be distinguished from 'gender' as a marker of identity, the role of biological essentialism in describing sexed identity, the possibilities for an 'equality' of the sexes once patriarchy has been identified and disassembled, or the need to retain and celebrate differences. While clearly sounding these contentious issues, Potter's *Orlando* could perhaps best be read in the light of Judith Butler's important study of gender as *performance*, as first outlined in her book *Gender Trouble: Feminism and the Subversion of Identity* (1990). Moving beyond some of the more simple and confrontational modes of second-wave feminist

inquiry, and crucially informed by some of the approaches of postmodernity, deconstruction and Lacanian psychoanalysis, Butler signalled a movement within feminism to critique the broader notion of gender – i.e., how masculine/feminine is produced/written across certain kinds of biological bodies, and thus how it might be performed, parodied and re-performed, depending very much upon the fluid dynamic between performer and who might be looking/reading what is written upon the suggestive page of the body.

Potter's key questions regarding the problematic relationship between 'identity', sexed bodies and gendered behaviours can literally be seen and displayed in the sequence detailing Orlando's transformation from male to female. Inspired by bonds of brotherhood with The Khan (Lothaire Bluteau), Orlando, the English Ambassador, has changed costumes once again, from the ornate, out-of-place wigs and finery of the Empire into the loose, free-flowing clothing of the local inhabitants. In this way, he enacts the cliché of the coloniser 'gone native' – an embrace of otherness which nevertheless leaves the power dynamic of imperialism, of centre and margins, intact and unexamined. However, when the Archduke Harry (John Wood) arrives with honours from Queen Anne, Orlando is reclaimed by the garb and the values of England, thereby testing his sense of role and identity. This identity is further destabilised by The Khan's request that he take up arms 'in brotherhood' with him against an unspecified enemy. Attempting to honour his commitment to his host and friend, Orlando finds himself on the battlements, in the chaos and grotesquerie of warfare. When Harry fatally wounds an assailant Orlando responds on the level of a common humanity, kneeling beside the dying soldier with a compassion that is later echoed in her care of Shelmerdine when, Florence Nightingale-like, the same act of kindness is coded as acceptable because feminine. However, within the intense compression of the moment, the structures of patriarchy, and the models of masculinity which it offers, are shown to be rigidly dichotomous, offering Orlando no room for a particularised or non-gendered response. If war can be seen as a crucial paradigm for the inflexible oppositions of phallocentrism, then Orlando's 'dying man' can only ever be 'the enemy', and there is thus only scope to be either a winner or a loser, a real man or an illegitimate man – i.e. a woman. In the face of this impossible predicament, Orlando retreats for a second time to a week-long sleep, signalling, as in the aftermath of the loss of Sasha (Charlotte Valandrey), both a response to emotional trauma and, potentially, a transition to something new. Unable finally to sustain the pressures and expectations of a violent and dominating masculinity, Orlando becomes a woman – not, however, in the sense of defeat or 'not-maleness', but, at least within the fantastical logic of the film narrative, as

a seamless movement into a state of body and being that appeared to offer a different set of liberating options. Waking from this trance-like state, Orlando slips off the wig of aristocratic masculinity to reveal the sensuous fall of long straight hair. Washing at the basin, his/her face in the light, and with the music and female-sounding voice on the soundtrack rising to a pitch of anticipation Orlando turns, amazed but accepting, to see her body, now female, displayed in the mirror. Not the object of a constraining, masculinised gaze, Orlando is here the looker-at-herself, and, at least in that self-reflexive moment, able to define herself outside the rigid dichotomy of male/female and the invidiousness expectations of masculine/feminine: 'It's the same person. No difference at all. Just a different body.'

In important ways, this image of Orlando's naked female body, crucially mediated by her own active looking, is symbolically linked to the film's closing images of Orlando watching her daughter, her daughter watching her, now through the mediated look of her own camcorder, and Orlando's gaze returning at last, both reflective and challenging, to the camera/viewer. It is a self-defining gaze, a gaze that has not been possible for women for many hundreds of years, except in fantasy, a gaze that has been almost fatally interrupted by the masculinised gaze of society – epitomised here by the poets who see her as lost without the support of a male figure, by the Archduke Harry who, in an ironic reversal of Orlando's relationship with Sasha, feels he must own her because he 'is England' and adores her, by the legal system which sees her 'as good as dead' now that she is a woman, even by Shelmerdine who wants her to leave everything to follow him on a masculinised quest toward a frenetic future.

The character of Orlando, like Potter's film itself, must negotiate the past and its influences both in order to recognise the ways in which it has worked to produce him/her and also to move beyond it. As an avant-garde filmmaker of the late twentieth-century, Potter reworks the past – the past of the imagined, represented history of England, the vice-like grips of power and class, the legacies of the written text and even of literary 'fore-mothers' such as Virginia Woolf – in order to journey, as Julianne Pidduck has described it, through and beyond, to find, in apparent sameness, the possibilities of difference. Orlando is not galloping toward the future on the back of Shelmerdine's horse, a woman still yoked to the dichotomies of sex. Rather, she is travelling herself, in nurturing relationship with a daughter, forward to a reconsidered past and to a brief, and arguably still fantastical glimpse of a future that is – somehow – free from the grids and constraints of the divide of gender.

Rose Lucas

REFERENCES

Butler, J. (1990) *Gender Trouble: Feminism and the Subversion of Identity*. London, Routledge.

Florence, P. (1993) 'A Conversation with Sally Potter', *Screen*, 34, 3, 275–84.

MacDonald, S. (1995) 'Interview with Sally Potter', *camera obscura*, 35, 187–220.

Mulvey, L. (1975) 'Visual Pleasure and Narrative Cinema', *Screen*, 16, 3, 6–18.

Pidduck, J. (1997) 'Travels with Sally Potter's *Orlando*: gender, narrative, movement', *Screen*, 38, 2, 172–89.

Woolf, V. (1977 [1938]) *Three Guineas*. London: Hogarth Press.

_____ (1978 [1929]) *A Room of One's Own*. London: Hogarth Press.

_____ (1992 [1928]) *Orlando*. Oxford: Oxford University Press.

DIVORCING JACK

22

DAVID CAFFREY, NORTHERN IRELAND/FRANCE/UK, 1998

The peculiar status of Northern Ireland since the 1920s – geographically a part of the island of Ireland but politically a part of the UK – has meant that the history of filmmaking in Northern Ireland has been modest, restricted to the margins of both the British and Irish film industries. An initial burst of filmmaking activity occurred in the 1930s when the Northern Ireland singer and actor, Richard Hayward starred in a number of low-budget musical comedies, partly shot in Northern Ireland. While such films – Donovan Pedelty's *The Luck of the Irish* (1935) and *The Early Bird* (1936) and Germaine Burger's *Devil's Rock* (1938) – were all low-budget 'quota quickies', they were nevertheless immensely popular with local audiences who obtained a rare opportunity to see Northern Ireland locations (mainly the Glens of Antrim) on screen. Although there were plans to build on these successes, and even establish a film studio in Northern Ireland, none of these came to fruition.

As a result, there was virtually no feature filmmaking in Northern Ireland until the 1980s, when the support of the then new television station Channel 4 for film workshops led to the production of Belfast Film Workshop's *Acceptable Levels* (John Davies, 1984) and Derry Film and Video's *Hush-a-Bye Baby* (Margo Harkin, 1989). However, filmmaking in Northern Ireland only really gathered momentum in the 1990s, when, in the span of a few short years, more Northern Ireland features were made than in the previous seventy. Of the films made, *Divorcing Jack* (David Caffrey, 1997) enjoyed one of the highest profiles. Although not a big-budget film, it was nevertheless one of the most expensive films to be made in Northern Ireland and, unlike the politically conscious films of the 1980s, was clearly conceived as a popular piece of genre filmmaking aimed squarely at the box office. Made at a time when Hollywood films such as *Patriot Games* (Phillip Noyce, 1992), *Blown Away* (Stephen Hopkins, 1994) and *The Devil's Own* (Alan J. Pakula, 1997) were responsible for the most widely-circulated images of the 'troubles', it was also one of the first 'popular' films about the 'troubles' actually to have been made in Northern Ireland. As such, the film raises some interesting questions not only about the economics of filmmaking in Northern Ireland but also the politics of representing the Northern Irish conflict on screen, particularly within the conventions of a 'popular' format.

THE CINEMA OF BRITAIN AND IRELAND 227

The upsurge of film production in Northern Ireland that occurred during the 1990s resulted from both a change in the political climate as well as the availability of new forms of support for local filmmaking. In the early 1990s the newly-established Northern Ireland Film Council (NIFC) launched a production fund intended to provide support for locally-made film and television. This was followed, in 1995, by a UK government decision to use lottery funding in support of film production. Lottery funds were initially administered by the four UK Arts Councils and, in a flush of early excitement between 1995 and 1998, the Arts Council of Northern Ireland provided part-funding for eight feature films, including *Divorcing Jack* (which was awarded the largest sum available of £200,000).

This development was further sustained by changes in policy at the BBC. During the 1980s, the BBC Drama Department in Northern Ireland produced a number of one-off dramas, often shot on film but shown only on television (including, in the late 1980s, a number of pieces directed by Danny Boyle). In line with BBC policy more generally, BBC Northern Ireland began, in the 1990s, to move more in the direction of drama series (most notably the hugely successful *Ballykissangel*) and films with theatrical potential, such as *All Things Bright and Beautiful* (Barry Devlin, 1994) and *A Man of No Importance* (Suri Krishnamma, 1995). Like *Ballykissangel*, both of these features were shot mostly in the Republic of Ireland in order to take advantage of tax benefits. The availability of lottery funding (along with changes to the UK tax regime), however, increased the attractiveness of filming in the North and *Divorcing Jack* was the first of the BBC's film features to be shot entirely in Northern Ireland.

The film itself was a BBC co-production in association with the London-based production company Scala. The film's budget was around £3 million and made up of the BBC's own money, an investment from the French company Ima Films, and lottery funding from both the Arts Council of Northern Ireland *and* the Arts Council of England which pitched in an extra £800,000. Flush from its recent success with the British romantic comedy *Shooting Fish* (Stefan Schwartz, 1997), and sensing it might have a cult hit on its hands, the sales company Winchester Films advanced a further £950,000. It was also Winchester who were responsible for the film's strong marketing campaign based around the image of Rachel Griffiths as 'the nun with a gun' adapted from the cover of the original novel. Although the film was shot in Northern Ireland, and employed a number of local actors, the lead roles were all filled, mainly because of commercial considerations, by outsiders (who struggled with varying degrees of success to master the local accent). The lead role of Dan Starkey, initially intended for Robert Carlyle, was filled by David Thewlis whose performance as a drunken shambolic journalist at odds

with the world around him bore similarities to (if not quite the intensity of) his earlier role as Johnny in Mike Leigh's *Naked* (1994). The English actors Robert Lindsay and Jason Isaacs took on the roles of the aspiring politician Brinn and self-serving paramilitary 'Cow Pat' Keegan, respectively. Australian actress Rachel Griffiths played the small but show-stealing role of Lee, the NHS nurse by day who doubles as a 'nun-o-gram' by night. The young Irish director David Caffrey was recruited to direct his first feature while Colin Bateman, the Northern Ireland journalist who wrote the original novel, prepared the screenplay.

The coming together of all these elements was, of course, underpinned by a broader set of political developments. After some 25 years of armed conflict, both republican and loyalist groups declared ceasefires in 1994. Although outbursts of violence continued, the ceasefires nonetheless laid the basis for a transformation of the political landscape within Northern Ireland, resulting in the Good Friday Agreement of 1998 and the subsequent elections to a devolved assembly. As long as the 'troubles' continued, there were clearly major risks involved in filming in Northern Ireland and the majority of films dealing with the North during this period substituted English or southern Irish locations for actual northern ones. The onset of a new political dispensation within Northern Ireland, combined with the provision of financial incentives, therefore encouraged the growth of new forms of filmmaking activity. In this respect, many of the resulting films have been characterised as 'ceasefire cinema', suggesting not only the way in which they have been enabled by the ceasefires but have also been engaged in representing, and reflecting upon, the 'new' Northern Ireland wrought by the peace process. Made in 1997, and dealing with the prospect of new political arrangements in Northern Ireland, *Divorcing Jack* could be regarded as a 'ceasefire film' on both counts. Set in 1999, on the eve of elections to a new Northern Ireland parliament, the story deals with the misadventures of the journalist Starkey who is mistakenly assumed to have murdered Margaret (Laura Fraser), the daughter of a local politician. The film's title derives from a central 'MacGuffin' – a supposed tape of Dvořák (which, if the joke is to work, everyone must mispronounce with a hard 'D'). Margaret gives the tape to Starkey who only realises later that it in fact contains a recording of Brinn's confession to planting the bomb of which he had previously claimed to be the victim.

Although emerging out of a period of ceasefire, the extent to which the film succeeds in breaking with the mould of earlier 'troubles' movies is open to question. As I have argued elsewhere, the British film *Odd Man Out* (Carol Reed, 1947), a gloomy *film noir* dealing with the demise of a wounded IRA man, has proved something of a milestone in the history of Northern Ireland cinema. Not only was it the first film to deal with the political conflict within the North

since the onset of partition but, aesthetically, it also set the pattern for many cinematic portraits of the 'troubles' to follow, such as *Angel* (Neil Jordan, 1982), *Cal* (Pat O'Connor, 1984), *The Crying Game* (Neil Jordan, 1992) and *The Boxer* (Jim Sheridan, 1997). Involving a combination of tragic narration and expressionist stylistics, this aesthetic may also be seen to have been responsible for encouraging a particular view of the 'troubles' dominated by the pessimistic workings of fate and a conflict between public and private spheres. These are also features evident in *Divorcing Jack*.

This is not to deny, of course, that the film does attempt to depart from the conventions of earlier 'troubles' movies. For the makers of the film, the decision to shoot in Belfast was not simply a means to achieve 'authenticity' but also to represent the 'new Belfast' emerging in the wake of the peace process. According to the film's director, quoted in a 1998 *Film West* article, there was a deliberate attempt to avoid 'the visual stereotypes of a gritty, poor run-down Northern Ireland' and present Belfast as 'bright, modern and cosmopolitan'. Thus, while the film acknowledges an iconographic debt to *Odd Man Out* by staging a short scene in Belfast's Crown Bar, it also searches out locations that are relatively unusual in the cinematic representation of Belfast: the suburbs of south Belfast, the redeveloped cathedral quarter, the city hall and, that icon of the 'new Belfast', the modern concert hall and exhibition centre, the Waterfront. The use of this imagery aligns the film with other 'ceasefire' films, such as Michael Winterbottom's *With or Without You* (1999) and Declan Lowney's *Wild About Harry* (2000), that have employed similar locations to suggest the new prosperous and peaceful Belfast arising from the ashes of the 'troubles'. However, there is also a central tension within the film between the modern urban realities suggested by the film's settings and the darkness of the film's plot and conclusion. This is partly hinted at by the film itself in a scene set in a pretentious modern restaurant of the type that has recently flourished in Belfast. A snobbish waiter arrives at the table at which Starkey is the prisoner of the vicious paramilitary, Keegan. The waiter proceeds to announce the day's special – 'a breaded escalope of turbot, which is prepared in a mixture of white bread and brioche crumbs and served with sorrel cream' – only to be interrupted by Keegan demanding a jam sandwich. Despite the waiter's protests, the order is taken, mainly due to the production of a gun by Keegan's sidekick, 'Mad Dog' (Paddy Rocks). While the scene may be read as a – slightly feeble – homage to Jack Nicholson's taunting of a waitress in *Five Easy Pieces* (Bob Rafelson, 1970), it also clearly dramatises the conflict between the 'new' Belfast of affluent consumerism and the 'old' Belfast of intimidation and physical force which refuses to bow to the changes. Thus, while the film's locations appear to foreground 'the sunny

side of the city' (as the film's Production Notes put it), this 'sunniness' is nevertheless belied by the darkness of the rest of the film.

Divorcing Jack does not, however, simply reproduce the fatalism and pessimism of earlier 'troubles' movies in the conventional manner. In contrast to the high seriousness of its predecessors, it is a self-styled black comedy that has few 'no go areas' in what it is prepared to turn into a joke. It is also a film acutely self-conscious of its literary and cinematic forebears and one that promiscuously recycles elements inherited from other works. If it has an antecedent, it is undoubtedly Mike Hodges' eccentric reworking of Jack Higgins' dour thriller, *A Prayer for the Dying* (1988), in which pastiches of Hitchcock, Hammer horror and, even, the spaghetti western are worked into an improbable tale of an IRA man's search for redemption. Like that film, *Divorcing Jack* is also something of a postmodern mélange, in which the conventional *dramatis personae* of the 'troubles drama' are intermingled with a wide range of references to other films and fictions. Bateman himself refers to the story as a demented version of *The 39 Steps* (1935) in which 'a complete eejit', rather than a 'dashing hero', is 'on the run'. The original novel also draws a parallel with *North by Northwest* (1959) (which the film, rather wisely, chooses to omit). However, although the film derives its 'man on the run' story from John Buchan and Alfred Hitchcock, it is filtered through a very different sensibility from that found in their work. In part, this derives from the comic reworking of the hardboiled tradition of crime fiction by writers such as Carl Hiaasen and Elmore Leonard. In more specifically cinematic terms, it is also indebted to the mixing of black humour, casual violence and popular culture references found in the work of Quentin Tarantino, and *Pulp Fiction* (1994) in particular. The film's determination to avoid the gentility associated with traditional forms of British cinema (such as the costume drama) and its apparent pursuit of the youth audience (through the use of a loud soundtrack and liberal doses of swearing and toilet humour) also suggests a strong desire to emulate the example of *Trainspotting* (Danny Boyle, 1996).

It is, of course, potentially risky to draw out socio-political meanings from a film that so diligently declares both its artifice and wish to be funny. Thus, in a review positive enough to merit quotation on the cover of the video, the critic for *Empire* magazine (November, 1998) was happy to declare that the film had 'nothing to say about the Troubles'. However, while the film certainly makes considerable effort to suppress the political aspects of the 'troubles' this does not mean that it is then itself apolitical. There is, in this regard, a degree of difference between the novel and film. In the original novel, Starkey is explicitly identified as 'a Unionist with a sense of humour' and the novel itself is imbued with a sceptical unionist sensibility (albeit of a

wry, unorthodox kind). Thus, a key joke at the end of the novel (omitted from the film) concerns a Catholic priest who has received a heart transplant from an English Protestant and become more 'attuned to reconciliation' in the process. In the film, Starkey's unionism is omitted and he is largely identified as a punk-enthused sceptic and trouble-maker. However, while this was no doubt a commercially sensible precaution to have taken, it also creates a problem for how the character of Starkey then functions as a point of orientation within the film.

This is a problem of which the film's co-producer, Robert Cooper, was aware. Reflecting on changes to the script, he argues that that there was an absence of 'moral purpose' to Starkey's actions and that it would be impossible to 'like a character who doesn't believe in anything'. His solution was to provide a new speech at the film's end in which Starkey speaks up on behalf of the importance of 'individuals'. However, this was not the 'solution' that Cooper appeared to believe. On the one hand, it has all the hallmarks of a tacked-on speech that lacks conviction in the face of what has preceded. On the other, its expression of 'moral purpose' is fundamentally undermined by the film's own complicity with the cynical outlook that Starkey professes to oppose.

As Fredric Jameson has famously argued, a central feature of postmodern culture has been what he refers to as the 'waning of affect'. In the same way, *Divorcing Jack*'s knowing use of pastiche and intertextual reference works against complex psychological characterisation and the emotional engagement of audiences with the characters and their predicaments. As a result, Starkey's end-of-reel conversion to liberal-humanist values itself takes on the characteristics of a second-hand 'quoted' scene devoid of dramatic intensity. These values, moreover, are further undermined by the film's own lack of investment in 'affect'. While any number of the film's scenes would demonstrate this, it is, perhaps, most striking in the film's treatment of death. Although Starkey accuses Brinn and Keegan of placing no value on the individual, the film itself, following in the footsteps of *Pulp Fiction*, displays a casual disregard towards the taking of life and its emotional consequences. Starkey, for example, mistakenly murders Margaret's mother by jumping on her and breaking her neck. While this partly explains his subsequent reluctance to go to the police, the incident is primarily used for comic effect and the mother herself is simply brought into the plot for the purpose of a speedy exit. In a later scene, not in the novel, Lee shoots one of Keegan's men, Frankie (Derek Halligan), through the forehead. This is played entirely for laughs – Lee believed the gun was a replica – and no time is allowed for reflection on the nature of this incident and its effects upon Lee, a nurse otherwise devoted to the saving of life.

The casualness with which the film deals with violence has a further dimension. Both Starkey and Lee are intended as fundamentally 'good' characters who are nevertheless drawn into the evils of the world around them. In this respect, for all of its status as a 'ceasefire film', *Divorcing Jack* is gloomy about the prospects of change. There are two aspects to this. On the one hand, the film appears to imply that, despite the onset of 'peace', it will still be in the (economic) interests of the main protagonists to continue violence. 'Cow Pat' Keegan – the designer-clad 'godfather' of *Crossmaheart* (Henry Herbert, 1998) ruled by economic self-interest rather than political motivation – provides the clearest example of this. However, his counterpart, the loyalist leader Billy McCoubrey (B. J. Hogg) is also a 'gun for hire', happy to work for the former IRA man Brinn if he is paid to do so. In this respect, the film's use of references to the gangster film not only echo a common association of paramilitaries with organised crime but also reinforces a de-politicised view of the 'troubles' as no more than 'business'. This is also true of the film's references to the western. In the novel, the theme of the degeneration of the paramilitaries into racketeers is quite explicit and, in an interview with the American reporter Parker (Richard Gant), Brinn explains how the 'political figures' on both sides will disappear and 'we'll be down to a straightforward game of cowboys and Indians'. Although this speech does not appear in the film, the reference to 'cowboys' does become something of a running gag. Parker is bemused that he is unable to hear anything other than country'n'western on the local radio; the loyalist paramilitaries dress up as cowboys at a local club and then pursue Starkey to the accompaniment of Elmer Bernstein's score for *The Magnificent Seven* (John Sturges, 1960). Although, at one level, a fairly ghastly pastiche, substituting Loyalist killers for the protectors of downtrodden peasants, the scene nevertheless implies quite clearly how the 'troubles' have, indeed, become no more than a 'game of cowboys and Indians'.

This sense of the enduring character of violence is brought to a stark conclusion in the climactic scene near the end of the film when all the main protagonists are finally brought together at the Silent Valley in the Mountains of Mourne. Starkey has retrieved the tape containing Brinn's confession of involvement in a bombing that killed thirteen people. In return, Keegan has promised to release his wife Patricia (Laine Megaw) and friend Mouse (Alan McKee) from captivity. Brinn has also arrived with the money he has promised to pay Keegan for the handing over of the tape. What follows is a grimly comic finale. Brinn takes the tape but is blown up by the tape recorder in which it has been presented to him. Keegan drives off with his payment but is himself blown up by the booby-trapped briefcase in which the money has been carried. This is a particularly pessimistic conclusion given that it has occurred on the very day that Northern

Ireland has been voting for a new political dispensation under Brinn's leadership. Brinn's campaign has been based on peace and reconciliation but he does not survive to see his programme through. More significantly, the film implies that this programme was inherently flawed. Brinn was a former IRA man, responsible for the death of innocent civilians. Despite his protestations that his political ambitions have been fuelled by remorse and a desire to make amends, the film reveals the extent to which Brinn's activities as a 'man of peace' continue to depend on the use of violence. As the film shows, he is indirectly responsible for the death of Margaret at the hands of McCoubrey and also masterminds the murder of Keegan and his colleagues.

There is, perhaps, a degree of irony here. Following its publication in 1995, the original novel was praised for the way it had anticipated the forthcoming assembly (albeit that this was unlikely to lead to the independent Ulster anticipated in both novel and film). However, it is significant that the success (such as it has been) of the Northern Ireland Assembly has depended upon a commitment by former paramilitaries to the ending of violence and an engagement in the political process. The implication of the film, however, appears to be that this is a forlorn prospect: paramilitaries prove unable to renounce violence with the inevitable destructive consequences. As Lee observes, when Starkey subsequently wakes up in hospital: 'It's chaos out there – but then it always has been.' This attitude appears to be reinforced by the setting in which the scene occurs. There has been a longstanding tradition within literature and film of associating Irish violence with the 'wildness' of the Irish landscape. By dramatising its violent dénouement against the backdrop of the spare landscape of the Mountains of Mourne, so the film appears to reinforce a view that violence is the 'natural' – and inevitable – outgrowth of the land itself.

There is, of course, one counter-current to this overall dramatic and ideological logic. Despite the expectation that he will be killed, Starkey is left by Keegan who, in an unconvincing outburst of romantic feeling towards Margaret, encourages him to write up the story of what has happened. Following his spell in hospital, Starkey returns home to his wife, where they embark upon a bout of love-making on their 'magic settee'. In a sense, this concluding coda reinforces the conservative nature of the film's outlook. Starkey's involvement in the world of 'chaos' has been precipitated by the appeal of marital infidelity. His escape from 'chaos', and return to normality, is signalled by his return to the marital home and reconciliation with his wife. In this way, the film is not only pressing home the dangers of straying from the security of home and marriage but also counterpointing this private, domestic universe to the threatening world of public disorder beyond the home. It has been a common feature

of 'troubles' movies to set up a conflict between the 'private' spheres of romance, home and domesticity and the 'public' world of politics and violence. In this way, for all its postmodern twists, *Divorcing Jack* conforms to a longstanding tradition of representing the Northern Irish conflicts.

Given its predominant tone of cynicism and irreverence, it is not entirely surprising that the film divided critics on its appearance. In some quarters, it was welcomed for its freshness and avoidance of liberal pieties. Thus, at least one critic, Stephen Dalton, provided the accolade – 'the best British film since *Trainspotting*' – that the film had undoubtedly been seeking. In other cases, however, the film was rebuked for its superficiality, confusing plot and tasteless- ness. Perhaps, the most indignant critic was the Northern Irish writer Alexander Walker who complained in the London *Evening Standard* that it was 'coarse' and 'unfunny' and 'one of the worst ever made on Ulster soil'. The film also suffered from a release not long after the Omagh bombing (in August 1998) and suggestions in some quarters that it should not be shown. Although the film's co-producer declared that the film's 'black wit' constituted a legitimate way of dealing with 'the wounds of a divided society', it is also clear that the film was capable of provoking genuine discomfort in the way that it made dark capital out of continuing conflict. Whereas Tarantino's films occupy a displaced mythic world of popular culture and comic-book violence far removed from the direct experience of its audience, audiences were less insulated against the realities of the 'troubles' (or the continuing news reports about them). The film, in this regard, walks a fine line between comic subversion and bad taste which leaves an audi- ence unsure whether or not it is appropriate to laugh. This, in turn, may partly explain why the film did only modest business at the box office and failed to become the cult hit that had been hoped.

At the time of *Divorcing Jack*'s production, Robert Cooper, the Head of BBC Northern Ireland's Drama Department and the film's co-producer, commented that it was essential that Northern Ireland 'becomes known as a place where you can make commercially viable films'. However, the poor commercial performance of *Divorcing Jack* and other lottery-funded films (including a second Bateman adaptation, *Crossmaheart*) has meant that some of the initial enthusiasm for local film production has waned. The use of lottery funds in support of film has been more sparing than before while BBC Northern Ireland, after two other relatively unsuccessful ventures into film feature production (*Titanic Town* [Roger Michell, 1998]; *Wild About Harry* [Declan Lowney, 2000]) has refocused its energies on television drama. The Northern Ireland Film Council has also changed its name to the Northern Film and Television

Commission as a way of signalling the increasing importance of television, rather than film, to the local economy.

Despite these setbacks, it would be wrong to underestimate the significance of recent levels of film production in Northern Ireland when there has been no sustained tradition of filmmaking and violent conflicts have been a characteristic of social life for so long. In this respect, the economic costs of public support for film production must be weighed against the cultural value of nurturing creative talent and promoting new and challenging forms of cultural expression. In a sense, this may have been the more serious weakness of recent developments. Although *Divorcing Jack* set out to initiate a new direction in Northern Irish filmmaking, it nevertheless remained locked within a longstanding tradition of representing the 'troubles'. To a large extent, the pressure for commercial success has encouraged recent Northern Irish films to adopt conventional dramatic formats and genre conventions (such as those of the thriller and the romantic comedy). It may well be, however, that if Northern Irish films are to succeed – both culturally and economically – they will have to be prepared to take more artistic risks than hitherto, not only in the stories that they tell but also in the ways in which they tell them.

John Hill

REFERENCES

Bateman, C. (1995) *Divorcing Jack*. London: HarperCollins.

Dalton, S. (1998) 'Just Pure Genius', *Uncut*, 17, 98.

Hayden, J. (1998) 'The Only Way is Up', *Film West*, 34, 26–8.

Hill, J. (1987) 'Images of Violence', in K. Rockett, L. Gibbons and J. Hill, *Cinema and Ireland*. London: Routledge.

ORDINARY DECENT CRIMINAL

THADDEUS O'SULLIVAN, IRELAND/GERMANY/UK/US, 2000

Thaddeus O'Sullivan's *Ordinary Decent Criminal* (2000), a slick gangster caper, peppered with satire, parody, irony, wit and slapstick is, without doubt, postmodern. It blurs distinctions between reality and fantasy, and the real and the fake within and beyond the film, as it celebrates the role of the trickster who, as theorist Jean François Lyotard would suggest, 'wages a war on totality', or authority and meaning.

Though the film, at times beautifully and stylishly shot, and directed with a sure hand, appropriates American genre and film history and makes use of the star system, it nevertheless does not lose sight of the cultural specificity that is contemporary Ireland, and in that way operates as an imaginative social text. Yet, for the most part, critics and reviewers seem to have failed to appreciate the film under these terms. Instead, it has been cast as an all-too-slight and light film with an improbable and torturously convoluted narrative; a poorly cast, cynical attempt at commercial cinema for an international, predominantly American, audience (however, Miramax, one of the film's distributors, did not give it a theatrical release there); and most notably, as an inferior version of John Boorman's successful 1997 biopic of Dublin criminal Martin Cahill, eponymously referred to in the film's title *The General*. This is despite the fact that the films belong to entirely different aesthetic worlds, and, notwithstanding that Cahill is the inspiration behind the texts as he is in David Blair's television drama *Vicious Circle* (1998), ultimately, they have a different focus. In short, the film has been dogged with an unfruitful search for the authentic or real (as played out in accent, location or event) which radically misses the point. Positive readings have tended to concentrate on the film's visual quality.

The narrative centres on mastermind criminal Lynch (Kevin Spacey), who lives with wife Christine (Linda Fiorentino) and children and has, as his lover, her sister Tina (Helen Baxendale). They enjoy relative prosperity in middle-class Dublin suburbia, courtesy of the State and his criminal activities. During legal proceeding against him, he commits a number of crimes. These include a bank robbery (part of the proceeds used to pay his barrister's fee which is represented as extortionist); a robbery of the social welfare office where he has just collected his weekly dole money; organising the vandalising of the police golf course as a

reply to his being brought in for interrogation (the carnivalesque silhouetted image recalls the scene featuring the Lambeg drum in O'Sullivan's *December Bride* [1990]); a robbery of the seemingly impenetrable O'Donnell's Jewelry factory (which needles the IRA); torture of one of his own men whom he suspects of stealing from him; and arranging a warning bomb to be sent to the Judge, which has the effect of his directing the jury to a non-guilty verdict. His masterstroke, however, is the stealing of Caravaggio's 'The Taking of Christ' from the National Gallery of Ireland.

Dressed and acting in a parody of the Irish perception of American tourists, they walk into the gallery. Following the intertextual signal of the kiss from the painting, they lift a number of paintings and walk out. (Fittingly, Stevie [Peter Mullan] gives the Judas kiss. Later, he betrays Lynch to IRA man Higgins. Initially, Higgins had been inscribed in the actual painting as Judas. Lynch, of course, is God.) A comic chase ensues, but the gang drive free. Lynch discovers that his Dutch art expert contact is working for the police. However, he 'finds' the bug, but forces him to continue as if they are ignorant of the device as they give false clues as to where they are. If this operates as a gag and fits the caper aesthetic, the separation of word from image also undercuts the dominant tourist (and film) image of the tranquil countryside, the log fires, the Irish music and the pint of Guinness, with images of a noisy congested Dublin. Lynch then switches the painting with its replica in a priest's house where it had hung undiscovered, before it had been donated to the Gallery. As he enjoys fame, and the fact that police have come down to his level, his gang become increasingly annoyed and want to return to making money, which Lynch sees as secondary. Stevie teams up with Higgins (Tim Loane), but there is a double betrayal, as Higgins tips off the police as to the painting's location. There, Stevie and Alec (Colin Farrell) are cornered and the painting (unbeknownst to all, a fake) is riddled with police bullets.

Meanwhile, Higgins is about to rob a bank with his gang. However, Lynch finds out about the robbery, and with Tony (David Hayman) plans to get in on the action. Outside the bank, the police arrest Higgins' Shay (Vincent Regan), an ex-associate of Lynch, who tells them that Lynch is inside. He seems to give himself up, but when the police grab him, it turns out that it is Tony. In the rush of people from the bank, Tony escapes. Later, he goes to Lynch's 'wives' with the money. Finally, Lynch comes out of the bank brandishing a gun and the guards shoot. His face is a mess. Detective Noel Quigley (Stephen Dillane) correctly suspects that the sisters have lied in their identification of the body as Lynch. It transpires, through flashback, that he had sent out Higgins to be shot. During the funeral, Lynch leaves a postcard of the painting on Quigley's

car-screen. The film ends with the priest's dining-hall where the Caravaggio, posing as a fake, hangs. A smiling Lynch is inserted as Jesus; notably, there is no one superimposed as Judas.

Possibly the film's lukewarm reception resulted, in part, not just from over-familiarity with the Cahill story, and the fact that Irish audiences, as O'Sullivan suggested to Gerry McCarty, 'wanted a more profound reaction to Cahill and thought it was too soon to make it into a skit', but, more generally, from audience expectation of those involved with the production. Not only had it cast Kevin Spacey in the lead, which, as evidenced in reviews, seems to have worked to the film's disadvantage, but both the scriptwriter Gerry Stembridge and director, Dublin-born O'Sullivan, had made a number of challenging and refreshing films in terms of both form and content.

Stembridge, one of Ireland's leading dramatists who first came to prominence as originator and a writer of the popular satirical Irish radio series *Scrap Saturday*, directed the award-winning feature film *Guiltrip* (1995). With a dark narrative of domestic abuse and murder in smalltown suburbia revealed through a flash-forward/flashback structure, whereby the two lead characters recollect their respective day, it opened up relatively new filmic discourses around Irish masculinity and society. O'Sullivan's contribution to Irish cinema has been more extensive. If in terms of recognition or commercial success he follows Irish directors Neil Jordan, Jim Sheridan and Pat O'Connor, he nevertheless provides an interesting figure through whom to understand contemporary Irish filmmaking, from the critical indigenous cinema of the late 1970s and 1980s through to the more mainstream international cinema of the 1990s and 2000s. More than any other filmmaker, his work, without losing its identifying fascinations, maps the cultural trajectory of the Irish film industry and its relation to European and American filmmaking. Put another way, his work ranges from an avant-gardist or artisan and European-influenced cinema, overt in its cultural, socio-political engagement, through to the more highly-polished commodities that look to Hollywood and entertainment, though not necessarily at the expense of their Irish specificity.

O'Sullivan's career dates back to the early 1970s when as a student of design at Ealing School of Art (1969–72), and of film and television at the Royal College of Art, London (1972–75), he made a number of shorts including *Foreshore* (1969), *Sweet Thoughts* (1970), *The Picnic* (1971), *The Entertainer* (1972), *Flanagan* (1973) and *Mass* (1974). He went on to make the longer *A Pint of Plain* (1975), and the avant-garde feature, *On a Paving Stone Mounted* (1978). If these display O'Sullivan's concern with form and the visual, their deconstructive aesthetic and 'anti-story, anti-narrative, anti-industry' aspect helped O'Sullivan discover that what he really

loves are stories, and to appreciate that (Hollywood) cinema offers a *re*presentation of reality, or a 'hyperreality'. It is to such a cinema, emptied of psuedo-naturalistic pretension, that *Ordinary Decent Criminal*, complete with its emblematic narcissistic hero, belongs.

However, these early works also signal his interest in the non-normative or the unseen, those things that the Presbyterian minister in O'Sullivan's first mainstream feature *December Bride* wants to 'make smooth to the eye'. In short, he is drawn to those aspects of society that go against or move beyond ideological or representational norms and the status quo, and, in so doing, also challenges the nature of history as it is bound up with storytelling and the construction of memory. For example, both *A Pint of Plain*, celebrated by Marc Karlin for its startling realism, and the more formally complex and sadder *On a Paving Stone Mounted* take as their subjects an invisible people: Irish economic emigrants in Britain. (O'Sullivan regards himself as the last of these when he left Ireland unskilled in the mid-1960s.) In the latter film, in which the roaming camera and non-linear editing echoes the randomness of the exiles' lives, they reminisce about 'back home', but, as O'Sullivan, in the *BFI Production Catalogue 1977–78*, points out, 'the memories become fiction, and the fiction becomes memory'. This attempt at reconstruction of the past through story and remembrance is complemented by professional *seanchaí* Eamon Kelly's stage show telling of a returned emigrant from New York and its exaggerated grandeur, itself undercut by how it is edited, fragmented and repeated. In that, it looks forward to the storytelling in *Ordinary Decent Criminal*. Here, it is self-consciously mocked through postmodern intertextual references that announce its level as artifice or fiction. When Lynch tells his 'history' to his children, it is as a bedtime story that alludes to the fairytale tradition (specifically 'The Three Little Pigs') with all its recourse to exaggeration and the binary of good and bad, as well as the cinematic shorthand of the brutal Men in Black Suits. Additionally, the framing acts to situate Lynch in another space, beyond the domestic. Theatrical goldenochre curtains hang in the background, through which a blue light shines. It is clearly marked as performance. Of course, Lynch's interest in storytelling or narrative is central to his own perception of himself as an artist and identification with the 'unholy' Caravaggio. This is also evident when he speaks to one of his sons through a thinly-veiled parable as he repairs a puncture in a scene which reinforces the notion of Lynch as a good father, just as it is when he sees himself as Jesus in Caravaggio's painting. Arguably, the latter says more about his narcissism and messianic pretensions.

Before he became a director of narrative cinema, O'Sullivan worked as a cinematographer. (He has also directed a number of television dramas, commercials and documentaries.) While

his credits include *Rocinante* (Ann and Eduardo Guedes, 1986), *On The Black Hill* (Andrew Grieve, 1988) and *Ladder of Swords* (Norman Hull, 1989), the most interesting, with regard to his own cinema, and more generally from an Irish cultural perspective, has been his work on some key independent Irish films which sought to counter the romantic and stereo-typical images of Ireland conceived of and perpetuated by predominantly foreign cinema, mostly British and American. These include Joe Comerford's elliptical 'road-movie' *Traveller* (1981) which follows the fortunes of a traveller couple and a renegade IRA man; Comerford's experimental short *Waterbag* (1984); Bob Quinn's three-part television series *Atlantean* (1983) which sought to discover the Irish 'Celtic' past in North Africa/Middle East; Pat Murphy's *Anne Devlin* (1984) which focuses on the forgotten woman of the 1803 rebellion, Robert Emmet's 'housekeeper', and in which the image and the symbolic are given heightened importance; and Cathal Black's *Our Boys* (1981) which, shot in monochrome, explores clerical abuse, physical and psychological, within the Irish education system under which O'Sullivan suffered; and *Pigs* (Cathal Black, 1984) which features a derelict Georgian Dublin house where a number of social (and in terms of Irish film representations) outcasts squat. While O'Sullivan turns the abject squat into an aesthetic object, in this instance, it lends poignancy to the Georgian faded splendour.

This architecture of the colonial past is central to *Ordinary Decent Criminal* where it comes to signify power and the establishment. The imagined topography of Dublin through which Lynch morphs and penetrates is one of large-scale imperial buildings, Georgian city squares and streets. The Four Courts (actually the Customs House), the police station, the building outside which he leaves the police informant art expert, the National Gallery of Ireland (government buildings), the social welfare office, the Judge's house (once a Big House), and the bank of the opening scene as well as the one in the climactic scene at College Green (once the eighteenth-century Irish Houses of Parliament), visually encapsulate the symbolic nature of his crimes. That the Irish State should be represented as an ersatz coloniser is suggestive, and inevitably hints at the ambiguous relationship of Ireland to Britain (and, at the cultural level, America) which is more fully explored in Neil Jordan's *The Butcher Boy* (1997). Indeed, a postcolonial inferiority is certainly evident in Commissioner Daly's (Patrick Malahide) attitude both to Lynch and detective Quigley. A parody of the old-style *gombeen* country guard, he, with his FBI experience, cannot entertain Quigley's suspicion, backed up with evidence, that Lynch, an Irish working-class criminal, could be in the big boys' league of international art robbery, until an Interpol detective comes to that conclusion. If such a representation may seem offensive, not to say incredible, it should be seen within the Keystone Cop or slapstick tradition

of sticking it to the law, but also in terms of Irish people's relation to authority defined by the colonial legacy, and the fact that, as Cahill himself observed prior to the early 1990s, Irish police were seen as predominantly from the country, decent and honest, as well as being unarmed. In short, they were ineffectual against the new breed of gangland criminal of which Cahill was exemplary.

The Woman who Married Clark Gable (1985) was O'Sullivan's first theatrically-released narrative-driven short film. Shot and directed by him, it is adapted from a Sean O'Faoláin story, and was nominated for a BAFTA award. Though set in 1930s Dublin, according to O'Sullivan, it equally recaptures the importance of the weekly visit to the cinema that he enjoyed when he was growing up in the otherwise repressive 1950s. Starring Bob Hoskins (George) as an English factory worker married to childless Brenda Fricker (Mary), it hints at O'Sullivan's own later engagement with Hollywood in *Ordinary Decent Criminal*, as it focuses on Fricker's fantasy that her husband is Clark Gable. This erupts after she sees *San Francisco* (W. S. Van Dyke, 1936) and ends when he shaves off his moustache. However, it was not until 1990 that he made his directorial foray into mainstream feature cinema with *December Bride*, influenced by the European art film. Another period piece, it was an adaptation of Sam Hanna Bell's 1951 novel of the same name. Set in the late nineteenth century in a closed community of Presbyterians in County Down, it tells of a young woman, Sarah (Saskia Reeves), who stays on without her mother's approval as housekeeper to two brothers after their father drowns. She subsequently becomes pregnant by one of them, and though she refuses to marry either, the three offend the god-observing locals by living together in a *ménage-à-trois*, an arrangement that O'Sullivan returns to in *Ordinary Decent Criminal* and *The Heart of Me* (2003), a period piece that cuts back and forth between 1930s and post-war London. In both, a woman falls in love and consummates a relationship with her sister's husband. For the sake of her daughter who wishes to marry and live conventionally, Sarah marries older brother Hamilton (Donal McCann).

Winner of fifteen international awards, it is one of the most important films set in Northern Ireland, not least for its decision to look at an alternative reality to that of Republican/Loyalist violence, but also for its de-romanticising of the landscape, and allowing a woman's voice to emerge. Beautifully composed and with a painterly quality to it, akin perhaps to the equally, though very different, poetic film *Anne Devlin*, which he shot, it is noteworthy in terms of its visual aspect and how the imagery complements or becomes the film's narrative. Indeed, as O'Sullivan in an interview with Nicky Fennell has said, 'I work visually. I will look at a story and see how the locations and the background and the world these people live in is going to

inform [the film] and how I can best get that across visually. Consequently, to apply the criteria of realism is inappropriate. In a recent conversation with McCarty about the minimalist decoration within *The Heart of Me*, adapted from Rosamund Lehman's novel *The Echoing Grove*, he argued that 'you'd be a bad director if authenticity got in the way of drama or good storytelling'. The cinematic-looking warehouse, bathed in a blue light, complete with golden-lit magnificent chandelier hanging over the green pool table in *Ordinary Decent Criminal* is incredible as a 'headquarters', but makes perfect sense within the logic of the film and as a mirror to Lynch's egocentric personality. This is also the case in his second commercial film, the somewhat melodramatic, angry and fast-paced *Nothing Personal* (1995).

Just as O'Sullivan refigured the landscape in *December Bride*, in *Nothing Personal*, as Martin McLoone notes, a new geography of Belfast and its streets of violence is imagined, one which is theatrical rather than naturalistic, and echoes the sense of entrapment felt by the characters who are bound up with paramilitary violence. Also set in the North, but this time in Belfast during the most violent period of the 'troubles', the mid-1970s, and about a people who also have been largely ignored by cinematic representations – loyalist paramilitaries – the film, like his award-winning television drama *In the Border Country* (1991), is a humanist plea against sectarian violence. However, just as *Ordinary Decent Criminal* is not limited to a real Dublin criminal, so, too, *Nothing Personal*, though never leaving Belfast, extends as a narrative or a poetics of imagination to the universal. History and the Northern problem are, in a sense, unimportant. The next major project with which he was involved was the well-received NBC mafia drama *Witness to the Mob* (1997) about Sammy Gravano who was John Gotti's enforcer. Made for Robert De Niro's production company Tribeca, it is directly relevant to *Ordinary Decent Criminal*, not just because of its focus, or because it took him away from working on the project, but the experience of getting it right, and having to spend more time looking at FBI records and interviewing people than making the film, turned him off the idea of having to follow every detail of Cahill's life. When he returned, he, together with Stembrigde and producer Jonathan Cavendish (producer of O'Sullivan's first two mainstream features), decided against optioning Paul Williams' real-life crime history *The General*. Subsequently, John Boorman bought the rights, and following a court case between Merlin and Little Bird (the production companies of *The General* and *Ordinary Decent Criminal* respectively), it was decided that both productions were sufficiently different to go ahead without interference from the other. Investors and those who made the film, then, were clear about its unique identity as a tall tale far removed from either the real streets of Dublin, or the standard cinematic versions of these.

Ordinary Decent Criminal is similarly removed from the dark gritty underworld of the gangster movie or the psychological and social probing of *The General*. Nevertheless, the majority of critics, invoking realism, naturalism or genre have (mis)read and dismissed the film as getting it wrong, or, at best, as a remake of Boorman's. Little has been said of how the film remodels the (American) gangster to fit within an Irish context of Dublin suburbia, just as Paddy Breathnach did in relation to small-time criminals in his comedy gangster road-movie *I Went Down* (1997). Consequently, *Ordinary Decent Criminal* can be read not just in relation to films based on real crime such as Boorman's, or John McKenzie's *When the Sky Falls* (2000) and Joel Schumacher's *Veronica Guerin* (2003), both focusing on murdered crime reporter Guerin, but also as part of the more general appropriation of the genre by contemporary Irish film, arguably beginning with the urban crime film *The Courier* (Frank Deasy/Joe Lee, 1987). These include films such as Vinny Murphy's road-movie tale of joyriders, *Accelerator* (2000), Fintan Connolly's *Flick* (1999) which has a small-time drug dealer in Dublin's trendy Temple Bar find sanctuary and love in the West of Ireland, or more appropriately as one of the number of crime comedies including *Dead Bodies* (Robert Quinn, 2003), *The Actors* (Conor McPherson, 2003), *Intermission* (John Crowley, 2003), *Headrush* (Shimmy Marcus, 2003) and *The Mystics* (David Blair, 2003).

Undeniably, Lynch is inspired by Dublin gangster Martin Cahill, who masterminded one of the world's largest art robberies when he stole eleven paintings from the Beit Collection in 1986 and which, in retrospect, jinxed his career and indirectly led to his death at the hands of the IRA in August 1994. (Schumacher's *Veronica Guerin* suggests another assassin.) Until then Cahill, who came from a disadvantaged background and whose crimes included robbery, assassination, kidnap, intimidation and bombings, seemed over his twenty-year career to be untouchable. Operating with impunity, this 'underworld hooded bogey man', as described by Williams, was a complex man of contradictions 'from devoted father, loyal friend, prolific lover, absurd joker, to hated outlaw, feared gangster, sadistic fiend, meticulous planner.' However, the suave and charismatic Lynch who enjoys acts of crime as a cerebral game by which to frustrate the establishment and criminal fraternity and to display his superiority over them, and, increasingly, in order to court media fame, is not Cahill by another name. Even if many of his crimes, as well as the domestic arrangement with two sisters as wife and lover, are similar, and the contradictions remain between, on the one hand, good family values and notions around duty, loyalty and honesty, and, on the other, hatred of the State, Lynch is bigger, more brash, refined, and most of all more imaginative. As O'Sullivan told Derek O'Connor, 'we just cherry-picked

what we wanted to say from Cahill's life and used it to say what we wanted to say about the Spacey/Lynch character'. In short, he is no Robin Hood, but a witty artist whose performance pieces are his crimes. Detective Quigley sums this up when giving evidence: 'Sometimes I think he's not a real criminal at all, he's just a big show-off'. This is most apparent in his audacious daylight robbery of the paintings. But then, the film also delights in the spectacle and the image.

Content and form, as is characteristic of O'Sullivan, match. While this can be seen generally in the film's cinematic look, attention to detail, composition and unified palette, or in the various textures of, and layering within, the image – such as in the television and video-recorded images, or the silhouetted blue shots – it is best understood in terms of how Lynch and his world is inscribed visually. For example, in the warehouse scene following the theft of the Caravaggio, Lynch, speaking to his audience (within and beyond the film), is framed by an arch which, with its suffused blue lighting, becomes the proscenium arch of a performance that abounds with fragments of self-images. To his left is a widescreen television on which he plays a video with news footage of his crimes and his striptease which he performed outside the court for the media, while the wall is plastered with news clippings and headlines, all of which serve to massage his ego so that he becomes literally the centre of his world. During this scene, he tells his gang, with a reference to new Irish cultural success, what drives him is that 'We're number one, not the guards, not the IRA, not anyone else. The whole country is in awe of us, because of a little divine intervention – we're bigger than "Riverdance"'.

As the film clearly belongs to Lynch, it is also Spacey's film. However, O'Sullivan's decision to cast in an Irish story an American star, albeit one with a reputation for playing flawed or egocentric characters (for example in *Se7en* [David Fincher, 1995], *The Usual Suspects* [Bryan Singer, 1995], *LA Confidential* [Curtis Hanson, 1997], *American Beauty* [Sam Mendes, 1999]), has come in for some criticism. That Spacey (like Fiorentino) has an inauthentic Dublin accent only lends further weight to this. However, the decision is ultimately financial rather than artistic. The problem that faces all Irish directors who want to make a big-budget commercial movie, complete with the look and production values of Hollywood, is the need to cast a highly saleable actor. This is even more apparent in *Ordinary Decent Criminal's* decision to cast Fiorentino, who sprang to success with John Dahl's 1994 *film noir*, *The Last Seduction*, and the English Baxendale who starred in *Friends* and *Cold Feet*. It is for this reason that local talent has unfortunately tended to play second fiddle in internationally marketed Irish films. In *Ordinary Decent Criminal*, it plays third as the Irish actors including a young Colin Farrell, Paul Ronan and Gerard McSorley, have been limited to small parts, while the bigger roles have

been given to British actors including, amongst others, the English Stephen Dillane who gives a superb performance as Lynch's batting partner, David Hayman, Patrick Malahide and the Scottish Peter Mullan who won best actor at Cannes for his role in *My Name is Joe* (Ken Loach, 1998). However, that the story is not ultimately Cahill's and is not limited to the real world of Dublin vindicates O'Sullivan's casting decision, as does the fact that the performances, for the most part, are convincing.

Apart from the film's play with notions around art, value and appearance or decoys and doubles (in which it looks forward to Neil Jordan's *The Good Thief* [2002]), 'Celtic Tiger' consumerist Ireland, its creating of a new topography of Dublin and indeed, the reworking of the gangster-caper, the film deserves to be celebrated for its deliberate eschewing of realism in favour of a hyperreal fantasy and its rejection of the mono-cultural representation of Ireland. Perhaps most importantly, it offers a rare glance at a liberatory, guilt-free cinema (in which it looks forward to Stembridge's *About Adam* [2000]) where Irish gangsters are allowed to enjoy the success and fame of the artist. For all its flaws (including sound synchronicity), or unevenness, it is an upbeat film helped by the jazzy pulsating score by Blur's Damon Albarn, and one which clearly encapsulates the new direction of Irish cinema, where cultural comment, postmodern play, as well as visual and artistic flair are present.

Emer Rockett

REFERENCES

Fennell, N. (1995) 'Fanatic Heart', *Film West*, 22, 16–18.

Karlin, M., S. Dwoskin and T. O'Sullivan (1978) 'On A Paving Stone Mounted', *British Film Institute Productions Catalogue 1977–1978*. London: British Film Institute, 35–8.

McCarty, G. (2002) 'Ordinary Decent Director', *Sunday Independent*, Magazine section, 17 November, 10–11.

McLoone, M. (2000) *Irish Film: The Emergence of a Contemporary Cinema*. London: British Film Institute.

O'Connor, D. (2000) 'Ordinary Decent Director', *Film West*, 39, 38–40.

Williams, P. (1998 [1995]) *The General*. Dublin: O'Brien Press.

SWEET SIXTEEN

KEN LOACH, UK/FRANCE/GERMANY/ITALY/SPAIN, 2002

The vibrant and powerful *Sweet Sixteen* (2002) proves that, four decades after his ground-breaking television play *Cathy Come Home* (1966) and his feature-film debut *Poor Cow* (1967), Ken Loach's work remains passionately contemporary, sending out 'a report from the front line' of modern Britain. Contrary to accusations that Loach's films are didactic or even depressing, this story of teenager Liam's struggle to make a better future for his family balances its starkness with suspense and humour. It combines a moving personal story with an awareness of its social causes and political implications; achieving this difficult balance remains Loach's defining gift.

A director who has remained loyal to his political principles and to British cinema rather than moving to Hollywood like many of his contemporaries, Loach is one of very few established British directors still punching their weight, acclaimed across Europe – if not always at home – as a true *auteur*. Upon the release of *Sweet Sixteen*, it and *All or Nothing*, directed by fellow veteran Mike Leigh, were welcomed by Ryan Gilbey as abrasive, risk-taking films which demonstrated, alongside Lynne Ramsay's *Morvern Callar* and Marc Evans' *My Little Eye*, that 2002 had been 'a dazzling year for adventurous cinema'. *Sweet Sixteen*, which won Best British Independent Film at the British Independent Film Awards, was a relief for critics tired of 'the Miramaxation of what was formerly known as independent cinema' in the wake of Stephen Daldry's *Billy Elliot* (2000) and Gurinder Chadha's *Bend It Like Beckham* (2002). It is testament to Loach's staying power that such a long-established director should be responsible for the most recent film in this collection, even if it also demonstrates the lack of a young successor. *Sweet Sixteen* is an appropriate film with which to discuss issues which are crucial to contemporary British cinema, not least the existence within it of a Scottish cinema.

Set in Greenock, *Sweet Sixteen* follows the attempts of Liam (Martin Compston) to pay for a new life for his mother Jean (Michelle Coulter) when she gets out of prison, away from her drug-dealer boyfriend Stan (Gary McCormack). Liam wants to buy a new home for his family, a caravan looking out over a picture-postcard scene: an expanse of river with mountains in the distance. The space framed in these evocative shots reinforces the contrast between the security and breathing space Liam seeks and the narrowed alternatives he is trapped within, literally in

the entrapping *mise-en-scène* of his decaying drug-infested urban estate. Often these polarised settings are framed in the same shot because of the 'spectacular' setting of Greenock which, as Loach observed, 'contrasts rather sadly with the quality of life of people who live there'. However, this picture-postcard image of escape comes up against the reality of paying for it, as Liam faces a lack of options that recalls Joe's situation in Loach's *My Name is Joe* (1998): 'some of us cannae go to the bank for a loan, some of us cannae just move house and fuck off out of here … every fucking choice stinks'. Joe was dragged into dealing to save a friend from a debt, and similarly Liam steals Stan's heroin stash and starts to sell it (writer Paul Laverty has described Liam as a younger version of Joe, and *Sweet Sixteen* as almost a prequel). When Liam deals on gangster Douglas's territory, he is abducted and warned off. However, admiring Liam's attitude, Douglas employs Liam to run drugs with pizza deliveries.

Motivating Liam's actions is his love for his mother, which forms the core of the film. In this way, *Sweet Sixteen* reflects George McKnight's belief that Loach's films are 'domestic morality tales', albeit ones in which Loach contextualises 'domestic or community scenarios in terms of the impact of social and economic policies and institutional practices on the emotional and psychological life of his central characters'. The first time Liam meets his mother in the film is during a prison visit, when he is bullied by Stan and his granddad into passing drugs to her. The transaction is meant to take place during a kiss, in a scene in which the intimate becomes unsettlingly claustrophobic in framing and in Stan's menacing demand that Liam should 'Kiss your fucking mother'. After refusing for his mother's sake, Liam is beaten up and thrown out, and moves in with his sister Chantelle. But the dream of his mother lingers on. He expresses his love in a tape, recording the Pretenders' *I'll Stand By You*, a touching scene undercut by his friend's attempt at a friendly greeting: 'Hope your porridge isnae too lumpy, Jean.' To reinforce Liam's motivations, Loach holds the song over a montage of his dealing. Though this technique is familiar from conventional filmmaking and risks sentimentality, Loach maintains a harsh edge through the lingering feeling of documentary (in the almost hidden-camera long shots of Liam dealing in a real environment), and the use of music as expression of its protagonist's worldview rather than directorial editorialising (in the way the music's tinny quality sources it to Liam's tape recorder).

Liam's dream appears to be destroyed when someone firebombs the caravan he has paid a deposit on, but thanks to Douglas, Liam ends up with an impressive apartment. Bringing Jean home from prison, he tries to reconcile her with daughter Chantelle and grandson Calum, and throws a party for her. However, he wakes the next day to find that she has gone. Liam blames

Chantelle, and after a heartbreaking scene in which he nearly strangles the one family member who really loves him, he goes to Stan's to find her. However, Jean left of her own free will, and clearly loves Stan, who explains that she has belittled the tape he made and the idea of the caravan, and has said that the idea of living with Liam makes her flesh crawl. In the row that follows, Liam stabs Stan. The film ends with Liam staring out at the river; on the day he turns sixteen, he faces a bleak future.

This narrative structure is familiar from several Loach films, in which characters demonstrate their vitality, only for it to be shaken in endings which invite us to step back from our identification with an individual character to an understanding of social factors. Critics have argued that this demonstrates both a tendency towards outright melodrama and an expression of fatalistic economic essentialism – working-class youths like Liam, or Billy Casper in *Kes* (1969), another boy on the cusp of manhood facing a bleak future in spite of his neglected talent, will not escape the role in life allocated to them under capitalism. This might explain why Loach became frustrated with media comparisons of *Sweet Sixteen* with *Billy Elliot*. Although the latter film showed the consequences of the miners' strike and unemployment, its sense of an individual's escape unbalanced the wider social representation, because, as John Hill has argued, the audience's relationship with the conventions of narrative creates a sense of 'resolution' by which underlying issues are bypassed.

As well as harrowingly affirming Liam's social position, the ending of *Sweet Sixteen* is rooted in Liam's character and family psychology. Anyone with a passing knowledge of Freud could simplify the narrative trajectory – Liam spends the whole film trying to set up home with his mother, 'just you and me', and when he is thwarted, kills his 'father' – but what Liam has been deprived of is his *image* of his mother. During her absence the story is told from Liam's point of view; but as Stan disillusions Liam he also disillusions us, discrediting the scenes in which Liam expresses his dreams for the future. Equally, accusations that Loach's characters are victims of the social circumstances he is 'didactically' attacking are undermined by the contrast between the film's two mothers: Jean and Chantelle. Although Chantelle has had to cope with a harsh upbringing, and was taken into care during her mother's absences, she is a devoted mother striving to bring up her son. Insisting to Liam that Jean does not love either of them and 'can't care', Chantelle is essentially Liam's substitute mother. The intimacy and love between them is emphasised by Loach's use of space, for instance taking a sympathetic distance from a position outside the kitchen in the two sequences in which Chantelle cleans Liam up after beatings. Interestingly, Liam reacts with mock-frustration to her loving parenting: 'Nae smoking, it's bad

for Calum … Nae farting, it's bad for Calum.' Though Liam's statements to his mother that 'I love you' are torn apart, Chantelle in the final scene reaffirms that 'I love you, Liam.'

The other crucial relationship in the film is that between Liam and his best friend Pinball (William Ruane), which deteriorates once Liam gets involved with Douglas. Liam has to increasingly disown Pinball, opening a rift which deepens to the point at which Pinball steals Douglas's car and crashes it into his health club. Liam faces a crushing dilemma: Douglas's offer of a flat for Liam and his mother depends upon him punishing his best friend for the health club attack. In the emotional exchange which follows – in which Liam discovers it was not Stan but a jealous Pinball who burnt down the caravan – Pinball is so upset that Liam seems prepared to act against him that he uses Liam's knife to slash his own face. In this exploration of shifting loyalties, the film offers a modern take on the familiar terrain of the strains of growing up; other evocative moments include Liam's sister teasing him over his first shave and the baffled reaction of one boy slightly behind his contemporaries as they rush to watch a girl outside: 'What's all the fuss about?'

But these loyalties, and the communal living they are a part of, have also been eroded by socio-political factors. Away from the collective and politically active workplaces that feature in earlier Loach pieces like *The Big Flame* (1969), the atomised individuals of his films from *Riff-Raff* (1991) onwards reflect the casualisation of labour under consecutive administrations since Thatcher. As Pinball joyrides in a stolen car, expelling his energy in hopeless circles, he is overlooked by Greenock's long-since closed-down shipyards. In the ravages of this former industrial heartland, Chantelle can hope at best for a part-time job in a call centre, while Liam embraces the shift to a service economy in selling imported products: pizzas and drugs. 'Thatcher would have been proud' of this 'ideal entrepreneur' according to Loach; the film opens with Liam selling views through a telescope, a clash between nature and commerce to rival that of the shanty-town dweller in Vittorio De Sica's *Miracle in Milan* (1952) who sells views of the sunset. Loach observed that 'Most kids [want] unity in their family and a job to look forward to, and it seems that we aren't able to make that society happen.' 'What a waste', as Chantelle observes of Liam's position at the end of the film.

Far from alienating audiences from 'hopeless' situations as his critics argue, Loach strives to make an audience feel that 'they're me, I'm them, we have a collective responsibility'. He achieves this through his distinctive technique as a filmmaker, which reinforces the ideas in his films, because 'style reflects content'. His progressive style is often misrepresented in Britain because of the care with which Loach and his cinematographers strive, according to James

Mottram, 'for a naturalistic look that disguises the "craft" of their profession'. The problem with mainstream cinema according to Loach is that 'just as people are alienated in the society they're living in, the characters in a film are alienated from the audience. I think that's a pity, and that's to do with a kind of writing … [and] shooting which puts people at arm's length … the choice of lenses.'

The key to Loach's technique is generating a sense of immediacy. One of the ways he achieves this is through his observational, semi-documentary style. Loach praises cinematographer Barry Ackroyd's contribution to *Sweet Sixteen*: Ackroyd's flexibility, born of 'a documentary background', gives actors 'the freedom to move as their instinct tells them'. The desire to give actors space is not simply part of visual style, but is ingrained in how Loach makes his films: Iciar Bollain, who appeared in *Land and Freedom* (1995), told Elizabeth Nash that 'Loach breaks all the rules to put everything at the service of the actor'. For instance, he shoots his films in continuity order. Most films are made out of sequence, with scenes recorded in blocks at different locations, so actors can end up filming a death scene before their first scene. But Loach films scenes in the order they appear in the film, which means that actors experience events almost as their characters do. This is reinforced by his refusal to let actors see a completed script, instead filtering scripts through a bit at a time. He allows room for improvisation. One scene in *Sweet Sixteen* was due to end with Liam imploring Chantelle to come out of the bathroom after an argument, but Annmarie Fulton came out and hugged Liam, which showed Loach that 'sometimes actors' instincts can tell you a lot about how a scene should be played'. In *Bread and Roses* (2000), Elpidia Carrillo had to throw her character's sister out of her home but, as Ricardo Méndez Matta recalls, Pilar, in character, refused to leave: 'What Pilar and Elpidia had improvised was the truth and [Loach and Paul Laverty] were not about to argue with that', so Laverty spent the night rewriting the rest of the film. 'The rest of us', Méndez Matta concluded, 'thought about how truly magical filmmaking can be'.

Loach also occasionally surprises his actors. This can take a comic form – for instance, Pinball's anger at being thrown in the showers by Douglas's men was shared by the unwarned actor – but is often more serious. The most suspenseful scene in *Sweet Sixteen* features Liam having to prove himself to Douglas by killing a man. The scene builds to Liam moving in on his victim in a nightclub's toilets, at which point Douglas's men step out and stop him – this set-up was purely a test. Compston himself was unaware, and is so surprised that it takes a while for him to regain his composure; Compston's nervous preparation and ultimate surprise lend the scene tension and genuine shock. As Méndez Matta argued, moments like this enable 'the

camera to capture a genuine moment of surprise, where the actor becomes the character ... Why act surprised, when you can be surprised?' This is reinforced by Loach's casting of non-professional actors, who – as the Italian neorealists argued before him – may react to events rather than 'acting' their response. His casting of Martin Compston, at the time set on a football career, is a case in point. Alan Morrison called this 'a storming debut', arguing that Compston 'carries the movie like a veteran, drawing us right into the tragic heart of Liam's dilemma. He's a cheeky, dignified, loving boy who is caught between a child's sense of fun and an adult's sense of burdensome responsibility.' This is reminiscent of the casting of David Bradley in *Kes*. As Loach told Graham Fuller, because 'the way you make a film is an important way of validating the ideas in it', to cast Bradley he 'went to one classroom in one school in Barnsley ... the idea being that there's a kid in every class like Billy'. Loach creates a space for Compston, like Liam, to demonstrate his talent.

His aesthetic of immediacy is precisely that: an artistic framework. Tiring of critics misrepresenting his style as an attempt to fool audiences into thinking his films are 'real', Loach told Fuller that he uses 'classic filmmaking techniques ... I shoot a scene from two or three angles so that you can cut it together. I repeat the action for each set-up. It's based on a script ... There are obviously little tricks of the trade to try and make it look as though it is happening for the first time, but it's set up like a piece of fiction.' For instance, in the scene in which Liam is first taken to see Douglas, Compston – who often, as Loach observes, exercises a fluid approach to the script – superbly performs the script almost verbatim. Loach's 'tricks of the trade' work in service of the script, a stunning piece of writing which won Paul Laverty the Best Screenplay award at Cannes.

This collaboration with Laverty, the latest in a string of productive collaborations with writers, has powered Loach's concern with modern Scotland, one of the most impressive features of his resurgence as a filmmaker in the past fifteen years. Loach's first film with Laverty, *Carla's Song* (1996), opened in Glasgow before Robert Carlyle's character accompanied an immigrant back to witness CIA-sponsored terrorism in Nicaragua. Following *My Name is Joe* and *Sweet Sixteen*, they have further explored contemporary communities through an inter-racial relationship in *Ae Fond Kiss* (2004), which James Mottram described as 'the final part in an unofficial trilogy of Glaswegian films'. Describing these as Scottish films is fair enough in terms of their content and the fact that Scotland provided a key part of their finance and production infrastructure. And yet, it seems odd to squeeze Loach in with the critically-heralded boom in modern Scottish cinema, and particularly the cultural rebranding which has made publicity

capital out of it: Loach is English, a social realist uninterested in aping popular culture; he is old-school, old Labour and, well, old.

But the youthful vitality of his work certainly bears comparison with the invigorating role which has been played by Scotland in the recent renaissance of British cinema. This has been so well documented that it is hard to imagine a list of the major artistically and/or commercially successful British films of the 1990s *not* prominently featuring Scottish films. Any list which can jump from the exceptional *Shallow Grave* (1994) to the ubiquitous *Trainspotting* (1996) – both from the trailblazing Danny Boyle (another Englishman) and Andrew MacDonald – onto Paul McGuigan's patchily inventive *The Acid House* (1998), or Peter Mullan's gorgeous magic-realist *Orphans* (1997), demonstrates a very healthy diversity. With new investment has come an opportunity for British cinema to more readily harness regional diversity, with new initiatives taking place across Scotland, Wales, Northern Ireland and at provincial centres challenging its English-centric – or London-centric – bias. Prior to this, the nearest Britain had to an integrated regional film culture was television: BBC Birmingham broadcast to large national audiences challenging 16mm films on regional identity like David Rudkin and Alan Clarke's astonishing *Penda's Fen* (1974), whilst BBC Scotland provided an outlet for works rooted in Scottish experience. Therefore, Duncan Petrie astutely considers in his study of Scottish cinema the *Play for Today* work of Peter McDougall, and John McGrath's *The Cheviot, the Stag and the Black, Black Oil* (1974), a formally radical exploration of history and identity.

In recent years, funding from a range of sources, including local councils and the Scottish and Welsh offices, arts agencies and the British Film Institute, has given a platform to local filmmakers and filmmakers like Loach who explore the locale. Whilst the Scottish Film Council and Scottish Film Production Fund were already in place, their creation of a Glasgow Film Fund in 1993, with input from Glasgow's council and development agency as well as from Europe, resulted in increased filming (although the fact that many used Scotland to represent other countries indicates that this did not automatically result in indigenous productions). In the late 1990s, Scottish Screen united many disparate sources of funding, but there remained obvious problems with talking about a distinctive regional cinema. For instance, although Gareth Stanton identifies a 'New Welsh cinema', for each film addressing national identity like Kevin Allen's *Twin Town* (1997) there are films like Justin Kerrigan's *Human Traffic* (1999), whose 'locale is something of an irrelevance'. Films like this and Edward Thomas's *Rancid Aluminium* (1999) may be celebrated as regional successes and support a publicity rebranding of 'Cool Cymru', but 'it is increasingly difficult to pinpoint what "quality" they might have that makes

them Welsh'. But then this is a problem faced in any understanding of British or any 'national' cinema. In contrast to the culturally unspecific no-man's-land in which many films get lost amongst their concessions to an international audience, or in the 'Scottishness' of 'movements' heralded by film magazines, *Sweet Sixteen* is rooted in its location.

This commitment is also one of the reasons why Loach's work is successful in Europe, even if it seems paradoxical that a film about Scotland, written and performed by Scottish talent and directed by a major British director was more successful across Europe than at home, like most of Loach's films from the 1990s onwards. This popularity helped finance the film; in administrative (though not practical) terms it was a British-German-Spanish-French-Italian co-production. European critics respect Loach's craft free from the politically-motivated opposition of British critics – for instance, those who whined that British cinema could not compete internationally then fought to stop *Hidden Agenda* (1990), Loach's thriller on the British shoot-to-kill policy in Northern Ireland, from winning Best Film at European festivals. After visiting a Loach season in Poland, Ricky Tomlinson observed that 'you just put "Ken Loach" up there and it's a full house'. Geoff Brown's theory as to why Loach's work is not as popular in his own country is that multiplex audiences 'want to be taken away from their drab urban surroundings' towards 'Hollywood pizzazz', and 'do not want to go' to Loach's 'drab council housing' and war-torn Spain or Nicaragua. As a result, 'Britain's film culture tolerates Loach's Spartan humanism, but does not endorse it'.

But Loach has never been given wide enough distribution to test this theory. Unlike his work for television in the 1960s and 1970s, when he could confront large audiences with material for which they were receptive (having been conditioned by television drama's then-radical culture), in the commodity culture of modern cinema his work gains at best limited multiplex exhibition before being restricted to the art houses, a marginalising arena which is totally alien to his social imperatives and populist tone. Ian Christie observed that, given the 'structural weaknesses of exhibition and distribution', even a 'radical yet populist film like *Riff-Raff* stands little chance of reaching a mass audience in Britain'. This will continue in spite of the popularity of *Sweet Sixteen* in Scottish cinemas, mirroring the success of *Kes* in Northern England which forced distributors to exhibit it nationally – in both cases, the excuse given was that British audiences would not be able to understand regional British accents. Britain is disappearing from British cinema screens, save for the Blairite Neverland of *Love Actually* (Richard Curtis, 2003). Nowhere is the absence of this mirror on Britain clearer than in the British Board of Film Classification's decision to give *Sweet Sixteen* an '18' certificate because

of its swearing, which denied access to the age group who could gain most from seeing it. This is particularly offensive when the '12A' certificate permits distributors to maximise profits by selling products containing sex and violence to ever younger customers. This decision represents, as Loach observed, 'a special kind of British hypocrisy'.

Nevertheless, whilst distribution issues threaten a narrowing of styles available at British cinemas, which in a self-perpetuating circle may ultimately result in a narrowing of audience expectation, Loach remains committed to 'the political challenge', to 'recapture the cinema for a really broad spread of films … the equivalent of a library'. The kind of spread with which, as this book has demonstrated, British cinema has long been associated.

Dave Rolinson

REFERENCES

Brown, G. (2000) 'Something for Everyone: British Film Culture in the 1990s', in R. Murphy (ed.) *British Cinema of the 90s*. London: British Film Institute.

Christie, I. (2000) 'As Others See Us: British Film-making and Europe in the 90s', in R. Murphy (ed.) *British Cinema of the 90s*. London: British Film Institute.

Fuller, G. (1998) *Loach on Loach*. London: Faber.

Gilbey, R. (2002) 'Reasons to be cheerful', *Sight and Sound*, 12, 10, 14–17.

Hill, J. (1986) *Sex, Class and Realism: British Cinema 1956–1963*. London: British Film Institute.

Loach, K. (2003) Commentary to DVD release of *Sweet Sixteen*.

McKnight, G. (1997) 'Ken Loach's domestic morality tales', in G. McKnight (ed.) *Agent of Challenge and Defiance: The Films of Ken Loach*. Trowbridge: Flicks Books.

Méndez Matta, R. (2001) 'Through a Glass, Clearly', in P. Laverty, *Bread and Roses*. Suffolk: ScreenPress Books.

Morrison, A. (2002) '*Sweet Sixteen*', *Empire*, November, 49.

Mottram, J. (2004) 'In the mood for love', *Sight and Sound*, Volume 14, Issue 3, March: 22-23.

Nash, E. (1997) 'In Spain, drama is plastic, fake. For us, Loach is authentic', *Independent*, 1 May, 2-3.

Petrie, D. (2000) *Screening Scotland*. London: British Film Institute.

Stanton, G. (2002) 'New Welsh cinema as postcolonial critique?', in J. Petley and D. Petrie (eds) *Journal of Popular British Cinema 5: New British Cinema*. Trowbridge: Flicks Books, 37–52.

FILMOGRAPHY

note:

1. The term 'Production design' has been used throughout, replacing what was earlier credited variously as 'Art direction' or 'Settings'. In some cases no credit is given for, say, 'Costumes'.

2. Credits for films of more recent decades are generally available in more detail than was formerly the case; hence some disparities below.

3. Dates refer to UK first release.

SHOOTING STARS 1928

Directors: A.V. Bramble, Anthony Asquith

Production: Bruce Woolfe, for British International

Screenplay: Anthony Asquith and J. O. C. Orton, from original story by Anthony Asquith

Photography: Stanley Rodwell and Henry Harris

Production Design: Ian Campbell-Gray

Cast: Annette Benson (Mae Feather), Brian Aherne (Julian Gordon), Donald Calthrop (Andy Wilks), Wally Patch (property man), Chili Bouchier (Winnie), David Brooks (Turner), Ella Daincourt (Asphodel Smythe), Tubby Phillips (Fatty), Ian Wilson (reporter), Judd Green (lighting man), Jack Rawl (hero)

Running time: 7,089 feet

A NIGHT LIKE THIS 1932

Director: Tom Walls

Production: Herbert Wilcox, for British and Dominions

Screenplay: Ben Travers (from his play, though not so credited), Tom Walls, W. P. Lipscomb

Photography: F. A. Young

Editing: P. McLean Rogers

Music: Lew Stone, played by Roy Fox's Band

Production Design: L. P. Williams

Costumes: Design by Doris Zinkeisen, executed by Lady Victor Paget Ltd and L&N Nathan Ltd.

Sound: L. E. Overton (recordist)

Cast: Ralph Lynn (Clifford Tope), Tom Walls (Michael Mahoney), Winifred Shotter (Cora Mellish), Mary Brough (Mrs Decent), Robertson Hare (Miles Tuckett), Claude Hulbert (Aubrey Slott), C. V. France (Micky the Mailer), Joan Brierly (Molly Dean), Boris Ranevsky (Koski), Norma Varden (Mrs Tuckett), Reginald Purdell (waiter), Kay Hammond (Mimi, the cocktail shaker), Al Bowlly (singer), Hal Gordon (taxi driver), Lew Stone (piano player)

Running time: 74 minutes

THE GOOD COMPANIONS 1933

Director: Victor Saville

Production: Producer credit is variously given as Michael Balcon and as T. A. Welsh and George Pearson. One print gives no producer credit but lists the following as 'Production personnel': Louis Levy, George Pearson, Angus Macphail, George Gunn. For Gaumont-British

Screenplay: W. P. Lipscomb (scenario and additional dialogue), Angus Macphail, Ian Dalrymple, based on the novel

by J. B. Priestley and play derived from it by Priestley and Edward Knoblock.
Photography: Bernard Knowles
Editing: Frederick Y. Smith
Music: George Posford
Production Design: A. (Alfred) Junge
Costumes: Gordon Conway
Sound: William Salter
Cast: Jessie Matthews (Susie Dean), Edmund Gwenn (Jess Oakroyd), John Gielgud (Inigo Jones), Mary Glynne (Miss Trant), Percy Parsons (Morton Mitcham), A. W. Baskcomb (Jimmy), Dennis Hoey (Joe), Richard Dolman (Jerry), Margery Binner (Elsie), D. A. Clarke-Smith (Ridvers), Florence Gregson (Mrs Oakroyd), Frank Pettingell (Sam Oglethorpe), Alex Frazer (Dr Macfarlane), Finlay Currie (Monte Mortimer), Millbrau (Max Miller), Ivor Barnard (Eric Tipstead), Muriel Aked (Vicar's wife), Henry Ainley (Narrator of prologue – voice only). Uncredited: Polly Emery (Miss Thong), Annie Esmond (Mrs Tarvin), Ben Field (Mr Droke), Barbara Gott (Big Annie), Laurence Hanray (Mr Tarvin), Jack Hawkins (Albert), Wally Patch (driver), Arnold Riches (Hilary), Olive Sloane (Effie), Cyril Smith (Leonard Oakroyd), J. Fisher White (Vicar), Hugh E. Wright (librarian), Margaret Yarde (Mrs Mounder), George Zucco (Fauntley), and Harry Adnes, Mai Bacon, Jimmy Bishop, John E. Burch, John Clifford, Jane Cornell, Harry Crocker, Gilbert Davis, Mike Johnson, Violet Kane, George Manship, Harold Meade, Mignon O'Doherty, Frederick Piper, Daphne Scorer, Tom Shale, J. B. Spendlove, Robert Victor.
Running time: 113 minutes

MAN OF ARAN 1934
Director: Robert J. Flaherty
Production: Michael Balcon, for Gainsborough Pictures
Screenplay: Robert J. Flaherty and John Goldman
Photography: Robert J. Flaherty
Editing: John Monck and John Goldman
Music: John Greenwood (composer), Louis Levy (director)
Sound: Harry (aka 'Slim') Hand
Field laboratory: John Taylor
Cast: Colman King (a man of Aran), Maggie Dirrane (his wife), Michael Dillane (their son), Pat Mullin, Patch Ruadh, Patcheen Faherty, Tommy O'Rourke (shark hunters), 'Big Patcheen' Conneely, Stephen Dirrane, Pat McDonough (canoemen).
Running time: 75 minutes

PINK STRING AND SEALING WAX 1945
Director: Robert Hamer
Production: Michael Balcon (associate produder S. C. Balcon), for Ealing Studios
Screenplay: Diana Morgan and Robert Hamer, from play by Roland Pertwee
Photography: Richard S. Pavey
Editing: Michael Truman
Music: Norman Demuth (composer), Ernest Irving (conductor)
Production Design: Duncan Sutherland
Costumes: Marion Horn (wardrobe supervision)
Sound: Eric Williams
Cast: Googie Withers (Pearl Bond), Mervyn Johns (Edward Sutton), Gordon Jackson (David Sutton), Sally Ann Howes (Peggy Sutton), Mary Merrall (Mrs Sutton), Jean Ireland (Victoria Sutton), John Carol (Dan Powell), Garry Marsh (Joe Bond), Catherine Lacey (Miss Porter), Frederick Piper (Dr Pepper), Valentine Dyall (Police Inspector), Colin Simpson (James Sutton), David Wallbridge (Nicholas Sutton), Don Stannard (John Bevan), Pauline Letts (Louise), Helen Goss (Maudie), Maudie Edwards (Mrs Webster), Margaret Ritchie (Adelina Patti), John Ruddock

(Judge) Charles Carson (editor)
Running time: 89 minutes

HOLIDAY CAMP 1947
Director: Ken Annakin
Production: Sydney Box for Gainsborough Pictures
Screenplay: Sydney Box, Muriel Box, Peter Rogers, with additional dialogue by Ted Willis, Mabel Constanduros, Dennis Constanduros, story by Godfrey Winn
Photography: Jack Cox
Editing: Alfred Roome
Music: Bob Busby (composer), Louis Levy (director)
Production Design: Richard Yarrow
Costumes: Julie Harris
Sound: B. C. Sewell and L. Hammond
Cast: Flora Robson (Esther Harman), S. L. Hardwicke (Dennis Price), Jack Warner (Joe Huggett), Kathleen Harrison (Ethel Huggett), Hazel Court (Joan Martin), Emrys Jones (Michael Halliday), Yvonne Owen (Angela Kirby), Esmond Knight (announcer), Jimmy Hanley (Jimmy Gardner), Peter Hammond (Harry Huggett), Dennis Harkin (Charlie), Esma Cannon (Elsie Dawson), John Blythe (Steve), Jeannette Tregarthen (Valerie Thompson), Beatrice Varley (Aunt), Susan Shaw (Patsy Crawford), Maurice Denham (doctor), Jane Hylton (receptionist), Jack Raine (detective), Reginald Purdell, Alfie Bass (Redcoats), Bill Owen, Phil Fowler, Jack Ellis, Patricia Bramah, John Stone, Jeremy Hanley, guests Patricia Roc, Gerry Wilmot, 'Cheerful' Charlie Chester, and (uncredited) Diana Dors
Running time: 97 minutes

THE ROCKING HORSE WINNER 1949
Director: Anthony Pelissier
Production: John Mills, for Two Cities Films
Screenplay: Anthony Pelissier, from the short story by D. H. Lawrence
Photography: Desmond Dickinson
Editing: John Seabourne
Music: William Alwyn (composer), Muir Mathieson (conductor)
Production Design: Carmen Dillon
Costumes: (uncredited) Fred Pridmore and Mrs W. Jackson
Sound: George Croll and John W. Mitchell
Cast: Valerie Hobson (Hester Grahame), John Mills (Bassett), Hugh Sinclair (Richard Grahame), Ronald Squire (Oscar Cresswell), John Howard Davies (Paul Grahame), Cyril Smith (bailiff), Charles Goldner (Mr Tsaldouris), Susan Richards (Nanny), Melanie McKenzie (Matilda Grahame), Caroline Steer (Joan Grahame), Antony Holles (man in bowler hat), Johnnie Scofield (chauffeur)
Running time: 90 minutes

THE LONG MEMORY 1952
Director: Robert Hamer
Production: Hugh Stewart, for Europa Films and British Film Makers
Screenplay: Robert Hamer and Frank Harvey, from the novel by Howard Clewes
Photography: Harry Waxman
Editing: Gordon Hales
Music: William Alwyn (composer), Muir Mathieson (director)
Production Design: Alex Vetchinsky
Costumes: Joan Ellacott
Sound: C. C. Stevens and Gordon K. McCallum

Cast: John Mills (Davidson), John McCallum (Det. Inspector Lowther), Elizabeth Sellars (Fay Lowther), Eva Bergh (Elsa), Geoffrey Keen (Craig), Michael Martin-Harvey (Jackson), John Chandos (Boyd), John Slater (Pewsey), Thora Hird (Mrs Pewsey), Harold Lang (Boyd's chauffeur), Vida Hope (Alice), Mary Mackenzie (Gladys), Laurence Naismith (Asprey), Peter Jones (Fisher), Henry Edwards (Judge), John Glyn-Jones (Gedge), John Horsley (Bletchley), Fred Johnson (driver), Christopher Beeny (Mickie), Julian Somers (Delaney), Denis Shaw (Shaw), Russell Waters (Scotson)
Running time: 96 minutes

KNIGHTS OF THE ROUND TABLE 1954
Director: Richard Thorpe
Production: Pandro S. Berman, for Metro-Goldwyn-Mayer's British Studios
Screenplay: Talbot Jennings, Jan Lustig, Noel Langley, from the works of Thomas Malory
Photography: Freddie Young and Stephen Dade
Editing: Frank Clarke
Music: Miklos Rozca
Production Design: Alfred Junge, Hans Peters
Costumes: Roger Furse
Sound: A. W. Watkins
Cast: Robert Taylor (Lancelot), Ava Gardner (Guinevere), Mel Ferrer (King Arthur), Anne Crawford (Morgan Le Fay), Stanley Baker (Modred), Felix Aylmer (Merlin), Maureen Swanson (Elaine), Gabriel Woolf (Percival), Anthony Forwood (Gareth), Robert Urquhart (Gawaine), Niall Macginnis (The Green Knight), Ann Hanslip (Nan), Jill Clifford (Bronwyn), Howard Marion Crawford (Simon), Stephen Vercoe (Agravaine), Dagmar (Dana) Wynter (servant), John Brooking (Bedivere), Peter Gawthorne (bishop), Alan Tilvern (steward), John Sherman (Lambert), Martin Wyldeck (John), Barry Mackay, Derek Tansley (squires to Green Knight), Roy Russell (Leogrance), Michel De Lutry (dancer), Gwendoline Evans (Enid), Mary Germaine (Brigid), Desmond Llewelyn (herald), Patricia Owens (Lady Vivien), Doreen Dawne, Julia Arnall, and Valentine Dyall (narrator, voice only)
Running time: 115 minutes

ROOM AT THE TOP 1959
Director: Jack Clayton
Production: John and James Woolf, for Remus Films
Screenplay: Neil Paterson, from John Braine's novel
Photography: Freddie Francis
Editing: Ralph Kemplen
Music: Mario Nascimbene (composer), Lambert Williamson (conductor)
Production Design: Ralph Brinton
Costumes: Heather Sears's costumes by Rahvis (no other credit given)
Sound: John Cox (director) and Peter Handford (recordist)
Cast: Simone Signoret (Alice Aisgill), Laurence Harvey (Joe Lampton), Heather Sears (Susan Brown), Donald Wolfit (Mr Brown), Donald Houston (Charles Soames), Hermione Baddeley (Elspeth), Allan Cuthbertson (George Aisgill), Raymond Huntley (Mr. Hoylake), John Westbrook (Jack Wales), Ambrosine Phillpotts (Mrs. Brown), Richard Pasco (Teddy Merrick), Beatrice Varley(Aunt), Wilfred Lawson (Uncle), Delena Kidd (Eva Kent), Ian Hendry (Cyril Kent), April Olrich (Mavis), Mary Peach (June Samson), Anthony Newlands (Bernard), Avril Elgar (Miss Gilchrist), Thelma Ruby (Miss Breith), Paul Whitsun-Jones (Laughing Man At Bar), Derren Nesbitt (Bert), Prunella Scales (Meg), Katharine Page (Mary), Anne Leon (Janet), Wendy Craig (Joan), Miriam Karlin (Gertrude), Kenneth Waller (Reggie), Andrew Irvine (Raymond), Stephen Jack (Darnley), John Welsh (Mayor), Everley Gregg (Mayoress), Basil Dignam (Priest), May Hallett (Miss Tanfield), Sheila Raynor (Ethel's Mother), Gilda Emmanueli (Ethel), Jane Eccles (Mrs. Thomson), Dennis Linford (Harry), Edward Palmer (Porter), Michael Atkinson (Grant), Julian Somers (landlord), Richard Caldicot (taxi driver), Pat Lanski (Girl Guide leader), Yvonne Buckingham (girl at

tote window), Doreen Dawn (high-stepping girl), Harry Moore (first thespian), Joan Leake (second thespian)
Running time: 117 minutes

TUNES OF GLORY 1960
Director: Ronald Neame
Production: Colin Lesslie
Screenplay: James Kennaway, from his novel
Photography: Arthur Ibbetson
Editing: Anne V. Coates
Music: Malcolm Arnold
Production Design: Wilfrid Shingleton
Costumes: Charles Guerin (wardrober)
Sound: Bert Ross
Cast: Alec Guinness (Lt.-Col. Jock Sinclair), John Mills (Lt.-Col. Basil Barrow), Dennis Price (Major Charlie Scott), Gordon Jackson (Capt. Jimmy Cairns), John Fraser (Cpl. Piper Fraser), Kay Walsh (Mary), Susannah York (Morag), Duncan Macrae (Pipe Major Maclean), Allan Cuthbertson (Capt. Eric Simpson), Paul Whitsun-Jones (Maj. Dusty Miller), Gerald Harper (Maj. Hugo MacMillan), Richard Leech (Capt. Alec Rattray), Peter McEnery (2nd Lt. David MacKinnon), Keith Faulkner (Cpl. Piper Adam), Angus Lennie (orderly room clerk), John Harvey (Sgt. Finney), Bryan Hulme (Cpl. Drummer), Andrew Keir (L/Cpl. Campbell), Eric Woodburn (landlord), Andrew Downie (Cpl. Waiter), Jameson Clark (Sir Alan), Lockwood West (Provost), Gwen Nelson (Provost's wife)
Running time: 107 minutes

NO LOVE FOR JOHNNIE 1961
Director: Ralph Thomas
Production: Betty E. Box, for Five Star Films
Screenplay: Nicholas Phipps and Mordecai Richler, from novel by Wilfred Fienburgh
Photography: Ernest Steward
Editing: Alfred Roome
Music: Malcolm Arnold
Production Design: Maurice Carter
Costumes: Yvonne Caffin
Sound: Gordon K. McCallum, Dudley Messenger
Cast: Peter Finch (Johnnie Byrne), Stanley Holloway (Fred Andrews), Mary Peach (Pauline), Donald Pleasence (Roger Renfrew), Billie Whitelaw (Mary), Hugh Burden (Tim Maxwell), Rosalie Crutchley (Alice), Michael Goodliffe (Dr West), Mervyn Johns (Charlie Young), Geoffrey Keen (Prime Minister), Paul Rogers (Sydney Johnson), Dennis Price (Flagg), Peter Barkworth (Henderson), Fenella Fielding (Sheilah), Gladys Henson (Constituent), Oliver Reed (guest), Derek Francis, Conrad Phillips, Maureen Pryor, Peter Sallis, George Rose.
Running time: 111 minutes

80,000 SUSPECTS 1963
Director: Val Guest
Production: Val Guest, for Val Guest Productions/Rank Organisation
Screenplay: Val Guest, from novel by Ellaston Trevor
Photography: Arthur Grant, CinemaScope
Editing: Bill Lenny
Music: Stanley Black (composer and director)
Production Design: Geoffrey Tozer
Sound: James Shields, (recordists) Dudley Messenger and Gordon K. Mccallum
Cast: Claire Bloom (Julie Monks), Richard Johnson (Steven Monks), Yolande Donlan (Ruth Preston), Cyril Cusack

(Father Maguire), Michael Goodliffe (Clifford Preston), Mervyn Johns (Buckridge), Kay Walsh (Matron), Basil Dignam (Medical Officer of Health), Ray Barrett (Health Inspector Bennett), Ursula Howells (Joanna Duten), Andrew Crawford (Dr Davis), Norman Bird (Mr Davis), Norman Chappell (Welford), Arthur Christiansen (Mr Gracey), Vanda Godsell (Mrs Davis), Joby Blanshard (Health Inspector Matthews), Pauline Barker (Clara), Leonie Forbes (Nurse Vicky), Jill Curzon (Nurse Jill), Maureen Combie (auxiliary nurse), Marian Diamond (Sister Durrell), Rachel Clay (Jane Davis), Bruce Lewis (TV reporter), Suzan Farmer (Nurse Carole), Ray Barrett (Bennett), Norman Chappell (Welford), H. Leonard Coggins (waiter)
Running time: 113 minutes

THE ITALIAN JOB 1969
Director: Peter Collinson
Production: Stanley Baker and Michael Deeley, for Oakhurst Productions/Paramount Pictures
Screenplay: Troy Kennedy Martin
Photography: Douglas Slocombe
Editing: John Trumper
Music: Quincy Jones
Production Design: Disley Jones
Costumes: Roy Ponting (wardrobe master)
Sound: Gerry Humphreys (dubbing), Stephen Warwick and John Aldred (editors)
Cast: Michael Caine (Charlie Croker), Noël Coward (Mr Bridger), Benny Hill (Professor Simon Peach), Raf Vallone (Altabani), Tony Beckley (Camp Freddie), Rossano Brazzi (Beckerman), Maggie Blye (Lorna), Irene Handl (Miss Peach), John Le Mesurier (Governor), Fred Emney (Birkenshaw), John Clive (garage manager), Graham Payn (Keats), Michael Standing (Arthur), Stanley Caine (Coco), Barry Cox (Chris), Harry Baird (Big William), George Innes (Bill Bailey), John Forgeham (Frank), Robert Powell (Yellow), Derek Ware (Rozzer), Frank Jarvis (Roger), David Salamone (Dominic), Richard Essame (Tony), Mario Volgoi (Manzo), Renato Romano (Cosca), Robert Rietty (Police Chief), Timothy Bateson (dentist), Arnold Diamond (senior computer room official), Simon Dee (Shirtmaker), Alastair Hunter (warder in prison cinema), Louis Mansi (computer room official), Franco Novelli (Altabani's driver), David Kelly (Vicar), Henry Grace (tailor), Valerie Leon (receptionist, Royal Lancaster), Stanley Baker (uncredited)
Running time: 100 minutes

SUNDAY BLOODY SUNDAY 1971
Director: John Schlesinger
Production: Joseph Janni, for Vectia Films/Vic Films
Screenplay: Penelope Gilliatt
Photography: Billy Williams
Editing: Richard Marden
Music: Ron Geesin (composer), Douglas Gamley (director)
Production Design: Luciana Arrighi
Costumes: Jocelyn Rickards
Sound: David Campling (Editor), Simon Kaye and Gerry Humphreys (recordists)
Cast: Peter Finch (Dr Daniel Hirsh), Glenda Jackson (Alex Greville), Murray Head (Bob Elkin), Peggy Ashcroft (Mrs Greville), Tony Britton (George Harding), Maurice Denham (Mr Greville), Bessie Love (answering service lady), Vivian Pickles (Alva Hodson), Frank Windsor (Bill Hodson), Thomas Baptiste (Professor Johns), Richard Pearson (middle-aged patient), June Brown (woman patient), Hannah Norbert (Daniel's mother), Harold Goldblatt (Daniel's father), Marie Burke (Aunt Astrid), Caroline Blakiston (rowing woman at Daniel's party), Peter Halliday (rowing woman's husband), Douglas Lambert (man at Daniel's party), Jon Finch (Scotsman), Kimi Tallmadge (Lucy Hodson), Russell Lewis (Timothy Hodson), Emma Schlesinger (Tess Hodson), Karl Ferber (Hodson son), Patrick Thornberry (John-Stuart Hodson), Robert Rietty (Daniel's brother), Liane Aukin (Daniel's sister-in-law), Robin Presky (Daniel's

nephew), Edward Evans (husband at hospital), Gabrielle Daye (wife at hospital), George Belbin (next-door neighbour), Richard Loncraine (Bob's partner), Royce Mills (Bob's partner), Monica Vassiliou (travel agent), John Rae (airline doctor), Ellis Dale (chemist), Joe Wadham (lorry driver), Henry Danziger (Cantor), Ann Firbank, Derek Gilbert, William Job, John Warner, Nike Arrighi, Francis Ghent, Rohan Mcculloch, Barbara Markham, Robert Wilde (party guests), Esta Charkham, Hilary Hardiman, Simon Joseph, Gideon Kolb, Martin Lawrence, Mercia Mansfield, Reuben Elvy, Jouey Douben (Barvitzmah guests), Cindy Burrows (Alex as a child), Daniel Day-Lewis (schoolboy kicking a car), Petra Markham (designer's girlfriend)
Running time: 110 minutes

DEMONS OF THE MIND 1971
Director: Peter Sykes
Production: Frank Godwin, for Frank Godwin Productions and Hammer Film Productions
Screenplay: Christopher Wicking, from story by Christopher Wicking and Frank Godwin
Photography: Arthur Grant
Editing: Chris Barnes
Music: Harry Robinson (composer), Phillip Martell (director)
Production Design: Michael Stringer
Costumes: Rosemary Burrows
Sound: John Purchese
Cast: Paul Jones (Carl Richter), Gillian Hills (Elizabeth Zorn), Robert Hardy (Baron Friedrich Zorn), Michael Hordern (Priest), Patrick Magee (Dr Falkenberg), Shane Briant (Emil Zorn), Yvonne Mitchell (Aunt Hilda), Kenneth J. Warren (Klaus), Robert Brown (Fischinger), Virginia Wetherell (Inge), Deirdre Costello (Magda), Barry Stanton (Ernst), Sidonie Bond (Baron's wife), Sheila Raynor (crone), Mary Hignett (matronly woman), Jan Adair (1st girl), Jane Cardew (2nd girl), Thomas Heathcote (Coachman)
Running time: 89 minutes

HOPE AND GLORY 1987
Director: John Boorman
Production: John Boorman, for Columbia, in association with Nelson Entertainment and Goldcrest
Screenplay: John Boorman
Photography: Philippe Rousselot
Editing: Ian Crafford
Music: Peter Martin
Production Design: Anthony Pratt
Costumes: Shirley Russell
Sound: Ron Davis, Paul Smith (editors), Peter Handford (recordist)
Cast: Sebastian Rice-Edwards (Bill Rohan), Geraldine Muir (Sue Rohan), Sarah Miles (Grace Rohan), David Hayman (Clive Rohan), Sammi Davis (Dawn Rohan), Susan Wooldridge (Molly), Jean-Marc Barr (Bruce), Ian Bannen (Grandfather George), Annie Leon (Grandma), Jill Baker (Faith), Amelda Brown (Hope), Katrine Boorman (Charity), Colin Higgins (Clive's friend), Shelagh Fraser (WVS woman), Gerald James (headmaster), Barbara Pierson (teacher), Nicky Taylor (Roger), Jodie Andrews, Nicholas Askew, Jamie Bowman, Colin Dale, David Parkin, Carlton Taylor (Roger's gang), Sara Langton (Pauline), Imogen Cawrse (Jennifer), Susan Brown (Mrs Evans), Charley Boorman (Luftwaffe pilot), Peter Hughes (policeman), Ann Thornton, Andrew Bickell (honeymoon couple), Christine Crowshaw (pianist), William Armstrong (Canadian sergeant), Arthur Cox (fireman)
Running time: 112 minutes

DISTANT VOICES, STILL LIVES 1988
Director: Terence Davies
Production: Jennifer Howarth, for BFI Production, in association with Channel 4/ZDF

Screenplay: Terence Davies
Photography: William Diver and Patrick Duval
Editing: William Diver
Music: Tommy Reilly (harmonica)
Production Design: Miki van Zwanenberg and Jocelyn James
Costumes: Monica Howe
Sound: Alex Mackie (editor), Moya Burns, Colin Nicholson (recordists)
Cast: Freda Dowie (Mother), Pete Postlethwaite (Father), Angela Walsh (Eileen), Dean Williams (Tony), Lorraine Ashbourne (Maisie), Sally Davies (Eileen as a child), Nathan Walsh (Tony as a child), Susan Flanagan (Maisie as a child), Michael Starke (Dave), Vincent Maguire (George), Antonia Mallen (Rose), Anne Dyson (Granny), Andrew Schofield (Les), Debi Jones (Micky), Jean Boht (Aunty Nell), Alan Bird (baptismal priest), Pauline Quirke (Doreen), Matthew Long (Mr Spaull), Frances Dell (Margie), Carl Chase (Uncle Ted), Roy Ford (wedding priest), Terry Melia, John Thomalla (military policemen), John Carr (registrar), John Michie (soldier), Jeanette Moseley (barmaid), Ina Clough (licensee), Chris Benson, Judith Barker, Tom Williamson, Lorraine Michaels (Rose's family)
Running time: 84 minutes

SCANDAL 1989
Director: Michael Caton-Jones
Production: Stephen Woolley, for Palace Pictures, Miramax and British Screen
Screenplay: Michael Thomas
Photography: Mike Molloy
Editing: Angus Newton
Music: Carl Davis
Production Design: Simon Holland
Costumes: Jane Robinson
Sound: David John, Eddy Joseph (editor)
Cast: John Hurt (Stephen Ward), Joanne Whalley-Kilmer (Christine Keeler), Bridget Fonda (Mandy Rice-Davies), Ian Mckellen (John Profumo), Leslie Phillips (Lord Astor), Britt Ekland (Mariella Novotny), Daniel Massey (Mervyn Griffith-Jones), Roland Gift (Johnnie Edgecomb), Jean Alexander (Mrs. Keeler), Paul Brooke (Detective-Sergeant), Ronald Fraser (Justice Marshal), Alex Norton (Detective-Inspector), Jeroen Krabbé (Eugene Ivanov), Keith Allen (Kevin), Ralph Brown (Paul Mann), Ken Campbell (Editor of 'Pictorial'), Iain Cuthbertson (Lord Hailsham), Susannah Doyle (Jackie), Joanna Dunham (Lady Astor), Trevor Eve (matinée idol), Oliver Ford Davies (Mr Woods), Deborah Grant (Valerie Profumo), Valerie Griffiths (landlady), Czeslaw Grocholski (Polish gent), Leon Herbert (Lucky Gordon), Chris Humphreys (Clive), Stefan Kalipha (Hanif), Tacy Kneale (Jennifer), Tony Mathews (Press Secretary), Richard Morant (D'laszlo), Mia Nadasi (Olga), Jeff Nuttall (Percy Murray), Sarah Prince (Mr. Woods' secretary), Ann Queensberry (Mrs Hare), Raad Rawi (Aziz), Terence Rigby (James Burge), Jennifer Scott Malden (Jilly), Johnny Shannon (Peter Rachman), Malcolm Terris (northern gent), Joan Turner (plump neighbour), Doremy Vernon (head girl), James Villiers (Conservative MP), Alison Waters (Joanie), Susie Ann Watkins (redhead), Arkie Whitely (Vicky), Tariq Yunus (Ayub Khan), Tony Shiletto, Colette Dolan, Jackie Harvey, Kate Charmen (Murray's dancers), Chevalier Brothers (Murray's Band): Mark Adelman, Ray Irwin, Patrice Serapiglia (band members)
Running time: 115 minutes

THE MIRACLE 1991
Director: Neil Jordan
Production: Stephen Woolley, Bob Weinstein and Harvey Weinstein, for Palace Pictures in association with Film Four International and British Screen
Screenplay: Neil Jordan
Photography: Philippe Rousselot
Editing: Joke Van Wijk

Music: Anne Dudley
Production Design: Gemma Jackson
Costumes: Sandy Powell
Sound: Kant Pan (super ed), Chris Ackland and Colin Nicholson
Cast: Beverly D'Angelo (Renee), Donal McCann (Sam), Nial Byrne (Jimmy), Lorraine Pilkington (Rose), J. G. Devlin (Mr Beausang), Cathleen Delaney (Miss Strange), Tom Hickey (Tommy), Shane Connaughton (Rose's father), Mikkel Gaup (Jonner), Sylvia Teron (muscular lady), Anita Reeves (ballroom singer), Ger O'Leary (barman), Earl Gill, Johnny Devlin, Chris Kenevey, Tommy Donaghue (Sam's band); 'Destry Rides Again': Patrick Mason (director), Stephen Brennan, Martin Dunne, Stanley Townsend, Dermod Moore, Mary Coughlan, Mal Whyte, Darragh Kelly, Alan Archbold, the Clane Musical Society (members of cast)
Running time: 97 minutes

ORLANDO 1993
Director: Sally Potter
Production: Christopher Shepherd for Adventure Pictures (London), Lenfilm (St Petersburg), Rio (Paris), Mikado Film (Rome), Sigma Film Productions (Maarsson)
Screenplay: Sally Potter
Photography: Aleksei Rodionov
Editing: Herve Schneid
Music: David Motion and Sally Potter
Production Design: Ben Van Os and Jan Roelfs
Costumes: Sandy Powell
Sound: Kant Pan (Super), Martin Evans and Jean-Louis Ducarme
Cast: (Tilda Swinton) Orlando, Billy Zane (Shelmerdine), John Wood (Archduke Harry), Lothaire Bluteau (The Khan), Charlotte Valandrey (Sasha), Heathcote Williams (Nick Greene/Publisher), Quentin Crisp (Queen Elizabeth I), Dudley Sutton (King James I), Thom Hoffman (King William of Orange), Anna Healy (Euphrosyne), Anna Farnworth (Clorinda), Simon Russell Beale (Earl of Moray), Matthew Sim (Lord Francis Vere), Mary Macleod, Barbara Hicks (women), Toby Stephens (Othello), Jerome Willis (translator), Oleg Pogodin (Desdemona), Viktor Stepanov (Russian ambassador), Aleksander Medvedev (Russian sailor), John Bolt (Orlando's father), Elaine Banham (Orlando's mother), Kathryn Hunter (countess), Peter Eyre (Mr Pope), Ned Sherrin (Mr Addison), Roger Hammond (Mr Swift), Lol Coxhill, Hugh Munro, Terence Soall (butlers), George Yiasoumi, Toby Jones, Robert Demeger (valets), Thom Osborn (doctor), Jimmy Somerville (singer/angel), Giles Taylor (singing valet), Andrew Watts (counter tenor), Peter Hayward (harpsichordist), John Grillo, Martin Wimbush (officials), Sarah Crowden (Queen Mary), Olivia Lancelot (young woman), Cyril Lecomte (young man), Jessica Swinton (Orlando's daughter), John Byrne (courtier)
Running time: 93 minutes

DIVORCING JACK 1998
Director: David Caffrey
Production: Robert Cooper, for BBC Films, Winchester Films, Scala, with Arts Councils of England and of Northern Ireland, IMA Films, Le Studio Canal
Screenplay: Colin Bateman, from his novel
Photography: James Welland
Editing: Nick Moore
Music: Adrian Johnston
Production Design: Claire Kenny
Costumes: Pam Tait
Sound: Andy Kennedy (super), Mervyn Moore (recordist)
Cast: David Thewlis (Dan Starkey), Rachel Griffiths (Lee Cooper), Jason Isaacs ('Cow Pat' Keegan), Laura Fraser (Margaret), Richard Gant (Charles Parker), Laine Megaw (Patricia Starkey), Robert Lindsay (Michael Brinn, Prime

Minister), Kitty Aldridge (Agnes Brinn), Bronagh Gallagher (taxi driver), Adam Black (young Dan), Simon Magill (Starkey's brother), George Shane (Woods), Alan McKee (Mouse), Strapper (Patch), Brian Devlin (Paul), Sean Caffrey (Joe), Birdy Sweeney (lift attendant), Katie Tumelty (reporter), Ian McElhinney (Alfie Stewart), B. J. Hogg (Billy McCoubrey), Gerard Quinn (pizza shop boy), Dale Kirkpatrick (Robert Brinn), Jonathan Collier (voice of Robert Brinn), Philip Young (skinhead), Thomas Hourican (sod), Danny Kelly ('space hopper' man), Frank Mannion (Finbar Kelly), Colin Murphy (Giblet O'Gibber), John Linehan (announcer), Barbara Adair (old woman), Paddy Rocks (Mad Dog), Derek Halligan (Frankie), Patrick Duncan (waiter), Dick Holland (crony), James Duran (hood), Norman Hagan (balaclava), John Keegan (Father Flynn), Brendan McNally (postal), Robert Cooper (civil servant), Alison Black, Alec Fennell, Christine Bleakley, Stephen Nolan, Chris Buckler (radio newsreaders)
Running time: 109 minutes

ORDINARY DECENT CRIMINAL 2000
Director: Thaddeus O'Sullivan
Production: Jonathan Cavendish, for Icon Entertainment/Little Bird, in association with Tatfilm, Trigger Street Productions, Bord Scannán na hÉireann, the Irish Film Board, the Greenlight Fund, Filmstiftung NRW, Miramax Films
Screenplay: Gerard Stembridge
Photography: Andrew Dunn
Editing: William Anderson
Music: Damon Albarn
Production Design: Tony Burrough
Costumes: Jane Robinson
Sound: Mike Wood (super), Kieran Horgan (recordist)
Cast: Kevin Spacey (Michael Lynch), Linda Fiorentino (Christine Lynch), Peter Mullan (Stevie), Stephen Dillane (Noel Quigley), Helen Baxendale (Lisa), David Hayman (Tony Brady), Patrick Malahide (Commissioner Daly), Gerard McSorley (Harrison), David Kelly (Father Grogan), Gary Lydon (Tom Rooney), Paul Ronan (Billy Lynch), Colin Farrell (Alec), Vincent Regan (Shay Kirby), Tim Loane (Jerome Higgins), Christoph Waltz (Peter), Bill Murphy (Barry), Tony Coleman (Con), Barry Barnes (Larry), Anthony Brophy (Liam), Paul Roe (Luke), Paul Hickey (Ger), Tom Maguire (Lenny), Joe Gallagher (dole office clerk), Herbert Knaup (De Heer), Alan Devlin (Lord Mayor), Jer O'Leary (Padraig Lynch), Hugh B. O'Brien (Flinton Doorley), Gerard Lee (desk sergeant), Conor Evans, Des Braidon (judges), Conor Mullen (McHale), Enda Oates (Brian), Anne Cassin (news reporter), Dave Fanning (radio presenter), Ann O'Neill (country shopkeeper), Jonathan Shankey (man outside bank), Bronco McLoughling (Mr Harmless), Angel McLoughlin (Mrs Harmless), Tanzin Shaw (Mrs Hippy), Ross Dungan (Tommy Lynch), Sarah Barrett (Breda Lynch), Alex Hayes (Shane Lynch), Darragh Mullen (Eddie), Maeve De Blacam (Niamh), Eva Barrett (Oonagh), Mary Driscoll (judge's daughter), Michael Hayes (her boyfriend), Rory Egan, Leonard Hayden, Brendan Morrisey, Sarah Pilkington, Mario Rosenstock (journalists)
Running time: 93 minutes

SWEET SIXTEEN 2002
Director: Ken Loach
Production: Paul Laverty, for Sixteen Films, Road Movies Filmproduktion, Tornasol Films, Alta Films, Scottish Screen, BBC Films.
Screenplay: Paul Laverty
Photography: Barry Ackroyd
Editing: Jonathan Morris
Music: George Fenton
Production Design: Martin Johnson
Costumes: Carole K. Millar
Sound: Kevin Brazier (super), Ray Beckett (recordist)

Cast: Martin Compston (Liam), Annemarie Fulton (Chantelle), William Ruane (Pinball), Michelle Abercromby (Suzanne), Michelle Coulter (Jean), Gary McCormack (Stan), Tommy McKee (Rab), Calum McAlees (Calum), Robert Rennie (Scullion), Martin McCardie (Tony), Robert Harrison, George McNellage, Rikki Traynor (Tony's gang), Jon Morrison (Douglas), Junior Walker (Night-Time), Gary Maitland (Side-Kick), Scott Dymond (Davi-Vampire), Mark Dallas, Stephen McGivern, Robert Muir (pizza boys), Matt Costello (motor bike policeman), Sandy Hewitt (truck driver), Lily Smart (barmaid), Bruce Sturrock (caravan site manager), William Cassidy, Robert McFadyen, Stephen Purdon (muggers), Tony Collins (old pizza man), Marie Shankley (woman on stairs)
Running time: 105 minutes

BIBLIOGRAPHY

note:
This bibliography contains only books, not journal articles. It also stresses books that provide various kinds of background to the chapters which make up the body of the present volume, in additon to the references given at the end of each of the chapters; thus there is little intention here to be comprehensive in relation to British or Irish cinema at large.

BRITAIN

Adair, G. and N. Roddick (1985) *A Night at the Pictures: Ten Decades of British Film*. Bromley: Columbus Books.

Aitken, I. (ed.) (1998) *The Documentary Movement: An Anthology*. Edinburgh: Edinburgh University Press.

Aldgate, A. (1995) *Censorship and the Permissive Society: British Cinema and Theatre 1955-1965*. Oxford: Clarendon Press.

Allon, Y., D. Cullen and H. Patterson (eds) (2001) *Contemporary British and Irish Film Directors*. London: Wallflower Press.

Armes, R. (1978) *A Critical History of British Cinema*. London: Secker and Warburg.

Ashby, J. and A. Higson (eds) (2000) *British Cinema, Past and Present*. London: Routledge.

Babington, B. (2001) *British Stars and Stardom*. Manchester: Manchester University Press.

Barr, C. (ed.) (1986) *All Our Yesterdays: 90 Years of British Cinema*. London: British Film Institute.

_____ (1997 [1977]) *Ealing Studios* (revised edition). London: Cameron & Tayleur/David & Charles.

Betts, E. (1973) *The Film Business: A History of British Cinema 1896–1972*. London: George Allen & Unwin.

Bourne, S. (1998) *Black in the British Frame: Black People in British Film and Television 1896–1996*. London: Cassell.

_____ (1996) *Brief Encounters: Lesbians and Gays in British Cinema 1930–1971*. London: Cassell.

British Film Institute (1983–) *BFI Film and Television Handbook*. London: British Film Institute.

Bruce, D. (1996) *Scotland the Movie*. Edinburgh: Polygon.

Burrows, E., J. Moat, D. Sharp and L. Wood (1995) *The British Source Book: BFI Archive Viewing Copies and Library Materials*. London: British Film Institute.

Burton, A. and J. Petley (eds) (1988) *Journal of Popular British Cinema: No. 1 Genre and British Cinema*. Trowbridge: Flicks Books.

Caughie, J. and K. Rockett (1996) *The Companion to British and Irish Cinema*. London: Cassell.

Chibnall, S. and R. Murphy (eds) (1998) *British Crime Cinema*. London: Routledge.

Cook, C. (ed.) (1992) *The Dilys Powell Film Reader*. Oxford: Oxford University Press.

Cook, P. (1996) *Fashioning the Nation: Costume and Identity in British Cinema*. London: British Film Institute.

_____ (ed.) (1997) *Gainsborough Pictures*. London: Cassell.

Cross, R. (1984) *The Big Book of British Cinema*. London: Charles Herridge.

Curran, J. and Porter, V. (eds.) (1983) *British Cinema History*. London: Weidenfeld and Nicholson

Dickinson, M. and Street, S. (1985) *Cinema and State: The Film Industry and the British Government 1927–84*. London: British Film Institute.

Dixon, W. W. (ed.) (1994) *Re-viewing British Cinema 1900–1992*. Albany, NY: State University of New York Press.

Docherty, D., D. Morrison and M. Tracy (1987) *The Last Picture Show? Britain's Changing Film Audiences*. London: British Film Institute.

Drazin, C. (1998) *The Finest Years: British Cinema of the 1940s*. London: André Deutsch.

Durgnat, R. (1970) *A Mirror for England: British Movies from Austerity to Affluence*. London: Faber and Faber.

Eberts, J. and T. Ilott (1990) *My Indecision is Final*. London: Faber and Faber.

Everett, W. (2004) *Terence Davies*. Manchester: Manchester University Press.

Eyles, A., R. Adkinson and N. Fry (eds) (1984) *The House of Horror: The Story of Hammer Films*. London: Lorrimer.

Falk, Q. (1987) *The Golden Gong: Fifty Years of the Rank Organisation*. London: Columbus Books.

Finney, A. (1996) *The Egos Have Landed: The Rise and Fall of Palace Pictures*. London: Heinemann.

Forman, D. (1951) *Films 1945–1950*. London: Longmans.

Friedman, L. (ed.) (2006) *Fires Were Started: British Cinema and Thatcherism* (second edition). London: Wallflower Press.

Geraghty, C. (2000) *British Cinema in the Fifties: Gender, Genre and the 'New Look'*. London and New York: Routledge.

Gifford, Denis (2001 [1986]) *The British Film Catalogue (third edition): Volume 1 – Fiction Film, 1895–1994; Volume 2 – Non-Fiction Film, 1888–1994*. London: Fitzroy Dearborn.

Gillett, P. (2003) *The British Working Class in Post-war Film*. Manchester: Manchester University Press.

Hacker, J. and D. Price (1991) *Take Ten: Contemporary British Film Directors*. Oxford: Clarendon Press.

Harper, S. (2000) *Women in British Cinema: Mad, Bad and Dangerous to Know*. London and New York: Continuum.

Harper, S. and V. Porter (2004) *British Cinema of the 1950s*. Oxford: Oxford University Press.

Higson, A. (1995) *Waving the Flag: Constructing a National Cinema in Britain*. Oxford: Clarendon Press.

____ (ed.) (1996) *Dissolving Views: Key Writings on British Cinema*. London: Cassell.

____ (ed.) (2002) *Young and Innocent? The Cinema in Britain 1896–1930*. Exeter: University of Exeter Press.

Hill, J. (1999) *British Cinema in the 1980s: Issues and Themes*. Oxford: Clarendon Press.

____ (1986) *Sex, Class and Realism: British Cinema 1956–63*. London: British Film Institute.

Hill, J., M. McLoone and P. Hainsworth (eds) (1994) *Border Crossing: Film in Ireland, Britain and Europe*. Belfast/London: Institute of Irish Studies/British Film Institute.

Hutchings, P. (1973) *Hammer and Beyond: The British Horror Film*. Manchester: Manchester University Press.

Kelly, T., G. Norton and G. Perry (1966) *A Competitive Cinema*. London: Institute of Economic Affairs.

Landy, M. (1991) *British Genres: Cinema and Society, 1930–1960*. Princeton: Princeton University Press.

Lay, S. (2002) *British Social Realism: From Documentary to Brit Grit*. London: Wallflower Press.

Low, R. *The History of the British Film* (7 volumess): Vol. 1 *1896–1906* (1948), Vol. 2 *1906–1914* (1949), Vol. 3 *1914–1918* (1950), Vol. 4 *1918–1929* (1971), Vol. 5 *Documentary and Educational Films of the 1930s* (1979), Vol. 6 *Films of Comment and Persuasion* (1979), Vol. 7 *Filmmaking in 1930s Britain* (1985). London: Allen & Unwin/British Film Institute (earlier editions); Routledge (1997).

____ (1971) *The History of the British Film, 1918–1929*. London: George Allen & Unwin.

____ (2003) *The Encyclopedia of British Film*. London: Methuen/British Film Institute.

Macnab, G. (1993) *J. Arthur Rank and the British Film Industry*. London: Routledge.

____ (2000) *Searching for Stars: Stardom and Screen Acting in British Cinema*. London: Cassell.

MacPherson, D. (1980) *Traditions of Independence: British Cinema in the Thirties*. London: British Film Institute.

McArthur, C. (ed.) (1982) *Scotch Reels: Scotland in Cinema and Television*. London: British Film Institute.

McFarlane, B. (1992) *Sixty Voices: Celebrities Recall the Golden Age of British Cinema*. London: British Film Institute.

____ (1997) *An Autobiography of British Cinema as Told by the Filmmakers and Actors Who Made It*. London: Methuen/British Film Institute.

____ (2005) *The Encyclopeadia of British Cinema* (second edition). London: Methuen/British Film Institute.

Meikle, D. (1996) *A History of Horrors: The Rise and Fall of the House of Hammer*. Lanham, MD/London: Scarecrow Press.

Murphy, R. (2001) *The British Cinema Book*, London: British Film Institute.

____ (2001) *British Cinema and the Second World War*. London and New York: Continuum.

____ (1989) *Realism and Tinsel: Cinema and Society in Britain 1939–1948*. London: Routledge.

____ (1992) *Sixties British Cinema*. London: British Film Institute.

____ (ed.) (2000) *British Cinema of the 90s*. London: British Film Institute.

Oakley, C. (1964) *Where We Came In: The Story of the British Cinematograph Industry*. London: Allen & Unwin.

Owen, G. and B. Burford (2000) *The Pinewood Story*. Richmond, Surrey: Reynolds & Hearn.

Palmer, S. (1988) *British Film Actors' Credits*. Jefferson, NC/London: McFarland.

Park, J. (1990) *British Cinema: The Lights That Failed*. London: B. T. Batsford.

____ (1984) *Learning to Dream: The New British Cinema*. London and Boston: Faber and Faber.

Parkinson, D. (ed.) (1993) *The Graham Greene Film Reader: Mornings in the Dark*. Manchester: Carcanet Press.

Perry, G. (1974) *The Great British Picture Show*. London: Pavilion Books.

Petrie, D. (1996) *The British Cinematographer*. London: British Film Institute.

____ (1990) *Creativity and Constraint: Contemporary British Cinema*. London: MacMillan

____ (2000) *Screening Scotland*. London: British Film Institute.

Pettigrew, T. (1982) *British Character Actors: Great Names and Memorable Moments*. London: David and Charles.

Pirie, D. (1973) *A Heritage of Horror: The English Gothic Cinema 1946–1972*. London: Gordon Fraser.

Quinlan, D. (1984) *British Sound Films: The Studio Years*. London: B. T. Batsford.

Richards, J. (1984) *The Age of the Dream Palace: Cinema and Society in Britain 1929–39*. London: Routledge and Kegan Paul.

____ (1997) *Films and British National Identity*. Manchester: Manchester University Press.

____ (ed) (1998) *The Unknown 1930s: An Alternative History of the British Cinema 1929–39*. London: I. B. Tauris.

Richards, J. and A. Aldgate (1999) *Best of British: Cinema and Society 1930–1970*. London: I. B. Tauris.

Robertson, J. C. (1989) *The Hidden Cinema: British Film Censorship in Action, 1913–1972*. London: Routledge.

Rotha, P. (1973) *Documentary Diary: An Informal History of the British Documentary Film, 1928–1939*. London: Hill and Wang.

Rotha, P. (ed.) (1975) *Richard Winnington: Film Criticism and Caricatures 1943–53*. London: Elek.

Ryall, T. (1986) *Alfred Hitchcock and the British Cinema*. London: Athlone.

____ (2001) *Britain and the American Cinema*. London: Sage.

Ryan, P. (ed.) (2004) *Never Apologise: The Collected Writings of Lindsay Anderson*. London: Plexus.

Sellar, M. (1987) *Best of British*. London: Sphere Books.

Shafer, S. (1997) *British Popular Films 1929–39: The Cinema of Reassurance*. London: Routledge.

Sinyard, N. (2000) *Jack Clayton*. Manchester: Manchester University Press.

Sinyard, N. and I. McKillop (eds) (2002) *British Cinema in the 50s: A Celebration*. Manchester: Manchester University Press.

Spicer, A. (2001) *Typical Men: The Representation of Masculinity in Popular British Cinema*. London: I. B. Tauris.

Street, S. (2000) *British Cinema in Documents*. London: Routledge.

____ (1997) *British National Cinema*. London: Routledge.

____ (2002) *Transatlantic Crossings: British Feature Films in the USA*. London and New York: Continuum.

Sussex, E. (1975) *The Rise and Fall of British Documentary: The Story of the Film Movement Founded by John Grierson*. Berkeley, Los Angeles and London: University of California Press.

Sutton, D. (2000) *A Chorus of Raspberries: British Film Comedy 1929–1939*. Exeter: University of Exeter Press.

Taylor, J. R. and J. Kobal (1985) *Portraits of the British Cinema*. London: Aurum.

Threadgall, D. (1994) *Shepperton Studios: An Independent View*. London: British Film Institute.

Trevelyan, J. (1973) *What the Censor Saw*. London: Michael Joseph.

Vermilye, J. (1978) *The Great British Films*. Secaucus, NJ: Citadel.

Walker, A. (1986) *Hollywood England: British Cinema in the Sixties*. London: Harrap.

____ (1985) *National Heroes: British Cinema in the Seventies and Eighties*. London: Harrap.

Warren, P. (1993) *British Cinema in Pictures: The British Film Collection*. London: B. T. Batsford.

____ (2001) *British Film Studios: An Illustrated History* (revised edition). London: B. T. Batsford.

Warren, P. (1983) *Elstree: The British Hollywood*. London: Elm Tree Books.

Williams, T. (2000) *Structures of Desire: British Cinema 1939–1955*. Albany, NY: State University of New York Press.

IRELAND

Allon, Y., D. Cullen and H. Patterson (eds) (2001) *Contemporary British and Irish Film Directors*. London: Wallflower Press.

Barton, R. and H. O'Brien (eds) (2004) *Keeping it Real: Irish Film and Television*. London: Wallflower Press.

Caughie, J. and K. Rockett (1996) *The Companion to British and Irish Cinema*. London: Cassell.

Hill, J., M. McLoone and P. Hainsworth (eds) (1994) *Border Crossing: Film in Ireland, Britain and Europe*. Belfast/London: Institute of Irish Studies/British Film Institute.

McIlroy, B. (1989) *World Cinema 4: Ireland*. Trowbridge: Flicks Books.

McKillop, J. (ed.) (1999) *Contemporary Irish Cinema*. Syracuse, NY: Syracuse University Press.

McLoone, M. (2000) *Irish Film: The Emergence of a Contemporary Cinema*. London: British Film Institute.

Rockett, E. and R, Rockett (2003) *Neil Jordan: Exploring Boundaries*. Dublin: The Liffey Press.

Rockett, K. (1996) *The Irish Filmography: Fiction Films 1896–1996*. Dublin: Red Mountain Press.

_____ (2003) *Ten Years After: The Irish Film Board 1993–2003*. Dublin: The Irish Film Board.

Rockett, K., L. Gibbons and J. Hill (1988) *Cinema and Ireland*. London: Routledge.

INDEX